Praise for the novels of

WILBUR SMITH

'Read on, adventure fans.'
NEW YORK TIMES

'A rich, compelling look back in time [to]
when history and myth intermingled.'
SAN FRANCISCO CHRONICLE

'Only a handful of 20th century writers tantalize
our senses as well as Smith. A rare author who
wields a razor-sharp sword of craftsmanship.'
TULSA WORLD

'He paces his tale as swiftly as he can with
swordplay aplenty and killing strokes that come
like lightning out of a sunny blue sky.'
KIRKUS REVIEWS

'Best Historical Novelist – I say Wilbur Smith, with his
swashbuckling novels of Africa. The bodices rip and the
blood flows. You can get lost in Wilbur Smith and
misplace all of August.'
STEPHEN KING

'Action is the name of Wilbur Smith's game
and he is the master.'
WASHINGTON POST

'Smith manages to serve up adventure, history and melodrama in one thrilling package that will be eagerly devoured by series fans.'

'This well-crafted novel is full of adventure, tension, and intrigue.'

'Life-threatening dangers loom around every turn, leaving the reader breathless . . . An incredibly exciting and satisfying read.'

'When it comes to writing the adventure novel, Wilbur Smith is the master; a 21st century H. Rider Haggard.'

Wilbur Smith was born in Central Africa in 1933. He became a full-time writer in 1964 following the success of *When the Lion Feeds*, and has since published over forty global best-sellers, including the Courtney Series, the Ballantyne Series, the Egyptian Series, the Hector Cross Series and many successful standalone novels, all meticulously researched on his numerous expeditions worldwide. A worldwide phenomenon, his readership built up over fifty-five years of writing, establishing him as one of the most successful and impressive brand authors in the world.

The establishment of the Wilbur & Niso Smith Foundation in 2015 cemented Wilbur's passion for empowering writers, promoting literacy and advancing adventure writing as a genre. The foundation's flagship program is the Wilbur Smith Adventure Writing Prize.

Wilbur Smith passed away peacefully at home in 2021 with his wife, Niso, by his side, leaving behind him a rich treasure-trove of novels and stories that will delight readers for years to come.

For all the latest information on Wilbur Smith's writing visit www.wilbursmithbooks.com or facebook.com/WilburSmith

Mark Chadbourn is a *Sunday Times* bestselling author of historical fiction novels about the Anglo-Saxon warrior Hereward, published under his pseudonym James Wilde. His *Age of Misrule* books, under his own name, have been translated into many languages. As a screenwriter, he's written for the BBC and is currently developing a series for Lionsgate and several of the streaming networks. He began his career as a journalist reporting from the world's hotspots.

WILBUR SMITH

WITH

MARK CHADBOURN

THE NEW KINGDOM

ZAFFRE

Copyright © Orion Mintaka (UK) Ltd. 2022

All rights reserved, including the right of reproduction in whole or in part in any form.
First published in the United States of America in 2022 by Zaffre,
an imprint of Bonnier Books UK

Typeset by IDSUK (Data Connection) Ltd
Printed in the USA

10 9 8 7 6 5 4 3 2 1

Paperback ISBN: 978–1–8387–7440–0
Digital ISBN: 978–1–8387–7439–4

For information, contact
251 Park Avenue South, Floor 12, New York, New York 10010
www.bonnierbooks.co.uk

SUSTAINABLE
FORESTRY
INITIATIVE

Certified Sourcing

www.forests.org
SFI-01984

For Mokhiniso

You mended my heart and gave me the strength of an army

Thank you for pushing me to be the best writer I can be

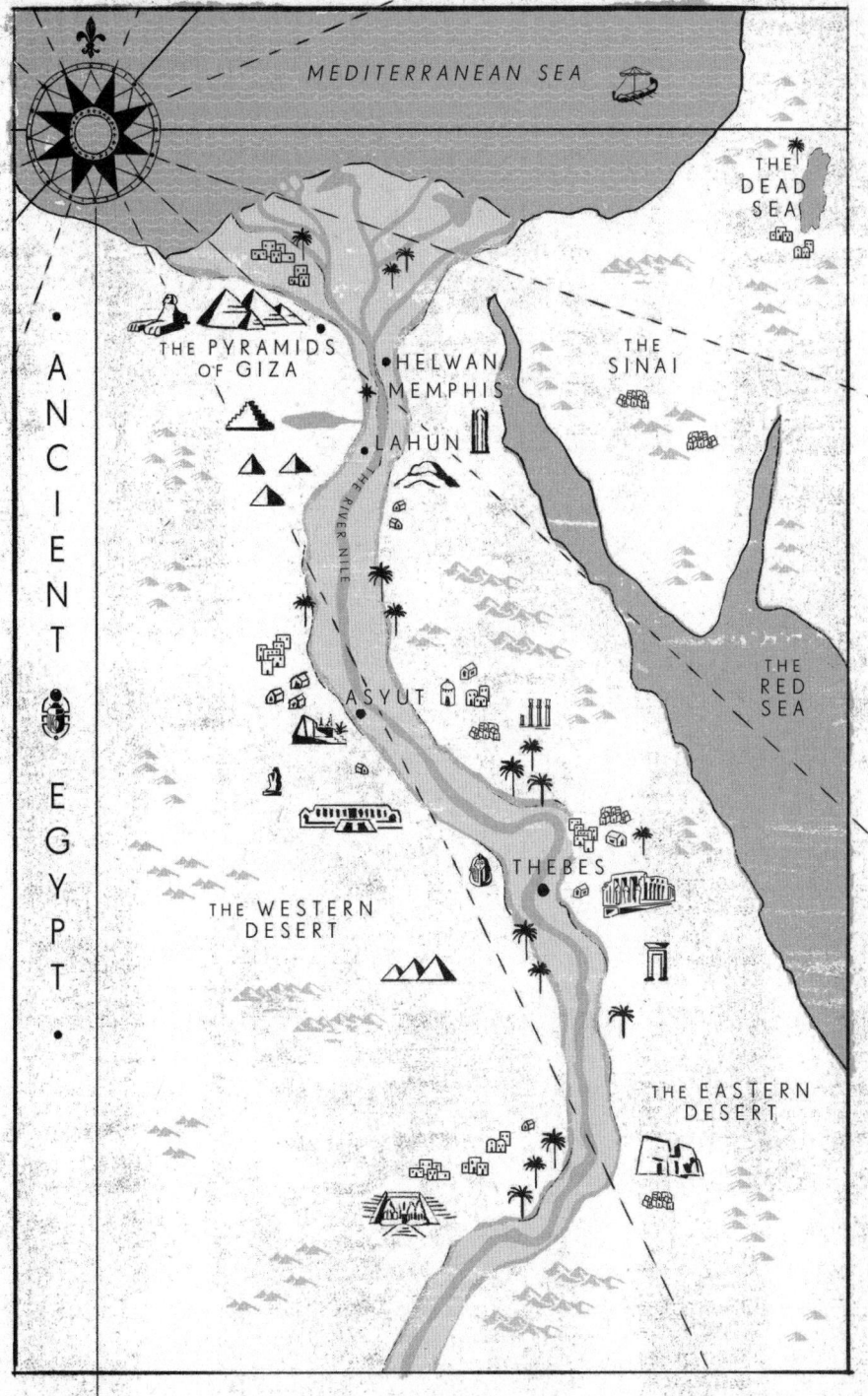

Dear Reader,

One of the most satisfying surprises of my career was the success of *River God* and the novels that followed in the Ancient Egyptian Series: *The Seventh Scroll*, *Warlock*, *The Quest*, *Desert God* and *Pharaoh*. When a publisher first expressed interest in working with me and co-authors to explore untold Taita yarns, I was excited by their interest and the ensuing publicity, and was ready to revisit my own Ancient Egypt. I re-read the series and discovered a gap and saw vividly in my imagination what Taita was up to. It was in this space between *River God* and *Warlock* where *Desert God* and *Pharaoh* now stand. It was a good feeling to spend more time with Taita. Some claim he is my alter-ego (but that is a matter between Taita and myself).

Egypt had always fascinated me, it was the crossroads of the continents, the foundation of the history of civilization – it all happened there. The Hyksos invasion was a time of confusion and chaos, which was why I was able to indulge my imagination by filling in the gaps of that period.

One of the pleasures of communicating with my fans is the questions they ask me on social media. They want to know so much more about the world of *River God*. When I finished re-reading the Egyptian Series, I realised that in all six novels I was so totally focused on Taita's first person narrative and his quest to protect the Two Kingdoms that I had totally missed a secondary character who earned a stage of his own and could offer another view of that extraordinary time.

You may recall Hui, the young bandit who becomes the Pharaoh's best charioteer, training an army to regain the throne against Hui's own people. Hui's story runs parallel to the world of *River God* and I hope you will find the cameo from Taita

satisfying. It's a story of vengeance, as Hui plots against his brother Qen. Keep an eye out for another personal favourite of mine from *River God*. The Easter eggs are there to be found and savoured for my old and new readers. I hope you enjoy this new series as much as I did plotting it and co-writing it.

As ever,
Wilbur Smith

The two men clambered across the high ground under the watchful eye of the gods. At the summit, the barren landscape rolled out, silvered by moonlight and carved by shadow. A cool breeze blew from the east, ripe with the earthy aromas of the lush vegetation swelling around the Nile.

They were friends from their earliest days. Of the two, Hui was the braver. He wore no more than a linen kilt, wrapped around him and knotted at the waist, showing off limbs that were hard and strong. In Lahun, the home they had crept away from at sunset, many still thought of him as a child. Hui blamed his youthful features, which still glowed with innocence – cheeks a little too plump, no worry lines around his mouth or on his forehead. A child! Seventeen, he was! He wrinkled his nose. Those detractors would be proved wrong soon enough.

'Do you see it?' Kyky said in a tremulous voice.

His nickname meant 'monkey', for that was what he resembled, with thin arms that seemed to reach almost to his knees, and a small face with big dark eyes.

Hui pressed a finger to his lips. Crouching, he craned his neck to stare at the stars flowing across the sky. Yes, the gods were always watching, every fool knew that. He trembled under the weight of those glittering eyes.

A grand destiny lay ahead of him, if those higher powers were willing, and tonight he would take his first step along that road to glory.

The eerie barking they had heard on the climb echoed again, closer this time, and his heart hammered.

Hui looked around the jagged teeth of the rocks on the hills where he had followed the old desert wanderers' tracks, to the undulating waves of the desert sands to the west. Squinting towards the east, he could make out the faintest glimmer of the Great River mirroring that sweep of twinkling stars overhead.

That otherworldly yowling rang out again, almost at his elbow this time, and Hui jumped to his feet.

'What is that?' Kyky whined. He grabbed Hui's shoulder, his eyes widening.

Hui let out what he hoped was a comforting laugh. 'Stay strong, my friend.'

'You dragged us to this lonely place, far from the safety of our homes, and now you tell me not to be afraid?' Kyky jabbered. 'The old men on the benches by the walls say the hills are haunted. Demons walk here.'

Hui choked back his scorn as Kyky reached out a trembling finger. A silhouette was rising behind a rib of brown rock. Twin horns stabbed up from the head. Coldly glimmering eyes stared at them. That mournful barking rolled out again.

Kyky clutched his face and whimpered, 'Oh, Hui, you have doomed us.'

Hui stiffened. He would stand his ground, even though his legs were shaking, for that is what great leaders did.

The silhouette eased up further until the moonlight burned the darkness from it, and Hui sagged with relief. Those horns were long, pointed ears, the narrow face and almond eyes feline. It was a desert cat. He'd seen one only once before, but he'd heard they barked like dogs instead of purring or hissing.

Slapping his hands on his thighs, Hui convulsed with laughter, then hurled a stone to frighten the cat away.

'We are jumping at shadows,' he chuckled.

'And can you blame us?'

'This is a night for momentous things—'

'A night where fools get their comeuppance, more like.' Kyky kicked up a whirl of sand in defiance. 'We are more likely to get our throats slit and be left as a feast for the vultures.'

Hui couldn't argue with that. But he showed a cheerful face for his friend's sake.

'You'll sing a different song when we return with a gift from the gods.'

'*If* we return.'

'Courage, little monkey!' Hui said, clapping an arm around his friend's shoulders. 'Let the fire in your belly roar! This night your life will change.' When he saw Kyky screw up his nose, he added with haste, 'For the better, of course. Girls will fall to their knees before you, begging you to take them. The bullies who've tormented you all your life will bow their heads in deference. You will be a king amongst men. Embrace this moment.'

Kyky shook his head. 'It is too dangerous. We should turn back.'

Hui smiled to hide his frustration. He had more persuading to do.

'And lose a prize beyond all value?' He scrambled onto a boulder and pointed towards the stars. '"A fire blazing across the sky" – that's what the old desert wanderer said. Where it crashed upon the earth, the sand was turned to glass and at the centre of a wide crater was a black stone. The Ka Stone, the desert wanderer called it. Not the Ka Stones that are left in the tombs, no. One filled with the essence of the gods. Why, he told me himself it had magical powers. Some say it could make a man fly with the birds, if he utters the right prayers.

Others that it raises the phantoms of those denied a place in the afterlife—'

'Some say, some say.' Kyky paced impatiently. 'And why did that old desert wanderer not benefit from this magic himself? Because it was stolen from him – dragged from dead fingers when every man who walked beside him was slaughtered.' Kyky threw his hands into the air. 'Stolen by the Shrikes! The most bloodthirsty bandits in all Egypt. And now you want to steal the stone back from them. Madness. Why did I ever listen to you?'

Hui turned away, pretending to search for the track through the jumble of rock and dust. Kyky was tired and irritable from the trek, but there was truth in his words. Hui couldn't deny he'd been swallowing his own apprehension that now fluttered in his belly like a small bird. For all his bravado, he knew the risks. To rob a robber, that was one thing. To sneak into the camp of the Shrikes and steal their most prized possession . . . well, Kyky was right for once. That was lunacy.

Stay calm, Hui thought. *You are brave.*

Hui raised his eyes to the heavens again and searched the constellations until he found the Four Sons of Horus – there, just as his father had pointed out to him when he was a boy. His guide. His destiny. He felt comforted.

He thought back to the white walls of Lahun, when he had met the lone desert wanderer begging for bread to fill his empty stomach. Wrapped in black robes, with a scarf tied around his head, the man had a face as wind-blasted and sunburned as the wastes through which those *habiru* travelled. In exchange for a dry crust, he'd told Hui of the Ka Stone and the attack on his caravan. Hui's eyes had lit up when he heard the potential in the story. It could be nothing, of course. Those tribes of wanderers loved their tales. But if true, the gods had presented

Hui with a chance to seize something greater than he had ever known – for himself, for his father and family, for Lahun.

He didn't dare speak of it widely. His father, Khawy, would have banished him to his room – the dangers were too great. The bandits had left trails of blood across all of Egypt. Yet he imagined the Shrikes' camp in the hills, swollen by captured girls to be sold into slavery, and vast tents filled with unimaginable booty from their raids along the Nile's fringe south of Dahshur. The bandits would no doubt be drunk, celebrating their great success and basking in the certainty that they were the ones who would be blessed by the gods. Drunk, and sleeping it off, and too stupefied to notice little rats scurrying amongst their tents to relieve them of their great prize.

Hui leaped from his rock. 'Nothing great was ever gained by timid hearts. But if you wish to turn back, I cannot stand in your way.'

Kyky looked down the hillside to the empty wastes.

'Alone?'

'Or you could follow me towards a great destiny. Think – a gift from the gods themselves. What eminence would be heaped upon the man who brought that back to Lahun? Why, even Pharaoh himself would shine his magnificence upon such a hero. Or heroes.'

Kyky bowed his head, undecided. 'I am content with my lot. Hero sounds like a dangerous title. No, tell me once more what we stand to gain by risking our necks? Something I can hold in my hands.'

'Riches beyond your wildest imaginings. Something so blessed, so rare, will be coveted by great and powerful men everywhere. They will pay anything to possess it. That is why the desert wanderers first took it. That is why the Shrikes stole

it from them. Seize this moment, Kyky, and we will be the wealthiest, most honourable men in all Lahun. You will never want for anything again. There is no prize more valuable in all the world.'

Before Kyky could make his choice, Hui heard footsteps crunching towards them. He whipped out his short-bladed knife from the folds of his kilt. He had no idea how to use it to defend himself, had never been in a fight in his life. He prayed the glint of moonlight on the copper would be enough of a deterrent.

Kyky let out a quavering moan.

A figure loomed out of the night, and with a shudder of relief, Hui saw that it was Qen.

'Brother!' he hailed. 'Are you trying to frighten the ghost out of us both?'

'Keep your voice down,' Qen snapped.

When the new arrival skidded to a halt in front of them, Hui saw his elder brother's eyes were darting around, wide with fear. He'd been scouting the path ahead now that they were closing on the bandit camp.

'What is it?' Hui asked.

Qen gripped his arm. 'We must turn back.'

'Are the Shrikes coming? Do they know of our plan? Are they going to gut us and leave us out for the vultures?' Kyky's panic edged his words.

'Come with me.'

Qen spun on his heel and raced back across the stones, this time keeping low.

Hui felt that knot of apprehension inside him grow tighter. Qen was taller than he was, and as thin as a needle, with hollow cheeks that made him look as if he hadn't eaten a good meal in

days. But when he grinned, his face lit up and everyone around him felt bathed in joy. They had the same father, but different mothers. Khawy had taken Qen's mother Isetnofret first, an arrangement for political reasons, and she had also provided him with a daughter, Ipwet. Hui loved her dearly. But Khawy had fallen in love with Kiya, Hui's mother, who had died giving birth to him. That explained why the two brothers looked so unalike. But they were different in character, too. Qen was as hard as the jutting rocks on that hillside, unyielding when he desired something. And his slim frame hid a powerful strength. When they were younger, Hui had witnessed him beat two bullies, smashing one of the youths' heads repeatedly into the wall of their father's house until the nose was broken, the lips turned to pulp and half the teeth were knocked out. Qen had courage, too. Whatever troubled him, it would be wise to take heed.

Hui and Kyky set off after Qen, the three of them running together as they had done since they were boys. These were the ones Hui trusted more than any in the world, the only men he'd been prepared to tell about this great adventure. They'd barely spent a day apart all their lives. Once they'd raced through the streets of the Upper City with their whip-tops, and bickered over skittles. Now they were would-be thieves and heroes. How right it felt that they were here together this night.

Ahead, Qen slowed his pace and came to a halt at the beginning of a track along a gully between two towering rocks. He looked up.

Hui followed Qen's gaze. Silhouetted against that starry sky, shapes hovered, six of them, seemingly floating above the ground. They fluttered in the wind blasting across the high land.

At first, Hui struggled to understand what he was seeing. Kyky, though, released another strangled moan. He glanced up

at that sight, as if praying he had been mistaken, before wrenching his head away in horror.

Hui edged forward beside his brother. Bonded in silence, they stared.

Six bodies hung on a rope strung between the two rocks. The buzzards and kites had already feasted on the soft flesh of the faces. Picked clean, the cheekbones and jaws gleamed in the moonlight, and rows of yellowing teeth grimaced. But it was those hollow sockets, deep and black as the pits of *Duat*, looking down upon them, judging them unworthy, that filled them with dread.

Kyky slumped to his knees and wrung his hands.

'The Shrikes have little regard for the souls of their victims,' Qen muttered.

He was staring into the shadowed sockets of the nearest vision of torment.

'A warning,' Hui replied.

And the message was clear. For strangers, only death lay ahead.

Golden sparks swirled towards the twinkling constellations in the sky. Though the night wind whipped up the campfire in one final roar, the flames were beginning to die down, the embers glowing red in waves of grey ash. In the wavering amber light, a jumble of tall, square tents billowed. Sobbing was heard from amongst them, no doubt from one of the girl captives, stifled as suddenly as it began.

Under the lamp of the full moon, the camp of the Shrikes was slumbering.

Hui's eyes watered from a stray wisp of smoke. He could taste the sweet fragrance of the sheep dung and straw that provided

the fire's fuel. How long had he been lying on his belly on this slab of rock, scrutinizing the bandit camp, with Kyky and Qen barely daring to breathe beside him? An age, it seemed. But the time had to be right, even though his ribs were sore, and his knees and elbows ached from sliding across the hard ground like vipers to avoid being picked out by the moonlight.

Egypt had once been the greatest empire on earth, Hui had overheard his father, the governor, telling one of the visiting dignitaries. But now it was besieged by jackals on all sides, and the good folk lived in constant fear. Their king lacked an heir and the strength to hold the Great House of Egypt together, and in the chaos, a false pharaoh had arisen as challenger in the lower reaches of the Nile. His soldiers dominated there. In the west, the Libyans held sway along with the desert wanderers, the *habiru*, rogues and cut-throats all. Foreigners, not Egyptians. They had no standing in this land and never would. And in the east the barbarians, the Hyksos, tested the resolve of Egypt's defenders with their bloody war bands. Hui had heard many stories of those terrifying warriors. He prayed he would never meet one.

But it seemed, listening to his father, that it was the Shrikes who invoked the greatest fear.

These robber gangs, each led by their own chieftain, terrorized the length and breadth of the Nile. They would attack in broad daylight, even striking within the shadow of the city walls, cutting down any man, woman or child who stood in their way. They took what they wanted with impunity, disappearing into the wilderness to plan their next raid. Khawy had bemoaned the weakness of the palace officials who seemed incapable of doing anything to bring the Shrikes to justice.

'The Shrikes are a force in the land to rival the state itself. No one would dare challenge them,' Khawy had whispered.

'They have no kindness, no compassion. Those murderous bandits would slit the throats of their own mothers if they saw gain in it.'

And here Hui was, daring to challenge them. Perhaps Kyky had been right to call him a fool. And yet the thought of the wealth that would tumble into his hands once he'd returned with the Ka Stone – the grand house he could own, larger even than his father's, the army of slaves, the land, the adoration . . . A life like that was worth any risk.

One tent was larger than the others. It was set close to the fire so the flames would keep the occupant warm throughout the watches of the night. Though it appeared grey in the moonlight, Hui imagined it a sumptuous purple, a residence befitting whichever man was powerful enough to lead these scourges of the desert. A banner fluttered above it. Black stripes slashed across a field of colour. Blood red? That's what he would have chosen.

Beside the leader's tent was a smaller one, though still larger than the resting places of the fighting men. Surely that must be where the Shrikes kept their booty, close enough so the chieftain would be aware if any of his men tried to steal something for themselves. Then that was where they needed to go. Hui extended a finger, tracing a path to it amongst the smaller tents.

'Please,' Kyky hissed, 'let us think again.'

'You are free to return to your mother,' Qen said in a voice as icy as deep river water. 'Let her wipe away your baby tears.'

Hui rested a hand on his friend's shoulder.

'This is not the time to back out, Little Monkey,' he whispered. 'Not when the most glorious of prizes is almost within our grasp.'

Kyky's face was ashen in the moonlight, his stare fixed. Would he be able to overcome his terror and do what would be expected of him? Hui wasn't sure.

He thought back to that grisly display of the Shrikes' hanging victims, and once again he was choking on the stink of rot.

Hui could feel his heart thundering inside him, and that queasy knot in his stomach. His plan had seemed infallible when they sat in the shade of a canopy on the roof of his father's house in Lahun.

'We are not fighters,' Kyky blurted. 'We are fools who laugh too much and fall over when we're drunk and always say the wrong things to the girls.'

He is right, Hui thought. But this was their one chance to become something else.

Poor, oft-bullied Kyky. Hui's heart ached for him. How could he put his friend through any more misery than what he had already experienced in his short life? As they sprawled in the dust, Hui glanced at Qen.

Qen eased himself onto his elbows, his face burning with defiance.

'Mother told me that the gods have a plan for all men,' he said, his words emphatic and hard. 'They reveal it, not with a clap of thunder, but with the slowness of the wind uncovering a gold plate buried in the sand. It is easy to miss that message, and that is how the gods wish it, for they want men to pay attention to their presence at all times. We stand at a fork in the road. One way leads to our destiny. One way leads to a path where the gods will punish us for being blind. On that path, we have nothing but toil and suffering until the day we die.'

Hui felt the hairs on his neck prickle. Yes, this was how he felt, though he would never have been able to express it so eloquently, nor to frame it in the wisdom of Qen's birth-mother, Isetnofret.

Qen looked at both of them. 'This is our moment.'

Hui nodded. 'Our choice. A life of toil or a life of joy.'

Kyky said, 'You promise me this is the right decision?'

'I have no doubt,' Hui replied.

Yet, with the camp so close, it was impossible to deny the reality of what lay ahead.

The campfire crackled.

The fork in the road. The path to destiny.

Squinting against the smoke, Hui saw a guard hunched beside a rolling dune. Just the one, by the look of it. And why would there be more? No one in their right mind would attack this band of throat-slitters.

The guard was as unmoving as one of those hillside rocks, his legs tucked up, his forehead resting on his knees. Asleep. The gods smiled upon them.

Qen glanced at the moon. 'Too bright. We might as well have danced in there at noon.'

'At noon, our hosts would not be sleeping, drunk,' Hui replied. 'It was this night or not at all.'

They had come too far to turn back. Soon they would know what plan the gods had for them.

Hui glanced from one face to the other, and then, with a nod, he crawled forward, keeping one eye on the slumbering sentry. He sensed Qen and Kyky follow him.

Though his elbows and knees burned, he dragged himself along at a slow pace, as silent as a tomb. Drunk the Shrikes might be, but rogues like that would always sleep with one ear cocked and a hand on a sword.

Crawling into a strip of moon-shadow along the edge of the camp, Hui steadied himself and waited for Qen and Kyky to join him. From inside the nearest tent, snoring rumbled.

He cupped his hand against his ear. They had to be alert for the slightest sound of stirring.

Now was the time of greatest danger.

Blood thundered in his temples as he crept around the edge of the tent, keeping low. At the end of a maze of guy ropes and pegs, the campfire flickered lower and the circle of orange light receded. No one stirred.

Soon Hui was crouching in front of what he was sure was the booty tent. When he was certain he could hear only silence within, he touched the three leather thongs that tied the tent flaps shut, and with deft movements plucked each knot loose.

He could feel the eyes of Qen and Kyky upon him. Steeling himself, he eased the flap aside.

A blade of light from the dying fire carved through the dark in the tent. Waist-high baskets made from tightly bound reeds were stacked against a multitude of clay pots. One basket was overflowing with silver amulets and copper plate, gleaming necklaces embedded with lapis lazuli, and gem-studded headbands ripped from the wealthiest female victims of these raiders. One of the lids of the clay pots had slipped, and inside it Hui glimpsed grain. The rich scent of oil hung in the air. The bandits could barter everything here for whatever their hearts desired.

Hui slipped inside. Qen and Kyky followed.

Hui left the flap slightly open so the glow from the fire would illuminate their search, and he crept amongst the plunder. Qen moved steadily from basket to basket, lifting each lid and peering inside.

Kyky lingered by the entrance to the tent, ignoring Hui's frantic beckoning. The Little Monkey pointed to one basket. It was caught in the shaft of amber light breaking through the gap in the tent flaps, almost as if the gods had illuminated it for them. The pannier stood alone with a space around it, an odd sight in the jumble of spoils.

Hui saw what Kyky had noticed. The basket had been placed there with care, and a path left to it so the contents could be easily inspected. Hui grinned at his friend. Kyky had always been the clever one.

Hui's heart thumped as his hand hovered over the lid of the basket. It might have been his superstitious mind, but he felt a cold force radiating from the vessel. The skin on his forearms prickled into gooseflesh, and for a moment he dreaded the thought of lifting the lid and staring at something that had had contact with the gods themselves.

He carefully lifted the lid.

There was no flash of light, nor a crack of thunder. But as Hui stared into the shadows, he sensed whispers licking in his head, strange voices speaking in a language he didn't recognize but which seemed weighted with terrible meaning. This was the right place.

Whispering a prayer, he reached a trembling hand inside. His fingers brushed something hard, wrapped in what felt like the softest linen.

Suddenly Hui sensed movement in the corner of his eye in the depths of the basket. With a muted cry, he threw himself backwards.

A sinuous shape lashed out of the dark interior. The hooded head of a cobra swayed before him, jewelled black and silver, glinting in the firelight. A forked tongue flickered from a mouth gaping wide, those venom-filled fangs agleam.

Hui stiffened in fear, mesmerized by the serpent's supple undulation. He'd seen a man die in slow agony from one bite of those clamping jaws.

Kyky hissed a warning, flapping his hands towards the tent's entrance. His involuntary cry! He'd been too confident, and now he'd doomed them all.

Lunging back, Hui dropped low. The cobra lashed, but those savage jaws snapped thin air. Hui kicked out and the creaking basket spun away. The snake flew with it. His last vision was of its coiled tail gleaming like molten metal as it thrashed into the shadowed recesses.

Digging deep into the basket, Hui wrenched the prize from the depths. He had to be sure. Peeling back the linen, he raised up a pitted black rock with jagged edges, about the size of a man's head. The boy's eyes shone with wonder and they gaped as they stared at it, but only for a fleeting moment. Wrapping up the Ka Stone and clutching it against his chest, Hui scrambled towards the tent flaps. Outside he could hear cries echo, and whistles ringing from the camp's edge. The moment they stepped out and revealed themselves, the Shrikes would fall upon them. But nor could they wait there. The booty tent would be the first place the rogues searched.

'You jolt-head,' Qen spat. 'You've killed us all.'

'Away,' Hui exhorted. 'The gods will watch over us.'

He barged past the other two and crashed into the smoky night.

With one glance, the blood in his veins turned to ice-water. All around, heads were pushing their way out of tents, the last vestiges of sleep being blinked away in an instant. A few Shrikes lumbered here and there, searching for the cause of the noise that had disturbed them.

Another already had his bronze sword in his hand and was marching towards the tent where their plunder was stored. When he saw Hui and the Ka Stone, his face lit up with shock, twisting into fury. A cry of alarm ripped from his mouth, soaring up to the heavens. And then the camp erupted into wild life, like a teeming anthill that had been disturbed.

Hui hurled himself on. Their path through the camp looked clear. A chance, then, if only a slim one.

Hui leaped over the guy ropes as he raced. His feet danced past pegs, instinct keeping him moving forward.

Someone was shouting that they'd been robbed, that the Ka Stone had been stolen. A further outpouring of rage boomed.

Behind him, Kyky was whining like steam escaping from a covered pot bubbling on the hearth.

As he darted past the edge of the camp, Hui heard a crash and a yell. He whirled, only to see it wasn't the Little Monkey, but Qen who had fallen. Kyky was ahead of his brother, and he skidded to a halt and half-turned.

Silhouetted against the campfire, a storm of Shrikes gathered. Glinting swords flashed. Their roar merged into one single bellow, like a giant beast hungry to fill its belly.

Qen was struggling to pull himself to his feet as the horde surged forward.

Hui's brother! His brother, whom he loved more than anything!

Before Hui could move, Kyky threw himself back over those treacherous guy ropes, grasped Qen by the wrist and wrenched the fallen man to his feet. Qen came up hard, staggering into the Little Monkey's arms.

But it was too late. The Shrikes were almost upon them.

For the briefest instant, Qen and Kyky stared into each other's eyes. Hui couldn't tell what silent communication was

travelling between them – perhaps a prayer of thanks for the friendship they had shared, perhaps a recognition that they would meet death together, brothers in all but blood.

Qen gripped Kyky's shoulders, in what must have been one final embrace . . . and then spun him around and heaved him towards the mob.

Hui was astounded. Qen had never shown cowardice before, nor a disregard for any other life, certainly not that of a friend as close as any kin.

'Brother, what have you done?' Hui whispered to himself, struggling to comprehend what was unfolding before his eyes. He'd always looked up to Qen, for his bravery, and his strength. But this was not the brother he knew!

Kyky spun backwards, arms flailing. Hui watched his friend's features crumple with horror when he realized his fate.

Hui half-stepped forward to help, and then caught himself. What could he do? It was hopeless.

The Little Monkey snagged his foot on a guy rope and fell onto his back. The Shrikes pounced on him, howling.

As he scrambled away, Hui felt a spasm of revulsion. His friend's screams sliced through the victorious baying. Kyky had been hauled to his feet. A muscular arm snaked around his throat, ready to snap his neck. His wrists were grabbed and yanked back, and the tips of swords stabbed against his chest to run him through in an instant when the moment came.

Qen bounded to Hui's side. He couldn't bring himself to look at his brother. And when Qen grabbed his arm to drag him away, Hui threw the hand off. He was frozen, unable to flee and leave his friend to his fate, knowing he would surely die if he stayed.

The Shrikes seemed to sense his torment. Grins flickered across faces and they slowed their step now they knew they had the upper hand, edging forward with Kyky in their midst. Taunting. Urging Hui and Qen to come to them.

'Stand your ground!'

The voice boomed across the camp and every man fell silent. The Shrikes stumbled to a halt, a spear's throw away from where Hui and Qen stood.

A path opened amongst the horde of Shrikes. Hui watched a figure striding along it. Tall and lean, his skin was burned to mahogany by the desert sun. The man grinned, his white teeth shining amongst the black bristles of his thick, curled beard.

When the man came to a halt beside the quavering Kyky, he said, 'Do you know who you have challenged?' The voice rang with arrogance. Here was a man who was *never* challenged. 'My name is Basti the Cruel, and I bear that title for good reason.'

Hui felt the blood drain from him. He knew that name, and the reputation that went with it. Who in Lahun didn't? Basti had the blood of a thousand men staining his hands. For more than five seasons, this leader of the raptors had destroyed caravan after caravan bringing trade from the east. Basti, who had raided the copper mines and put every engineer to the sword, and who had slaughtered so many slaves in the fertile estates along the Nile that the fields themselves had turned red. And once he had killed those workers, he had burned the crops for no reason but torment. Only weeds grew there now; that's what the merchants had said when they arrived in Lahun.

'The Cruel.' A fitting title.

'Let my friend go,' Hui called. His voice was unsteady.

'Leave him,' Qen whispered. 'He is already dead. But we can still save our own necks. We are faster by far than those lumbering Shrikes and they know it. Younger and filled with more fire than them. If we run away now, they will never catch us.'

How cold his brother sounded. Hui had never heard him talk like this before.

Basti uttered an order and the arm around Kyky's throat fell away. Basti replaced it with his curved knife. The blade dug into the skin, a bubble of blood forming. Kyky began to sob.

'Give me the object you hold in your hands and I will be generous,' the raptor lord continued.

Hui was still carrying the cloth-covered bundle.

The leader of the Shrikes was wise enough to know the two young thieves had the upper hand here. Qen was right; their youth gave them speed that these raiders no longer possessed. They could easily disappear into the dark of the desert night and Basti might never see his prize again. And so he was prepared to bargain.

'I will let you all live, and you will be free to walk away from here. That is not a gift I have offered to any other enemy,' Basti continued. 'And I will allow you each to take with you a purse of silver, so all will know that cruelty can be tempered with kindness.' His lips curled into a tight smile that contained no warmth.

Hui's mouth was as dry as the sands around them. He didn't trust this bloodthirsty bandit for an instant. But what could he do? He watched tears glistening in the moonlight on his friend's cheeks, and he tried to imagine what terrible thoughts would be swirling in Kyky's head at that moment.

Hui held out the bundle, feeling the weight of the Ka Stone inside it.

Basti grinned. He nodded, and two men stepped forward to reclaim their gift from the gods. Hui mouthed a silent prayer to the gods to save them. He should run, he knew, but he couldn't tear his gaze away from Kyky's terrified face.

Beside him, he could sense his brother shifting, perhaps feeling guilt at the cowardly act he had committed.

'I have no choice but to hand over the Ka Stone,' Hui murmured.

When Qen didn't answer, Hui flashed him a glance. A strange, unfocused look hovered in his brother's eyes.

Suddenly, like the uncoiling of a vast serpent, Qen lunged. He grasped the Ka Stone and wrenched it from Hui's grip. Hui thought his brother was going to offer the prize back to the Shrikes in return for their freedom. Instead Qen swung about, launching himself away from the camp.

'Fools!' Basti bellowed. 'This is not a game.'

With a whisk of his hand, he raked the edge of his blade across Kyky's throat. Blood gushed. Hui's friend gurgled, his legs crumpled, and he fell back into the mass of raiders, sparing Hui the horror of seeing his final moment.

Hui felt a rush of despair that he thought might drive him mad. But Basti raised his hand and jerked it forward, and the Shrikes surged like a pack of dogs released by their master, snapping and yowling and filled with bloodlust.

Spinning on his heel, Hui hurled himself away. He could just make out the grey shape of Qen vanishing across the wasteland and he sprinted after him.

All that Hui could think in the whirlpool of his grief was that Kyky was the bravest of them all. And Hui, in his cowardice, had killed him.

But then the desperate urge to survive swept through him and he was running as fast as he could, his thoughts dashed away by the madness of his fear. The wild sounds of the hunting party thundered at his back, raiders who would never rest until he was dead.

A crimson line slashed across the horizon ahead of the two running men. Hui's chest burned and his legs shook as if he had a fever. Qen stumbled like a drunken man. How much longer could they flee before exhaustion brought them to their knees and death swiftly followed?

Behind them, the Shrikes pounded in pursuit, as relentless as death. Hui could hear their battle cries. He knew they would never turn back. The Ka Stone was too great a prize to give up. Basti the Cruel would have demanded the head of any man who failed in his mission. Fear and untold rewards, the two great forces that spurred men on to their destinies.

The bandits were closing. They were hard men, used to the privations of the road, made iron-strong by long marches under the hot sun, hearts turned to stone by the women they had raped, the children they had killed.

When Hui and Qen had fled the camp, the gods had smiled on them. The dark had swallowed them quickly. They'd plunged down into clefts in the rock, disappearing from view, and then switched direction back and forth using boulders for cover. It had bought them a little time while the Shrikes searched for a trail. Then they'd scrambled over scree in the direction of Lahun, although they knew their home was too far to reach before the sun burned them to a crisp and they were driven

to their knees by weariness. But Hui felt the breeze stinging his skin, growing harder by the moment, and he formulated a scheme. The outcome would be risky, but it was all they had.

'I have a plan,' Hui said.

The wind began to howl and soon a dust storm was whipping across the waste. When the sand drove hot needles into their faces, they wrapped the folds of cloth they always carried at their waists across their mouths and noses and bowed their heads to protect their eyes.

Staggering into the gale, Hui waved a hand to direct Qen. The roar of the storm would have swallowed any words. Qen obeyed. Hui pushed on as hard as they could endure in the buffeting wind. The dust storm clouded out the moon, turning it into the darkest of nights, and the wind wiped away their footprints.

Moving by instinct, Hui led the way towards a row of rocks protruding from the ground like the fangs of some buried beast. When they pulled themselves around the other side of the outcropping, they used the line of boulders to guide them towards the east. The Nile and the civilization that throbbed along its banks were closer than their home. Hui calculated they could lose themselves in the settlements that edged the winding river until they could find their way back to their home.

That was now their only hope.

The ploy had at least bought them some time. As the dust storm swept ahead of them, and the whine of the wind died down, they'd heard the raucous cries of the Shrikes disappearing into the west. Hui knew it would only be a matter of time before the bandits realized their error. He prayed that would be enough.

They kept running east, heading towards the banks of the Nile. They scrambled over rocks until they reached the foot of the hills. And for a while it seemed they'd escaped.

But Hui heard that bone-chilling call and response of the hunting pack again, and his heart sank. Now he realized that if they were going to die, he had to confront his brother first. He came to a halt.

Unfurling the cloth from his mouth, Hui said, 'How could you, brother?' His voice cracked and he choked back a sob. 'You all but murdered Kyky yourself. Throwing him to those killers! He was our friend – our friend since we could barely walk. And you discarded him as if he meant nothing to you—'

Qen held up his hand, demanding silence. Hui watched his brother's eyes in the gap between the folds of cloth and in that moment he didn't recognize him at all.

Slowly Qen pulled the cloth from his mouth.

'Basti was never going to let Kyky go, you know that. He was dead the moment he came back for me. I will always give thanks for his sacrifice—'

'Sacrifice! You threw him into that slavering pack!'

'Better one of us die than both.'

Hui felt sick at the unfeeling tone he heard in his brother's voice. He'd always known Qen was hard and ambitious. But the ruthlessness he'd shown in that moment was shocking. It was lying there inside Qen all the time, and it had burst forth at the moment his instinct told him what he needed to do to survive. Kyky's life had meant nothing to Qen. How could Hui never have seen this quality in his brother before?

Hui felt the world shifting beneath his feet. He would never be able to look at Qen in the same light. Those bonds they

shared were broken and they could never be pieced together. But something more troubling stirred within him.

Should there be justice? Hui thought of Kyky's mother, and the grief that would consume her when she learned of her beloved son's death.

Could Hui carry Qen's secret with him for the rest of his days, the guilt eating away at him? Kyky had been denied the afterlife by his brother's actions. No funeral rites would ever usher him across that threshold. Should he tell all, so that in some small way things could be made right? Could he betray his brother?

'If you had given up the prize, Basti would have shown no mercy,' Qen was saying. 'The three of us would now be hanging from that rope with his other victims, the vultures tearing at our flesh, a warning to any who dared challenge him.' He nodded to the bundle Hui was now clutching to his chest. 'We still have that – the glory that we came to gain. We still have the one thing that powerful men would kill to hold in their hands, and the key to great riches. We still have our lives. And we still have our destiny.'

'But Kyky—' Hui protested.

'You killed him, brother. You,' Qen spat. 'You persuaded him to come on this fool's errand. You bewitched him with stories of riches and fame. And you told him he would be safe, whatever happened. If there is blame to be had, it is on you. Your greed for greater things killed Kyky. Not me.'

Qen showed Hui his back. There was nothing more to be said.

Hui felt tears sting his eyes. That accusation had burned its way into his heart, and he knew, in truth, that he couldn't deny it.

Hui's legs shuddered with every step. Qen weaved from side to side. Sweat slicked them both, soaking through their kilts and stinging their eyes as the day's heat licked across the land. Soon it would sap what little strength remained in their limbs.

Hui sucked in a juddering breath and suddenly his nostrils wrinkled from a new scent.

'Wait,' he exclaimed. Qen glanced back. 'Breathe in the air.'

Qen's eyes narrowed. A grin crept across his face.

'The river!'

Hui could taste the faintest hint of vegetation and dank earth, but it was like a morsel of bread to a starving man. The Shrikes were out of sight at their backs, but they were closing fast – Hui could hear their whoops growing louder. With any luck he and his brother could lose themselves amongst the multitudes dwelling along the banks.

Somehow they found it within them to break into a stumbling run. Soon Hui shielded his eyes against the light reflecting off the Nile. His lungs filled with the smells of the vast, life-giving river.

They plunged into an emerald world, a blanket of ordered fields where men toiled, burned black by the sun. A kilted man with a grey brimmed hat hunched over a wooden-bladed plough yoked to a cow. He raised his head from his labours to watch the two men race past the edge of his field and cursed at their foolishness.

'We could ask the farmers for help,' Qen gasped.

How close he is to dropping to his knees and waiting for the blades to fall, Hui thought.

He shifted the weight of the Ka Stone in his hands. It seemed to be growing heavier by the moment.

'You think they will down their tools and stand firm against a horde of blood-crazed bandits for our sake? They will likely run in the other direction faster than rats fleeing a grain store.' Hui hooked a hand under his brother's arm and dragged him on. 'Fear not. I have another plan.'

He had no plan.

Near to the river, farmers knelt on their dykes, inspecting the vents that would trap the water and the torrent of black silt that came with it during the next flood season. Hui looked around for a place to hide. But the land was flat and too well cultivated, with only copses of date palm for shade.

'Perhaps there are soldiers here,' Qen said, his voice cracking with desperation.

Hui ignored him. He'd been listening to the creaking of the shadoofs, with their water buckets swinging on counterbalanced arms that the farmers used to irrigate their land, but now even that sound had been drowned out by the howls at their backs.

On the banks of the Nile, Qen crashed to the soft ground.

'I can run no more,' he wheezed.

Hui wrestled with despair. There was nowhere to hide where they wouldn't be discovered. No one to help them.

There seemed nothing more to do but wait there to die.

Hui looked out across the Nile and his thoughts jumped back to a vision he'd had as a boy, standing on those banks with his father. Khawy had travelled from Lahun to conduct business with the traders who plied the canal, and Hui had begged to accompany him. It was dawn, and as the sun rose up above the hills, the ruddy light turned the Great Lifegiver into a river of blood flowing across Egypt. He'd mentioned this to his father.

Hui had never forgotten Khawy's words: 'It is a reminder that for all the wonders of our life today, the history of our land

is steeped in blood. It is the duty of all men to do whatever they can to ensure no more blood is spilled, and that we can create an age where we live in harmony to enjoy all that the gods have bequeathed us.'

Even as a boy, Hui couldn't imagine that time. Now, with the raids from the Shrikes getting worse by the day, and with the lawlessness and government failings mounting, it seemed farther away than ever. He had little interest in politics, but he'd heard fragments of conversations between his father and mother. The world seemed to be getting worse, not better.

Hui looked at the bundle containing the Ka Stone. Perhaps this gift from the gods was designed to change that. To usher in a new age of peace and joy. Perhaps that was the destiny the gods intended for him. And would that make the sacrifice of Kyky worthwhile? He thought his friend might believe it would.

His heart swelled.

'We will not die here, brother. You have my word on that.' Hui felt surprised to hear the steel in his own voice.

He looked across the papyrus beds to the broad river, his mind dredging the scene for any escape he had not yet considered. The Nile was busy with boats of all sizes. As Hui watched them sail by, the rising sun remade the river into a flood of molten metal, bright and hot and burning with the promise of a new existence.

From blood to gold, he thought. His father had been right. Here was the lesson.

Qen heaved himself upright.

'Look,' he croaked, pointing.

Through the glassy heat haze, Hui could make out the shimmering shapes of fifty or more Shrikes storming across the

fields, past the farmers' houses. The bandits trampled through crops, hacking down the hard-won fruits of those who toiled for a living along the river's edge. As Hui stared, a farmer burst out of his hut. All he had to defend his land was a stick with a rock tied to the end. He ran forward, swinging it in a desperate attempt to save his livelihood.

Three of the bandits fell on him with their swords, hacking and thrusting. He was dead before he hit the ground.

'That's our fate,' Qen spat. 'That's what you have brought us to.'

Hui could see their scout prowling ahead, following the two fugitives' tracks. The Shrike scouts could follow a man across the blasted wastes days after he had set out ahead of them. Wherever they ran, those bandits would find them.

'Into the water,' Hui said, thrusting his brother forward.

'You are mad!'

'We will do as we did when we were children. Kyky showed us the way, remember!'

Hui squelched through the sucking mud into the papyrus beds. He ripped out one of the green rushes and raised it to his lips.

'We'll hide beneath the surface and breathe through this. The Shrikes will think we've dived into the river and tried to swim away. Even drowned. As they search downstream, we can creep out and find another way home.'

Qen knew, as Hui did, that it was their only chance.

They splashed into the shallows with reeds clasped in their hands. Hui felt his chest tighten. He wasn't a good swimmer. Some of the currents that surged along the river were strong enough to rip them from the banks and carry them away to their deaths.

'Stay as close to the edge as you can,' he hissed.

Beyond the papyrus beds, he could hear the rumbling voices of their pursuers. Orders were barked. Feet pounded.

When the current began to tug at his ankles, Hui heaved in a deep breath and dropped beneath the surface, his feet clinging to the mud near the riverbank. Clamping the hollow reed between his lips, he held the other end above the surface so he could breathe in the life-giving air. He wrapped his other arm around the Ka Stone and held it tight against him.

In the grey world, the boom and rumble of the water filled his ears. Hui felt the weight of the Ka Stone drag him down. That made it easier to hold his place in the current. As the cold crept into his bones, and the throb of the river swallowed all thoughts, he screwed his eyes shut, lost to that murky world.

Time passed; how long he didn't know. It seemed like an age, but it was likely only moments.

Hui jerked at a sudden churning in the water and opened his eyes, trying to see through the dimness. Had one or more of the Shrikes jumped in to search the water's edge? His heart thundered and he reached out. His fingers closed on Qen's clammy forearm and that gave him some comfort.

But still the water heaved. Whatever was moving through the flow was bigger than a man.

A wave of panic surged. Had they disturbed a hippopotamus? Those vast beasts had a terrible temper when troubled, and their jaws could rip a man in half. Hui held himself as still as he could. With any luck, the creature would lose interest and drift away.

A sinuous shape flashed by.

It wasn't a hippopotamus. Hui tensed, every fibre of his being alert.

The intruder curled and swept by again, closer this time. Even through the leaden water he could make out the broad snout and the armoured hide the colour of dark bronze. The crested tail flicked, and he knew it was one of the great crocodiles.

His blood ran as cold as the river water. Every season these silent killers claimed the lives of dozens of unwitting folk along the Nile's bank. No man was strong enough to stop those crushing jaws once they had descended upon their prey.

As the beast circled closer, Hui glimpsed its pale eyes fixed upon him. He saw the rows of fangs along the snout, dagger-sharp bones in a powerful jaw that could rend him in two in an instant.

The Shrikes would still be prowling nearby along the riverbank. Hui had a choice – death by sword or eaten alive by the river's most savage killer.

As he burst out of the water, Qen thrust his head up.

'Crocodile,' Hui gasped. 'Crocodile.'

The two brothers lunged towards the bank and Hui sensed the beast sweeping towards them. Somehow he stumbled out of the shallows and into the mud before the jaws closed on him. But the saurian would keep coming for them now that it had sensed prey, and it was as fast on land as it was in the water.

Hui scrabbled through the sucking mud away from the river's edge, and as he did so he sensed movement around him. The reeds were swaying in the papyrus beds in several places. There were more crocodiles. He knew then how fortunate they had been, but they were still in great danger.

'The gods are with us,' he muttered.

Without a second thought, he waved his arms and shouted.

'Are you mad?' cried Qen.

Farther along the bank, the Shrikes turned and looked back. As their roars boomed to the heavens, Hui turned north and lurched along the reed beds.

'Stay with me!' he shouted.

Choosing his spot, Hui skidded to a halt and faced the racing bandits.

'Do just as I do,' Hui said. 'Follow in my footsteps. Do not veer off to the right or left, at peril of your life.'

Qen shook his head. He had given up trying to make sense of what his brother was doing.

As the bandits thundered closer, Hui could see the rictus smiles on their faces. They whooped and howled. They thought they'd won.

Qen cowered as the bandits swooped. When they were almost upon them, Hui yelled 'Now!', and he leaped into the reed beds, following a path away from where he'd seen movement. Qen dived after him.

The Shrikes were not as cautious, just as Hui had calculated. They hurtled pell-mell into the muddy beds, hollering as they waved their swords above their heads.

Their shouts died on their lips a moment later.

Wild thrashing erupted amongst the reeds as the crocodiles attacked. Throat-rending screams rang out.

As he squelched through the mud as fast as he could, Hui glanced back. The bandits were hacking at what was hidden in the reeds. Hands were thrown up high, mouths torn wide in agony. One by one the flailing men were dragged down. Behind the terrible sounds of torment, Hui could hear the crunching of bones.

Armoured tails lashed as the crocodiles thrashed and rolled in a feeding frenzy. The other Shrikes clustered beyond the

reed beds, too terrified to enter the killing ground to help their comrades. They were gripped by the slaughter, all thoughts of Hui and Qen and the Ka Stone forgotten for the moment.

Hui bowed his head at the slaughter as he pulled himself onto dry land.

'When we return to Lahun, we will make an offering to Sobek,' he muttered.

Without looking back, Hui nursed the Ka Stone as if it were the only thing of value in the world and pushed on away from the reek of blood.

The white-painted walls of Lahun shimmered in the haze. The air was glassy in the baking heat, and the grand homes of the Upper City perched higher on the hillside seemed to gleam as if in a dream. Sweet scents of jasmine from the temple gardens drifted out into the dusty waste.

Nearing the gate, Hui closed his eyes and felt his senses tingle. The din of the smiths' hammers and the cries of traders bartering over their wares caught on the dry wind. He'd been imagining this moment since he and Qen had fled the Nile's banks.

And yet the elation he'd envisaged wasn't there, nor was the feeling of comfort that he'd believed would be waiting for him. Nothing seemed out of place, but everything was different.

They'd travelled through the dark hours for three nights, picking a circuitous route to mask their trail in the hope that the Shrikes would not be able to track them. Now, weary and miserable, they trudged the final steps home.

Hui slaked his thirst from the skin that hung at his hip. Long periods of silence had dogged the brothers. In the past, they would babble and taunt each other and engage in horseplay.

They'd been so close. How had it come to this? Qen had always looked out for him, threatening the older boys who wanted to give him a beating. They'd lain side by side looking up at the stars, weaving stories for each other, sharing their secrets – the girls they liked, their dreams.

The moment they ran from the Shrike camp their intimacy seemed over. Now Hui felt as if Qen hated him, wanted to hurt him. As they trekked home, Hui had felt those sullen eyes on his back at every turn, as if danger was close. And once when they edged along a precipitous drop in the hills, Qen had crept close and Hui thought his brother was going to pitch him to his death. Madness, surely?

'What are you going to say?' Qen asked.

'About what?' Hui could see that his brother wasn't looking at him.

'You know. About Kyky. How he died.'

Hui didn't want this conversation now; he hadn't decided what the best course of action was. Whatever his choice, he couldn't see a good outcome.

'We will tell his mother that he died a hero, saving your life.'

'That is all?'

When Hui didn't answer, Qen rounded on him, fists bunching. Those black eyes burned with a fire that Hui didn't recognize.

'I know what you are going to do,' Qen growled. 'You will put the blame for Kyky's death on me. I know you will. And then you alone will bask in the glory for bringing the Ka Stone home.'

Hui held the Ka Stone more tightly under his arm.

'How can you say such a thing?'

'I have watched you twisting Father around your finger—'

'What are you saying?'

'You will not be satisfied until you are raised up higher, and I am . . . damned for—' Qen lunged, gripping Hui around the throat, his burning eyes so close they swam in Hui's vision. 'I will not allow you to destroy me,' he hissed through gritted teeth.

Hui smacked the hand away. He'd always been calm and level-headed, but Kyky's death and the terror of the Shrikes had thrown him into a spin. He felt all those conflicting emotions meld into anger at the injustice, that what should have been his greatest achievement had been soured. And he felt afraid. What he saw in those eyes chilled him. He placed the Ka Stone carefully on the ground away from him and then slammed both of his hands into his brother's chest, sending him sprawling.

A low, bestial growl came from Qen's snarling mouth, and then he launched himself upwards, ramming his shoulder into Hui's gut and propelling him back. They crashed down together in a whirl of flailing limbs, wrestling as they rolled in the dust. Qen was bigger, stronger. Using his weight, he hauled himself astride Hui, pinning him down. His fists smashed down, one after the other. Hui's head rang as his wits were dashed away. He felt his lip burst, pain stinging his jaw. His tongue tasted the iron tang of blood. But Qen wasn't stopping. Hui felt suddenly terrified for his life.

In a blur of instinct, his fingers fumbled for the side of his kilt and closed around the wooden handle of his knife. He yanked it out and pressed the blade against the taut skin of his brother's belly.

'I will,' Hui said, his voice breaking. 'I will do it.'

Qen's fist hung in the air. He looked down at the blade, the prick of blood by the tip, and then he stared into Hui's eyes. Hui watched the emotions shifting there, from sadness to loathing. He was sickened by what he saw.

Qen pushed himself to his feet and, without another word, stalked towards the gate.

Hui felt as if his own knife had been turned against his heart. As a boy, he'd once been sick with the fever, lying in his bed in a pool of sweat. Qen had remained by his bedside, mopping his brow, singing lullabies and praying to the gods. Qen's face had hovered over his, filled with love, his eyes brimming with tears.

Hui's heart broke for what had been lost that night in the Shrikes' camp.

The gates opened and Qen vanished into the shadows beneath the arch.

Hui convulsed as sobs tore through him. All the emotions he'd beaten down during their flight filled his veins like the Nile during the Great Flood. Poor Kyky! And Qen lost to him.

When the tears ceased, Hui staggered to his feet and retrieved the Ka Stone. He wiped the blood from his mouth and followed his brother into the city.

Hui passed under the arch and the sounds and smells of the city assailed him. Builders bellowing at their apprentices. Girls singing in their rooms. The throb of the street chatter. His nostrils flared at the acrid smoke from the forges, and his mouth watered at the greasy scent of meat cooking on charcoal.

At least here they were safe. Hui looked around, but Qen had already lost himself in the flow of human life.

Ducking around a lumbering donkey, he pushed past boys chasing each other along the street. The city was built on a slope. In the lower third, near the gate, were the homes of the poorest, a suffocating jumble of back-to-back one-room houses where families of up to ten clustered to eat and sleep in their

single room. The walls were constructed from rough bricks made from animal dung mixed with sand and water, the roofs layers of palm fronds. Too many people in too little space, as hot as the ovens that baked the daily bread. Arguments blew up like lightning strikes during a storm, escalating in the blink of an eye from raised voices to punches thrown. In this part of the city was a babble of tongues that Hui didn't recognize. He heard hunger in the cries of babies and the wailing of their mothers.

His stomach knotted at the familiar sense of threat, and suspicion that if he ventured into the shadows, he might get his throat slit at any moment. He hated spending time there, although when he was younger, he and Qen and Kyky would creep down to the gates to watch the whores waiting for business under the torches along the walls. With a mixture of embarrassment and excitement, the three would spy on the rutting in the narrow alleys as if the participants were beasts in the field.

Hui strode up the street and through the gate in the interior wall that separated the poor quarter from the rest of the city. Here were the large villas of the wealthier citizens, constructed from stone. Higher up on the slope, this part of the city benefited from the breeze. The streets were broader, the larger houses painted white so they reflected the light and kept the shadows to a minimum. It smelled sweeter, too, the scents of rose and chrysanthemum drifting from the gardens.

Could there be a greater city in all Egypt? Yes, there were larger ones. He'd heard the stories of Memphis, throbbing with more life than he could imagine. The wonders of the grand buildings, the riches, and music always in the air. But Lahun was not only beautiful, it was a gateway to the home of the gods. The City of the King.

Hui thought over the stories of glory and wonder that Khawy had told him when he was a boy, about how Lahun had been a blessed place. Now, after his ordeal, Hui was seeing his home with new eyes, and he could understand what his father meant. He paused before the grandest building in the Upper City. Soaring white columns rose along the front, each carved with images of bundled palm leaves and painted with hieroglyphs telling the city's story. Once it had been the home of a king from days long before his father and his father's father's father. That king had stayed to oversee Lahun becoming more than a handful of farmers' huts at the mouth of the canal.

Hui looked beyond the walls, to where the pyramid stood on a terrace that had been hacked out of the rock on the sloping ground. This was where the great king had been interred when he had taken his place in the afterlife.

The pyramid had seen better days. The pristine white facing that had made it a shimmering sun-washed beacon to all who passed nearby had mostly flaked away. The mud bricks beneath were crumbling. Pits lay around, dug in the night by robbers who hoped to find a way to the magnificent treasures that had been buried with the king. None had succeeded, Khawy had said, and they should pray that they had failed. What fools would risk the curse that would doom them in this world and the next?

The site of the pyramid had been chosen by the king's priests after consulting the gods and the stars to discover the most sacred place in Egypt. For that pharaoh, it was Lahun, and it would be his portal to the world beyond. Slaves had been brought from the lands to the east to build it. They were the original occupants of the lower town. They were a strange breed, unlike any Egyptians, his father had said. Skilled in the art of building,

they brought with them techniques that few knew, such as the creation of the True Arch. And as they laboured to build the pyramid, and the smaller Queen's Pyramid beyond it, they also constructed these grand villas that were the pharaoh's home and the homes of his friends.

When the slaves' children died young, they buried them in a box beneath the floor of their home so their loved ones would always be with them. Hui thought of Kyky. He would never see him again, not even in the afterlife that Qen had denied him.

Hui trudged up the steps, the Ka Stone seeming heavier in his arms. He went through the fragrant shade of the acacia and juniper trees to the great house at the highest point of Lahun, the home earned by his father's success. Behind its high walls where a guard with a spear stood watch at the gate, the house rose up through two floors, a rarity for Lahun, with a terrace on the roof. Canopies kept the heat of the sun at bay, and the family could enjoy the breeze while looking across the city. Khawy was the governor of Lahun and spent his days debating with advisers, poring over dusty papyri and talking about trade and repairs to the walls and the canal.

What a dreary life, Hui thought. *Where is the adventure? The joy?*

As he stepped into the courtyard, he felt comforted by the bustle from the servants' quarters. Beyond that were the stables and the cattle byres, the brewhouse, the grain silos and other food stores.

'You have not been eaten by jackals.'

His elder sister Ipwet stood in the shadowy doorway of their home. In his mind's eye, Hui still saw her as the girl who taunted him and tripped him and twisted his ear. But she'd grown into a beautiful woman, with long tanned legs and a slim

waist and a heart-shaped face. Her sleeveless linen dress clung to her curves, that smiling face framed by a wig with intricate plaits. Once Hui had caught Kyky looking at her with a glint in his eye, and Hui had cuffed his friend around the ears.

'Where have you been, brother?' she said, arching one eyebrow. 'Father was so angry his eyes bulged and his voice cracked. He sent men to search for you, time and again. He couldn't hide his worry. You know you were always his favourite . . .'

Remembering Qen's angry words, Hui was about to protest, but Ipwet waved her hand in dismissal.

'Mother was so irritated. She kept saying, "Qen is missing too!"' Her teasing smile faded. 'Father thought you were dead, or taken by bandits and he would get demands for gold soon. We all did.'

'As you can see, I am still alive.' His voice was flat.

Ipwet furrowed her brow. 'Why do you look so sad? Is this not a day for rejoicing?'

'And we will. But first I must see Father.'

'You have found some courage on the road, then.' She grinned, until her gaze fell to the now-grubby bundle Hui clutched in his arms. 'What is that?'

'The reason I was gone. This will change everything.'

Ipwet's eyes widened. 'Let me see.'

'Later. Father must see it first. Perhaps that will save me from the rough side of his tongue.'

Ipwet stepped to one side and swept her arm to usher him into the cool house. The vast reception room was dark at that time of the day, though Hui could still smell the smoke from the lamps that were lit at sunset. Four granite pillars soared up to support the upper floor, each of them intricately carved

with sheaves of corn around the top, and painted with red and black and blue vertical lines against a white background. The hall was designed to show off the family's standing to any visiting dignitaries, and it was here that Khawy kept the few items of luxury that he owned. A veneered and inlaid chest painted on one side stood against the far wall. The ochre and yellow used for the background had been chosen to make it appear as if it were made of gold. And there was real gold on the arms and legs of a finely crafted chair in one corner; the seat was made of mahogany, as his father never tired of telling him.

Their family had earned their place in Lahun. But with the Ka Stone, Hui knew that greater things lay ahead.

Khawy's deep voice drifted out of his office beyond the stairs to the next floor. He was in discussions with old Nimlot, his chief adviser. Khawy was tall and slim, with eyes that always looked tired and shoulders that seemed to stoop more with each passing day. When he saw Hui standing in the doorway, he dismissed Nimlot with a flap of his hand. Looking into that stern face, Hui expected a burst of rage or a cold condemnation. Instead, those graven features melted and a smile of relief spread across his father's face. Khawy held out his arms.

'Kyky is dead,' Hui blurted, no longer able to hold back. Hot tears burned once more and he rubbed them away. He was a man now, and men didn't cry at such things.

Khawy stepped forward and rested both hands on his son's shoulders.

'Tell me what happened.'

Hui recounted the confrontation in the Shrike camp.

His father gaped. 'Have you lost your wits? You ventured amongst the Shrikes of your own accord? What could have possessed you?'

Hui unfurled the filthy cloth from the bundle upon which he had gambled his life. The Ka Stone was pitted and black and jagged. Hui hadn't dared look at it again on the journey. He'd been terrified that his eyes would be burned out of their sockets if his gaze fell upon it, or that it would turn him into a locust and he'd have been consumed by a kestrel a moment later.

But here it was, as dull as any of the stones that littered the edge of the track up to Lahun's gates.

And yet Khawy stared at it as if he was bewitched.

'What is this?' he breathed.

Hui told the story of the Ka Stone as it had been recounted to him. Khawy continued to stare, his pupils widening.

'Can you hear them?' he whispered.

'Hear what?'

'The voices. The voices of the gods themselves. They . . . They are speaking to me. In my head.'

Hui was convinced he had heard those whispers when he'd stared into the basket in the tent of the Shrikes. But now he thought it might have been his imagination. Could his father, too, have given himself up to the story that surrounded the stone?

'There is power here,' Khawy said. 'I feel it.'

Hui's spirits lifted when he saw a light begin to glow in Khawy's eyes.

'I have heard tell of this object,' his father said, his hands hovering over the Ka Stone as if he, too, were afraid to touch it. 'The governor of Fayuum spoke of it. He heard tell of it from the *habiru* he met on the road. A wonder, indeed. And now it is here.'

Shaking off his trance, Khawy pressed his hands against Hui's cheeks and held his face.

'I cannot condone the risks you took, and my heart breaks for the death of your friend. But this is every bit the prize you thought it was. I will send word immediately.' His father paced around the chamber, one finger pressed against his chin in thought. 'To the priests at . . . No, no, perhaps we can get word to Pharaoh himself. Yes, that would be perfect.' He turned to Hui. 'We must begin our preparations. This will bring great wealth to you, to our house and to Lahun. With this bounty from the gods, all our lives will change. More trade will flow the way of Lahun as we are recognized as a city blessed by the gods, and alongside that, more taxes. Lahun will become rich, Hui, and all who live here will benefit from that new-found wealth, none more so than our own family. Why, we may even be invited to visit the court! A richer husband for your sister! So much to think on. You are a clever boy. You know full well many thought Lahun's best days were behind it. Since the Red Pretender took power in the north and strife has been constant along the border, we have suffered. The caravans have drifted to better cities, where the walls are not crumbling and the defenders are not poorly armed. Now all will be renewed.'

Khawy was babbling, but Hui felt pleased to witness his exhilaration.

'But we must be cautious,' Khawy continued. 'An object of such immense value will attract the attention of the greedy, the sly, the lawbreakers, men who will stop at nothing to lay their hands on it. I will ensure we have more guards at our gates, and they will carry swords at all times. We must be watchful. We must be diligent.'

All our lives will change. Hui liked the sound of that.

'We must ensure the Ka Stone is in the hands of Pharaoh's men as soon as we can,' Khawy continued. 'Only then will the threat against us diminish.'

Hui felt his shoulders tighten. What if he had inadvertently brought misfortune upon the family? Plots could be brewing everywhere once word had spread to the city. He would not relax his guard for an instant until the Ka Stone was gone and they had earned their new-found wealth.

Khawy showed a soothing smile. 'I always knew you had a courageous heart, my son. From the moment you were born, I saw in your eyes the promise of great things. You will be well rewarded for this success. You have made me very proud.'

Hui's heart swelled, and for a moment all thought of Kyky vanished.

Hui retired to his room, exhaustion burning through his legs. He thought he might have to crawl to his bath. After the servants had brought jugs of water, he sluiced the dirt of the road and the mud of the river off him and cleaned himself with the perfumed soap of clay and ash. Afterwards, he lost himself to the ritual of the slave massaging scented unguents into his skin. He felt he was not only cleansing his body, but washing away the deeper stains in his mind. The servants laid before him bread, bowls of dates, figs and lentils flavoured with garlic, and a pitcher of beer. They were only scraps from the kitchen, but he devoured everything put before him.

As soon as Hui had finished eating, he went to look for his brother. His argument with Qen couldn't be left to stand. It would poison both of them, like cobra venom. He had to make it right, if he could.

But his brother wasn't in his room, or anywhere at home. As Hui searched, he heard a voice call his name. His mother, Isetnofret, stood by the window looking over the city, so that

the sunlight limned her with gold. The years hadn't dimmed her beauty. She turned to face him. The hair of her wig had a blue-black sheen and her emerald eye make-up, made from the finest crushed malachite, reached from her eyebrows to her nose. Her breasts were full, her waist slim despite giving birth to Qen and Ipwet. Her dress hugged her form, and it was made of such fine linen that it was almost transparent.

Many men lusted after her, Hui knew. But those same men averted their gaze whenever she passed by. She was feared as much as she was desired. When he was younger, Hui had never understood why his friends refused to visit their house, and why the people of the Lower City curled their fingers and thumbs into a circle whenever she passed – a sign of protection, he had been told by one of them. As Hui had grown older he had understood, and the clue was in the circlet she wore upon her brow. It bore upon it a gold oval, studded with ebony and lapis lazuli to create an image of a beast's head with a curved snout and long rectangular ears. The mark of the god Seth.

Isetnofret had devoted herself to the god's cult since she was young, when her mother had sent her into the temple for a ritual which lasted for a day and a night. What had transpired in the inner sanctum was known only to the priests and Isetnofret, Khawy had said. But in return for her service, the god had granted her powers beyond mortal reach.

Sorceress, the people in the Lower City whispered.

'Hello, Mother,' he said with warmth.

'Qen has told me of your great success. I would see this gift of the gods that you rescued from the grip of the Shrikes. Perhaps it was sent by Seth himself.' She smiled with her full lips, but her black eyes glittered.

'I have given it to Father—'

'Already? You wasted little time claiming your rewards.' Her smile hardened.

Hui furrowed his brow. 'My rewards? No . . . I took it to Father because he would know best what course of action to take to ensure the prize reached the right hands.'

'And I am sure he showered you with praise. Deserving praise, of course. Was Qen not with you when you had your audience with your father?'

'No—'

'Did you not think Qen deserved some of that praise, too?'

'Qen left me the moment we entered Lahun, I . . . knew not where,' Hui stuttered. He could sense the irritation beneath his mother's words, but he couldn't understand it. 'Of course, Qen is just as deserving of Father's admiration. I told him Qen had helped me bring the Ka Stone here—'

'I would think Qen played a great role – perhaps the greatest. He is older than you, stronger, wiser . . .' Isetnofret caught herself, her smile softening, but her eyes losing none of their hardness. 'But let us not mire ourselves in detail. You and Qen have achieved something of consequence this day. We must prepare a celebration.'

Isetnofret folded her hands and glided away into the depths of the house to make preparations for whatever celebration she had planned. Hui felt uneasy. There'd been no mention of Kyky, no expression of condolence. Surely she knew three had departed and only two had returned.

Hui wandered towards the door. He would search their familiar haunts to find where Qen was hiding. Perhaps he was drowning his guilt at Kyky's death with beer. As he passed through the arch from the stairs, he started at a figure standing close by. It was Ipwet. She'd been eavesdropping on the conversation.

'Keep your wits about you, brother,' she breathed.

'What do you mean?'

Ipwet peered through the arch, checking that Isetnofret was gone. When she was satisfied they were alone, she relaxed.

'Mother is wise – some would say cunning. She has many chambers hidden inside her that the likes of you and I will never see into. And she is not your blood mother.'

Hui screwed up his face in bafflement. Ipwet had the soul of a poet, and sometimes her words took wing that lifted them beyond his comprehension.

Ipwet hid her giggle at his confusion behind her hand.

'Mother schemes. She is very good at it. And she has her anger, which you have seen, and her jealousies, and her ambition. She speaks honeyed words, and can lead many a man by the nose, if she so wishes. But we will never know the truth of her desires, or her plots, for she keeps them locked away.' His sister tapped her breastbone.

Hui had never heard Ipwet speak of their mother this way. There had been some harsh words between the two of them, he knew, though he had no idea why. Perhaps it was as Kyky had once said: that they were too alike, two poppies competing for the same light and water and attention from those who passed by.

'What scheme is there here?'

'Perhaps none. Who knows? But Father has told me of the Ka Stone, and an object of such value would be of great interest to Mother.'

Hui laughed. 'Father already has it, and so Mother has it.'

'True.' Ipwet laughed silently. 'You are so grown-up now, Hui, but in many ways you are still a boy.'

He snorted indignantly.

Ipwet rapped a knuckle on his head. 'So much learning still to do. Open your eyes, brother, and see the world as it truly is, not as you imagine. It will be better for your continued health, believe me.'

'And what should I learn, pray tell?' he responded.

In many ways you are still a boy. He would show her.

'Remember when the statue of Bes was found shattered?'

How could I forget?

That effigy of the dwarfish, bandy-legged household protector had been handed down to Khawy from his father, and his father's father. It was supposed to convey good fortune to anyone who owned it. Khawy had been heartbroken.

'Father beat me. I could not sit for three days. But I did not do it!'

'No. It was Qen.'

'What? How do you know?'

Ipwet pressed a finger to her lips. 'Yes, it was unfair that Father beat you for something you did not do. But he had good reason. Mother told him it was you.'

Hui gaped.

'She knew it was Qen, Hui, and still she told Father it was you.'

'I do not believe it. Why would she do such a thing?'

'Mother knows you are Father's favourite and she believes you get too much attention from him, that Qen – her son, from her loins, her blood – does not get enough.'

'We are equals in Father's eyes.'

'We both know that is not true.'

'Still, he does not favour me.'

'But he might, you see. That is Mother's fear.'

This was making his head hurt.

'Is this another of your games to torment me? Have I not suffered enough all my life, with an elder sister who sees me as little more than an object of sport?'

'Good sport, too.' Ipwet laughed. 'I love you, Hui, and I would see you well. Qen can look after himself. But you—'

'I can look after myself!'

'Run on, then, brave warrior and master thief,' she teased, holding both hands wide to weigh admiration. 'Consider my words. And get a thick hide. That will serve you well.'

Ipwet breezed away, casting a smiling glance over her shoulder. Hui watched her go, feeling oddly adrift.

The celebration was glorious, all the more so for being arranged at short notice. Isetnofret wore her most beautiful dress, one embroidered with honey bees at the waist. Standing at the door, she welcomed the wealthiest families in Lahun and ushered them into the main hall, which the slaves had decorated with roses plucked from the garden, and candles floating in bowls of water. The reflected light danced around the room, and the air was sweetened with the scent of the flowers.

The guests settled on low benches or sat cross-legged on sumptuous cushions. The Ka Stone rested on a cloth of gold on a plinth at the end of the room. As each visitor passed, they knelt and bowed their heads to it. Hui could sense the awe in them, and he revelled in the looks of admiration they flashed his way. It was all he'd ever dreamed of. The respect he truly deserved. But some, he could see, looked at the stone with covetousness. Ever since word of it had leaked out, there had been talk of no other thing in the city – of the powers it possessed; of what the gods would grant anyone who owned it.

Qen slipped in unannounced. Hui saw he was wearing black paint around his eyes that made them look even more intense than usual. But when his brother glanced at him, he nodded and smiled. Hui felt relief. The bad blood he'd feared seemed to have vanished. Yet could he ever forgive Qen for what he'd done to Kyky?

Servants brought bowls of pigeon and waterfowl, onions, eggs and butter, the air ripe with succulent aromas. Soon everyone was gorging themselves, and swilling back cups of spiced and honeyed red wine.

'Where have you been?' Hui whispered to Qen when he sat beside him.

'Asking the gods for forgiveness. For peace.'

From his grim expression, he has found little solace, Hui thought.

'Father visited Kyky's mother to break the news to her,' Hui said. 'He went on our behalf, so we would not have to endure the pain of the encounter.'

'He is a good man,' Qen said in a flat tone.

Throughout the feast, eyes flickered towards the Ka Stone as if everyone expected it to manifest its powers. Guest after guest would stand and toast the magical artefact. Hui watched their faces, trying to see the signs of anyone who secretly coveted this great and powerful god-stone. Surely they could trust their neighbours and friends? No, he would not trust anyone. Now he had brought wealth into this house, it was his responsibility to make sure his family was safe.

Yet this was a time for celebration. Khawy sipped cup after cup of wine until he grew heavy-lidded, a permanent lopsided smile on his lips. He seemed to be enjoying basking in the goodwill directed towards his house from the gathered guests. Hui was pleased.

As he felt a haze of drunkenness descend on him, too, Hui leaned in to Qen and murmured, 'For a time, everything looked dark, but now I can see all will turn out well.'

Qen said nothing. A moment later, Isetnofret stood and waved her hand for silence. She weaved a spell with her words, and everyone fell rapt as her resonant voice filled the space. Emphasizing the courage and the danger, she spun the tale of the adventure to capture the Ka Stone, lacing it with elements that paralleled stories of the gods, so that Hui and Qen seemed to be striding across the heavens.

Isetnofret made more of Qen's role than was strictly true – as if the quest had been his idea and he had led it, and Hui had been a mere accomplice. But Hui didn't mind. Let Qen luxuriate in the glory.

Once the feast came to an end and the guests drifted away, Hui stumbled to the roof terrace. He was filled with drink and the joy that came from an evening celebrating his success. A figure was sitting beyond the circle of flickering amber light from the torch above the doorway. From the silhouette, he could tell that it was Khawy.

'What are you doing here?' Hui asked as he sat beside him.

These days Hui rarely got to spend time talking with his father as they had often done when he was younger. It was Khawy who had filled the gaps in his knowledge left by the tutor who had been hired to ensure he had good prospects when he matured. Nowadays his father was mostly caught up in the relentless, day-to-day business of his role as governor. How Hui missed those old times.

'I like to sit here and remind myself that the gods have blessed me with a good life.' Khawy's voice was slurred, but Hui heard warmth. 'My sons and daughter, my wife, the prosperity we

share. Yes, there has been hardship, as there is in all lives – it is the nature of this world of men. Sometimes when you stare into the night, the vast, unending dark is all you see. But the light is always there, if you look hard enough . . .'

Khawy's words drifted as his thoughts engulfed him. Hui followed his father's gaze and felt a tingle along his spine. The ocean of night washed across the waste towards the fertile Nile valley, but in it the torches of Lahun glimmered like a constellation of stars. He followed the milky trail across the heavens above them, each speck of light twinkling. He felt there was magic in the air; that the gods, and the world they inhabited, were only a heartbeat away, and, perhaps, the Ka Stone provided a path to them.

Khawy patted Hui's forearm. 'You are a good son,' he murmured.

Hui breathed in the scents of pitch smoke and cooking meat drifting up to the high villas.

'Tell me about my mother,' he said. 'My real mother.'

For a long moment, Hui thought Khawy was not going to answer. When he did speak, his voice was heavy with emotion.

'When I first laid eyes on Kiya, I felt carried away across the land and ocean to a place of eternal joy. I had already taken Isetnofret as a wife, as you know. That was arranged, and I do not regret that. Two families coming together. Our union created a greater strength that would aid us in the defence of our city during a time of upheaval, a time that still continues. But there was no love there. That was not to be expected. But the arrangement has worked well for both of us. And Isetnofret bore me two children who filled my heart with hope for days yet to come. But Kiya . . .' His voice drifted away.

In the Lower City, a woman began to sing, a voice of such purity soaring up to the stars. Hui couldn't recognize the

tongue, but it seemed to him that the singer was telling a tale of lost love, and struggle, and the joy that came from two hearts finding union.

'Kiya was the daughter of a scribe,' Khawy continued. 'I saw her one morning as I walked along the canal. It was not her beauty, though beautiful she was, tall and slender with large, dark eyes and plump lips. It was the way she looked at me, as if she could see deep into my heart. And to the end, I believed she could. She knew my strengths, and my weaknesses, things that I never told anyone, and she made my life better from the moment we were wed.' He swallowed. 'We had so little time together, but I will always thank the gods for the days we shared. For her kindness. For the joy she brought. For giving me you. For a part of Kiya lives on in you, my son. I see her in your eyes. I hear her in your voice.'

Hui tried to imagine Kiya from Khawy's description. Though he had never known her, he felt happy that this woman his father had loved and admired so much was a part of him.

Before he could ask Khawy more, Hui sensed movement behind him. Glancing round, he glimpsed someone disappearing through the door into the house. He couldn't tell who it had been, man or woman. But he was sure the intruder had been eavesdropping on their conversation.

It was the smallest thing, likely nothing, but Hui felt his mood change. Now, when he looked out over the city, he saw only the dark amongst the light and he sensed enemies everywhere.

Hui drifted from the depths of a dreamless sleep and blinked awake. It was still night, the dark in the room swimming and the jasmine-scented breeze through the window as cool as spring water.

The sound of rhythmic chanting reached his ears through the silence of the villa. He had no idea where it was coming from. Lahun slumbered, ready for the day of labour ahead.

Something inside him prickled with unease, and he hauled himself up on shaky legs and padded through the house. Snores rumbled from his father's room. Ipwet was curled on her bed, muttering in the throes of a dream. Qen's room was empty.

Hui wandered through the reception hall, still ripe with the aromas of the lavish meal. Outside in the night air the chanting was clearer, a steady throb of voices, like a heartbeat. The strangeness of the sound, at that hour, possessed him.

He crept past the old king's palace and down to the city walls. The city gate hung ajar. He looked up and saw no watchmen standing sentry in their towers. What could have possessed them to leave their posts?

Hui wondered if this could be the first sign of an attack by the Shrikes, desperate to reclaim the Ka Stone. He eased out of the gate. The droning was coming from the direction of the crumbling pyramid, on the north side, hidden from Lahun's stately villas. The pyramid soared up, silhouetted against the brilliant spray of stars. Hui considered waking his father from his drunken sleep, but it seemed too soon. What if he was wrong? He would embarrass himself.

As Hui neared the source of the chanting, he saw a man squatting near the foot of the pyramid, barely more than a darker smudge in the shadow cast by the moon. A guard. He was still, apart from his head, which Hui could just make out was turning back and forth. Scanning the approach. Whoever was there didn't want to be disturbed.

Snatching up a stone, Hui hurled it into the night. The sound echoed and the guard lunged, moving low and fast like a hunting

dog in the direction of the disturbance. Hui darted forward, and around the edge of the pyramid.

He emerged into a brilliant glare, the moon's rays reflecting off the age-old slabs of white limestone paving spreading northwards from the pyramid's edge.

On the north side of the structure, not far from the smaller Queen's Pyramid, eight rectangular stone blocks loomed. They were the mastabas, the Houses of Eternity, tombs for members of that long-forgotten king's royal court. Khawy had told him how the sarcophagi containing the mummified bodies would have been carried in, the coffins painted in bright green, red and white and inscribed with the prayers that would keep the occupants safe on their journey to the afterlife. The bodies would have been covered with linen decorated with texts from the *Book of the Dead.*

In front of the mastabas, twenty cloaked and cowled figures stood in a crescent. The hooded assembly were chanting, a prayer by the sound of it. Hui strained to make out the words.

Another cowled figure faced them, arms extended. From the slender wrists that emerged from the sleeves, Hui could see it was a woman.

It was not the Shrikes, then, but what ritual was being enacted here? Hui had never heard of such a thing. If these were priests they would be in their temple, and at this time they would be conducting their sacred nightly ablutions, not praying, which he knew they only did at sunrise and sunset.

The chanting ebbed away and there was silence, broken only by the wind soughing amongst the shattered stones of the crumbling pyramid. The central figure continued to stand with arms outstretched, and with a languid movement she shucked off her cloak and robe. The moon burnished her naked body, and Hui

couldn't help but let his gaze linger on her heavy breasts, broad hips and the darkness at her sex. But when he looked up to her face, he recoiled. It was Isetnofret, his mother. Gripped by shame at the thoughts that had surfaced, he turned away. He could feel his cheeks burning. But curiosity at what was taking place got the better of him, and he was once again gripped by the ritual.

The only thing Isetnofret wore was the circlet on her brow with the mark of Seth. But Hui saw her body had been painted with magical symbols, along her long legs, across the swell of her belly, on her ribs, flexing with each deep breath, and on to her upper arms. Hui glimpsed a pattern of stars, a moon, and the beast-head of the god to whom she had devoted her life.

With her hands reaching out once more, she began to intone in a clear voice, 'Here we stand before the all-seeing eyes of Seth, Lord of Chaos, our God of Fire and the Desert, King of Envy, Master of Trickery, Overseer of Storms.' She paused and licked her lips. 'Lord of Violence.' There was another long silence, heavy with intent. 'God of Foreigners. God of the Hyksos.'

Hui flinched at the mention of that warlike barbarian breed. Why would his mother invoke their name?

'Seth, son of Geb, the earth, and Nut, the sky,' Isetnofret continued, her voice rising up to the pinnacle of the pyramid. 'Brother of Osiris, Isis and Nephthys. We call on you.'

His mother turned to a small altar that had been set up behind her and plucked from it a long bronze knife. Resting it on the palms of her hands, she raised it to the heavens. Her head fell back and she breathed, 'Accept this sacrifice.'

One of the worshippers stepped away, out of Hui's sight. When he returned, he was holding a rope and at the other end was a crocodile, smaller than the ones Hui had witnessed in

the Nile. The armoured hide was a lighter bronze, too, and smoother. Hui knew that some of these savage beasts made their way up the canal from the great river in search of prey. This one was not savage, though. Its broad snout had been bound tightly shut, and it was oddly compliant, its steps slow, that long ridged tail not thrashing around. Had they given it some potion to sap its life force? he wondered.

The cowled figure dragged the beast in front of Isetnofret, where it seemed to lose the last of its will. Three others stepped forward and heaved the beast onto its crusty back, exposing its pale belly to the moonlight. Gripping the handle of the knife above her head, Isetnofret stabbed down. Blood spurted onto the pristine limestone. The ones who had brought it held it down as its life force ebbed away.

Once the ritual killing was done, one of the worshippers took the knife and began to hack away small chunks of meat from the gaping wound in the crocodile's belly. Hui watched as he moved along the crescent of supplicants, handing out the gobbets, which each one then popped into their mouth and devoured.

The last chunk was reserved for his mother. The crocodile's blood smeared her mouth and trickled down her chin as she chewed and swallowed the raw flesh.

Hui was transfixed. It was erotic but terrifying. These must be members of his mother's Cult of Seth, but he could not comprehend the purpose of this ritual. How had these things escaped him all his life? There were secrets in Lahun, that was clear, and his own family kept them. He felt troubled by this revelation.

'The time has come,' Isetnofret continued, 'to welcome the great Seth into us. To become one with him, and he one with us. He will live in our hearts.'

Isetnofret reached out a hand and another of the suppli-cants stepped forward – the tallest one there. From the altar, he lifted a golden bowl with an inlaid design of a scorpion. As the man walked towards Isetnofret, Hui saw that in the bowl a flower was floating on the surface of liquid the colour of melted amber. Even at that distance, Hui could see the blue tinge on the flower's finger-like petals.

It was the sacred Blue Lotus, the blue lily found in the waters of the Nile and renowned for its magical properties. Many secrets surrounded the flower, but Hui had no doubt of its beauty. Had the priests not created entire lakes to grow the lily so they could use it in their rituals? He had been told those delicate petals held the power of all life. Sweetly fragrant, the azure flowers bloomed for only three days once a year, and contained the essence of Ra, the Lord of the Sun, himself, the priests said. The petals closed when night fell across the land; the lily sank beneath the waters, and then rose again at dawn to open with the first blush of the sun's rays.

His heart beat faster. Here was a magic that he'd never dreamed he would see performed. Once the priests drank the essence of the Blue Lotus, they became one with the gods, it was said. They could see beyond the realm of man, hear whispers of great secrets. This was why the flower was so important during the funerary rite, as they guided the soul towards the afterlife. What wonders, what powers. And now that fabled Blue Lotus was in the hands of his mother.

Isetnofret raised the bowl to her lips and drank a deep draught, and Hui began to see her in a new light – as powerful as all those in Lahun said, perhaps even feared. How could she not be, if she had laid claim to the Blue Lotus?

Once she had licked her lips clean, Isetnofret raised the gleaming bowl above her head to show the gods, as she had done with the sacrificial knife. As she did so, the supplicant who had delivered the bowl to her let his own robes fall to his ankles.

Once again, Hui jolted in shock. It was Qen, also naked, also adorned with painted symbols across his flesh. He knelt before his mother. She lowered the Blue Lotus bowl to his lips and tipped it so that he could drink. When he was finished, Isetnofret set the bowl on the ground, then cupped her son's face in her hands and raised him to his feet.

'I am Seth,' she said.

'I am Seth,' Qen replied, his voice strong and clear as he held his mother's gaze.

For a long moment, they remained locked in that position, with Isetnofret's hands holding her son's face. As Hui watched, he could see the Blue Lotus working its magic upon them. Shudders rippled through them, their muscles flexing in the moonlight. Sweat beaded their brows, trickling between Isetnofret's breasts. Once the tremors reached the tips of their fingers, their chests rose and fell with rapid breaths, and their eyes rolled back in their heads until Hui could only see white. The ecstasy seemed to consume them. Isetnofret's lips opened into a crescent that seemed to hold a seductive promise. Qen smiled.

Isetnofret's nipples, already hard in the chill, seemed to become more engorged. Qen's member hanging between his legs began to stiffen, until it was rigid against his flat belly. If he felt embarrassment at his arousal in front of his mother, he didn't show it. They both held that penetrating gaze, as if they were looking deep inside each other.

'Seth recognizes Seth.' His mother's words were a murmur, but somehow the wind caught them and Hui could hear.

Hui stared, barely able to comprehend what he was seeing. Leaning in, Isetnofret embraced Qen, their bodies pressing hard against each other. And then they began to kiss, not as mother and son, but as lovers, deep and long. Hui gaped. They were lost to the dreams induced by the Blue Lotus; that could be the only explanation.

As one, the gathered supplicants who had been observing this ritual turned, facing towards the pyramid. The shadows from their cowls swallowed their faces so Hui could not tell their identities. What neighbours hid there, what fathers of his friends, what rich and powerful masters of Lahun?

Behind them, Isetnofret leaned back on that gleaming limestone and spread her legs wide. Qen fell upon her, and within an instant they were rutting like beasts of the field, their moans rising into the heavens.

Hui felt a wave of nausea and he spun away. He could not watch any more of this madness. The world no longer made sense.

Creeping well away from the sentinel who had returned to his post, Hui slipped into the shadows. And then he was running as hard as he could, back to Lahun, to the grand villas, to the home that had sheltered him since he was a boy. Panting with exertion, he entered the house. His father still snored. Ipwet still trembled in the throes of her dream. Both of them were oblivious to the night's secrets.

Hui crawled into his bed. Staring into the dark, he willed his heart to return to a steady beat, trying to unsee those awful visions parading through his mind.

So many questions. There could be no doubt now that Isetnofret was a sorceress of some renown. Those tales Hui thought had been whipped up by cowardly men were true.

That she had drawn Qen into her web filled him with disgust. Congress between family members was accepted amongst royals; everyone knew that. But the kings and queens were above men, one step away from the gods. For did Isis not marry her brother Osiris, and Seth marry his sister Nephthys? But such a thing was considered obscene amongst the common herd.

Yet there was much about that ritual that troubled him beyond that. His mother had summoned the powers of the great and terrifying Seth into herself and Qen for a reason he couldn't fathom. This could only be in the service of some great ambition that Isetnofret harboured, otherwise why would she need the god's aid? This plot could not bode any good, though. The ritual had been conducted in secret, away from prying eyes. And those other members of that cult had been hooded to keep their identities hidden. They did not want to be judged, that much was clear.

Hui hugged his arms around him, turning over these questions until his stomach knotted. Though he thought he would never sleep again, as sudden as a storm in the desert, he fell into a deep slumber.

In his dream, Hui found himself on a vast, featureless plain running to the distant horizon. The jagged teeth of a mountain range rose towards the sable sky. In the vault of the heavens, more stars glimmered than he had ever seen in his life.

A figure soared high above him. When Hui craned his neck, he glimpsed the beast-head of Seth, with its curved snout, the white-rimmed black eyes staring down with terrible fury.

Hui wanted to ask what he had done that was so wrong, but his lips were sealed, his mouth as dry as the dust beneath his feet.

In his left hand, Seth held the *ankh*, the sign of life, and in his right the *Was*-sceptre, the symbol of his power. Hui trembled as that sceptre levelled, and the god stared down its length at him, before sweeping it away, towards the desert. Hui followed the line of the staff and saw a vast river snaking across the plain. Floating in it was a body.

When Hui looked back, Seth opened his mouth and the words boomed like claps of thunder: 'Who will be king?'

This time the *ankh* swept out, and Hui saw a sprawling city of bone-white tombs and open graves. Prowling amongst them was what Hui first took as a black jackal, the head swaying back and forth as it searched for carrion. But as the beast raised itself up, Hui saw the head sat upon a man's body. Here was Anubis, who stalked the boundary between life and death. He, too, gripped an *ankh* and a *Was*-sceptre.

'The Dog Who Swallows Millions!' Seth boomed.

Hui felt a terrible dread. There were secrets hidden here, but what they were he had no idea. Of one thing he was sure: it promised no good for him.

And then Hui was rushing back as if he had been lifted by a powerful wind, across that grey plain, under that starry night sky, with Seth and Anubis diminishing, fading into the distance, but still judging him with piercing stares.

When he crashed to earth, his eyes opened and he was in his own bed once again, the sweat soaking his body. His heart thundered as if he'd run for miles. Had this been the Ka Stone speaking to him?

The ruddy light of a new day turned the white walls the colour of blood.

Hui had no stomach to break his night-time fast. He sat cross-legged on his bed, head in his hands, as he turned over what he had seen the previous night. After what Qen had done to Kyky, should he keep this secret, too? He felt in torment.

Stumbling from his room, Hui wandered through the house, part of him terrified that he might come face to face with Qen. He halted at the sound of angry voices. Hui recognized his father's deep rumble and his mother's higher-pitched voice, as sharp as a blade. He turned away to leave them to their marital dispute when he heard his own name mentioned.

'Hui deserves all the credit, you know that,' Khawy raged. 'Qen would never have had the courage to brave a camp of the Shrikes.'

'You do not know him. Qen has—' Isetnofret began.

'Qen has strengths, but courage is not one of them,' his father interrupted. 'He says nothing until he is certain that everyone already agrees with his view. Qen watches and waits and acts when it is in his own interest. He—'

'He has more wit than that spawn of the whore you call your "true love"!'

Silence fell. Hui could not believe his mother would address his father in such a disrespectful way, even with her fierce temper.

When Khawy next spoke, his words were cold and steady.

'When Lord Bakari arrives, Hui will accompany me to meet him. And it will be Hui who will hand over the stone of the gods.'

'Qen must be there.'

Finally Khawy replied, 'Very well. But be in no doubt that Hui will earn the full praise that he deserves.'

As Isetnofret stormed out of the chamber, Hui pressed himself behind a statue of Taweret, the pregnant hippopotamus deity. Isetnofret swept away, her bare feet slapping on the stones and the hem of her linen dress flowing behind her.

Once he was sure she was gone, Hui stepped into the room. His father was standing by the window, looking across the jumbled roofs of the Lower City. A melancholy air hung over him.

Khawy turned when he heard footsteps behind him, and smiled.

'My son. You are well?'

'Well, Father.' Hui felt queasy from the secret he was keeping locked inside him.

'The feast was good, was it not? Your mother outdid herself.'

'I have never eaten so much. Nor drank so much wine.'

'I am still paying the price for my revels,' his father said with a laugh. 'My son, on the day you returned to us I sent word to Pharaoh's palace about the great prize you had seized and the courage you'd shown to gain it. In truth, I expected no response. The king's advisers are involved in important work that takes up all the hours of the day. They have little time for the words of a poorly educated governor from a small place like Lahun.'

'You are a great man, Father,' said Hui, sad that Khawy would see himself in that light.

Khawy smiled, tight and humourless. 'This is our entire world, my son. We live our lives within these four walls and all that happens here shapes us. That makes us believe that what we experience is important. And it is, to us. We have our struggles, and our loves, our rivalries, our enmities, and they

seem all-consuming. But to any other eyes, they are small. There is a greater world beyond these walls, where greater things happen, monumental things. We are the flea upon the flank of an elephant.'

Hui nodded. His father was wise. He hoped, one day, that he would live up to him. Filled with love for his father, he said, 'And that is the world I wish to be a part of. There is a greater destiny awaiting me, I have always felt that. I will make you proud of me, Father, and all the riches I attain I will bring back here to Lahun to shower on you.'

'Then perhaps you have already set foot on the road to that destiny. I have good news. Pharaoh's advisers did indeed heed me. Lord Bakari has been dispatched to Lahun to see this magical stone, and to hear your story. And if it meets his expectations, he will take it with him to Elephantine Island, where it will be offered to the priests for the glory of Pharaoh. Your name will travel with it, Hui, and you will be rewarded.' Khawy folded his hands. 'Lord Bakari will arrive within four days.'

Hui felt his thoughts tumble as if he'd been struck across the head with a cudgel. Then exhilaration rushed through him. The gods had answered his prayers. The shadow cast by the dream burned away in the bright light of this news. Yet unease still prickled.

'Mother is not pleased?' He couldn't look Khawy in the eye when he mentioned Isetnofret.

'Your mother fears Qen will be forgotten in this excitement, that he will not get his just rewards. That is not true. I am fair, and I will ensure he gets fair recognition. But not at your expense.'

'I would not cause any trouble. If Mother believes Qen should stand at my side in front of the lord, then I would not complain.'

'Do not worry yourself about your mother. Her temper is like a furnace. I have felt its heat a thousand times across the years, but it always cools. In the end, she will do as I say.'

Khawy strode across the room and squeezed Hui's shoulder. Hui felt moved by the pride he saw glowing in his father's face.

'For you, for Lahun . . . for me, this will be a great day,' Khawy said. 'We must begin arrangements immediately.'

Hui wandered into the sunlit garden and found Ipwet sitting under a vine-covered pergola in the shady arbour of fig trees. The air was rich with the lemony zest of coriander.

His sister turned up her nose when she saw him.

'Are you ill? You look as if all the blood has drained from you.'

'I did not sleep well.'

'And you smell of vinegar.'

Hui waved a hand to dismiss her words. He had no time for Ipwet's teasing now.

'What are you doing?' he said, looking around at the swaying date palms.

'Father is arranging for me to be wed,' she said, without enthusiasm. 'He has been discussing it with the governor of Shedet for a season now.'

Hui found it hard to imagine Ipwet married. She'd always seemed like a boy to him, racing with the other lads, playing their games, beating them in fights. He didn't know if she'd fallen in love with any of the other young men in the Upper City who watched with desire as she passed by – Ipwet would never have told him such a thing – but he suspected there was no one for whom she cared.

'It will be good for you. And us. Get you out from under our feet.'

Ipwet stuck her tongue out at him. But she still wrinkled her nose as if she breathed in a bad smell. Hui felt puzzled. He would have thought she would have been excited to be wed.

'At least I will have some value,' she said with a note of disgust.

'What value is there in this marriage?'

Ipwet raised her eyes, the shadows of the leaves playing across her face.

'Father and the governor of Shedet are worried about the barbarians in the east.'

'The Hyksos?' Hui flinched, remembering Isetnofret mentioning the murderous breed during the ritual by the pyramid.

She nodded. He understood why Khawy would be so concerned. Even the Shrikes, he suspected, would be in awe of them. They were masters of horse and bow, and fears had been growing about their warlike nature. Increasingly, bands of their warriors had ridden out of the Sinai and into the fertile Nile valley, seizing upon the chaos caused by the constant struggle with the Red Pretender in the north. Too much blood had been spilled already, but their hunger for land and power never seemed to abate.

'Khawy and the governor of Shebet fear those foreigners will not be satisfied with the land they have seized. Sooner or later, Father says, they will come for the rest of Egypt.' Ipwet lowered her voice, looking around the garden. 'Father says the king is weak and will not defend us properly. He is letting Egypt drift away from the magnificence of years gone by. We will have to defend ourselves, he insists. And through my wedding, we will join our forces and offer some resistance should those bloodthirsty creatures attack.'

Just as Khawy married Isetnofret, Hui thought.

He dropped down onto the flagstones in front of the bench and sat cross-legged, looking up at her. Ipwet must have seen in his face his struggle to find the words to discuss the worries that burdened him, for she said in a gentle tone, 'What ails you, brother?'

'Life seemed so much simpler when we were children,' Hui said.

'That is because we were like blind rats snuffling around for grains of corn. The curse of life is that we learn to see.'

Hui looked at her, puzzled. Why had he never noticed that she was as wise as Father? And was he the only one in the family who was as simple as an infant?

'I am burdened by things that I have seen,' he began. 'They lie heavy on me.'

'Then speak, brother, and that weight will be lifted from you.' She rested a comforting hand on his forearm. 'You know I love you. I will help.'

Though her words were meant to comfort, Hui felt concern. He couldn't say anything that would hurt her – certainly not what he had witnessed between Isetnofret and Qen. That would have to be his own secret, and his shame. But the rest of it . . . Ipwet could aid him there without much harm.

'Qen brought about Kyky's death,' he said.

He told the story of their foray into the Shrike camp, of the discovery, and the chase by the bandits, and when Qen had stumbled and almost been caught. His words dried and tears stung his eyes as he remembered Kyky's face, and the love that was there for his friends, and how, without a thought for his own safety, he had turned back to help Qen. And finally he brought up the truth: that Qen had sacrificed their childhood friend to save his own neck.

A shadow fell upon Ipwet's face.

'Please, do not tell Father,' Hui begged. 'I would see no punishment come to Qen. He is weak, that is all. And the gods know, we all have our weaknesses.'

Ipwet bit her lip in reflection, and then she nodded her agreement.

'Weakness, indeed. Then it is only right that Qen is not rewarded for his cowardice.' She wrapped her arms around him, as she had done when he had fallen as a boy. 'You should not have had to carry this secret,' she murmured. 'These things eat away at you until they bring a sickness, so the physicians say. You deserve all that is coming to you, brother. Do not let Qen – or Mother – steal that away from you.'

Hui eased himself out of her embrace. Ipwet studied his eyes. 'There is more?'

'I have questions. About Mother.'

'You would not be alone.'

'When I was a boy, I heard the tales of her being a sorceress. I thought it was that weaving of fantasies that children do so well. But now I wonder who my own mother truly is.'

Ipwet pursed her lips. She seemed to understand what Hui was saying. Perhaps he could get some of the answers that might quell the turmoil inside him.

'Mother has many secrets,' his sister began. 'Over the years, I have learned some of them, seen the shadows of others. In the light, she smiles at everyone. But away from the flame, she weaves her plots. What does she want? I do not know.' She paused, choosing her words with care. 'I repeat what I said before. It would be wise not to trust her too much, and it pains me to say this about our own mother. What allows me some peace is that whatever she does, it will always be to the benefit of our family.'

Ipwet's words gave him the courage to open his heart.

'Last night I crept from my bed and watched her conduct a ritual in the court beyond the pyramid. Hidden from view. She was not alone. There were twenty others there – men, I think, though I could not see their faces. I am sure she was casting a spell, though to what end I do not know.'

'A spell, you say?'

He nodded. 'Who were those others? Does Father know them? Does Father know any of this?'

'Isetnofret regularly makes her offerings to the Lord of the Desert.'

'It was the way she weaved her magic so secretly.'

Hui's thoughts flashed back to his mother's naked body, and her congress with Qen, and he covered his face with his hands to try to drive the vision from his head.

'She seemed to think no one could touch her,' he mumbled, 'as if her power was too great.'

Ipwet said, 'Keep this to yourself, for now. I know nothing of this, although, like you, I have heard many tales and it is often hard to pick the grains of gold from the filth. But I will see what I can do to discover more.'

'What spell was she weaving?'

Ipwet shook her head.

'Who were those others?'

She shook her head again, irritated that he was asking questions which he knew she couldn't answer.

'Should we tell Father?'

'No!' Her voice hardened with certainty. 'Father has his own troubles. Not only you running off to risk your neck in search of adventure . . .' She glared and Hui felt chastened. 'The burdens of governing Lahun in this time of growing chaos are

heavy on him. Some governors seek that post only to fill their own coffers with gold. But Father feels a responsibility for our people. You know how it is.'

Hui nodded. 'He is a good man.'

'Now he worries that the Hyksos barbarians will come under cover of the night and rape the women and kill the men and steal the city, and it will happen while he is the watchman.' She sighed. 'No. Let's not trouble him further. Let him have the joy that you have earned for him with the gods' gift. Mother has caused him much pain across the years with her independent ways . . .'

Hui sensed there was more than he had ever realized in her words. He was a blind rat indeed.

'No more,' she continued. 'Leave Mother to me.'

The wind had dropped along the lush valley. The date palms barely stirred and the square sails of the skiffs on the canal hung limp. From a brassy sky, the sun blasted down, turning the water into a stream of gold blazing from the furnace in the ochre hills. The aroma of the pink flowers on the tamarisk shrubs that dotted the higher slopes sweetened the dank smell of the steaming vegetation. On any other day, it would have been still in that oppressive heat, with only the splash of oars and the creak of mooring lines to break the silence.

Today, the din of hammers rang out.

Hui stood on the quayside and looked out over men sweating in the heat as they laboured to complete the annual canal works before the next flood season came. Masons chiselled blocks of stone to replace the crumbling facing of the wharf. Clouds of chalky dust drifted in the air where flies droned.

Slaves burned almost black by the sun heaved more of the quarried raw materials on hods on their shoulders, towering heaps that seemed as if they would topple at any moment. Along the canal, more slaves waded in the shallows, dredging out what silt they could with tightly woven nets so that the channel wouldn't clog. Their voices rolled out in a lilting shanty as they ducked and pulled.

Angry shouts rang out. Hui turned to see a man on his back in the mud, blood flowing from a gash on his forehead. One of the masons hovered over him, snarling, chisel in hand. His face was twisted with rage and Hui could see this dispute could become nasty.

Hui leaped into the ankle-deep silt.

'Stand back!' he bellowed.

He was not someone who could command men with the tone of his voice or a murderous glare – that was not in his nature – but Khawy had entrusted him with the oversight of these important works. Since he had returned with the Ka Stone, his father had been keen to give him more responsibilities. No doubt that would anger his mother even more.

Yet for all Hui's lack of authority, the mason stepped back and lowered the chisel. The man on the ground pushed himself up. Both of the brawlers hung their heads, but watched Hui from under heavy brows.

'They are fighting over some woman or other,' the Master of Works grunted. 'Leave them to me. I will keep them apart.'

Hui nodded and squelched to the dock. As he glanced back, he saw the two battling men were still eyeing him, as were many of the others who lined the canal. Was that respect he saw in their faces? He'd never received those kinds of looks before.

Contempt and dismissal, that's what he was used to. Was it because he was the governor's son, or because word had spread about his exploits in the Shrike camp?

Under the shade of the canopy that had been erected on the wharf, he looked over the works. All seemed to be progressing at the pace Khawy had demanded. Hui did not want to let his father down, not when he'd been elevated to such an exalted position.

In truth, he'd rather have been anywhere but there. His troubles were weighing him down, and those worries were growing worse. But this was important work. The canal was a vital artery for life in Lahun, irrigating the rich farmland that provided sustenance, bringing in trade from the cities along the Nile.

Hui stared along the length of the watercourse to the hazy distance where it passed through the hills. The *Mer-Wer*, they called it in the old tongue – the Great Canal. Once, long ago, it had been a tributary of the Nile which formed a vast lake to the west during the time of the annual floods. One of the old kings who had recognized that in a land like Egypt, water was more valuable than gold, had opened his coffers. Armies of labourers sweated to widen and deepen the river course. They carved the canal into the natural incline of the valley so that at its deepest it could drown two men, one standing on the other's shoulders. With a dam constructed, the Fayuum oasis became a reservoir for when water was scarce, and the land on either side of the watercourse was transformed into fertile farmland.

'Brother!'

Hui turned at the voice and saw Qen striding towards him past the heaps of masonry.

'Have you been avoiding me?' the new arrival asked with a laugh.

Of course, he had. Hui could barely look his brother in the face.

'I have busied myself in the preparations for the visit of Lord Bakari. And Father has me overseeing the canal works.' He swept out his hand to indicate the extent of the labouring.

'You are doing work for Father now?'

'He has always wanted me to follow in his footsteps as governor,' Hui said. 'A life of dusty papyri and balancing accounts and sorting out petty disputes. Who would dream of that?'

He saw Qen's face harden, and he felt a pang of regret at his insensitivity. This should have been an honour to be offered to the eldest son, whether Qen wanted it or not.

'Father sees me as someone who is only capable of the dullest of work,' Hui added, with what he hoped wasn't obvious haste. 'You, of course, are destined for greater things in his eyes.'

Qen grinned. 'And greater things are what I have on my mind. One day, soon.'

Hui smiled back, and he prayed that his expression didn't seem false and that his eyes didn't give away what he was thinking. Inside he was squirming as he recalled the act Qen had committed with his mother.

'Come, help me,' Hui said, beckoning. He hoped he could distract himself from these thoughts.

They walked along the causeway from the wharf and then leaped onto the paths of dried rushes that made for easier access along the marshy canal side.

'You have said nothing to Father about what happened in the camp of the Shrikes?' Qen asked as he watched a skiff drifting along from the east.

'My lips are sealed. What is done is done, and there is no benefit in dredging up old memories.'

'Kyky was your old friend—'

'Kyky was *our* friend, yours as much as mine.' Hui stiffened. He was surprised how much anger still bubbled inside him.

'I have thought about this,' Qen mused, 'and I now think that is not true. I convinced myself that it was, but it cannot be, for . . .' His words dried up, but Hui knew what he wanted to say: that he wouldn't have sacrificed Kyky to save himself if they had been good friends. If that was the only way he could live with his actions, then so be it. 'I only pretended to be friends with Kyky for your sake,' he insisted with a nod of his head.

They stood in silence, turning their attention from the slaves to the farmers in their fields.

'What is that?'

Qen cupped his ear and was looking past the walls of Lahun into the distance. The ground and sky wavered and became as one under the searing rays of the sun.

Hui strained to hear. A shout echoed from the hazy wastes, and it was followed by more voices rising up, this time from Lahun.

'Look!' Qen shouted.

Qen was pointing into the azure sky. Hui saw charcoal smudges circling in the silvery haze. Vultures, broad wings gliding, those cruel curved beaks jutting from their blueish bald heads. They were ready to fill their bellies with some carrion they had identified from the heavens. Hui could see nothing on the ground. Yet the cries from the watchmen along the walls were now ringing with an edge of alarm.

'We should see what is amiss,' he said.

As the two brothers neared the white walls of the city, the gates creaked open and people flooded out into the oven-like heat of the morning. Hui pushed through the merchants and smiths, the builders and carpenters, and saw a grey shape wavering in the glassy air. It was a man slumped on a donkey.

The crowd fell silent, watching the lone rider making his way to the city. It was not an unusual sight. Traders came daily with their wares – caravans from the cities along the Nile, *habiru* hoping to barter. But everyone sensed something was wrong.

The rider lurched to one side and slipped off his beast. Hui ran towards him. The donkey was wounded. An arrow protruded from its flank and there was a gash above its eyes. Before he reached it, the beast dropped onto its front legs and crashed onto its side. It looked dead.

The rider was lying on his back. A man of perhaps fifty years. Blood was smeared from crown to jaw. His ivory robe was slashed in many places and soaked with gore from his wounds. It was astonishing that he had made it this far.

Hui put his hand under the man's neck and raised his head.

'Save your breath,' he said. 'You have reached Lahun. You will be well cared for here.'

Hui took his water skin from his waist and sluiced water into the man's mouth. The rider lapped desperately at the drink. The man tried to speak, but he barely had the strength. His head shook with the effort.

Qen arrived.

'Who did this to him?' he demanded without a hint of pity.

'What is it you want to say?' Hui asked the man.

The rider worked his mouth again, the movements becoming more insistent. He emitted a groan.

Hui pressed his ear close to the man's mouth.

'Say again,' he said.

The rider summoned up what little reserves he had, and this time Hui heard.

'The Hyksos are coming.'

Hui hailed four of the strongest men to carry the wounded stranger into the city. When they reached the house of the physician, Pakhom, Hui commanded one of the bearers to fetch his father and they hauled the injured man inside. Pakhom was a big, shaven-headed man, his belly hanging over his kilt. To Hui, he always seemed as if he had a toothache.

'What is the meaning of this?' the physician demanded.

'This visitor was attacked on his way to Lahun,' Hui said. 'He needs your help to save his life.'

Pakhom stared.

'My father will pay you.'

Grudgingly, Pakhom waved a hand towards the back of the room. The bearers lugged the bloody victim to where the physician worked his magic, a dark room lined with shelves overflowing with jars and flasks, phials and rolls of papyrus. In the centre was a cracked and stained table. Once the rider had been lowered onto it, Qen herded the babbling helpers out and shut the door.

'Help him,' Hui said, adding, 'He has information that may be vital to all our safety.'

'Sword strokes, by the look of it,' Qen whispered. 'It's a miracle he's survived this long.'

All Hui could think of was the rider's desperate warning. If the Hyksos were considering an attack on Lahun, they would need to marshal their defences immediately, drafting in every able-bodied man to fight. It would be a bloody battle. There were no skilled warriors there, only tradesmen and farmers and smooth-skinned wealthy merchants. They relied on the

pharaoh's army for defence – and the Hyksos were renowned as some of the fiercest fighting men in all the world.

The door swung open and his father strode in.

'Why have you disturbed me?' Khawy asked with a note of irritation.

'You must hear what this stranger has to say,' Hui replied. 'You will thank me when you do.'

Once he'd recounted the rider's words, he watched the lines on his father's face deepen like the marks of a chisel in a stone.

'Why would they risk an attack on Lahun?' he said, as if trying to convince himself. 'Even with their horses and their bows, the walls of the city are strong.'

'They could try to starve us out,' Qen ventured.

'Not before Pharaoh sent his army to crush them.' Khawy rubbed his chin, turning over the strategic possibilities. 'Do whatever you can to save him,' he said to Pakhom. 'I would hear what he has to say.'

The physician was already moving around his patient, examining the wounds and identifying the most severe. Once he was done, Pakhom held out both arms wide beside the patient, closed his eyes and pushed his head back.

'I call upon Heka, the god of magic and medicine,' he intoned. He shifted to the wounded man's head and adopted the same position. 'And I call upon Sobek to help heal these wounds.' The physician stepped to the patient's other side. 'And I call on Seth,' he continued, 'the great God of the Desert who watches over us all, to protect the soul of this poor individual, and to provide his great strength to bring life back to these failing limbs.'

On hearing Seth's name, Hui studied the physician as he hunched over the victim and wondered if he was one of the

hooded figures who had joined Isetnofret at the ritual near the pyramid.

Pakhom snatched a papyrus from one of the shelves. When he unfurled it, Hui peered over his shoulder. It was one of the medical texts, written by doctors for other doctors, and it made little sense to the uninitiated. These were normally kept in that part of the temple called the *Per-Ankh*, the House of Life, but a physician of Pakhom's standing would have his own copies to refer to at his home or when he visited the sick in their villas.

Pakhom then poured a cup of beer from a pitcher and began to crumble dried herbs into it before adding a mysterious golden liquid.

'This will strengthen his heart,' the physician said. 'It is weak. He has lost so much blood.' He held the cup to his patient's dry lips and poured a little into his mouth.

Pakhom set the cup aside, opened a mahogany box carved with images of snakes and pulled out an amulet made of polished stone. The image of a scarab had been engraved in the shiny surface. The talisman hung on a silver chain, and the physician slipped it over the patient's head.

'This will protect him from any ghosts or demons that may try to suck his soul out of his body.'

Hui's eyes darted around the shadowy room, and he sensed his brother do the same. Everyone knew otherworldly forces tried to prey on the wavering flame of those who were close to death.

Pakhom seemed pleased with his work.

'Good. Now we can begin.'

Pakhom was both *swnw*, a trained doctor skilled in all the medical arts, and also a *sau*, who specialized in the use of magic to help his patients. The two in combination provided the best hope for the sick, and Lahun had benefited from his expertise

for many a year. As he watched the physician, Hui marvelled at the dedication Pakhom had to show to maintain his ritual purity, so that the gods would aid him when he called upon them. Bathing five times a day was only one small part of it. The physician also had to obey a list of strict directions to cleanse his body. Only then would he be considered *wabau*, as untainted as any priest.

Hui eyed another table where the tools of Pakhom's trade had been laid out. Flint and copper scalpels, a bone saw, clamps, pliers, probes, catheters, scissors, lancets, as well as rolls of linen bandages and a set of scales to weigh his medicines.

Pakhom plucked up the scissors and sliced away his patient's sodden robe. Selecting the clamps, he pinched them to the wounds where the most blood was flowing. Hui watched the rise and fall of the stranger's chest. It was slowing, he was sure. He could not be long for this world.

Khawy murmured, 'Hurry. We need to hear what this poor soul has to say.'

From a jar, Pakhom scooped a handful of sweet-smelling honey and smeared it into a bowl. To this he added a whirl of bitter unguent, white and sticky, and the dust of some small brown seeds which he'd ground up in a mortar. He applied the foul concoction into the gaping wounds. The man cried out and shuddered, but then his eyelids fluttered and a dreamy smile crept across his lips. The physician had sucked the pain out of him, at least for now.

Pakhom said, 'He will not last the night. Talk to him now, if you will. But make haste. The medicine I have given him will steal his senses soon enough.'

Khawy nodded and bent over the stranger's face.

'I am Khawy, the governor of Lahun. Can you hear me?'

The patient licked his lips and gave a nod.

'What is your name?'

'Akil.'

'Tell me what transpired. How did you suffer so?'

'I was part of a caravan . . . travelling with my wife and son. We had come down from the high hills and were making our way towards Fayuum . . . near the oasis. You know it?'

'Yes, yes,' Khawy said, urging the man to continue.

'We were prepared for bandits. We know the Shrikes roam freely in this part of the land. We had one scout riding ahead. Two others on each flank, hidden from our eyes by the rocks. The first we knew something was amiss was when we saw the vultures circling. As we marched down a gully, we found our lead scout dead. Those scavengers were already feasting on his remains. His head had been cut off and set to one side. The eyes . . . He looked at me as if he was warning me . . .' Akil's words drained away.

Hui and Qen exchanged a glance.

'Shrikes, we thought,' Akil continued with effort. 'We would give them our wares and they would leave us alone. That was the plan. But no. The whoops rang out on every side, and then the Hyksos appeared as if from nowhere and fell on us like wolves. Arrows rained down. The screams . . . The cries of my friends . . . We are not fighting men. We had little more than cudgels and stones . . .' He grimaced. 'They tore through us. A river of blood ran down those rocks to the plain. My wife . . . My son . . .' He began to sob.

Khawy rested a comforting hand on the dying man's arm.

'What a coward I was,' Akil croaked. 'Even as their blades bit into me, I urged my donkey to ride on. I abandoned my friends . . .'

'There was nothing you could do,' Khawy said softly. 'Let your conscience be clear.'

The words seemed to calm the stranger. He added, 'It was a war band, have no doubt about that. They were armed to the teeth and carried enough supplies to survive for days in the desert. They . . .'

His eyes rolled back to white and his words turned into mumblings.

'You will get nothing further from him,' Pakhom said. 'He is walking with the gods now, on the threshold of the afterlife. I will watch over him until his candle burns out.'

Outside in the stifling heat of the day, Hui walked in silence with his father and brother. Finally Khawy said, 'We must begin preparing our defences. I will make arrangements. When Lord Bakari arrives, I will ask him to send the army to help defend Lahun. We suspected this day was coming. Once the Hyksos had a foothold in Egypt, it was only a matter of time before they decided to take the whole of the land for their own.'

'Must we fight them?' Qen asked.

Khawy eyed him as if he'd gone mad.

'I have heard tell that any lands they have conquered are prosperous,' Qen continued. 'They do not torment the people who surrender to them. In fact, they allow those people to rule—'

'Vassals,' Khawy snapped. 'Would we be slaves in our own land?'

'Here on the frontier, life has always rested on shifting sands. If it would save the lives of our people from unnecessary battle,

would we notice any difference in Lahun if the Hyksos ruled?' Qen pressed.

'Hold your tongue.' Khawy glared at his son. 'I will hear no more of that treacherous talk. Go to your mother. Tell her I will be delayed. She is making arrangements for Lord Bakari's visit, and Isetnofret, as always, wishes to impress. I have no time now for talk of feasts or music. Tell her to do as she will.'

Qen sloped off in the direction of the governor's villa.

'All will be well, Father,' Hui said. 'There could be no better man in charge of Lahun's defences.'

Khawy's smile was tight. He nodded, wearily.

'I will call the council together and we will begin our preparations. Men, we have, but we are short of weapons. The walls are strong, though.'

'The Hyksos may still not attack. They could be testing our resolve.'

'This is true,' Khawy said. 'But we must hope for the best and prepare for the worst.' He clapped his son's arm. 'I will not allow these preparations to disrupt your celebrations, you have my word on that.'

'That matters little—'

'No, it matters a great deal,' Khawy said firmly. 'You have brought glory to Lahun, to this family and to me. We have suffered hardship in days past. Your mother's death . . .' He blinked away a sudden tear. 'We will celebrate our joys when we have them. And we will celebrate this wonderful moment in your mother Kiya's name as well as yours. For as long as you are here, she is, too.'

Khawy marched off without another word. Hui knew he did not want his son to see his emotions. He felt a swell of love for

his father. If he could be a fraction of the man that Khawy was, he would have achieved greatness.

Hui trudged down to the Lower City, where the clamour usually made his head ring. Now it was quiet. Groups of men bowed their heads together on every corner, whispering. Eyes darted here and there. As he passed, Hui caught snippets of those conversations. Fear laced their words. Fear of invasion, of war and blood and death.

Reaching the gate, he walked along the inside of the wall, looking up at their defences. He could see how poor they were against a sustained attack. The wall was made of mud bricks, not the stone that protected the great cities along the Nile. Here and there, chunks had crumbled and fallen away. Khawy was always poring over the accounts to see what could be spared to repair the defences. There was never enough.

Hui knew he had some cunning, could talk himself out of difficult situations. But he yearned for some skills that might serve him well if there was a battle for Lahun. He was no fighting man. He'd likely trip over his own sword.

He wandered through the narrow streets to the family home. The villa throbbed with activity. Slaves hurried back and forth with baskets filled with figs and dates. Artisans waited with their scrolls in the cool shade of the reception hall to discuss their ideas with Isetnofret. She would need to outdo her previous feast or lose status in the eyes of her neighbours. She would want to dazzle the senses of Lord Bakari, so that when he returned to Elephantine Island all he would talk about were the wonders of Lahun.

He glimpsed his father briefly. Khawy's face was pale and drawn as advisers trailed in his wake. They were talking about

drafting all able-bodied men and posting more sentries along the wall. Hui could tell his father was not convinced it would be enough.

'The barbarians may not feel it is yet time to strike,' one of the advisers was saying.

'That is true,' Khawy replied. 'It may not be this day, or this week, or even this year. But come they will, I am certain of it, and we must be prepared.'

Khawy swept by without a glance at his son. Suddenly Hui heard his name called. Isetnofret strode through the throng towards him. She was wearing a diaphanous robe that revealed the heave of her breasts and clung tightly to her hips.

Hui felt a spasm of awkwardness. He couldn't look her in the face after what he'd seen, and he still hadn't decided how he would be able to continue to live his life around her.

When Isetnofret pulled him into an embrace and held him tight against her, Hui felt awkwardness turn to revulsion, and he prised himself from her grip.

'This will be a celebration that Lahun will never forget,' she said, still holding him by the shoulders. 'A celebration fit for a king. A celebration fit for my wonderful son who has brought glory to this house.'

Hui was relieved that her temper was no longer simmering. The attention that was about to be lavished on her house had lifted her spirits.

'When you and Qen are presented to Lord Bakari,' she continued, 'he will see what greatness lies in Lahun.' Her eyes sparkled and her cheeks were flushed.

'I will not let you down,' he replied.

'Of course not. But you must practise your speech for Lord Bakari this night. You have prepared it?' She frowned when she

saw his discomfort. 'We can have none of your stuttering words and ill-constructed sentences, Hui. And none of those stories which you think are humorous when all your drunken friends laugh. You need to show respect. You need to praise Pharaoh. But most of all, you must show Lord Bakari that you and Qen are worthy of attention from the highest. That way lies fortune.'

Hui nodded. 'I will retire to my room and work on my speech now. It will be as enticing as the most beautiful woman and as strong as a bull.'

Isetnofret smiled, but Hui could see from her eyes that she was not convinced.

'Make sure it is the best it can be. I want to hear it before you present it to Lord Bakari.' She paused before adding, 'And make sure Qen is given full credit for his part in bringing the Ka Stone to Lahun. No polishing only yourself until you shine like gold, do you hear?'

As Hui left, he edged past the jugglers and fire-eaters waiting to audition, and the rhymers and storytellers. That night, as he sat in his room, the house was filled with the delicate, soaring notes of the harp, the melodic thrum of the lute, and the beats of many drums, as the players presented compositions for Isetnofret to choose. Then came the harmonies of the chorus, their angelic voices echoing in every part of the villa. Isetnofret would not rest, would not leave a single detail unexamined, to create her perfect celebration.

Pacing the room, Hui poured passion into his speech. He would attempt to do all that Isetnofret had asked of him. Yet it was harder than he had anticipated. His words sounded leaden, and he reworked them time and again in his head until he stopped sounding like some fool who had only just learned how to speak.

As he neared the end of his labours, one of his father's slaves appeared and summoned him to the main hall. The activity had died down; the players and performers had all departed. Isetnofret waved the last remaining servants away when she saw Hui. Qen lounged on a cushion. Hui felt an uneasy feeling that he had interrupted a private conversation.

'Are you here to deliver your speech for my approval?' his mother asked.

'Father called for me,' he replied, looking round.

As if in response, Khawy strode in from the direction of his room. He was beaming, and in his outstretched hands he was holding what looked like a neatly folded piece of cloth.

'For you, my son. A gift to honour you for what you have achieved.'

Hui was surprised. His father had never offered him a gift in such a manner before. Hesitating, he grasped the tightly wrapped bundle and it fell open in his hands.

He gasped when he saw what he had been given. It was a linen robe, beautifully embroidered across the chest with a hawk with outstretched wings in red and gold and blue, and a repeating pattern of colourful squares cascading down each side to the hem. The workmanship was more beautiful than anything Hui had ever seen. It must have cost a small fortune.

'This is for me?' Hui said, amazed.

'You have earned it, my son.'

Hui pressed the robe against his chest and looked down the length. Surely anyone who saw him in that fine garment would have their breath taken away.

'Do you not think Hui will look magnificent when he is presented to Lord Bakari?' Khawy said. He looked his son up and down with pride. 'All eyes will be upon him.'

But the eyes Hui could feel upon him at that moment were as cold as the desert night. Isetnofret's and Qen's faces looked like they'd been carved from stone. He was baffled that his father seemed oblivious.

Hui looked away, troubled by the weight of their stares. He tried to understand what he sensed there. Anger, certainly. But, most of all, bitter jealousy.

The white sail billowed and the lines cracked as a good wind swept the skiff along the canal through the gap in the hills. On board, a sapphire pennant fluttered above a canopy of linen which kept the grand master of the vessel out of the sun. Lord Bakari was making his way to Lahun.

When the watchmen hailed the arrival from their mud-brick towers, their shout was carried across the city. Hammers were downed and pots abandoned as the citizens gathered in the streets to watch the arrival. Out here on the frontier between the Nile's fertile lands and the wastes beyond, the visit of such an exalted personage was a rare occasion and one to be celebrated.

Once the flag was raised on the main watchtower, the slaves waiting on the wharf bustled into life. Bowls of sweet incense were ignited, the spicy smoke filling the air so the lord would not have to breathe in the reek of the marshes. The limestone blocks of the quay had been swept of dust, the causeway covered with rushes.

Hui pushed his way to the front of the throng. Outside the gates, excitement crackled through him. He had once thought he would be struck with terror at the prospect of an audience with such a commanding presence. But he was enjoying the day he'd dreamed of for so long.

The approaching vessel was smaller than the great wooden ships Lord Bakari would have been used to when he travelled on the Nile. But the canal was not navigable by those magnificent vessels. The skiff was narrow, with a high, curved prow and stern and barely enough space for the crew and Lord Bakari's small entourage. Hui could see even at that distance that it was well constructed, the bundles of papyrus reeds tightly bound, their pockets of air keeping the skiff afloat on the calm water.

As the boat neared the small quay, the crew slid the oars out and heaved. The blades dipped in and out of the water, trailing diamonds glistening in the sunlight. When one of the crew leaped onto the dock to tie the mooring rope, the hubbub in the crowd ebbed away and silence fell. For many, this would be the first, and possibly only, glimpse they would have of such an exalted man – someone who basked in the presence of the pharaoh on a daily basis, perhaps even spoke with the god-king.

Hui shielded his eyes against the glare of the sun. He was determined every detail would stay with him for all time, and one day he would tell his own son of how the family's fortunes had been transformed.

When the travellers clambered onto the quayside, Hui strained to identify Bakari, but the waiting dignitaries hid him from view. Khawy was there somewhere, ready in the sticky heat to welcome their eminent visitor to Lahun, along with some members of the governing council, who, Hui knew, would be bowing and scraping to gain the lord's attention.

Someone grabbed the pole that held the sapphire pennant aloft, and four others heaved the travelling chair from its resting place behind the shelter. The struts supporting the chair had been painted white and scarlet, and emerald and black writing had been neatly etched along them, though what it might have

said, Hui had no idea. From the back of the chair, the wings of Horus sprouted, glinting golden in the sun so that when the lord travelled upon it, it would seem that his head was framed by them. Above the chair, another linen canopy provided shade.

Once the chair had been set down, Lord Bakari slipped into his seat and four muscular slaves hefted it aloft so none of the waiting crowd could have any doubt of his importance. Behind him trudged his entourage, fanning themselves. Khawy and the city dignitaries followed at the rear.

The cheers of the crowd rang out, growing in magnitude until the celebration became a full-throated roar. Hands waved and clapped, and a few wiped away tears of joy. Many were afraid of what they'd heard about the roaming Hyksos war band. They'd seen the drafted men practising marching and trying to master what few weapons could be scraped together. No one could have been filled with confidence by what they saw. Even the new sentries along the walls had done little to ease those worries, though night and day the watchers peered out into the wastes, ready to raise the alarm. Prayers were on lips everywhere, and now these people felt their prayers had been answered, and Lord Bakari would save them.

When the cavalcade had covered half the ground between the canal and the city gate, the drumming rang out, as Khawy had planned. As the steady beat swept into an exultant pounding, the other musicians waiting inside the walls began the soaring melody of lute and lyre. It seemed to stir the crowd into even greater excitement.

Hui pushed his way back through the sweaty bodies and returned to the city. He didn't want to meet Lord Bakari in his common kilt. As he darted up the sloping street past the foetid hovels, he heard the cacophony coming through the

gate. Passing through the arch into the deserted Upper City, he wiped the grime from his eyes and hurried to the governor's villa. Time was short. He washed the stink of the city off himself and painted the jade make-up around his eyes. He contemplated the robe laid out on the bed before him, still barely able to believe it was his. When he pulled it over his head, the fine linen caressed his skin, so unlike the roughness of the robes he usually wore. This would be his life from now on, he was sure of it. Only finery. Only joy.

'What stranger is this in the house of the governor? Away, before I have you beaten by the guards.'

It was Ipwet, teasing. She was standing in the doorway, a warm smile curling her lips, eyes wide as she looked him up and down.

'My little rat of a brother has become a man,' she breathed.

Hui held his hands wide. 'Do I look well?'

'You look like someone who can hold his head high in the presence of a lord.' She admired the intricate design of the hawk across his chest and the brilliance of the colours. 'Father has given you more than the gift of a robe, brother. He has given you standing. Not a man or woman who looks upon you will be in doubt that here is a great man, blessed with great days to come.'

'Th-thank you,' he stuttered.

Holding out her hands, she gripped his shoulders and kissed him on both cheeks.

'Father will be so proud of you,' she whispered. 'Enjoy this day, brother. You have earned it.'

She slipped away, casting one more admiring glance over her shoulder before vanishing into the depths of the house.

Hui felt sad that Ipwet would not be presented to Lord Bakari, but that wouldn't be seemly.

The clamour swept up to the front of the villa. The majority of the crowd would have remained in the Lower City, but the drumming still throbbed and the swooping melody of the lyre filled hearts with the wonder at the grandness of their guest. Hui steeled himself and hurried out of his room.

As he stepped into the main hall, he locked eyes with Qen, who was already waiting. A sullen nod greeted him. Hui saw Qen was dressed well, too. His robe was embroidered with a ruby scarab, but the stitching was not as intricate as the work on Hui's robe, the design was plainer, and the linen was of a lesser quality. Hui imagined Isetnofret had searched for a robe for Qen that could shine as brightly as Hui's. Though impressive, Qen's robe would always be in the shadows next to Hui's majestic attire, and Hui could see from his brother's narrowed eyes that Qen could see this, too.

They turned to face the door as the sound of the drumming ebbed away. Khawy entered first to welcome the guest into his home. He beamed when he saw Hui, and Hui felt a rush of joy at the pride he saw in his father's face. His eyes sparkled, his shoulders lifted and he looked ten years younger. Khawy nodded his approval, then turned to prepare for his greeting.

Hui sensed Qen simmering beside him. He wished his father had paid Qen some attention. He didn't want his brother feeling sad or abandoned, not when Hui felt so clearly the joy of acceptance.

A shadow fell across the floor and Khawy stepped aside as Lord Bakari loomed in the doorway. Butterflies fluttered in Hui's belly.

Lord Bakari was a tall man, almost skeletal, with hollow cheeks and sunken eyes. Hui knew Ipwet would have whispered that their guest looked like he had just emerged from a tomb, trailing his mummification bandages behind him.

Khawy welcomed Lord Bakari into his house, then held out a hand to guide him towards the two men waiting.

'My son, Hui,' Khawy said.

Lord Bakari peered down at him as if examining a curious flower he had found by the wayside.

'You are the one who rescued the gift of the gods from the hands of those loathsome bandits, through your own courage and wit?'

'I . . . I am,' Hui said, adding hastily, 'Alongside my brother Qen.'

Bakari's eyes flickered towards Qen, but it was a cursory glance, and then he returned his penetrating stare to Hui. The lord seemed to be looking deep inside him, weighing him, trying to decide his worth. Whatever he saw seemed to meet his approval, for he nodded, to Hui first and then to Khawy.

Remembering the first of his speeches, Hui launched into it, praising Lord Bakari's magnificence and thanking him profusely for the honour he had visited on Lahun and on the house of the governor.

He'd barely got halfway through his lyrical words when Bakari waved a dismissive hand to bring him to a halt. No doubt he was used to the gushing platitudes of the people he encountered, and these speeches had lost any meaning for him.

Leaning down, he said, 'I look forward to laying eyes upon this source of wonder I have heard so much about. And I hope you will tell me the story of your adventure to reclaim the gods' gift. They say you ventured into the Shrikes' camp, just three of you, with no swords, no weapons of any kind. Is this true?'

Hui nodded.

'Madness or great courage, I will wait for you to enlighten me. I will convey this story to Pharaoh at the earliest opportunity. Your name will become well known in all Egypt, I would wager.'

Hui felt his stomach tighten with anticipation. As Lord Bakari turned away, he exchanged a smile with Khawy. Hui thought his father might burst with pride. And yet he felt flat when he had expected to be soaring on the wings of Horus, and he knew why. His guilt gnawed away at him night and day. Guilt that Kyky would still be alive if he had not forced his friend to venture into danger. Guilt that he was to blame that his love for his brother had been poisoned.

'And to you, Khawy, governor of Lahun, great honour must also be bestowed, for your foresight and the speed with which you sent word to the royal palace of this treasure. There are some who would have kept this prize for themselves and for the benefit of their city.'

Khawy bowed. 'I am in service to Pharaoh, always and forever.'

'Now, before the pleasant events that lie ahead, let us talk of these serious matters you have raised. This war band you say is terrorizing the region. I confess I have heard no other reports of enemies so deep in our territory, but I would not wish to deny the truth of your belief at this stage. You must tell me all you know.'

Khawy bowed again, and led Lord Bakari towards the governor's office. Once the visitor had disappeared, Hui felt his shoulders sag and he realized he had been holding himself as rigid as one of the statues in the yard outside.

'You have dazzled our guest, as you and your father intended.' Qen was eyeing him, his face drained of emotion. He might as well have been looking at a stranger.

'That was not my intention. You know that, Qen. You are my brother. I love you. I would not deny you.'

Qen continued to stare with those unnerving dark eyes, looking as deep within him as Lord Bakari, but this time it seemed his brother found no good in his soul.

'You will be well rewarded. Who knows where this day will lead you.'

Qen's voice was as flat and empty as the featureless wastes.

'Please, brother, do not make your heart so cold to me,' Hui pleaded. 'You know me better than anyone. I am not the man you say I am. I do not connive, or plot to steal from you. I want only good things for you, whatever it is you truly desire.'

Qen said nothing.

'You must trust me,' Hui pressed. 'When I come to tell the tale of the Ka Stone to Lord Bakari, I will inform him that it was *our* victory. That you were there at my side in the face of such danger. That you showed only courage—'

'That I caused Kyky's death?'

'No!'

'I did, though. We both know that.'

'I will not talk about that again. I gave you my word.'

'But you *know*, Hui. It is etched in your mind and graven in your heart. You will never be able to forget it.' Qen walked away, glancing back before he departed. 'If no one had witnessed what happened, it would have been like the mists above the marshes by the Great River, vanishing in the first lick of sunlight. And it would have vanished from my mind, too.'

'You would not forget! You could not forget Kyky.'

'Now I must remember,' Qen continued as if Hui had not spoken. 'There is no peace for me.'

For a while Hui hovered outside the governor's office, listening to the drone of voices within. His father's arguments were calm, measured, but edged with the urgency which all of them in Lahun felt. By comparison, Lord Bakari's voice had the lazy drawl of a man

used to a comfortable life in a well-protected city, not one exposed to the threat of bandits and raiding parties on the frontier.

After a while, the two men stepped out. The lines had returned to Khawy's face and his eyelids drooped. Lord Bakari already seemed to have forgotten the discussion. With a cheery clap of his hands, he insisted on time alone to wash off the grit of his journey and to rest so that he would be refreshed for the feast that evening. Khawy showed him to the room that had been set aside for the duration of his stay.

When his father returned, Hui asked if Lord Bakari had been receptive to the plea for aid in the face of the Hyksos threat.

'Lord Bakari remains concerned that if he grants our request, with little evidence, every one of the twenty governors will be asking for the army to be sent to protect them.' Khawy sighed. 'Such resources cannot be spared from the constant struggle with the Red Pretender . . .' He let his words trail away before adding, 'I will try again once he has had a cup or two of wine at the feast. He may be more open to my pleas then.'

Hui tried not to consider how the city would be defended if the support was not forthcoming.

'He will listen to you, Father. How could he not? Perhaps when he has been impressed by the Ka Stone, and the story I will weave about how it was rescued from the grip of such a bloodthirsty band.'

'Let us pray to the gods that is the case, my son. For if not, we must prepare for the worst.'

As the day drew on, the furnace-like heat drifted away and the cooling wind blew in from the hills. Hui stood on the roof terrace, watching the lamps flicker into life across the Lower City. Once night

descended on the slope to the high houses, the slaves set the golden flames dancing in the villa's own lanterns. The air was scented with the oily tang of the sacred persea tree in the garden, and all seemed right with the world.

Hui had survived one trial in his introduction to Lord Bakari, but a greater ordeal lay ahead; it would require all his wit to ensure their eminent visitor was sufficiently entranced that he would do what they required of him. This was his moment.

The succulent aroma of roasting mutton drifted from the kitchens and his stomach growled. It would be a fine banquet, fit for a lord. The early evening stillness was broken by a voice singing of the magnificence of the pharaoh, ringing out as sharp and clear as a bell into the night. And when the harp chimed in, Hui knew the feast was about to begin. He stepped back into the villa. The guests were already arriving, bending their heads to receive their garlands of lily flowers. Khawy stood at the door, welcoming them in one by one, while Isetnofret waited at the rear of the main hall to guide them to the feast. When she caught sight of Hui, her face darkened, but he smiled and waved and that seemed to soften her mood.

'Take your seat,' she called. 'Our honoured guest will be waiting to speak to you.'

As Hui passed her, she leaned in and whispered, 'Our fortunes are tied to this night, my son. We are counting on you.'

'I will not let you down,' he whispered back.

Hui strode into the feasting hall. He thought the celebration Isetnofret had prepared for his return with the Ka Stone had been grand, but as he looked around, he was filled with awe. The Nile seemed to flow across the entire hall. His mother must have hired the most skilled craftsmen in Lahun to design a representation of the world they knew. The fertile black silt had

been brought from the fields alongside the canal and a channel had been shaped on the floor, meandering from the Ka Stone across the length of the hall. It was designed to echo the river itself, from the Delta to the southern reaches. Clay lined the channel so that it could be filled with water. On this miniature river, papyrus boats floated, each one bearing a candle. In the half-light of the feasting hall, the flickering flames reflected off the water so it seemed a river of molten gold was flowing. The spectacle had the desired effect, for everyone who stepped into that room stopped and gazed in amazement.

In one corner, the harpist's fingers danced across the strings with music that had been specially composed for the event. The accompanying singer was a boy of barely nine years whose voice was the purest Hui had ever heard, stirring the heart with each soaring melody.

The guests eased into their places, designed according to their social status – chairs for the highest, then stools, and sumptuous cushions upon the floor for the rest. Their heads bowed in polite conversation as the slaves bought in burning cones of scented fat to spread pleasant aromas and keep the insects at bay.

When they were all seated, Isetnofret clapped her hands and the slaves streamed out of the kitchens with the delights that had been created, until the vast table was laden with food: slabs of mutton glistening with fat; quail and partridge arranged so they still seemed to be in flight, both birds roasted with fenugreek and cumin; crane spiced with horseradish oil; baked hedgehog; bowls of lettuce and celery; lentils and garlic; and mounds of sweet honey bread.

Never in all his years had Hui experienced a celebration like this. They were not a wealthy family by the standards of Lord Bakari, though Khawy's work brought with it a good living for

Lahun and they resided in the grandest villa in the city. But somehow Isetnofret had worked her magic to conjure up this breathtaking display.

Perhaps it was *magic,* Hui thought, *and Seth had rewarded her.*

Hui lowered himself onto a cushion, overcome by the whirl of scents and sounds and sights. He glimpsed Ipwet peeking through the arch to the courtyard. She smiled and waved, ducking back into the dark before their mother saw her.

Someone slipped in next to him. It was Qen. The scent of sandalwood arose from the unguents he had massaged into his skin.

'Brother,' Hui began, but Qen held up a hand to silence him.

'No more sour words,' he said. 'You are right. We are kin and we must put any disagreements behind us. You know me well. I am quick to anger and I hold a grudge for too long. But Mother has convinced me that I need to rise above my petty annoyances for the sake of our family. Will you accept my apologies, delivered from my heart?'

Hui felt relief that their simmering argument would no longer cast a pall over the day. But he knew he could never escape the memory of Kyky's death, nor what he felt whenever he saw his brother's eyes meet with Isetnofret's.

'Of course. This is a celebration for all of us, and we all shall benefit. Let's speak no more of what's gone. What lies in days yet to come is more important.'

A slave filled their cups with spiced red wine and they clinked them together.

A crystal-clear tone rang through the hall and everyone fell silent. Hui knew that, at his father's command, one of the slaves had taken the silver hammer and struck the cymbal hanging at the foot of the stairs. All eyes turned to the entrance, and a moment later Lord Bakari strode in, his hands folded behind

his back. His chin was pushed up and he looked ahead through half-closed eyes. Khawy followed, one pace behind the visitor's right shoulder.

'Honoured guest,' his father said. 'Let me show you the wonder that has blessed this house.'

He led the way along the edge of the table to the dais at the end. Though Lord Bakari liked to feign disinterest, Hui watched his eyes widen as he approached the Ka Stone. He paused in front of the relic and his hands appeared to tremble.

Hui marvelled at the response. So many seemed deeply touched by their encounter with the Ka Stone, feeling its power worm into their minds and hearts. Though he had sensed something the first time he had come across it, he was sure, since then he had not been moved in its presence.

But Bakari was gripped. He stared at the stone without blinking, almost as if he was sleepwalking, and then his lips opened. A moment later, words in a language Hui couldn't recognize rolled out, in a voice that did not sound like the aristocrat. It was deeper, guttural, and in a rhythm that almost became a chant.

Hui shivered. Looking around, he saw all the guests were rapt, eyes wide.

Once the chant had ebbed, silence hung in the air for a long moment. Then Lord Bakari dropped to one knee and bowed his head in supplication.

All remained quiet as he muttered a prayer. When he stood, his face was flushed with delight, and he looked from Khawy to everyone sitting around the table.

'This is a wondrous thing,' he intoned. 'Remember this night well, for you have been blessed with an experience that you may never see again in your lifetime.'

'I am happy that you are pleased,' Khawy said with a bow.

'I am more than pleased. This is all that you promised. And Pharaoh himself will be pleased at your service. Have no doubt, you will be rewarded for this.'

A tremor ran round the room. This was high praise indeed, and Hui felt a tide of love that Khawy had been recognized, and that he had played some part in that.

And yet he couldn't understand what Lord Bakari had seen in that pitted black rock that proved to him it was as they had said. It seemed that the story told about that stone had a power of its own, and Bakari could not risk ignoring something that was purported to hold the power of the gods. And that was all that mattered.

'The gods have sent us such gifts before,' the lord said. His face was lit with awe as he stared at the Ka Stone. 'On very rare occasions, their munificence was bestowed in fire from the heavens, and where the flames struck was found a stone like this one. Our records tells us of each one, preserved for the glory of the pharaoh, and of the great powers they held within them.'

Bakari folded his hands behind his back and prowled around the Ka Stone.

'It has been said that the first of these great gifts was the Benben Stone. It was kept in the *net benben*, the House of the Benben, in a shrine to Atum in the innermost sanctuary of the temple in Heliopolis. A part of the mound on which Atum sat when he created all there is and all there ever will be. Some said it was a doorway between heaven and earth.'

The guests realized they truly were in the presence of the glory of the gods.

'Some of these stones bleed a life force when placed in the white heart of a furnace,' Bakari mused, almost to himself.

'A skilled smith can shape that blood into objects of great strength – a dagger, perhaps, or an amulet. They are said to be unbreakable.'

Lord Bakari turned to the guests.

'We have not had such a gift from the gods in many a season. This can only be a portent, a herald of a new age, when Egypt shall rise like a phoenix from the struggles of recent years. I will take the Ka Stone to the king on the morrow, with my recommendation for the rewards to be bestowed upon the governor, and upon Lahun. Now, let me hear the tale of the adventure that brought this treasure into our hands.'

Khawy held out a hand to Hui. He steeled himself and stood, tugging Qen to his feet as well.

'My Lord Bakari,' Hui began, 'this is a tale unlike any other.'

In a clear voice that rang to the corners of the hall, Hui told of how he had heard of the Ka Stone, of the desert wanderers who had first found it, and how he had hatched his plan to steal it from the Shrikes, who had wanted this source of wonder for their own benefit. He drew out the tension of the trek across the wastes under cover of the night, and how they crept past the guard and into the heart of the camp. His speech must have been good, for he saw some of the men there grow pale in the flickering candlelight. And when he described the shock of the discovery of the cobra, one woman cried out.

He wrung tears from those guests with his account of how Kyky had sacrificed himself to save Qen's life – and here his mouth grew as dry as the desert sands. He described the flight to the Nile, and their escape amongst the reeds when the crocodiles attacked, and the rapt audience broke into spontaneous cheers and clapping.

Hui made sure to include Qen's involvement, gilding his actions and inflating his courage. In the middle of his tale, he glanced at Isetnofret and she was smiling and nodding.

When he was finished, he bowed and sat back on his cushion. He tugged Qen down beside him, and this time it was Lord Bakari's turn to clap.

'What a tale!' their guest boomed, clearly moved. 'What courage. I will recount this story when I present the Ka Stone to the priests on Elephantine Island, and you can be sure it will spread far and wide.'

The guests cheered again and proposed toasts to the great fortune that had been bestowed upon the family of Khawy. Hui watch the elation glow in his father's and mother's faces as Lord Bakari spoke at length about the possibilities that lay ahead for the family: the riches, the high standing – they might even be invited to the court of the pharaoh himself – and the years of plenty in the future. Hui felt a giddy exhilaration. In his wildest dreams he had never imagined such great fortune, and his dreams had been wild indeed. His father was right when he said all their lives would now be elevated.

Khawy guided Lord Bakari to his place at the head of the table, and the feast began. Slaves circled, bringing more over-flowing bowls and pouring wine into cups from constantly refreshed pitchers. Whatever the cost, it was well spent if the flush in Bakari's face was anything to go by, an investment that would be recouped tenfold.

Relaxing on his cushion, Hui let the tension drain from him. He had done his work, and he had not tripped over his feet or his mouth, as he had feared. He watched his father drink yet another cup of wine. His eyes had started to glaze, but his smile was bright.

'Let the performance begin,' Isetnofret announced.

As the four players took their positions, a voice boomed as if from the gods themselves, 'Here then is the story of Osiris and Isis, Nephthys and Seth, the children of Geb, of the earth, and Nut, of the sky.'

The disembodied voice of the gods echoed around the hall and the guests smiled at the artifice. Isetnofret would have hidden the speaker behind the screen at the rear of the hall.

Qen walked to the centre of the floor and held out his arms. He seemed to be staring directly at Hui.

'And here is Osiris,' the actor said, 'lord of the dead and of rebirth, lord of the afterlife, who brings new life each year to the fertile valley of Mother Nile. He is the righteous king, and he bestows his blessings upon all righteous kings.'

Isetnofret swayed forward and rested one hand on Qen's shoulder.

'And here is his sister-wife Isis.'

The guests were rapt. They knew what was to come. This story was told to them from the moment they were lifted from their cradle. It was beloved by all, a soothing tale in the confusion of this mortal existence.

The performances of Isetnofret and Qen were powerful. How long had they been rehearsing in secret? Hui wondered. The guests gasped in horror when Seth murdered his brother Osiris, and choked back sobs as Isis and Nephthys fell into mourning. They were engrossed as the two sisters searched for the body of their dead brother, and they cheered when the remains were found, and when the player returned to the stage to show Isis pouring new life into him.

Qen rose from the floor, throwing his arms wide once more, reborn.

When the feasting was over, the entertainment began. T[] dancers came first, the most beautiful women Isetnofret h[] found. They were naked apart from ribbons tied around the[] waists and *menit*-necklaces. They swayed their hips and breas[] as they whirled in a sinuous line around the table, beaded nec[] laces rattling. Tumblers bounded around the hall and juggle[] dazzled, flipping flaming brands to each other.

While a master storyteller entranced with his wordplay ar[] a poet recited an epic account of Egypt's glorious histor[] Hui watched Isetnofret and Qen slip away from the table. H[] wondered what they were planning, but he did not want h[] suspicions to ruin such a joyous night. All was well. All woul[] be well.

A hush fell across the hall as Isetnofret suddenly appeare[] in the space set aside for the entertainment. Hui gasped. H[] mother was transformed. She was wearing a crimson sheat[] dress that hugged every curve, and in one hand she gripped a[] ankh and in the other a staff of papyrus.

'Isis!' Hui murmured, entranced.

Isetnofret clapped her hands and three others made thei[] entrance. The first was a beautiful young woman in an ochre[] dress, with a hawk's wings spreading out from her back. That was Nephthys, Isis' sister. The second was a muscular man wear-ing a mask carved into the beast-head of Seth. Hui suddenly remembered his terrifying dream on the night of his mother's ritual. Seth turned slowly, surveying the room, and the guests bowed their heads in fear as his gaze swept over them.

Hui started when he saw the third performer. Behind the green make-up of Osiris was his brother Qen. He was wearing the tall, white Atef crown with ostrich feathers curling from each side, and in his hands he held the crook and the flail.

Hui felt his skin grow clammy when he realized what was to come. Isetnofret pushed Qen down and climbed astride him, riding him as Isis impregnated herself with her brother-husband's seed. Hui looked away, swallowing the acid that had risen in his throat. No one else there seemed concerned by the sight of a mother in congress with her son – why would they? This was only two actors playing a part. But Hui felt it strike to the very heart of him.

When he next looked up, the act was over. A slave handed Isetnofret a babe, and his mother raised the child above her head. This was Horus, the son she had conceived with her brother.

The guests cheered as the players took their bows. Hui waved his goblet to be filled by a slave, and drained the wine in one swallow.

The players wandered away to take off their make-up and costumes, while men around the table strode up one by one to clap Hui on the shoulder and tell him what astonishing times lay ahead for his family. And it was all down to him. His heart swelled, as much for what this would mean for his father as for the praise that was being showered upon his head. Good times would come, and he had brought them here to Khawy's house.

Qen sauntered back, wiping the last of the green make-up from his face. His eyes sparkled and he seemed buoyed by the performance.

'You did well, brother,' Hui said, 'as did . . . As did . . .' He choked on the words for a moment. 'As did Mother. You both captured the imagination of everyone here.'

Qen slipped into his seat.

'There will be some heads hurting tomorrow,' he said.

'Father still has work to do,' Hui replied. 'He should watch himself.'

He caught Khawy's eye, who nodded in return.

It was time.

Khawy lurched over and clapped his hands on his sons' shoulders, leaning in to whisper with a blast of fruity breath, 'Lord Bakari has filled his belly with wine. As have I.' He tapped his forehead. 'But I have kept a clear mind.'

Qen frowned, looking from father to brother.

'What is this?'

'We need the king to give us what we require to defend ourselves against the Hyksos,' Khawy replied. 'Lord Bakari is in two minds about the threat, but I am in no doubt that if those barbarians attack, the streets will run red with blood. All we have built here will be destroyed. Hui suggested we wait until Lord Bakari is in his cups to convince him. It will be easier for him to say yes, then, and harder to go back on his word once the wine-haze clears.'

'A good plan,' Qen said under his breath. 'Well done, brother.'

Khawy went back to where Bakari was nodding along to the lyre-player's melody. Hui could see his father was exaggerating his drunkenness to put their honoured guest at ease. Khawy leaned down to whisper to Bakari, and the two men slipped away from the table and out of the feasting hall.

'Let us hope our prayers are answered,' Hui said.

Qen jumped to his feet. 'We must leave nothing to chance, brother.'

'What do you mean?'

'Take more wine! Make sure their cups are overflowing so Lord Bakari does not come to his senses. Wait here.' Qen hurried off, and a moment later, he returned with a pitcher. 'Take this.'

'Why not you?' Hui complained.

Qen laughed. 'You are Father's favourite. He will welcome you. If I walked into his office, he would cuff my ear and send me on my way.'

Hui hesitated. Were Qen's motives pure? But he was his brother, and all enmity between them had surely been smoothed over. He wanted to show his loyalty. In a drunken haze, Hui grasped the pitcher. Away from the tumult of the celebration, the villa was still, but laughter rumbled from the governor's office.

'I brought you more wine.'

Hui raised the pitcher as he stepped in. Bakari and Khawy were both red-faced.

'See – a good boy!' Khawy said. 'The best son a man could wish for.'

'That is true.'

Bakari sipped from his already brimming cup.

Hui refilled Khawy's drink and set the pitcher down.

Bakari continued, 'You are an honour to your family.'

Hui bowed. 'And you honour me.'

His words were slurred, but he realized the lord was too drunk to notice.

'Great things will come to this house,' Bakari said. 'Great things. You will be recognized above all in Lahun.'

Smiling, Hui edged away, keeping his eyes low. As he stepped out of the office, he heard his father say, 'Then let us pray we have what it takes to keep the Hyksos at bay. What a tragedy it would be to see this good fortune destroyed by the barbarians.'

'You believe this attack to be soon?'

'I have no doubt. The war bands roam closer. Caravans are torn apart. Victims speak of the horrors the Hyksos inflict . . .'

Khawy was already drawing Bakari under his spell. Hui hurried back to the feasting hall.

The tormented cry rang out before Hui had stepped over the threshold into the perfumed atmosphere. The howl had come from the office.

Turning, he raced back the way he had come. Bakari was stumbling towards him with outstretched hands, his face wretched with horror.

'Help us!' he yelled. 'Send for a physician!'

Hui darted past him.

A physician! Khawy must have been taken ill. From Lord Bakari's demeanour, it must be grave indeed.

'Great Horus, please help my father,' Hui muttered. When he entered the office, the prayer twisted into a strangled cry.

Khawy thrashed like a wild beast on the limestone floor. His fingers had curled into claws; his eyes were wide and bulging. Foam bubbled from his mouth where his lips had pulled back from his teeth. The cup Hui had filled lay on its side in a pool of ruby wine.

Hui dropped to his knees, as Khawy continued to writhe in violent convulsions.

'Father!' he cried. 'Father!'

Guests began crowding around the door. They stared, aghast.

'Khawy has been struck down,' someone gasped.

'He convulses! A sickness!' someone else cried.

'Please,' Hui begged, tears stinging his eyes. 'Fetch Pakhom—'

Khawy began to thrash even more wildly, and Hui flung himself across his father's chest in an attempt to prevent him from harming himself. But Khawy was filled with a preternatural strength and Hui was flung across the stone floor.

Thick foam bubbled in waves from Khawy's mouth and coated his lips, and now it had the pink stain of blood upon it.

Hui stared in horror, paralyzed by this terrible sight.

'Poison!' that same guest cried. 'Khawy has been poisoned!'

Fear darkened Hui's vision. All he could see were his father's agonies. His terror whipped up even more when he saw those spasms become weaker, turning to twitching. Finally, they ended and Khawy lay still.

Hui began sobbing. 'Do not die!' he cried. 'Do not die!'

'The governor has been poisoned!'

Hui saw Bakari looming over him. The aristocrat's face was contorted with fury. He turned and addressed the guests.

'The governor sipped his wine, and then began to choke and spit that vile foam. And then he fell to the floor in torment. Poisoned! By him!'

Hui gaped. 'N-no,' he stuttered. 'I did not do this! I would never—'

'Enough of your false anguish!' Bakari raged, jabbing a finger at him. 'Khawy has been poisoned, and there can be no doubt that this is the man who did it. His own son.'

The hole was deep and dark. Hui lay on his back on slick rocks and stared at the circle of blue sky at the end of the black shaft. In Lahun, they called it 'the Well'. It had once been one, so the scribes said, one of the few in the desert lands, but it had dried up beyond the memory of the living. It was where the rapists and the murderers and the thieves and the adulterers were thrown while they were waiting for the justice of Ma'at to be administered. All the rogues, and the cut-throats, and the most hopeless and pathetic members of society.

Hui breathed in damp air laced with the bitter tang of rat urine. The rodents scurried close every night as they emerged from the narrow tunnels riddling the walls.

Every bone in his body ached. His head still rang. Those were the lingering impacts from when rough hands had thrown him into this foul place.

Hui's robe – his beautiful robe, the last thing he had to remind him of his father – was torn by the jagged rocks that had raked him on the way down. The filth of the pit smeared the once-pristine linen. But it was his spirit that was more damaged. A tear ran through the dirt on his cheek.

His thoughts returned to that awful moment when his father's light finally dimmed. How many times had he shuddered in the horror of that memory, trying to make sense of something that seemed beyond madness? How could his father be gone? One instant celebrating their greatest victory, the next their dreams dashed.

His sorrow was so great Hui thought he might die.

He remembered the drunken guests turning into a mob as the accusations rained down upon him. How could they think he was capable of poisoning his own father? But his protestations of innocence had been drowned out by the furious demands for justice. Those men and women loved Khawy. His father had been responsible for their safety and for the order of their lives. They recognized that he did a difficult job with dedication. And now, when the threat of the Hyksos stole sleep from them every night, the one man who might have helped them had been snatched away.

Who could have slipped poison into the wine? A Hyksos spy? Who else would have any desire to kill a much-loved man like Khawy? Perhaps one of the slaves had been in their pay? His head spun with the questions.

Hui eased up on his elbows. Bolts of pain stabbed his joints. Were those footsteps he heard? Stairs had been carved

down through the bedrock to the foot of the Well, where a small opening had been cut in the stone. It was through this that his gaolers pushed the knobs of bread and cups of water that kept him alive until a decision could be made on his fate.

'Hui? Are you there?'

Ipwet's voice floated through the gloom. Hui hauled himself to his feet and staggered to the opening. In the half-light, he glimpsed his sister's face and he felt another sob convulse him. Her eyes were red-rimmed, her cheeks raw. Her lips trembled. In her chalky pallor, he saw no sleep. Mud still caked her jawline from where she had smeared it for the mourning, as she walked through the city beating her chest.

'It was not me,' he croaked. 'I did not kill Father . . .'

She reached a hand through the slot and Hui grabbed it as if he were a drowning man. His fingers folded into hers to hold her tight.

'I never doubted you,' she said. 'I know you too well, brother. I know your love for . . . for Father.'

'If only I can be released from this imprisonment, I can help search for whoever committed this terrible crime.' His voice hardened as his grief became a cold, righteous fury.

Ipwet withdrew her hand. 'They mean to keep you here. I wish it were otherwise, I truly do. But I hear it in their voices—'

'Whose voices?'

'Lord Bakari has stayed on to oversee the judgment. He believes this was an attack upon him, too. If his cup had not already been full, he could have drunk the same poisoned wine that Father did. That he could have died has chilled him to his core.'

'But why me?'

'You brought the wine.'

'That is all? I know nothing of poisons.'

Hui cast his mind back. How had he come to be taking the pitcher into the office? But he had been too dulled by his own drinking, and the memory was little more than a blur.

'The debate rages far from my ears, but the arguments are heated. For now, they can see no other culprit. But Qen fights for you – you can find some relief in that.'

'Qen?'

'He tells me he will not rest until he has proven your innocence. He has spoken of your nature, your honesty and courage and . . . your dedication . . .' Her voice sounded strangled. 'Lord Bakari is minded to allow Qen to fill Father's role as the new governor, if only for a while until a successor can be found.'

'Qen is too young . . . He lacks experience.'

'But he has strength, and courage. You yourself told those at the feast how Qen was key in helping you steal back the Ka Stone.' Her face brightened. 'Have faith, brother. If Qen is governor, he will have some power over the proceedings. He can make sure your name is cleared and the true murderer found.'

Ipwet was right. He must not lose hope. Despite the differences that had simmered for the last few days, Qen was all he now had.

'I wish I was there to comfort you,' Hui added in a gentle voice. 'Are you finding a path through this misery?'

When his sister finally spoke, her words were so filled with pain he thought his heart might break again.

'We are bereft, brother. Without Father, we wander through the desert alone.'

'Still, when you are married—' he began.

'There will be no marriage.'

'How can this be?'

'Word of Father's death was sent immediately to Shedet. I heard not an hour ago that the wedding discussions had been ended.'

Hui could find no words. He knew what this symbolic joining would have meant for Lahun, for the family. Their father's death would continue to cause pain, like the ripples from a stone tossed into the oasis.

'There could be no other course.' Ipwet seemed untroubled, though. 'What use is a bride without a father to give her away? There can be no alliance, no bolstering of defences between our two cities, no arrangements for increased trade.'

'Do not say such a thing!'

The narrow slot framed Ipwet's mouth as she forced a tight smile.

'Do not worry about me, brother. All that matters now is to free you from this imprisonment, and find the venomous snake who killed our father.' She added, 'I will be back soon with news.'

Hui heard her feet clattering up the stone steps to the world above, and once more he was alone.

Night fell, plunging the Well into an endless ocean of dark on which Hui floated. As the scrabbling started, he kicked out whenever the rats circled closer or he felt a scaly tail lash his feet.

The grief had drained away, and now he felt hollowed out. He imagined what would have happened to his father since his passing away.

Khawy's death had been violent, so his mother would not have waited to begin the arrangements to prepare him for the after-life. Slaves would wrap the body in a shroud and carry it on their shoulders. Embalmers would accept the remains and escort them

to the *ibw*, where they would wash his father to purify his remains. And then to *per nefer*, the House of Beauty, for the mummification. The family had enough standing to pay for that, and Hui was relieved that at least Khawy would be reborn.

At the Hour Vigil, the mourners would take the form of Osiris and Seth, Isis and Nephthys, Horus, Anubis and Thoth.

Ahead lay the procession to the tomb, with cattle pulling the sledge on which his father's body lay. The sickly sweet smell of incense. The splashing of milk upon the dusty path. And then the tomb, and the life beyond life.

Hui would not be given the chance to say farewell. Tears burned his eyes again.

For how long he was wrapped in his grief, he didn't know, but footsteps echoed once more and with excitement that Ipwet had come again, perhaps with good news, he clawed his way around the damp stone wall until he found the slot.

Moonlight shafted along the flight of steps. A dark figure crept down and Hui's heart fell when he saw it wasn't his sister. His visitor was hunched with age, her grey face a web of wrinkles hooded by a shawl. He didn't recognize her, but judging from the roughness of her heavy brown robe, she was poor. From the Lower City, no doubt.

'What do you want?' he asked.

The woman shuffled up to the slot and peered into the Well. Though he must have been little more than a ghost floating in the dark, she looked him up and down, taking in his filthy, tattered robe.

'You do not look so fine now.'

Her voice was that of a much younger woman. And though the evidence of his eyes told him otherwise, it sounded like his mother.

'Who are you?' Hui demanded.

The crone shook with a silent laugh.

Hui stared more closely. Isetnofret peered out from the shadows of the shawl, her face free of any of the wrinkles Hui had glimpsed. Her body no longer looked as hunched, and she appeared taller than the squat crone. Had his eyes been betraying him after so long trapped in the dark? Or was this sorcery? Did Isetnofret have the power to transform herself?

'My son,' she said. Her smile was cruel.

'Mother?'

'Are you suffering?'

'I . . . endure.'

Another silent laugh. 'What you endure is the curse I placed upon you,' she said. 'A curse given force by Seth himself.'

Hui tried to make sense of what he was hearing.

'Do you comprehend?' She leaned in, her eyes blazing. 'I am a loyal servant of Seth, and I called upon him to see you destroyed – to see you suffer as I hope my worm of a husband suffered at the end.'

Cursed by his own mother! Cursed by Seth! Hui reeled. He couldn't imagine that anything he had done could justify this torment that was now crushing his spirit.

'But . . . But why? Father only showed love for you.'

Isetnofret hawked and spat. 'He had no love for me, or Qen. No, the only space in his heart was for that foul witch, Kiya, and for the son she bore. Every time I look at you, I see her, and that was what your father saw, too. Even after her death, when I thought I was free of her, still she lived on.'

Hui could scarcely believe the loathing he saw twisting his mother's face. In all his days, he had not sensed how deep her anger was.

'I could have lived with your father's love for that empty-headed cow,' she continued. 'Though it irked me, it meant nothing, not after she was no more than a memory. But then your father turned all that love upon you. Qen, my beautiful Qen, his first-born son, became nothing in his eyes. A worthless stranger—'

'Not true—'

'True!' Isetnofret bared her teeth like a cornered jackal. 'Khawy was too weak. Too driven by his pathetic heart. Too thoughtless. He was stealing Qen's legacy by degrees. Bleeding the hope out of all his days to come. And all my days, too!' She looked down at his robe. 'When Khawy gave you that . . . I realized we could no longer go on as we had. It would not end there. He would give you everything and leave Qen, and me, with nothing.'

Hui shook his head. 'Father favoured me, that is true. But he would never have denied Qen, or you. He was too good a man.'

'I poisoned him.'

Hui recoiled, her words like a slap across his face. Even so, a part of him had refused to believe that his mother was capable of such an atrocity. Murdering his father, her husband. Damning him.

'Now Khawy is dead. And your punishment will be terrible indeed. I will sip the finest wine and toast the victory I have bought for myself, and Qen.'

'You will pay for this,' he snarled.

He felt shocked by the cold rage that surged through him. He thought he was not capable of such fury.

Isetnofret's laughter only stirred him to higher levels of wrath. Hui thrust his hands through the gap, and he knew that if they'd closed around her throat, he would have strangled her there and then, perhaps even unto death.

But his mother stepped back beyond the reach of his clutching fingers.

She said, 'I could have left you to your fate as bewildered as a sheep dragged into the slaughterhouse. But that would be no fair price for all the suffering I have sustained. You must feel the pain as I have. As you cower here in the dark, know there is no hope for you. However much you plead, your fate has already been decided. You will pay for your father's murder. And you will suffer unimaginable agonies. And only then will justice be done.'

Isetnofret was mad – there could be no other explanation. To imagine she had suffered so when his father had lavished only good things upon her, and Qen.

'That will not be the end of it,' she continued, her voice tinged with euphoria. 'I have power now to achieve all I ever dreamed. Seth has granted me my wishes. Lahun will belong to me.'

Mad.

'More. Egypt itself will be mine. I will be queen, with Qen as my consort. And then, once the Ka Stone is within my grasp . . . immortality. I will ascend. I will become the consort of Seth himself.'

Hui gaped at the extent of his mother's crazed imaginings.

'Godhood,' she murmured.

Hui thought back to the sickening ritual that he had seen Isetnofret and Qen conduct near the pyramid. There she had joined with Seth. This must always have been her intention – to become a god herself – and now she believed the Ka Stone gave her that opportunity. He shuddered at his mother's monstrous ambition, and the extent of the madness that drove it. To achieve such a prize, she would do anything.

Isetnofret pulled away from the slot, and in the moonbeam she once again resembled that hunched crone. But the cruel smile

was all his mother's. Before Hui could give voice to his desire for vengeance, she spun away and shuffled back up the steps.

Hui threw himself back into his cell. As he fell to the cold stones, his thoughts were like a whirlpool, and all he could summon from inside himself was a bestial howl of pain. He yelled until his throat was raw, that awful baying spiralling up the Well and out into Lahun, finally disappearing into the night.

Days passed with only the vermin for company. In the dark, Hui tried to keep his spirits up, but his hope was whittled away with each hour that passed. He longed for the sound of Ipwet's feet on the stone steps, but the only person who ventured down was the guard, with his meagre rations. Perhaps Ipwet had given up on him, too, pushed away from him by Isetnofret pouring venom into her ear, day and night, about her murderous brother.

On the fifth day, they came for him. The papyrus rope spun down from the circle of blue sky. Hui looped the end under his arms and the guards hauled him up into the harsh sunlight. He was dragged to his feet, then propelled at sword-point through the streets towards the governor's house. His house that would never be a home again. The men and women he passed glared at him, or made the sign of the eye, when only days ago they'd looked upon him as a hero who had brought glory to Lahun.

In the cool of the main hall, Bakari sat on the curve-backed chair that had once belonged to his father. His gaunt features now had the look of an open grave, warning Hui of what was to come. The steward and the elders of the governing council were there, and Qen, too, as the acting governor.

'You will be judged here in the *kenbet*,' Bakari intoned, 'and in this court of law your fate will be decided.'

Whatever his fate, Hui would meet it as a man, as his father would have expected of him. He looked around the gathered faces and glimpsed Isetnofret at the back of the group. Her eyes were downcast and her face drawn with grief, as befitted a new widow. Her mourning would command respect from all there. But when she saw him looking, she allowed the faintest smile, unseen by anyone else. Hui fought to keep himself calm. Now was not the time.

'I am innocent of the accusations that have been made against me,' Hui said.

'If you were not guilty,' Bakari said, 'you would not have been accused.'

Hui showed a confident face despite his fears. He would have to convince the court that the accusations were false. But he had no witnesses to draw on, no testimonies or petitions. Isetnofret knew that, and it justified her belief that for him all hope had been lost. Isetnofret may have confessed her crime to Hui, but it would be his word against hers. One thing lay in his favour: that there was not the slightest reason why he would have wanted to kill his own father.

'The Law of the Land was handed down to mankind by the gods on the First Occasion,' Bakari said to the court, in the speech that the law dictated. 'We make our judgment here upon the principles that Ma'at demands. A life of peace for oneself, and peace under the eyes of the gods, must be a life lived in balance. And let us not forget that of all the crimes a man can commit, the murder of his own father is one of the most monstrous.'

The steward stepped forward and read the accusation that Hui was guilty of the murder of his father. He proceeded to relate an account of how Hui had brought the wine in that

night, while the lord and Khawy were deep in discussion about the defence of Lahun.

'The accused poured the tainted wine into his father's cup and watched with malice until the governor drained it,' the steward continued.

Hui flinched. A lie to paint him in the worst possible colours. He made to speak out, but Bakari raised a hand to silence him.

'Within three beats of the heart, the governor began to shake as the poison took hold,' the steward continued. 'How powerful it must have been to take effect so quickly. And what evil must consume the one who sought out a poison of such strength and was prepared to use it. Aye, to use it against his own kin.'

The members of the court nodded in agreement. Hui set his jaw. He would need the full might of his silver tongue to counter this tale of imagination.

Hui tried again to speak, but Bakari only snapped, 'You will have your moment.'

'And when Lord Bakari raised the alarm,' the steward said, 'and did all he could to save the poor soul's life, the accused returned to gloat over the governor's death. These details remain central to this crime – the accused brought the pitcher of poisoned wine to the office, under his own power. No one directed him. And but for the will of the gods, Lord Bakari himself might now be dead.'

An exhalation of shock rustled through the court.

Bakari nodded to Hui. 'Speak, for whatever good it will do.'

Hui levelled his gaze at the accusing stares of those elders, moving from one to the next. He would not show fear, or any sign of weakness that they might use to determine his guilt.

'It is true that I brought the wine to the governor's office that night,' he said in a clear voice. 'But I had no knowledge that it was poisoned.'

'Then how did it come to be so?' Bakari demanded. 'The pitcher of wine was in your hands. If another hand had placed the poison in there, they could not have known that you would deliver it to your father. And to me.' Bakari's eyes seemed to disappear into shadow.

'There was one at the feast who stood to gain from my father's death—'

'Who?' Bakari snapped.

Hui caught the words in his throat. He would bide his time to reveal his mother's involvement. He could feel her gaze heavy upon him, but he did not look her way. It would be in his favour, too, to say Qen had unwittingly given him the wine under Isetnofret's direction. But he couldn't implicate his own brother to save his neck. That would not be honourable.

'I must have . . . I *was* . . . given the pitcher of poisoned wine and compelled to deliver it to you, my Lord Bakari, and to my father. I was merely a tool in the hands of others, who truly did have evil in their hearts.'

Bakari narrowed his eyes. Hui could see that if he hadn't yet convinced his accuser, he had at least piqued his interest, and for now that was enough.

'There is no reason why I would plot to kill my father,' Hui continued. 'I loved him with all my heart. Only the night before, he gave me this wondrous gift . . .'

Hui indicated his beautiful robe as he held Bakari's stare. But those eyes became puzzled, and when he looked down, Hui realized he was standing before them dressed in a filthy

robe, so ragged he looked like one of the beggars who shambled through the Lower City.

'I loved my father,' he repeated, choking on the words. 'I loved him with all my heart and I would have done anything to demonstrate the esteem in which I held him. He was a good man – a great man. And the tragedy of these events is that he met his end too soon.' Hui fought back the tears that threatened to come. He had to remain level-headed if they were to respect his words. 'Whoever committed this crime, Lord Bakari, still has their freedom in Lahun. They remain a threat to all good people. I beseech you. Give justice here. Justice for my father. And do not let this murderer escape the punishment they deserve.'

Bakari said, 'I feel you have someone you wish to condemn. If that is true, you must do so. But first . . . are there any here who speak for the accused?' His voice resounded across the hall.

A clear voice rang out.

'I will.'

Hui turned and saw Ipwet walking forward. She seemed undaunted by the faces glowering at her.

'I will give testimony upon the character of my brother,' she continued, 'and of his love for our father.'

Bakari watched her. 'You know that to give false witness is the greatest crime under the eyes of the gods?'

Ipwet nodded.

'And you know that if you are guilty of such a crime, your arms and legs will be hacked off and you will be drowned in the canal?'

This time Ipwet blanched, but she held firm.

'I vow to speak true, from my heart.'

'Very well,' the lord said, nodding his acceptance to the rest of the court. 'Proceed.'

When his sister looked at him, Hui saw the love in her eyes and felt a rush of warmth.

'My brother has much of my father in him. His strength. His dedication to what is right. He has grown to be a good man, and I know my father was very proud of him. Khawy told me so himself.'

Hui could barely listen to these words.

As Ipwet continued with her account of the many ways Hui had shown his love for his father, he watched the faces of Bakari and the court. His sister's impassioned plea seemed to be touching their hearts. Graven features softened. Heads nodded, or bowed to concentrate on her words. When the hint of a smile crept onto Bakari's dour expression, Hui felt a rising tide of relief. Ipwet had surely bought his freedom, and with it, he would find a way to bring Isetnofret to justice for the terrible crime she had committed, whether the lord listened to his accusation or not.

Hui glanced round. Isetnofret's mouth had twisted into a snarl and her eyes burned with fury. She would never forgive Ipwet for this.

His sister ended her speech and bowed.

'Kind words,' Bakari said. 'Good words. Now there is only one other we need to hear.'

Hui showed a cold face to his mother. She would do her worst, but there was nothing she could say that could counter Ipwet's heartfelt testimony. Isetnofret did not move, however. Instead it was Qen who stepped forward.

'As you know, my Lord Bakari, I have spent the last few days deep in the archives of Lahun and talking at length with the elders of the city,' Qen began. 'And I uncovered a buried truth that has a grave impact upon these proceedings.'

'Speak, then,' the lord commanded.

'What I have learned is this – the mother who gave birth to the accused was not the true-born Egyptian that she claimed to be. She lied to win the attention of the governor, my father, and to become his wife.' Qen paused, letting his words sink in before saying, 'Kiya was of the Hyksos.'

Shock rumbled through the members of the court.

'That is a lie!' Hui raged, his anger burning white-hot.

Now he could see why Isetnofret was so certain that his pleas would fall on deaf ears. He had refused to believe that Qen could be a part of their mother's plot. His brother loved him – had always loved him. But he had been a fool, and that childlike hope had damned him. Qen was his mother's instrument. Her lies were his lies. And he would say anything to see Hui destroyed.

'Now we can see the true motive behind my father's murder,' Qen continued as the guards stepped forward to drag Hui back. 'My brother is a snake hidden amongst the good people of Lahun. He knows full well his bloodline. That is where his loyalty lies. My father – a good man, yes, a brave man – was doing his duty to try to protect Lahun against those blood-thirsty barbarians. And the accused could not allow that. So he murdered the governor.'

Hui wrenched himself forward, but the guards yanked his arms back.

'Lies!' he roared. 'I will tell you who poisoned my father. My mother, Isetnofret, out of jealousy! Out of lust for power!'

But Hui had left his accusation too late. The faces of the members of the court darkened. His words sounded like the ravings of a desperate man. He glared at his mother. She allowed herself one more cruel smile and slipped away. She had her victory.

Hui felt despair as he looked up into Bakari's thunderous face.

'There we have it,' the lord said. 'The truth. The man who stands before us is not a true Egyptian. He is a barbarian, and he will be convicted as one. A murderer. A bastard. And a barbarian.'

Hui felt his head swim, and for a while the lord's words were lost in the pounding of his blood.

When his senses returned, Bakari was passing the sentence.

'Here is my judgment. You will be castrated, and then you will be taken to the place of execution and sliced into pieces. The afterlife will be denied you. So be it.'

Hui pressed his fingers to the burning gash on his forehead. When he took his hand away, blood trickled down to cover his left eye. What was the point in tending to himself? Soon he'd have his jewels hacked away before his eyes, and his member, too. Not long after that, he'd be dead. His body would be carved into pieces and the remnants scattered across the waste. He would never be buried intact, and so the gods would not accept him into the afterlife. He could not be reborn.

There was no hope left.

Hui slumped against the stone wall. At the top of the well shaft, stars twinkled in the circle of night sky. Since he'd been brought back to his prison after judgment had been passed, he'd spent his time trying to claw his way up the towering wall. Bloody fingers gouging their way into the cracks between blocks. Scrabbling with broken toenails to try to gain purchase. At each attempt he'd fallen, and this time he'd dashed his head on the stones at the bottom.

His chin sagged to his chest.

They'd come for him at dawn, dragging him away from those fine villas to a place beyond the walls where his blood could drain into the dust and not be a reminder of mortality for the wealthy citizens of Lahun. He'd seen such a punishment before, and the screams still rang in his head.

Hui would have to suffer with Isetnofret looking on, and Qen, as was their right, for those who had been wounded by his alleged crime. The two people who had conspired to murder Khawy and to destroy his own life, for no reason other than jealousy, would stand and gloat as his life ebbed away. He felt acid burn his throat.

There was no justice any more.

A scuffling echoed from the top of the Well. Hui glimpsed sudden movement. Something fell through the dark. It was a coil of rope unfurling. He caught the swinging line, but hesitated. Surely they wouldn't come for him in the deep of the night?

He heard a hiss and a head was hanging over the edge.

'Have your brains leaked out of your ears?' Ipwet said quietly. 'Or would you rather stay there and die?'

Hui's heart leaped. Wrapping the rope around him, he heaved himself on to the swinging rope and pulled himself up, hand over hand. Weak from lack of food, his limbs shook, but fear of death lit the fire in his belly and he found reserves he never knew he had. He felt the sweet cool of the night air on his hot skin, and hands grabbing him and pulling him onto the cracked slabs surrounding the Well.

Hui fell back, sucking air into his burning lungs, but Ipwet took hold of his robe and dragged him to his feet.

'No time to rest,' she cautioned, looking around.

Hui clambered to his feet. 'Where are the guards?'

'I told them my mother required them to wait at our house until she was ready to speak with them. Now move,' Ipwet urged.

'The Ka Stone,' he began. 'I could steal it – take it with me. It should not fall into Isetnofret's hands. And how much could it buy me—'

His sister shoved him away from the Well.

'Forget the Ka Stone. Flee! Or lose your life!'

With another tug, she pulled him away from the Well and into the dark, narrow streets of the Lower City.

'If the guards find you gone, they will raise the alarm.' His sister panted as they ran. 'And if they catch you again, they will throw you back down that hole and break all your bones along the way.'

Hui felt delirious from his unexpected escape from the pits of despair to the brink of freedom. As they passed a smith's workshop, still reeking of sulphur, he grabbed Ipwet and pulled her to a halt.

'Why do this?' he asked.

'You are my brother. I could not stand aside and see you die.'

'But you heard what Qen said . . .'

Ipwet shook her head and looked away.

'You know it was a lie,' Hui pressed.

'I know not if you are Hyksos, nor do I care. What I do know is what I said before the court of elders. I see Father in you all the time, and I see goodness and kindness. I know you could have no more murdered him than you could kill me.'

She was shaking, and Hui cursed himself for not recognizing what fears she had overcome to help him.

'You risked everything,' he said. 'If you had been caught, you would have ended up in the Well with me. You would have had your nose sliced off at the very least. Lord Bakari is not in a forgiving mood.'

Ipwet sighed. 'I could do no other.' The worry drained from her face as she looked at him and she forced a weak smile. 'All those times I used to tease you. Tripping you in front of your friends, twisting your ear until you howled. There was always love there, but I only realized how much when I heard the judgment today. Brother . . . Hui . . . When you walk down the darkest road, I will follow you. I have no choice in that.'

Hui blinked away a tear. 'But I cannot stay.'

'I know.'

'I cannot protect you.'

'I am a hardy flower. I bloom even in the hottest, driest desert.'

'You do not understand,' he pressed. 'When it is dawn and time for my punishment, and they find me gone, Lord Bakari will demand an investigation. He will not give up, knowing that the man who might have murdered him has escaped. They will arrest everyone who aided me, and you spoke out before the court—'

'Worry not! I will survive. You must look after yourself now. Get as far away from Lahun as you can. Begin a new life, and do it quickly. They will hunt you down like a dog, you know that.'

Hui looked around him. A few lamps gleamed, but there was no movement. The only sound was the wind soughing amongst the houses. He gripped Ipwet's shoulders.

'You must not trust your mother.'

'*Our* mother.'

'Mine no longer. My mother is dead and walks with my father in the afterlife. Isetnofret is no kin of mine.'

'What you said to the court . . . You believe Mother poisoned Father?' Ipwet asked.

'She told me herself when she visited me in the Well.'

Ipwet bowed her head and Hui felt a pang of regret for hurting her.

'Isetnofret will never forgive you for what you said in the court. She will bring misery down upon you. If not this day, then the next, or when she is ready to cause you the greatest harm.' Hui felt sick to his stomach.

'What is to become of us, Hui?' she asked.

'Come with me,' he pleaded. 'We will find a new life together.'

Ipwet shook her head. 'My life is here, brother. It is all I have ever known. My friends, our house . . . Whatever is to become of me, it will happen here.'

'Then I will return to aid you, when I can.'

Pulling her into an embrace, Hui hugged her tightly, as she had once hugged him, and dried his tears, when the bullies had beaten him and split his lip.

'Do not trust Qen either . . .' he began.

'I will trust myself, that is all.'

'Good. I will think of you every day, and I will miss you with all my heart.'

Ipwet broke the embrace, wiping the tears from her eyes.

'What does it take to save your life, brother? A kick on the rump, like I used to give you when you were a boy? Run! Run as fast as your legs will carry you and do not look back.'

She locked eyes with him for the briefest instant, then she kissed him once on the cheek and spun away. Hui watched her go until she disappeared into the shadows and he listened to her footsteps until they vanished, too.

Only then did he turn and trudge down the street towards the gates, free, but also lost and alone, with not a single thing from his old life to call his own.

The alarm rang out across the sleeping city long before Hui reached the walls. A raucous voice filled with panic; the signal picked up by a second voice, then another. He imagined the lamp lowered into the shaft, the shock when the light revealed the Well was empty. No doubt they would be rushing to Bakari's quarters to ensure their escaped prisoner wasn't trying to enact vengeance on the one who had passed judgment.

That might buy him time.

Hui kept to the moon-shadows along the houses. The city was already tense from the looming threat of the Hyksos war band. It wouldn't take much to make the citizens rise up in fear, and if they thought he was a traitor, they would tear him limb from limb. Though the moon was less than full, it had silvered the streets and any movement would be easily seen.

There was a row of storehouses along the street that lay before the gates, buildings taller than the single-room hovels of the poor, all of them casting a larger pool of shadow where he could lose himself.

The cries were echoing down the sloping streets towards the gate. Hui looked up and down that broad street, lit by the lamps along the walls. The whores had long since returned to their beds. No one else moved amongst the piles of donkey dung and heaps of mud bricks the masons had been using for their repairs.

But Hui could glimpse movement in the towers standing on each side of the gate. There the watchmen conducted their lonely vigil through the dark hours, peering out into the waste. In times past, they would have slumbered, on and off, despite

the orders of their superiors. But since the threat of the Hyksos had arisen, they would be alert, watchful. That might well have been his father's final command as governor. Hui hoped it wouldn't doom him.

The watchmen turned at the sound of the alarmed voices coming from the Upper City. One guard leaned on the low wall of his tower, peering across Lahun.

Hui pressed against the storehouse, praying the shadows were deep and dark enough to hide him.

The city wall was too high to climb, and there would be no chance of slipping through the gate without being seen by the sentries.

Hui gritted his teeth. He would not give up now, not when Ipwet had risked so much and he was so close to freedom. Could he slip back into the city and hide, hoping to creep out in the day when the gates were open and the craftsmen and merchants would be trooping in and out? It was too risky – his pursuers would be searching house to house, delving into every space, turning over every sack of grain and bolt of linen and clay jar of olives. They'd find him sooner or later. His only hope was to get beyond the gates.

Creeping along the row of storehouses until he reached a place beyond the circles of lamplight, Hui darted across the street to the foot of the city walls. The clamour of his pursuers was only a few streets away. One of the watchmen was preparing to descend the ladder.

It was now or never.

Come, *Hui*, he told himself. *Your destiny is in your hands.*

Steeling himself, Hui raced through the deep shadows along the wall until he reached the first circle of light. Reaching up, he grasped the lamp from its hook and continued his run.

His feet flew across the ground. He heard the watchmen's yell and knew the guards would be scrambling down their creaking ladders. The men from the Upper City would have heard the alarm and would be heading towards the gate.

Hui entered the nearest storehouse. Shadows swooped from the lamplight. Mounds of sacks and pitchers and clay pots swelled in the dark. Not far from the doorway, piles of flax for the weavers had been set to one side. Hui tossed the lamp. The burning oil spilled, the flax caught light, and within an instant the fire was roaring high.

As the heat seared his face, Hui threw himself into the cool night and away from the gates into the dark. The furious cry of one of the watchmen reached his ears, sounding as if he was right at his heels.

'Stop now! Stop!'

Hui kept running. It seemed the cries of a hunting pack were all around him.

Then the cries changed from threatening to panicked. Hui glanced back, seeing raging crimson flames in the doorway to the storehouse. Fire was the greatest threat to any community. It could sweep through entire towns with the speed of the spring floods that came with the swelling Nile.

His ploy seemed to have worked. The watchmen and the guards emerging from the Lower City were running towards the storehouse. Their bellows of 'Fire!' would have men scrambling from their beds to help with pitchers of water and palm beaters. Hui hoped they would catch the blaze early enough.

Smoke billowed across the street. Hui covered his mouth and ducked into the shadows again, hidden from the eyes of those swarming around the entrance to the storehouse. Reaching the gate, he pushed against the bar and heaved until it lifted from its

brackets and crashed to the ground. Grabbing the greasy rope handle, he tugged open the gate wide enough to slide through, and then he was outside the walls.

Hui fell back against the sun-blistered wood of the gate. As his gaze drifted up to the heavens, he saw the moon staring down at him, the majestic sweep of stars glowing. The dawn would come soon enough, as it always had. The world continued. Only his life had changed.

He breathed a deep draught of clean air after the choking smoke and pushed himself away from the gate, from Lahun, from all he had ever known.

This would be the first day of his new existence. Now he was *habiru*, an outlaw, with no home, no family, no work to buy food to fill his belly, no path along which to make his way.

Habiru.

Hui had a notion of what the word meant, but he would be learning the hard truth of it in the days to come. This was the lowest point in all his years. When his shoulders began to sag, he pushed them back, stiffening his body and his resolve. His life was his own. Only an hour ago, that was not the case, and then he could see nothing but death ahead of him. But the gods had given him this gift and he would not spurn it.

His fists clenched. No, his life was not empty. He had purpose now, and he was free to pursue it, no matter if it took days or years. And his purpose was this: to seek vengeance. For the murder of his father. For the cruel suffering inflicted on Ipwet. And for the grief that felt like a dagger in his heart.

Vengeance against Isetnofret. Vengeance against Qen.

In days gone by, Hui would never have dreamed of this. He was not a man of violence and blood; he was no warrior. He'd always considered himself a gentle soul. But he was determined

to be a different man now. By the will of the gods, he would be reborn and do whatever it took to achieve his revenge.

As the fire roared and the smoke swirled up to obscure the stars, Hui pushed away from Lahun, out into the wastes. A man with no past and no future, an outcast.

For the first time in his life, he had no notion of what lay ahead.

T he cries of the men fighting the fire drifted on the wind. Hui could see the ruddy glow licking above the white walls. But it seemed to be dying down already. Soon the hunt for him would begin anew.

As he jogged on, raising whirls of dust with each footfall, he decided it was too dangerous to take a path across the wastes. The watchmen had keen eyes, used to seeing far across the land. They would identify him in an instant on that flat, featureless plain long before he reached the cover of the hills.

Hui headed towards the canal. A few lamps glimmered amongst the date palms lining the waterway, the signs of the boatmen preparing for their day's labours. Soon he was breathing in the cool river smells of water and vegetation. Running though the barley fields, he stumbled into the black mud that lined the marshes and then clambered onto the causeway that led to the quay.

A scarlet strip edged the sable sky in the east. Shapes began to emerge from the gloom – the swaying acacias and the markh trees, the pools of stagnant water and the bones of an abandoned plough. Hui spied the piles of masonry where he had been overseeing the repairs to the flood walls, seemingly a lifetime ago. He'd find some cover there from anyone watching from Lahun. With dust clouding around him, he scrabbled over the half-cut stones and the hammers and chisels that the masons had thrown

aside at sunset the previous day. He ventured to the foot of the largest pile of masonry, and found himself with a clear view of the canal.

Hui squatted on an abandoned stone marked with chisel cuts and looked across the undulating field of water rats streaming back and forth, searching for morsels discarded during the loading and unloading of each day's trade. He had to make the right choice and he had to make it fast.

Bakari's large skiff strained at the creaking papyrus rope closest to the causeway. It was deserted and in darkness. Five other skiffs of varying sizes were moored along the remainder of the low stone dock. A couple of men were emerging from sleep beside the red embers of their dying fire. Another group sat on bales, chatting quietly as they enjoyed the peace of the last of the night. Others moved about on board, preparing to cast off.

One poor soul, probably no more than eleven years old, cursed and sweated as he struggled to heave a heavy clay pot off the quayside and up a ramp onto the skiff. His master sat on board, watching him. A large number of pots and two bales were silhouetted against one of the dock's lamps, still waiting to be shifted.

Glancing over his shoulder to make sure his pursuers had not yet left the city, Hui stood up and walked towards the quay. He came to a halt beside the skiff where the boy laboured. The master on the deck was a heavyset man with a hooked nose and a missing tooth. Naked to the waist, his belly hung over his tight kilt.

'You are hoping to depart before the sun is high?' Hui asked.

'Who wants to know?' The master of the boat studied him through narrowed eyes. He seemed like someone who was quick to suspicion.

'My name is . . . K-Kyky,' Hui said, stuttering over his alias.

The master repeated his name with a faint sneer, mocking his stutter.

Hui's cheeks burned. 'You could leave earlier with two more arms to help move your goods, and strong ones at that.'

The master looked him up and down, weighing his worth.

'I will give you a pitcher of beer and some bread.' He grunted. 'I will need you only on the journey to Helwan. You can help unload there. You will have to make your own way back here.'

The master, Hui learned, was called Adom. Hui agreed to the terms, and an instant later he was by the side of the boy, who looked relieved to have some aid. Grasping a bale, Hui dragged it along the stones and up the ramp, then returned for the next. The quicker he loaded the skiff, the quicker they could be away.

As Hui sweated, he glanced back towards Lahun. The glow of the fire had disappeared. His pursuers would be on his trail.

Adom watched him closely, and as Hui dumped a clay pot on board, the master said, 'If you miss the place so much, why are you looking to leave?'

'Miss it?'

'You keep looking back.'

'My father has sent me to be an apprentice with my uncle in Heliopolis for a year. I would rather stay here with the girl I love.'

Though he nodded, Adom's face gave nothing away and Hui couldn't tell if he believed him or not.

Soon the skiff was fully loaded. Hui eyed the goods piled on the deck. There seemed too much for a vessel of that size, and he was afraid the weight might sink it. Adom was a greedy man, and lazy; he hadn't wanted to make two trips. But though the skiff was low in the water, it seemed stable enough.

The sun sat red on the horizon when Adom ordered Hui to cast loose. He and the boy grasped an oar each, and soon they were sculling away from the quayside.

Hui looked to those white walls and wondered if he would ever see his home again. He imagined the guards trooping out of the gates, searching in the churned-up dust for his footprints and then dividing into two groups, one heading into the wastes, the other towards the canal. It no longer mattered. It was too late.

Though it was early, the sun was soon burning and sweat soaked his robe as he heaved the skiff on. He thought of Ipwet and his heart ached. He felt swamped by a sudden wave of grief for his father. Then his thoughts burned hot as he considered Isetnofret and Qen, and he found new strength in his arms. His loathing simmered.

The skiff moved into the centre of the channel. Hui watched the farmers wandering out into their fields, and the hunters examining their waterfowl traps. Soon, the banks of the canal became deserted.

As the hills loomed up ahead in stark browns and greys under a clear blue sky, Adom licked his finger and pointed it upright. Satisfied the wind was blowing in the right direction, he barked at the boy and the sail was unfurled. It was a sad thing, Hui thought, ragged along the bottom and patched in so many places that he wondered how much of the original sail remained.

Adom lounged in the stern under an equally ragged canopy, folded his hands on his fat belly and was soon snoring so loudly his entire carcass seemed to shake.

Hui eyed his fellow oarsman. The boy sported a black eye and a split lip which Hui presumed had been a punishment meted out by his master. His ribs showed through his skin and his eyes were sunken. Hui thought he looked like a whipped

dog at the back of a beggar's hovel. He didn't know if the lad was Adom's son or not. Whenever he tried to strike up conversation, the boy flinched, glanced at the master and looked away, hunching his shoulders as if he was trying to make himself so small he would not be seen.

After a while, they began to sail past other skiffs heading towards Lahun. They were bigger and in better condition, the crew strong as they heaved on the oars in unison. Their masters watched Adom's skiff pass by, their expressions filled with contempt.

When the shadow of the hills fell across them, Hui looked at the towering rock on both sides of the rift through which the canal ploughed. Only bandits and desert wanderers would inhabit such a harsh landscape. The cleft trapped the suffocating heat at water level, but Adom didn't let them use the canopy to protect them from the punishing sun. He lounged in the shade, slicing a fig with a short but wicked copper blade riveted to a wooden handle. He devoured the fruit like a beast, smacking his lips as the juice sprayed down his chin and splashed on his distended belly. The boy licked his dry lips, but there would be nothing for him.

Hui decided Adom was contemptible. But this was his life now. He would have to make his way with the help of strangers, however unpleasant. He must not weaken.

Once they were beyond the hills, the wind whipped over them, cooling Hui's sweat-beaded brow. He could smell the Nile, and the earthy scent of the black silt that coated the land after every flood. The banks on either side became lusher, the date palms more numerous, lining vast fields of crops where farmers and slaves bent at their labours. The drainage channels were thick with a carpet of lotuses, their delicate flowers absorbing the sun's rays.

They pushed out into the great river and Adom steered downstream. Great ships dotted the water along the centre of the channel, the acacia-wood hulls flexing against the current, the short planks hooked together and tied with ropes. Astern, the steersman guided the vessel with deft touches on the vast rudder. Hui marvelled at the largest ship he had ever seen, the magnificent hull low in the water. The crew stood on small decks in the prow and stern, but the belly of this vast vessel was left open for cargo. The ship carried stone to Cairo from the quarries, Adom said, though how he knew this, Hui wasn't sure.

By the time the sun was slipping towards the west, Hui's arms burned with exhaustion. His time in the Well had taken its toll. The simple act of sculling drained him. He felt relieved when Adom raised a hand towards the bank and they could steer the skiff in and moor it for the night.

'No point getting to Helwan after sundown,' Adom grunted. 'Won't be able to unload. Nobody to collect taxes.' He lurched to the prow, looking up and down the bank. 'Here is as good a place as any. You two will take it in turns to keep watch during the hours of darkness. If any bandits approach, do not wait until they are near enough to board. Shout. Rouse me from my slumbers. And while you are at it, throw off the mooring rope and get us away from the shallows.'

Adom grasped the pitcher from beside his seat and slopped beer into a cup. Once he'd ripped off a wedge of bread, he thrust both at Hui – his wage for the day's labours – and then slumped back down and was snoring within moments. The boy took first watch. Hui sprawled across a bale and felt sleep overcome him.

How long he dozed, he didn't know, but when Hui jerked awake the dark was deep and the stars were out. Shaking the

stupor from his head, he heard muffled sounds of a struggle and realized that was what had disturbed him.

Bandits! he thought.

A vision of Basti the Cruel flashed across his mind as he looked along the skiff.

He saw a shadowy, quivering bulk. Adom was naked, his stiffened member poking from under a roll of flab. The boy was pinned underneath him, face down.

Adom glowered under heavy brows, his eyes glinting.

'Return to your slumbers,' he growled. 'This is not for you.'

Hui looked down at the boy. Lit by the thin moonlight, his face was turned up and silently pleading.

'Leave him,' Hui said.

'Away, I said.' Adom clenched a fist and shook it. 'Or I will snap your neck like dry wood.'

The boy's head sagged, his body loose and compliant. He must have endured this torment time and again.

Whatever was coming over Hui, he'd never experienced its like before, but his blood was pounding in his temples and a red rage surged from somewhere deep inside him. Instinct urged him to defend the underdog, the weaker, the vulnerable. He understood too well the despair of the persecuted. Lunging past the blubbery mass, Hui fumbled on the seat under the canopy until his fingers closed on a wooden handle. Turning, he whisked Adom's copper blade in an arc.

The master's eyes flinched with fear as he saw the knife. He had no time to move. Hui threw himself onto Adom's back and pressed the blade against the folds of fat around the big man's throat.

'Leave him,' Hui whispered, 'or I'll slit you open and push you into the water, a fine feast for the crocodiles.'

Even as the words hissed out of his mouth, Hui didn't recognize them. They seemed to be coming from someone else – someone as bloody and vicious as the bandits he'd seen in the Shrike camp.

Adom felt the bite of the copper and whimpered. Bullies always crumbled in the face of a serious challenge; Hui had known that since he was a boy.

Easing off the master's back, Hui kept the knife pressed against flesh and pulled the bulky body backwards until the boy could wriggle out.

'Go to the prow and catch some sleep,' Hui breathed, his voice gentle. 'I will take the watch for the remainder of the night. You rest.'

The lad scrambled away into the shadows. Hui waved the knife in Adom's face.

'I will be keeping this,' he warned, 'and if you try anything like that again, I will gut you.'

With a sullen glare, Adom heaved himself back to his seat beneath the canopy, where the shadows engulfed him. Hui perched on a crate, scanning the moonlit bank, but he could feel the master's murderous stare on him from the dark. He'd made a mortal enemy. He would have to watch himself from now on.

His hand holding the knife was trembling. Never would Hui have thought he was capable of such a thing. A part of him cursed Isetnofret for destroying the meek and innocent person he'd once been. But a side of him also knew he should offer thanks. If he was to survive in this brutal world, this was the man he had to be. And there was something else he discerned – a sympathy for the suffering of others less privileged than himself.

When the sun rose, Adom begrudgingly tossed out another hunk of bread and slopped some beer into a cup. Once they'd finished their meal in silence, the master stepped to the side of the skiff and squinted into the receding shadows.

'There's a bale out there. Might have been lost overboard by some passing ship and washed up here. If the water hasn't damaged it, we might be able to trade it when we get to Helwan.' Without looking at Hui, he pointed into the reeds. 'See if it's worth the effort of dragging it aboard.'

Hui stared into the shadows. He didn't trust Adom for one instant, not after what he'd witnessed.

'You are young and strong,' Adom pressed. 'To save my poor limbs, I am prepared to give you half of whatever we make from that bale.'

Hui weighed the offer. He had nothing. Any profit would aid his flight. With a nod, he splashed into the shallows and squelched through the thick mud.

'Where is it?' he shouted as he searched amongst the rushes. 'I see nothing.'

Laughter rang out. Hui turned to see Adom grinning at him as the skiff pulled out into the current.

'When you're walking the rest of the way to Helwan with an empty belly,' the master barked, 'think long and hard about pushing your nose into other people's business.'

Beside him, the boy stared with wide, dismal eyes.

Hui cursed and waded back into the shallows, but it was too late. The skiff was already sweeping away.

He'd been a fool to let himself be swayed by material gain. And the price he'd pay for his gullible behaviour might be starving to death. Unless he could hail another passing boat,

he'd have to walk until he found somewhere to take him in. And even then, he had nothing to trade.

'You will survive,' Hui muttered to himself. 'But only if you learn your lessons. Trust no man. Be steely, resolute, ready to fight at the instant of provocation.'

The day dragged and the night, too. A crust of bread was not enough to fill a man's stomach, and the sustenance it offered was poor for the exertion he had to undertake. Hui trekked past vast tracts of lush farmland, sheltering in the cool emerald shade beneath the palms when the sun was at its highest. Time and again, he strode over to those labouring beside their ditches or went up to the gate of isolated farmhouses, pleading for work, begging for food. The answer was always the same. Hui became used to the narrowing of eyes and the suspicious questions. He would have done the same himself in Lahun. Who could trust an itinerant man, filthy with the dirt of the road, no master, no work? By way of explanation, his tales of woe became more elaborate, about how he had come to lose everything by a terrible turn of fate. But if the gods had chosen to punish him, why should any man help?

Behind their rebuttals, Hui started to see something else: fear. The reputation of the Shrikes had worked its way into all parts of the land, like worms in a rotting carcass. They suspected he was a scout for the bandits, judging the wealth of potential victims for the next raid. Nothing he could say or do would assuage that dread.

As he walked, he forced himself to think back on the death of his father to harden him, and he lost himself in plotting how he would achieve his vengeance. For now there was only survival.

Finding a crust to keep him alive, to put distance between himself and the authorities searching for him, lie low for a while until he was forgotten. Then he would be ready to devote everything to his quest. He would steal whatever he needed – gold, a donkey, a sword – and he would make his way back to Lahun. A faceless drifter in the crowds with murder in his heart. Until then, Hui could afford to bide his time. He would never forget.

Despite his exhortations to himself to keep the fire in his heart, hunger and exhaustion eventually began to strip the hope from him. He knew that if he was going to live, he had to be cunning.

When he spied a whitewashed villa radiant in the sunlight, Hui swallowed his urge to race up to it and beg, his desperation clear for all to see. Instead, he hurried to the river, stripped off his robe and jumped into the soothing, cool water. He scrubbed the dust off, polished his teeth with the tip of his finger and rinsed his robe and left it in the hot sun to dry. There was nothing he could do about his thickening hair or the black stubble growing along his jawline, but he was certain he could pass for something other than a beggar.

When his ragged robe had dried, it looked more grey than white. But the beautiful design still shone and would, Hui hoped, draw the eye away from the flaws in his appearance. Finally he walked back towards the villa.

He passed a patchwork of fields where tanned slaves in kilts tended the crops. These lonely rural houses were self-sufficient, and he could see the lettuce and the garlic growing alongside larger fields set aside for barley. The dung of the working oxen dotted the tracks, and his nose twitched at the musky aroma of sheep. The villa had a roof terrace, much like his old home, where the master of the house would be able to survey his land.

It was surrounded by a mud-brick wall with workshops built into it, where he knew the more skilled servants would weave and make pottery and brew the daily beer.

As Hui neared, his head began to swim with the most succulent aroma drifting from the villa's kitchens. In his hunger, it seemed the most astonishing meal ever created, though the scents told him it was only a spicy fish stew. His mouth watered and he feared he might become delirious.

Leaning on a palm in the shade, he watched the gate. He would have one chance to get this right. The slaves came in and out, eyes down and burdened by the tasks they'd been given. As Hui weighed which one to approach, he glimpsed a girl walking out of the villa gate, carrying a basket. His nostrils flared at the scent of fresh-baked bread. There was a small pitcher in it, too – beer, no doubt – and some other items he couldn't see.

The girl looked about three or four years younger than him, shorter, and with a round face and big dark eyes. Not unattractive, he thought, and made prettier by the way her lips naturally curved into a kindly smile. Hui steeled himself, and as she turned along a path into the fields, he hurried behind her.

'Would you like me to carry that for you?'

'Oh!' the girl exclaimed, almost dropping her basket. She half-turned and eyed Hui. Before she could decide Hui was a threat, he beamed.

'My name is Kyky. Yes, I am a little monkey for surprising you so. Please accept my apologies.' He bowed deeply.

When he looked up, she was smiling and her eyes sparkled.

'Little Monkey,' she asked, 'why are you walking here by my house?'

'I had heard tell of the most beautiful woman in all Egypt and had to see her with my own eyes.'

The girl's lashes fluttered and she didn't seem unpleased.

'I have been warned about men like you,' she said.

'What is your name?'

'Ahmes,' she replied. 'It means—'

'Child of the Moon. A beautiful name.'

Her smile grew wider, and this time her lips parted to reveal small pearly teeth.

'May I walk with you?' Hui pressed.

Ahmes nodded and began to stroll away, forcing him to skip to catch up. As they ambled, her shyness faded and she warmed to his conversation. Hui imagined that she received little attention from men, living in such a lonely location, and she would probably not see more until her father arranged for her to be wed. He felt a pang of guilt at the way he was playing with her emotions – her skin would thicken after this, and she'd be less trusting and less kind – but the growls from his stomach were drowning out his conscience.

She said she was taking the food to her brother, who was overseeing the slaves digging a new irrigation canal. She told him of her life, as dreary as Hui imagined, and then begged him for stories of the world beyond her farm. He mesmerized her with tales of romance and adventure that left her breathless and wanting to hear more. But then her face fell and her mouth tightened.

'What is wrong?' he asked.

'We are nearly at the field where my brother works.'

Hui could now hear the sound of digging and the lilting song of the slaves.

'Your brother will wait a moment or two longer to fill his belly, I would wager,' he said with a smile. 'Shall we rest a while here and talk some more?'

If she hadn't been holding the basket, Hui thought she might have clapped her hands with glee. He led her to a small copse where the palms swayed in the southerly breeze, and they sat in the shade. Hui felt his broad smile becoming fixed as the acid of self-loathing bubbled up. He couldn't find any more sweet words to seduce her; each one he dredged up died in his throat. As she set down the basket to smooth her white sheath dress, Hui lunged. At first she thought this was more of the playful little monkey, but he felt the hunger twist his features as his fingers closed on the basket. Ahmes recoiled as if she'd been slapped.

Hui flung himself away from the copse along one of the winding paths snaking towards the river. Ahmes' cries rang out, and what he heard was filled with such betrayal that his stomach knotted with a sickening hatred for himself.

The slaves would be after him soon, and if he was caught he'd be beaten within an inch of his life before being delivered to the authorities – and ultimately Lord Bakari. Hui drove himself on harder than he might ever have imagined on such weak legs, weaving along cross-paths until he lost himself in the marshes, wading to a small knob of solid ground where he sheltered from sight behind whispering banks of papyrus. He gorged himself on the contents of the basket: the loaf, a small clay pot of that fragrant fish stew he had smelled earlier, creamy cheese and mouth-watering olives. The feast ended with deep gulps of the sweet beer straight from the pitcher, the brew foaming down his chin and splashing on his robe.

Hui slumped back on the dirt and watched an ibis wading through the pools of murky water, its down-curved beak stabbing into the mud in search of tasty crustaceans. This was the great Thoth's bird – Thoth, who kept order in the universe – and Hui wondered if it was another sign from the gods. He didn't know

what it meant, nor did he have it within him to consider it. All he could consider was that this was his life now. He was a thief, a despicable robber no better than the snakes who joined the Shrikes. He could deceive an innocent like Ahmes with barely a second thought, leaving her to face punishment by her father for being so easily tricked.

If he could do that, surely Hui was capable of anything.

As Hui made his way north along the river, he stole food whenever hunger gnawed at him, climbing the walls of villas to raid the kitchens at night. More than once he was caught in the act, escaping by the skin of his teeth. After a spear had whistled a finger's breadth past his ear, he realized that sooner or later his luck was going to run out.

He thought he might be able to gain passage on another skiff. But as he approached one where the crew were repairing a broken oar on the bank, he overheard them discussing an outlaw roaming the farmlands and he turned away.

Worry began to eat its way into his heart. Adom must have spread the word of some rogue who had fled Lahun and was now wandering the western banks of the Nile. That kind of talk might reach the authorities and drift back to Bakari. The danger would increase with every day he spent there.

He had to get far away, somewhere no one would talk about him.

The next morning, shortly after the rising sun painted the sky rose and purple, Hui slipped down to a small quay of baked clay where the ferrymen plied their trade. Hiding in the undergrowth, he watched a group of traders gather for the first journey of the day across the river. He had nothing to buy

his passage, but when the ferryman pushed off with his passengers, Hui darted out from his hiding place and dived into the shallows. He gripped the rush hull of the stern, buffeted by the wake.

When the ferryman caught sight of him, he snarled and slammed his sounding pole down to try to knock Hui loose. The traders lounging on board jeered and told the ferryman to leave him be – if he was that desperate to cross, let him risk drowning or being eaten by crocodiles.

Somehow Hui clung on through the strongest of the currents, and when the ferry moored on the eastern bank, he staggered out of the shallows and raced away before the ferryman could cuff his ears.

The trek to Helwan took him three days, but Hui felt more at home once he was walking the dusty streets, breathing in the city smells of oil and smoke and midden heaps that reminded him of Lahun. It was easier to steal food there, too, though he felt pangs of guilt whenever he robbed one of the near-starving families in their hovels. After another three days, he heard tell of a caravan making ready to cross the Sinai to trade with the lands to the east.

Hui bargained hard with the hook-nosed desert wanderer who was leading the expedition to exchange fine Egyptian flax for spice. Eventually he persuaded the desert dweller, who was called Fareed, that he would be a fearless guard, able to keep watch at night, who fought like a panther and was as cunning as a jackal.

Fareed was unmoved by his boasting, but he said by way of agreement, 'If the bandits attack, you'll be one more body between me and them. That might just give me chance to escape.'

The wind howled across the barren land. Spirals of dust whirled through the featureless plain to the jagged fangs of mountains the colour of bronze. More mountains lay beyond, disappearing into the hazy distance beneath the sapphire sky. Hui had never seen a land so empty. They could have been alone in all the world.

The caravan trailed behind him, a motley collection of seasoned desert travellers, in white robes with colourful scarfs tied around their heads. They trudged beside creaking wagons laden with their wares and swaying donkeys with large baskets strapped across their backs.

Hui's scarf of deepest emerald was tied across his mouth to keep out the dust, with only a narrow strip clear around his eyes. When Fareed stepped beside him, Hui pulled the scarf free so his words could be heard.

'All looks well.'

The desert wanderer continued to stare towards the mountains, following the deep bands of shadow where the gorges were carved through the rocks. Hui still hadn't got the measure of him. Fareed said little, walking alone ahead of the caravan. He seemed to have none of the humour of the other chattering travellers, whose laughter seemed to help them survive in such harsh conditions. Fareed was always watching, and, it seemed to Hui, not trusting anyone. That was probably wise, he was coming to believe.

'You still have city eyes, good for what's at your feet, but near-useless here,' Fareed said. 'In the desert you learn to see over great distances. One day you will see a fox run across that peak.' He pointed. 'Until then, your usefulness lies elsewhere.'

Fareed scanned the range one more time and seemed to satisfy himself. Turning to the caravan, he put his fingers in his mouth and blasted a whistle. The line of travellers heaved on.

Chastened, Hui waited until the line had nearly passed and then set off alongside them. He'd already had to learn some hard lessons quickly. When the winds blew, he could be choking on dust in the blink of an eye without his scarf. The sun seemed to burn even hotter here, sucking the moisture out of him and he had to use the water skin at his hip sparingly to make it last between oases. The nights were colder still. On his first sleep, he'd spent it shivering and his teeth chattering until a cursing Fareed had found him one of the large blankets and shown him how to wrap it around him three times.

They were barely five days into their long journey to the east. The plan had been to follow the Way of Horus, the old military road to Canaan, past the forts and the turquoise mines. But Fareed had heard talk in Helwan that bandits had been drawn to that route in recent times. He decided to follow another old *habiru* track into the mountains.

But one thing did comfort Hui. Here he was known by his true name again, for what men made soft by city life would venture into this unforgiving territory? In the Sinai, he could be born again, a new Hui, perhaps the man he'd always dreamed he might be. As his strength returned, he thought of Isetnofret and the ways in which he might gain his vengeance. He'd expected the loathing to have faded over time, but it still simmered in his heart as strong as ever. He thought, too, of Ipwet and what perils his sister faced. Soon he would return to rescue her. That was his vow.

When the caravan left the plain and began to grind up the steep, rugged track into the lonely mountains, the going became slower. They wasted half a day repairing a broken wagon, and the track wound back and forth around boulders

and deep channels, sometimes skirting precipitous drops where one wrong foot meant death. That night was colder than anything Hui had ever experienced. An ache reached its fingers deep into his bones, and when he woke, staring up at that river of stars, his breath clouded around him.

The next morning they crested a ridge and with relief, plunged into a valley between towering cliffs. A few markhs sprouted here and there, those dismal leafless trees with bare branches and slender twigs, but the only other life Hui saw were two rock rabbits, the rat-like creatures that Fareed called *dassie*.

As they ambled down the valley, someone at the back of the caravan began to sing in that high-pitched, lilting manner so beloved of the people from the east. Hui realized he felt oddly at peace, for the first time since Lahun and the death of his father.

Uqab, a short man with a broad grin and three missing teeth, sidled up to him.

'My friend, is it true you are a great warrior who saved Pharaoh's life?'

Hui laughed. 'Where did you hear this, Uqab?'

The other man waved a hand towards the caravan.

'Ah, there is always talk. Except from you.' He wagged a finger at Hui. 'You never speak about what you did before you joined us on this journey.'

'My life was too dull for words. Your tales are better.'

Before he could reply, an arrow thumped into Uqab's face.

The desert traveller spun backwards, a spray of blood misting the sunlight. He twitched for an instant, then lay dead. Hui jumped back as a cacophony of cries erupted around him. He heard Fareed barking orders, but they were swallowed by the clamour of the desert travellers scrambling for cover. Some wriggled under wagons. Others threw themselves behind ridges

of rock, their heads turning this way and that as they searched the rugged mountain landscape.

Hui gaped, immobile with shock, and then he realized Fareed was bellowing at him to find shelter. The command came not a moment too soon. More arrows whined across the azure sky, a deluge of them. Hui rolled behind a low boulder as the shafts rained down, some bouncing off the hard ground close to where he had been standing. Others punched into the wooden sides of the wagons. A donkey collapsed with quivering shafts embedded in its body. One of the desert travellers lurched from behind a rock, screaming. An arrow was rammed in his eye socket. His hands flailed at his head before he pitched onto his back.

Everywhere Hui looked, he saw the men he'd been travelling with scattered across the mountainside, some of them wounded and crying out, others dead. The ground around the caravan was turning crimson.

Fareed was waving his hand, urging Hui to keep low, as if he needed any warning. As more arrows whined, Hui peeked out. The torrent seemed to be coming from beyond a ridge above them. How could that be? He'd never known an arrow fly so far; the bows he'd seen could only reach half that distance. It was as if the shafts were propelled by magic.

The arrows screamed down and the ground seemed to quake with their impact; anguished cries erupted, blood spurted.

Beyond one of the wagons, someone was raving, driven near-mad by the relentless assault. But no one could risk moving for fear he'd be picked off.

But then there came a lull in the attack, and Hui looked up again. Figures were emerging from their hiding places along the ridge. He squinted, but in the sun they were little more than silhouettes.

Fareed was on his feet, brandishing a sword he had pulled from one of the wagons. It looked impotent against the band of figures sweeping down the mountainside towards them.

'Hyksos!' the desert wanderer was yelling. 'Hyksos!'

Hui's blood ran cold.

The warriors were protected by leather armour and kilts, and they wore helms of the same material with flaps to protect the ears and a strip across the bridge of the nose. Unlike clean-shaven Egyptians, they sported black beards which curled into a point at the chin. Some had quivers strung across their backs and carried the strangest bows Hui had ever seen, small but curved, like one of the harps the musicians had played at his mother's feast. Others wielded long crescent swords, the metal greenish in the brassy light. Hui had never seen their like before.

He gasped as an even stranger sight broke into view – a man riding a great beast, larger than a donkey, nut-brown, its muscles rippling across its flanks. Hui stared at the power it exuded, and its dexterity as the rider guided it down a winding track so fast it seemed it should surely career off the edge.

This magnificent creature could only be a horse. Hui had never seen one, not in Lahun, but he'd heard tell the Hyksos had mastered these beasts and they were partly responsible for the barbarians' bloody success. Another rider appeared, and then more, until the valley rang with the sound of thundering hooves.

The surviving desert travellers scattered. But as they tried to flee the way they had come, Hui glimpsed more riders canter-ing behind them. They were trapped, ripe for the slaughter.

Hui grasped the handle of the copper knife he'd stolen from Adom on the skiff, and then realized how pathetic the blade was. Turning round, he threw himself at what looked like a

sheer rock face, his fingers and toes finding near-invisible cracks that gave him purchase. Hand over hand, he hauled himself up, driven by terror and the screams ringing out behind him.

When he reached a dizzying height, he glanced back at the carnage. The Hyksos riders were circling the caravan, hacking at anyone who moved with those cruel swords. Hui could see those crescent-shaped blades were illuminated with etchings, works of great craftsmanship.

Fareed was standing his ground, thrashing his straight bronze sword back and forth when any attacker neared. The Hyksos didn't seem to be daunted by him. They seemed to be playing with him, like the mill dogs did with the rats. Then one of the riders urged his steed directly at the desert wanderer, leaned to one side and whipped his sword down hard. Fareed's blade shattered into pieces. Hui gasped. What chance did any Egyptian soldier stand against these barbarians when their weapons were so much more powerful?

And yet the Hyksos warrior didn't cut down his unarmed opponent. He brought his steed to a halt and levelled his blade at Fareed's throat. The two men held each other's gaze, and with a resigned nod, the desert wanderer dropped to his knees and bowed his head. Along the bloody streak where the caravan had once been, the other barbarians were rounding up the survivors and at sword-point were forcing them to ransack their own wagons and carry the booty away.

A cry echoed and Hui saw one of the Hyksos warriors pointing at him. Another barbarian nocked an arrow in a flash and let it fly. It rattled off the rock a hand's width from Hui's head. He needed no more warning. Scrambling up the rock face like a monkey as shafts crashed around him, he pulled himself over a series of brown boulders into a deep channel. He couldn't stay

there, he knew. From the valley floor, he heard more barked orders in a tongue he didn't recognize and the thud of running feet. A band had been sent to hunt him down.

Hui ran and hid, crawling down criss-crossing channels, barely wide enough for a man, along the steep valley sides until his knees and elbows were ragged, drenched in fear-sweat as the barbarians circled. He could hear their babbling voices as they clambered up any of the myriad paths they could find, some trying to follow his trail, others rising up higher. Hui was sure that if any of them glanced down, they'd see him.

Back and forth, he scurried, like a rat, eventually making his way over the ridge of the valley side and into the strange high lands of twisted rock columns and clefts and basins clogged with the scrubby trees.

As dusk crept across the mountains and Hui shuddered in a hollow barely big enough for a desert cat, those voices began to move away and he realized they'd given up the search. When night had fallen, he summoned up enough courage to crawl out of his hiding place, and even then he jumped at every whisper the wind made as it swirled around the rocks.

And only then did the truth of his terrible predicament grip him. He was alone, in the mountains, far from any settlement, caught between the blistering heat of the day and the bone-numbing cold of the night. He still had his water skin but that was all. No bread, and nobody to teach him how to survive in this cruel place.

Hui slumped onto a rock and pressed his head into his hands.

But he couldn't give up so easily, not when he yearned for all that he'd lost. When woodsmoke floated on the breeze, Hui followed it.

From a hiding place, he looked down on a campfire roaring at the centre of a circle of flat land protected from the harsh

wind on three sides by towering rock faces. Around the fire, the camp of the Hyksos war band sprawled. The victorious warriors squatted around the blaze, swilling beer and laughing as they tore at chunks of some kind of dried meat. One of the barbarians grasped an armful of wood, no doubt ripped from those spindly markh trees, and tossed it onto the fire. The flames crackled and licked up higher, a spiral of sparks swirling.

The amber glow lit the faces of the warriors as they ate. Hui could see Fareed and the other survivors of the caravan sitting nearby. They were eating, and not harmed by the looks of it. The sound of snorting and stamping of hooves came from somewhere close, where the Hyksos had penned their horses.

Hui watched, and considered his options.

One lesson was here for the learning. In this brutal world, a man could not survive on his own. He needed allies. His friends and neighbours had abandoned him. He'd been branded an outlaw. Then why not become one?

Pulling himself from his hiding place, Hui strode down the mountainside towards the Hyksos camp.

The Hyksos warrior waved the scimitar in front of Hui's face, turning it so the reflection of the fire danced along it. Flashes of light dazzled along the cutting edge of the crescent blade. As a cloud of sweet woodsmoke billowed, gleaming with sparks, the circle of barbarians stamped their feet and clapped their hands.

'Take his head,' someone grunted in a faltering Egyptian tongue. Harsh laughter brayed.

The captain's white teeth showed amongst his black bristles. Flames flickered in his eyes. He was toying with Hui, making a show for his audience of bored fighting men. Hui

was kneeling, head bowed, but he looked up at his captor from under his brows. The warrior was wearing a polished leather hat and a padded leather breastplate which could stop an arrow. His skin was olive-coloured, his cheeks tanned like hide by the wind and the sun.

'I have come to join you,' Hui said.

More laughter.

'You?' the captain snorted. He looked at his men, feigning incredulity. 'You are little more than a boy. There is no meat on you. Your skin is as soft as that of a woman who bathes in asses' milk.'

'It is not wise to judge on the evidence of your eyes alone,' Hui said. 'I would have thought a seasoned warrior like you would know that. I am an outlaw, one of the most feared in all Egypt.'

The Hyksos warrior's eyes narrowed. He was not yet believing, but Hui had caught his interest.

'I killed the man who wronged the woman I loved,' Hui extemporized. 'It was a fair fight, but his family bribed the court to punish me as harshly as they could. Castration and execution. That alone shows how dangerous they believed me to be. The guards beat me with cudgels for three days. I survived. They threw me down a deep well. I survived. And more than that, I escaped from this terrible prison from which no man had ever escaped before. And since then, the jackals of the authorities have hunted me across the burning red sand and the black, through cities and farms and even into the Sinai. And not once have they come close to capturing me.' Hui tapped his forehead. 'My brain. That is my weapon.'

'And your tongue,' the captain chuckled. 'You weave a good tale, of that there is no doubt, though I have little notion how

much of it is true. Still, with that alone you may provide some entertainment on our long rides.' He addressed his men. 'What say you?'

The warriors cheered, punching their fists into the air.

Hui's shoulders loosened. He'd gambled his life when he'd walked into the camp. But it seemed as if his judgment had been correct. These were men who were not afraid of anything. Fear bred suspicion, and anger, and lethal responses. But they were so confident in their strength that they saw no threat anywhere, and after witnessing the attack upon the caravan, he could not argue with them.

'My men have given their answer. So be it.' The warrior sheathed his sword, the blade singing as it slipped into the leather scabbard, and he held out a hand to haul Hui to his feet. 'My name is Khyan. It means "The One Who Rides With the Wind". You will bow to me. You will obey all orders without question. The work will be hard, and we will ask much of you, even such an exalted outlaw as yourself. In return, you will not want for food, or beer. But if you disobey, even once, the Sword of the Moon will take your head and your blood will drain away into the sand. Do you hear me?'

Hui nodded.

Khyan looked him up and down.

'Small. Little Rat.' He nodded, thinking. 'What do you think of our horses, eh?'

Hui stared. Part of him felt terror at the sight of them – their size, their power. When he closed his eyes, he saw them with eyes of fire and sharp fangs that could rip the flesh from a man. But another side of him admired their grace and the intelligence he sensed in them.

'They are magnificent beasts.'

'They are clever, more than many a man, I'll tell you that, and they are braver than most, too. Be kind to them, and they will be kind to you.' Khyan prowled around Hui, watching him. 'A new soldier builds a bond with his horse, over time, and in that way we become kin. They are more valuable to us than gold. In some cases, more valuable than our own brothers.' His laughter rippled around the crowd of warriors. But Hui heard respect in his tone, if not love. 'Let us see, Little Rat, what skills you have that might be of use to us. Do well and you will have a long life amongst the Hyksos. Does this sound like a fine bargain?'

Hui nodded.

'Very good.' Khyan clapped one arm around Hui's shoulders and swept the other out towards the gathered men. 'Hail our new syce, brothers!' The men cheered again. The captain added, 'We will see if you can learn how to care for our horses, Little Rat. Can you be a good groom? Let us hope you can, for our horses will decide if you live or die.'

Hui jerked awake. Rough hands grabbed his blanket, shaking him. Meaty breath washed across his face. He stared into the coal-black eyes of Fareed. It was before dawn. The stars glimmered overhead and Hui's skin stung from the cold. Around him, he could hear the grunts of the men stirring, readying themselves to break camp.

'It is too early,' he complained.

Fareed pushed in closer so his face filled Hui's vision.

'Do not trust them.'

'What?'

'Do not trust the Hyksos,' the desert wanderer growled in a low voice that would not be overhead. 'They treat you well. But your life means nothing to them, nor mine. They care

about none but their own. They are cunning, putting their arms around shoulders, leading men by the nose. But they are interested in only one thing – power. They see many riches in Egypt and they covet them. Sooner or later they will take them for their own.'

'I have no intention of finding out. I will escape at the first opportunity.'

Fareed snorted. 'You will cross the Sinai alone?'

'You could join me. You know the paths. You can track. We could find one of the caravan routes—'

Fareed snorted again.

Before Hui could question him, the desert wanderer spun away into the dark. Hui brooded on his words.

As he stamped his feet and rubbed his hands, Hui decided he hated the cold more than anything. Once he'd folded his blanket, one of the Hyksos offered a strip of the cured meat which he was handing out to the men. Hui chewed on it, enjoying the warmth creeping through him from the spices.

Khyan was moving amongst his warriors, rousing them. When he saw Hui, he beckoned.

Hui trudged behind the captain across the camp to where he could smell the muskiness of the horses drifting on the air. In the half-light, he glimpsed the grey shadows of the grooms passing amongst them, tossing handfuls of hay for the beasts to graze on.

The captain searched amongst the horses. Rippling muscles gleamed in the dawn's first rays, and the snorts of their breath filled the air. Hui was impressed by their power and elegance.

Khyan tugged on his beard and pointed to one of the stallions, a majestic mahogany creature with a blaze of white along its head.

'That one. His name is Moon. You will be his servant, Little Rat, and you will serve him well.'

'What happened to his last servant?' Hui asked.

The captain eyed him, his tight smile giving nothing away.

'He did not serve well enough.'

'How do I learn?'

'The other grooms will show you all you need to know. They are a company of brothers and look out for each other. Horses are everything to the Hyksos. Without them, we are nothing but ants in the desert sand.'

Hui nodded. 'I will be the best syce you have seen.'

'Good.'

Khyan strode away, snapping his fingers for Hui to follow.

On the other side of the horses, rows of strange vessels emerged from the shadows. Hui furrowed his brow as he studied them. They seemed to be some kind of wagons, though of a kind he'd never seen before. Each one was curved at the front, with low sides, and stood on circles connected by a rod. Another pole protruded from the front, the end resting on the stony ground. A board across the front of this small wagon was gilded with gold leaf which flared in the rising sun. A leather quiver packed with arrows was fixed to one side.

Hui could feel Khyan's eyes on him as he tried to understand what he was seeing. One of the grooms led a horse and attached it to the yoke at the front of the wagon. As the beast heaved forwards, the vessel rolled on those circles with an ease that Hui had never known with the wagons of his home, resting as they did on wooden runners which dragged on the earth and stones behind the lumbering oxen that pulled them.

He felt as if a lightning bolt had struck him. In that instant he grasped the advantages of this thing. He heard the captain's laughter booming around him.

'You Egyptians,' Khyan chuckled. 'You think you are the chosen people of the gods. Thousands of years of civilization, and you believe you have learned all there is to know under the heavens. What arrogance. That will be your downfall, mark my words.'

'What magical thing is this?' Hui breathed.

'This is a chariot, Little Rat. When the horse pulls it, racing as fast as its muscles allow, it moves with the speed of the wind, and it moves smoothly. The charioteer can easily loose arrows from his bow as he attacks. When our chariots descend upon your forces, we will smite them.'

'I would learn how to ride one of these chariots.'

Khyan guffawed. 'This is not for you. You think I would teach you our secrets? No, Little Rat, you have your place and that is where you will stay.'

As the captain strode off, Hui stayed and watched as warriors jumped into the backs of the chariots, balancing their weight as they guided the strange wagons forward. They moved as smoothly as Khyan had said under the power of the horses.

The sight fanned the flame in Hui's brain until his mind was burning white-hot. Fantasies of vengeance against Isetnofret were never far from his thoughts, flickering into life when he woke each morning, lying heavy upon him when his eyelids fluttered shut at night. But one worry always haunted him, looming behind those visions: that he was not powerful enough to defeat the sorceress who had poisoned his life. Too weak, too unskilled. He wasn't a warrior. He was, at best, a thief, a little rat, as Khyan said, who survived on the world's midden heaps and scurried in the shadows.

But with this knowledge, Hui could transform himself from base lead into gold. Imagine thundering up to the gates of

Lahun on one of those chariots! Then all would know he had grown into a great warrior, and Isetnofret would quake when word reached her.

Hui observed every detail of the Hyksos warriors as they prepared to ride out. Perhaps he could learn enough by watching. He studied those strange arched bows that could loose an arrow twice as far as any Egyptian bow he'd seen, and those crescent swords which sang when they flashed through the air and seemed to cut deeper than the straight swords of the defenders of Lahun. Yes, he would learn to be a master of all these things. That was why the gods had brought him into the heart of the Hyksos. He would learn, and Isetnofret would finally pay for what she had done.

The war band rolled out from the bowl nestled amongst the towering cliff faces, through a pass, and along dizzying tracks that wound down to the plain. The chariots trundled ahead, with the rest of the warriors riding their mounts on the flanks. The grooms and slaves trudged along behind with the store wagons. But Fareed was pushed to the front, to use his skills as a scout and a tracker. The Hyksos did not kill for the love of it, and they had learned to benefit from the abilities of the captives they spared. The ground throbbed and a cloud of dust billowed.

They moved from oasis to oasis, filling their water skins each night and resting under palms as the horses snorted and stamped nearby. When it came time to sleep, the Hyksos retired to their tents, but the slaves were not allowed such comforts. Hui quickly learned that Moon was to be his constant companion. He slept beneath Moon's belly every night for shelter, and lapped up mares' milk for his meal. The other grooms taught

him his responsibilities, which he applied himself to diligently. He learned how to comb his stallion's mane to remove any parasites, and to bathe the beast's flanks every night as if it were a boy-king. When there was little to graze on around an oasis, he tossed Moon handfuls of hay, and he discovered how to tend the injuries the mounts were prone to on their long, hard rides across the rugged land. The relationship between groom and horse was far greater than that between rider and steed. This was the way of the Hyksos.

And Hui learned to be pleased that was the way, for Moon's rider, Uthan, was an unpleasant fellow. His moods were dark, his anger quick to rise, and though Moon was his horse-brother, he treated the beast with far too much harshness.

One early morning, Hui trudged from the feed-wagon with an armful of hay, only to hear loud whinnies cutting through the stillness. He raced through the fading shadows in the direction of the frantic sounds, where he found Moon cowering, white eyes rolling, as the rider wielded a whip. The horse reared up when the lash bit. Uthan snarled, spittle flying.

'You are no good,' he spat.

Tossing the hay aside, Hui cried out, 'What is wrong?'

'The beast is too sluggish in the first light. He needs to learn.'

As Moon's terrified whinnies grew louder, Hui felt sickened. Without thinking, he threw himself forward and tried to wrestle the whip from the rider's grasp.

Uthan whirled, slamming the back of his fist across Hui's face. As Hui fell back, the Hyksos warrior hissed, 'You will pay for this.'

Showing no fear, Hui pulled himself back to his feet and hurled himself forward once more.

'Leave him!' he cried.

Uthan raised his whip, ready to turn it on his groom.

'Do as the syce says.'

Hui glanced round at the voice. Khyan showed a cold face as he observed the encounter.

The whip fell limp in Uthan's trembling hand.

'I would speak to you,' Khyan growled.

As Uthan strode over to his commander, Hui snatched up handfuls of hay and hurried to comfort Moon. He stroked the horse's mane and whispered soothing words until it calmed. After a moment, the steed nuzzled him and Hui held out some hay for it to eat.

In Moon's dark eyes, Hui glimpsed a look that he had not seen before. Was that a connection he felt between the two of them? An understanding, perhaps? Or was it his imagination? Whatever it was, he felt a warm affection for the beast rise within him.

Sensing eyes upon him, Hui glanced back. Khyan was watching him with a curious, unreadable expression, before turning and walking away.

From that day, Hui learned to look on the horses with affection, and he began to understand Moon's instincts by staring into those huge chestnut eyes. He was sure Moon could read his thoughts, too.

Hui woke from a dream of Ipwet with tears streaming down his cheeks. For a while, he lay in the dark with the images fading, but he could still clearly see Isetnofret towering over his sister, with the looming shadow of Seth behind her.

Was it a portent? He couldn't be sure, but his heart thundered and he knew he would never forgive himself if he ignored it.

Crawling over, he shook Fareed awake.

'I am leaving,' he whispered. 'Tonight.'

'You are a fool,' Fareed grunted, then rolled over and went back to sleep.

Hui crawled out of the tent into the night. They were close to one of the caravan routes, he knew. Whether he could find it without Fareed was a different matter, but it was a risk he had to take.

For a while, he cocked an ear. He knew where the sentries were, and they would be looking out, not in. Everyone else was asleep.

On his hands and knees, Hui crept past the tents to the edge of the camp. Keeping away from the horses for fear he might disturb them, he clambered over loose rocks until he found the narrow trail he had noticed earlier, that led up the side of the banks sheltering the tents from the harsh winds.

Only a short climb would deliver him to a broader path he could follow to freedom.

Hui's heart beat faster as he climbed up the track.

If you don't act now, you will be trapped with the Hyksos forever, he told himself. These warriors had begun to treat him as one of their own.

No, now is the time.

When he was halfway up the trail, he heard the shriek of a whistle. Another answered. Hui stiffened. Surely the sentries couldn't have seen him under the cover of darkness. Yet he sensed movement nearby. He desperately scrambled up the side of the bank.

Run, Hui told himself. *You have enough of a lead.*

Hui heaved himself up onto the path and looked up. A silhouette blocked out the stars.

'Here!' the Hyksos warrior yelled.

A boot clattered into Hui's jaw and then he was spinning back, bouncing off the rocks until he slammed down onto the ground.

Winded, he marvelled that his skull hadn't been dashed in, but only for a moment. Figures gathered around him and when a torch swung up, Hui looked along the length of a blade into Khyan's cold face.

The Hyksos pushed the sword down until the tip bit into Hui's throat.

'Now I will take your head,' he said.

'Wait,' Hui pleaded. Pain burned in his neck.

'Kill him,' someone said. 'He has betrayed us.'

'I told you what would happen if you could not be trusted,' Khyan said. 'Do you think we are so addled that any rat can come and go freely in our camp?'

Hui wriggled under the sword, but Khyan seemed to sense his unasked question.

'Our sentries do not need to see. They can smell a droplet of sweat on the breeze. And now—'

'Wait. I beg you.' Hui's thoughts raced, and then he had it. 'I am one of you. I have Hyksos blood coursing through my veins.'

'You lie,' Khyan snarled.

'No! The story I told you, about why I fled Egypt. It . . . It wasn't true. I escaped by the skin of my teeth. They denied me a fair trial because my mother was Hyksos.'

'You would say anything to save your neck.' Khyan pressed his blade harder.

'I said nothing about this when I came here because . . . because I was ashamed,' Hui choked. 'I thought all my life that

I was pure Egyptian. When I learned the truth, I did not want to believe it.'

Khyan peered deep into Hui's eyes and must have seen something there, for he eased his sword back.

'Hyksos blood is nothing to be ashamed of. Other men dream to be so blessed.'

'I . . . I know,' Hui stuttered. 'I am learning the truth now.'

'Why did you try to flee?'

'Because it is not enough to be a syce. I was a free man once.'

Khyan stared at him. He seemed to be weighing everything Hui had said, and for what seemed like an age his decision appeared to hang in the balance. Then he pulled back his sword and sheathed it.

'Try to escape again and there will be no mercy,' the commander said. 'I will take your head myself, and I will hang it from my chariot.'

Hui heaved himself to his feet.

'I will not try to flee again.' The words felt like hammer blows to his heart. Fareed had been right. There was no escape from the Hyksos. But what then for Ipwet? What then for Isetnofret, and the threat she posed to all Egypt?

Khyan grabbed the back of Hui's neck with his huge hand and pulled him in close. His eyes burned.

'You will have to prove yourself all over again,' he growled so that only Hui could hear.

And prove himself Hui did, with hard work and obedience. Over the days, his view of the Hyksos was changing, too, for any group of people who could shower such love on those magnificent horses could not be all bad. Most of them showed a true admiration for

their steeds; they did not see them simply as beasts of burden, or weapons, like the bows and scimitars. They knew each one's personality, which was as mercurial as that of any man.

The Hyksos were once a wandering agricultural people before the conquest-fever overcame them, or so the ancient stories said. This barbarian tribe had lived in mountains in the distant north.

Much about them, Hui found strange as he listened to the conversations of these warriors. They had created this astonishing chariot, with its wheels, and the bow, and yet they could not read or write. They lived under the tyranny of a single king, who went by the name of Salitis, and it was his whims that controlled their lives.

While he tended to Moon, Hui spied on the warriors. They nursed their swords like mothers with babes, stroking whetstones along the blades to keep the edge as sharp as razors. Every day they would practise, whirling those crescents in breathtaking patterns. Hui noted their dance, the sweep of the blade, and after a while he felt sure he could repeat what he saw if he ever got his hands on one of the scimitars. The bows, too, seemed easy to use. The curved design made them far easier to draw than the bows his people used, and they flexed with such power they propelled a shaft three times the distance of any Egyptian bow. With one of those, he would be able to punch a shaft through his mother's heart while she stood on the roof of his father's home and he was standing at the city wall. But that would do no good, he decided. He wanted to see Isetnofret's eyes as she died, so she recognized what terrible crimes she had committed and it was Hui who was punishing her for them.

Weeks passed – perhaps seven. He lost count. They roamed back and forth across the eastern desert, searching for plunder.

Sometimes the Hyksos would raid caravans for more supplies and slaves, or attack the settlements clustering hard to the oasis. They were as bloodthirsty in the midst of battle as he'd heard. Though they were barbarians, they were not savages, however. They killed with the cold efficiency of seasoned warriors – calm, relentless, focused on victory over their foes. From the stories, Hui had expected them to feast on the hearts of their victims and to rip the corpses limb from limb. But they showed respect for the fallen. And away from battle, as they lounged around the campfire and supped their beer, their laughter rang out, and their song, and they seemed to live life as fully as any of the men Hui had known in Lahun.

Hui eagerly learned from everything he witnessed. Everything now would be directed to the only thing that mattered in his life: killing Isetnofret. As he looked out across the camp they had set up that night, he clenched his fists with such passion that his nails bit into his flesh.

The next day he strode up to Khyan and said, 'Teach me how to use your sword and your bow. I want to fight beside you.'

Khyan threw back his head and laughed.

Hui felt his cheeks burn, but he persevered.

'It is my birthright.'

This time Khyan looked at him askance, his eyes narrowing.

'Your birthright, eh? Perhaps it is. Very well. Let us see what you are made of.'

He bellowed to his generals and waved his arm until they gathered around.

'The little rat wants to be a warrior,' he said.

The generals guffawed.

Khyan ordered Uthan to hand over his sword to Hui.

'Fight me, then,' the commander said, drawing his own blade.

Hui weighed the crescent sword in his hand. It was heavier than he had expected, but he liked the feel of it. He swung it up and felt the muscles in his arm complain.

Khyan levelled his sword, holding it loosely.

'Come at me.'

Hui swept the sword as he had seen the warriors do, but it turned awkwardly in his hand and his weak arm could not keep it up. Khyan lazily clattered his sword against it and Hui's weapon flew away. Stepping in, Khyan swung his right foot and knocked Hui's legs from under him.

The generals laughed louder and Hui felt his cheeks redden even more.

'Bow,' Khyan said.

One of the generals handed a bow and arrow to Hui.

Khyan pointed to a sickly tree protruding from the side of the bank.

'Hit that,' he said.

This will be easier, Hui thought.

The bow was remarkably light. He nocked the shaft, drew the string and let the arrow fly. It buried itself in the earth a spear's length from where Hui stood.

This time the laughter was deafening.

Khyan reclaimed the bow and tossed it to its owner.

'You have asses' milk in your veins, not Hyksos blood,' he said.

Hui watched the warriors walk away, still chuckling. He felt defiance harden in his chest. This would not be the end of it.

 One dawn, Hui glimpsed Khyan walking away from the camp, beyond the row of swaying date palms that lined the cool oasis. He was carrying a bundle to his chest. Hui decided to follow.

In the glow of the rising sun, the captain knelt in the dust and unfurled his package. It looked to be a small statue, as black as ebony, though it had the glint of glass about it. Hui squinted, but could make out no further detail. Khyan broke off a chunk of flatbread and crumbled it in front of the idol, before bowing his head to the sand and muttering.

Praying, Hui thought.

After a while of droning words in the Hyksos tongue, the captain pushed himself up, folded the linen around the statue and turned towards the camp. He saw Hui watching him.

'My apologies,' Hui said, holding out one hand. 'I did not wish to disturb your devotions.'

'You are curious. That is understandable.'

'You pray to the gods?'

'Every man has gods. This is the way of the world.'

Khyan unfurled his bundle and the black, glassy statue emerged. Hui gaped as he saw the curved beast-head and the long ears.

'You worship Seth.'

'We call him Sutekh, the god of storms.'

As Khyan went on to describe the dread attributes of this god, Hui was left in no doubt that it was indeed Seth.

'One and the same,' Hui murmured.

'A wise man told me the gods are known everywhere, but in different places they are given different names, in the tongues of their worshippers. The gods are eternal and unchanging. It is only men who alter, like the seasons, like the tides.'

'And your god plays a part in your lives?'

'The gods shape us and direct us and punish us. They take away and they send us gifts.' Khyan paused and looked to the horizon. 'Everywhere there is talk of a stone which fell to earth,

and which is filled with the power of the gods themselves. Any man who owns it can become like a king. That would be a great prize, eh? One that deserves to be in the hands of the Hyksos. I would wager my brothers would do anything to lay claim to that god-given stone.'

Hui stared at the idol, but all he could see was Isetnofret, naked, smeared with crocodile blood, asking Seth to enter her. He felt his camaraderie with these barbarians begin to diminish.

Isetnofret and the Hyksos were alike in many ways. Though Hui was a captive, these people had still taken him in and shown him kindness. Yet he should have no qualms about deceiving them when the time came for him to break for freedom.

One night, as Hui slumbered under Moon, breathing in the comforting musk of his horse, he dreamed of his father. Khawy sat on the rooftop of their house, looking over Lahun, weaving magical tales of the past, and praising Hui for being a good boy, a brave boy, who had a heart filled with kindness. When he woke, his cheeks were wet once more.

He stumbled amongst the horses and the snorting grooms to where Fareed crouched, looking towards the eastern horizon. Every morning he greeted the rising of the sun, and every night he bowed his head to the west as it set. It was the *habiru* way.

Fareed's eyes flickered towards him.

'You thought it a good idea to disturb my time of peace?'

'You spend too much time alone. You are turning as sour as five-day-old milk.'

Fareed grunted and looked back towards the horizon. It was still dark, but he seemed to sense the light was near.

Over the weeks, Hui had grown to like him, despite his cold ways. He had a reassuring wisdom, not just about the desert and the wind and the birds and beasts, but about the hearts of men. His lined face was a map of the life that had taught him so well.

'Speak,' he said, as if he could read Hui's mind.

'I think a great deal about my sister, Ipwet,' Hui began, 'and about the life she is living in Lahun.'

Fareed had pieced together enough fragments to know Hui had fled his home under a cloud, but he'd never asked any questions.

'You worry about her?'

'She has no one to care for her,' he said, as all his long-held fears rushed out. 'No husband. No father to find her a husband. Her mother . . . Her brother . . . They will never look after her. She is not like them.'

My mother would kill her in an instant if the mood took her, he thought.

Fareed nodded. 'You feel you have abandoned her to this fate?'

'Yes! I thought only of myself. And she was ever selfless in helping me . . .' His words trailed away.

'Would she have come with you if you had asked her?'

'No.'

'Could you have stayed to care for her?'

'No.'

'Then why are you beating yourself around the head? Do you like to punish yourself? Do you enjoy misery?'

'I want her to be well. Safe.'

'Then you are a good brother. And one day you will find a way to make sure she is cared for, yes?'

'Soon, Fareed. I must get back to her soon.'

'Did you not learn your lesson?'

'I must find a way.' Hui paused. 'Will you come with me?'

'I am not a fool.'

'If I find a way that is safe, will you come?'

Fareed didn't reply.

'I am growing better with the sword and the bow by the day. I train hard. I learn my lessons well. I will be able to protect us on any road I travel. And there will be rewards aplenty when we get to Lahun. Riches will have flowed to the city during my time away.'

Hui told Fareed of the Ka Stone, and how he had found it and brought it to Lahun. With any luck Lord Bakari would have taken it far away from Isetnofret's grasp by now, but it still should have enriched his home as his father had imagined.

When he finished his tale, Fareed snorted.

'The power of the gods,' he sneered. 'I have heard tell of these rocks that fall from the heavens. They have power, yes, but it is this – when they are heated in hot coals, a silver metal flows from them which can be shaped into unbreakable weapons.'

Hui shook his head. 'Not this stone, my friend. Everyone who saw it has felt the gods touch them.'

Fareed snorted again.

'But that is neither here nor there,' Hui continued. 'I am promising you riches beyond your wildest dreams. Will you join me?'

Fareed eyed him for a long moment and then walked away without giving an answer.

Twenty-nine days later, Khyan gathered his men. They squatted in a circle as he prowled around them, his voice rumbling. Hui couldn't understand what the captain was saying, but Fareed had taken some time to learn the Hyksos tongue.

'The man who rode into camp at dawn had orders from the Hyksos king,' the desert wanderer translated. 'The plans that have been long-flowering are coming to fruition.'

'What plans?'

'We are to attack a turquoise mine to capture supplies before the next orders to invade Egypt. The Hyksos have been pushing deeper into Egypt. They have kept their grand scheme a secret for a long time, but soon they will be ready to make their move.' Fareed cocked his head, listening.

'Surely they wouldn't risk an invasion of Egypt. However good their bows and chariots are, they do not have the numbers . . . do they?' Hui said hesitantly.

'There are war bands like this across the Sinai and deep into Egypt. When they come together, are there enough to defeat the army that waits for them?' He shrugged. 'Egypt is divided. The rival pharaohs stare down their swords at each other in the Upper and Lower Kingdoms. And divided powers are weak.'

'But even if the Hyksos won every battle, how could they keep control of so proud a people as the Egyptians?' Hui asked.

'In my experience, people want a quiet life. They will do anything to get it, as long as there is food in their belly.' He jabbed his staff towards the east. 'They have shown us time and again how they rule, with only small numbers. When the Hyksos conquer a city, they raise up those from amongst the vanquished who will do their bidding. Seeing their own in positions of power, the citizens go about their business as before. But the Hyksos are the true rulers, deciding what laws should be, what taxes or tributes should be paid.'

'That could never happen in Egypt. Egyptians are too proud.'

Fareed didn't reply. Hui watched Khyan pounding his fist into the palm of his hand, and remembered his brother talking

about making common cause with the Hyksos in Lahun. To prevent bloodshed, Qen had said.

Now Hui dreaded what waited for him in his home.

'You see it?' Khyan barked.

The captain stood in his chariot and pointed through the heat haze. He was speaking to Fareed, who had led the way along one of the *habiru* tracks to the turquoise mine in the west of the Sinai, but Hui heard and squinted ahead. A column of smoke was twisting up from the featureless plain in the distance. The Hyksos' eyes were better than his, used as they were to traversing this land where distant-sight made the difference between life and death. But even he could now smell the acrid hints on the breeze.

'That is where the mine lies,' Fareed replied.

The captain tapped a long finger on the board of his chariot as he weighed his choice. Finally, he raised one hand and snapped it forward. The war band trundled on. He'd expected Khyan to order an attack, but his suspicions had made him cautious. As the chariots and riders moved on, Hui jogged alongside them, sweating in the heat.

When the outlines of mine buildings were clear in the brassy light, the captain brought the war band to a halt. He watched the line of black smoke rising, and he listened. Someone at the mine must surely have seen the cloud of dust rolling across the flat land. But there were no cries of alarm, no shouts of panic.

Khyan reached a decision. Holding his hand aloft, he waited for a moment and then tilted his head back and bellowed a furious command. As one, the war band heaved forward. The air boomed with the battle cry of the warriors, and the ground throbbed. Hui choked from the billowing dust and lost sight of

the attacking band, but he felt his heart thunder in response. He imagined the terror that must strike in the hearts of those witnessing a Hyksos attack. The speed of those chariots hurtling towards them, faster than the wind. The pounding of the mighty horses. Those blood-curdling war cries. Scimitars whirling like bands of light above every man's head.

Into the thick cloud he raced, with the other grooms running beside him, pulling his scarf across his mouth against the ochre dust. Soon, the battle cries died away and the ground grew still. He was sure something disastrous had happened to the barbarians.

The wind whisked the dust away, and then Hui was staring at the war band, which had ground to a halt on the edge of the mine. Their swords had fallen to their sides, as those seasoned warriors observed something which Hui could not see. He pushed his way to the front of the crowd.

On the edge of the rubble-strewn mine compound stood a mound of heads.

On the ground, the blood had baked dry in the sun. The eyes had been pecked away and strips of flesh dangled from the skulls where the desert birds had torn at their meal. But the bones were far from picked clean. The atrocity had only happened perhaps a day before.

'Shrikes!' Fareed's voice rang out through the still air.

Hui looked from the grisly display to Khyan's darkening face. Everyone knew that if the bandits had raided the mine, there would be slim pickings for the barbarians.

The captain pointed from left to right, and the warriors fanned out across the compound, swords drawn in case any resistance remained. Hui's thoughts returned to that night in the Shrike camp in the hills when he had stolen the Ka Stone, and he felt

acid burn his throat. He couldn't imagine which would have been a worse fate – attacked by the barbarians or the bandits.

Several low mud-brick buildings simmered in the heat. All around, vast holes in the rough ground gaped, as if giant worms had burrowed out of the desert depths. Wooden cranes creaked over the voids, used for lowering the miners into the dusty depths and raising buckets of the precious turquoise to the surface. Hui eased to the edge of one excavation and peered in. It was a bell-pit. The labourers had dug down with their shovels and picks, and then out as far as they dared go, propping up the overhang with columns of mud bricks.

As Hui's eyes grew accustomed to the gloom at the foot of the shaft, he could make out ghostly shapes: the headless corpses of the miners who had been tossed into the dark where they had lived their lives and now walked in death.

A hand dropped on his shoulder and he cried out, almost losing his balance. Fareed tugged him back.

'Pray that we do not linger here too long,' the desert wanderer breathed. 'Once word gets out that the turquoise trade has been disrupted, the army will be here soon enough.'

Hui stepped back from the open grave. The dry air was filled with the drone of fat flies. He watched the barbarians stalk around the compound, investigating the offices and the stores. Khyan's face was like thunder as he observed their failure. What now for the Hyksos' rapidly depleting supplies?

From the drag marks in the dust, the Shrikes seemed to have hauled off as much of the precious turquoise as they could carry, along with the miners' food provisions. The translucent stone was adored by the members of the pharaoh's court, Hui knew, as much for its magical ability to ward off evil spirits and bad luck as for its great beauty. Every necklace that adorned

the nobles' necks was a silent prayer to Hathor, the Mistress of Turquoise. She was also supposed to watch over the miners who laboured here, little good though it had done them. But the Shrikes would be able to barter their fabulous bounty for riches beyond measure, and enough bread and beer to keep their bellies full from one flooding of the Nile to the next.

Hui looked to where Khyan was standing. Something had caught his eye – a movement deep in the shadows beneath the timber.

A muscular man was crawling out of a hiding place, his naked body covered in white dust. As he emerged, he cowered like a cornered animal, wild eyes filled with madness born of the terrible things he had witnessed. He grasped a copper knife and when he saw Khyan, his lips pulled back from his teeth in a feral snarl.

Hui was crying out even as his feet flew across the hard ground. As the captain jerked round at the noise, the crazed miner lunged. With a desperate leap, Hui slammed into the attacker just as the glittering blade slashed towards Khyan's back.

Limbs tangling, the two men crashed down in a cloud of dust. The miner thrashed beneath Hui as if he were having a fit, but then Hui felt hands lift him off. Scimitars pointed towards the downed man's chest, but the madness consumed him and he seemed determined to continue fighting despite the risk to his life. Khyan grunted, and three of his men dragged the miner to the edge of a pit and tossed him in before Hui could protest. A scream spiralled through the air and ended in a crunch of bones, and then silence.

Khyan barked an order and his warriors returned to the chariots and the horses. The captain placed a hand on Hui's shoulder.

'You showed courage, and foresight,' Khyan said, 'and it seems I now owe you my life. I pay my debts, Little Rat. There will be a reward for you tonight.'

The war band made their way across the wastes and into the foothills, where camp was made beside a green pond in a narrow valley with a clear view of the approach. Once Khyan had dispatched the sentries and the warriors were busying themselves erecting their tents and building the campfire, he beckoned to Hui. They circled the camp to where the horses grazed and the rows of chariots gleamed in the low sun.

Hui saw one stallion was still yoked, though the leather armour had been stripped from its flanks by the waiting groom. Khyan climbed into the wheeled vehicle and beckoned to Hui. Once he'd jumped onto the chariot, he gripped the board at the front as if he might suddenly fly high in the sky.

'There is no better time to ride than when the sun is setting,' the captain said. 'The air is cool and the wind on your face is soothing. Are you ready?'

Hui nodded.

Khyan grasped two long leather thongs attached to the horse's neck and head and tugged.

'These are the reins,' he said. 'By exerting pressure, it is possible to guide the horse this way and that, or to speed up or slow down.'

With a flick of his wrist, the captain signalled to the stallion and the horse heaved forward, the chariot moving as smoothly as if it were on the waters of the Nile. Hui cried out, gripping the board so tight his knuckles whitened.

'Enjoy this moment, Little Rat. You will never know its like again – your first ride in a chariot.'

Down the steep track from the camp, they trundled, along one of the many constantly used routes criss-crossing the high land, worn flat by feet and hooves and carts, and perfect for the Hyksos chaiots. They wound around jagged outcroppings and wind-blasted trees until they straightened on to the flat plain. Khyan released a whooping, high-pitched cry that ended with several clicks of his tongue. He snapped the reins hard and the stallion thundered forward at such speed that Hui was almost thrown off the back.

Holding on for dear life, Hui screwed his eyes shut tight. He might well have been howling like a babe torn from its mother's breast, but the pounding of the hooves and the whine of the wind in his ears swallowed all other sound.

At first he felt cold terror. Surely no man should ever move this fast? But then he felt the tingle of exhilaration and he dared open his eyes again. Khyan was grinning, lost to the euphoria of his ride, his right hand cracking a leather whip to urge the stallion to go faster still.

They surged across the plain and, with a twist of the reins, Khyan guided the horse in a wide arc to head back the way they had come. Hui felt disappointment that this magical journey was soon to be over, but Khyan had been right – he would never forget it.

Once they'd trotted back into camp and the captain had handed over the stallion to the groom, Hui said, 'You have my thanks.'

Khyan grinned. 'There is no better feeling, is that not right? You will dream of flying tonight.'

Hui nodded, but for all the joy of the experience, he knew he had also learned another lesson in the ways of being a warrior.

In the days that followed, the captain allowed Hui to ride the chariot time and again, teaching his raw recruit the skills he had acquired over years as a charioteer.

'You learn well,' Khyan said. 'Perhaps you have Hyksos blood in you after all. I have seen you practising with a sword and bow. We may make a warrior of you yet.'

'Teach me to ride, then,' Hui said. 'With these skills, I will be of value to you in days yet to come.'

Khyan tweaked his beard in thought. Giving no response, he walked away. But later a sour-faced Uthan led Moon over.

'If you break your neck, it is your own fault,' he grunted.

Hui felt his hands trembling as the gruff warrior heaved him onto Moon's back. Sweat prickled his skin and his heart pounded. It was unnatural to be on such a beast. He felt the power beneath him, throbbing in the muscles as he held on for dear life.

But Moon seemed pleased to have him there. The horse tossed its mane and all but danced on the spot.

Uthan muttered some simple directions and then slapped Moon's flank. The horse cantered away. Hui felt as if he was flying; a moment later he was – off the steed's back. He crashed onto the hard ground, winding himself.

At least Uthan didn't laugh. Hui suspected Khyan had given strict instructions.

'Again!' Uthan barked.

Four more times Hui dragged himself onto Moon's back. Four times he dashed himself upon the ground. But he felt his confidence growing with each failure. Determination burned inside him. Everything he could learn here amongst the Hyksos would help him when he finally returned to Lahun.

After the fifth time, Khyan strode over.

'Every bruise is a lesson,' he said. 'Praise them. Soon you will have the knowledge you desire.'

One morning, after Hui had finally managed to remain on Moon's back, the captain pointed towards the chariot.

Hui narrowed his eyes. 'Alone?'

'You have earned it. Let us see if this little rat has what it takes to be a Hyksos charioteer.'

Hui clambered onto the back of the chariot. He gave the reins a flick and the horse tossed its mane in response. Within moments, the chariot was gliding out of the camp. Sweat slicked Hui's brow as he gripped the leather thongs, but soon he relaxed into the ride. His turns were awkward, the horse did not always respond as he wanted, but he felt a rush of exhilaration.

When he brought the chariot back, he climbed from the platform and accepted the captain's nod.

'Should a chariot ever come free,' Khyan said, 'you will fight alongside us, eh?'

Ten warm nights drifted by, and Hui could almost imagine the hardships he'd endured in Lahun were little more than a dream and he'd been reborn into a new life. He was growing stronger, harder, more skilled in the ways that would help him take vengeance on his father's murderer.

On the eleventh night, he was stirred from sleep by the sound of hooves along the rocky track into the camp. Moon, his constant companion, was framed against the starry sky, and the air smelled of woodsmoke from the dying fire.

He glimpsed shadows stirring from tents and lumbering towards the fire's red embers. The barbarians were gathering.

At this hour, the sight was rare enough that Hui's curiosity was piqued. He crept towards the campfire. Khyan stood in the circle of warriors with a tall, hawk-faced man Hui didn't recognize, no doubt the one who had just arrived in the camp. Despite the hour, the fighting men were alert – eyes bright, faces turned towards the captain as they waited to hear what he had to say.

Hui noticed another figure crouching nearby, balancing against a tall staff. It was Fareed. As always, the desert wanderer missed nothing, saw everything.

Hui crawled towards him and whispered, 'What is happening?'

Fareed silenced him with the raised flat of his hand. His companion's face was usually as hard and unfeeling as the desert landscape, but Hui thought it had become even more grave.

Fareed looked to him and murmured, 'New orders for this war band. No more talk of invasion for the time being. Khyan has been a wasp stinging the Egyptian flank for too long. They have been noticed. It seems the pharaoh is now blaming this band of warriors for the slaughter at the turquoise mine.'

'The Hyksos do not take heads.'

Fareed glanced at him with sly eyes. 'That matters little to the low men who advise the king. In truth, it is easier to pour blame on foreign barbarians than Egyptian bandits who come and go like ghosts and have escaped justice for so long.'

'They need an easy victory.'

'As if any battle with the Hyksos would be easy.' Fareed looked towards the silhouettes around the glowing fire, his features drawing tighter still. 'A regiment of Egyptian soldiers is sweeping towards us as we speak. Khyan has no choice but to fight them. Every man will need to be drafted in to fight. Me . . . you . . .'

'The Hyksos are fierce. They might win,' Hui pressed.

'Aye. They might.' Fareed stared at him, his silent communication presenting a clear choice. 'Or, at dawn, our blood could be draining into the dust of the Sinai.'

Hui weighed those words. He imagined the barbarians riding into battle, Hui and Fareed at their heart. He could see those fierce Egyptian soldiers waiting, with their bronze swords and shields gleaming in the sun. There would be nowhere to hide, nowhere to run. In a furious battle, they would likely be cut down in the first wave of battle.

'We creep away from here before dawn,' Hui said. 'I have spent too much time with these barbarians. I have a mission to complete in Egypt.'

'They have come to treat you as one of their own. Khyan, especially. He has placed his trust in you like a father with a son.' Fareed stared deep into Hui's eyes, though what he was searching for, Hui had no idea. 'Do you have it in you to betray that trust, and the generosity that you have been shown?'

Hui showed a cold face. 'I am no weak child. You know as well as I the Hyksos would gut us in an instant if we no longer served their purpose.'

'Perhaps.'

'You have grown soft in the time you have spent with them,' Hui chided.

Fareed continued to stare.

'The Hyksos mean nothing to me,' said Hui. 'Khyan means nothing to me. I would slit his throat in the blink of an eye if that was required.'

'That would not be the wisest choice of action. Not with a camp of barbarians ready to fall on you with their swords in revenge.' The desert wanderer's voice had a sardonic edge.

Hui felt his thoughts harden. His days here were finished. He would betray Khyan and the Hyksos without a second thought, though he had learned to respect them and even see them as friends during their weeks together. He'd leave them to their deaths on the morrow, and never think of them again. He had to be that man. Hui of Lahun must die. Hui the *habiru* must rise – a man who needed no one and nothing but what lay in his cold heart.

'We leave or we die,' he said in a firm voice. 'It is time.'

Fareed looked across the camp. 'Very well. But there are sentries everywhere. If we are caught, the way you were the first time you attempted this madness, the Hyksos will make sure we are a feast for the vultures by first light.'

Hui wrinkled his nose as he smeared the horse dung over his skin. Nearby the beasts rested, their grooms beneath them.

Fareed daubed a handful of the ripe-smelling dung on his skin. He eyed Hui as if he might murder him.

'This is for your own good,' Hui hissed. 'It will mask the smell of our sweat. If those sentries catch any of it on the breeze, they will think it is the beasts, nothing more.'

When they were done, Hui crawled on his belly away from the camp. The desert wanderer made no sound, but Hui could sense Fareed behind him.

Soon the Hyksos voices faded to little more than a whisper almost drowned by the wind. Hui knew where the sentries had been posted, and he had tried to plot a course amongst them.

But as he crawled on, he heard the crunch of footsteps approaching. He stiffened, his heart thumping in his chest.

A figure drew near, silhouetted against the stars. One of the sentries. Stopping three spears' lengths from where Hui and Fareed were cloaked by the dark, he pushed his head back and sniffed.

Hui's breath burned in his throat.

The sentry's hand dropped to the hilt of his sword.

Hui tensed. There would be no opportunity to flee back to the camp. The sentry would whistle his alarm and they would be caught before they reached the tents. No, his only option was to fight, to test those sword-skills he had learned against a seasoned warrior and attempt to cut him down before he could cry out.

But as Hui coiled his muscles ready to leap forward, the sentry sniffed the air once more and then strode on. The ploy had worked; the guard smelled only horses.

For a moment, Hui lay there, calming himself; then he crawled out into the night as fast as he could.

The two men trudged across the baking red sands towards the west. The wind whined, the dust swirled, and loneliness hung heavy over them. They were the only living things moving on that vast plain. At the front, Fareed bowed his head, following signs that only he could see. Every few steps, Hui glanced back into the wavering grey distance.

'Why waste your time looking?' the desert wanderer grunted. 'If Khyan decides to come for us, he will see us from a day's march away. There is nowhere to hide.'

It was true. But Hui could feel the burning anger of the Hyksos captain that he knew must have been simmering from the moment the barbarians discovered the two men had fled the camp in the night. If Khyan decided to pursue them, the punishment would be swift and brutal.

'Are we near?' Hui asked.

Fareed looked across the empty plain to the hazy distance.

'Do you see our destination?'

'No.'

'Then do not waste your breath asking the questions of a fool.'

The desert wanderer bowed his head once more and searched out the ghost of a trail in the dust. He was proving himself as a great tracker with every step. Left to himself, Hui would have been lost in the wilderness by now, food for the vultures that swept by above.

Hui shifted the weight of the stolen Hyksos bow hanging across his back, their one chance to buy their safety, he hoped.

'We could not stay behind, you know that.'

Fareed grunted.

'In all likelihood, we would have been dead in the first moments of battle,' Hui pressed.

The desert wanderer remained silent, and then he said, 'And you still think this plan of yours is any less dangerous?'

'I have no doubt,' Hui said. 'We will buy our way in and then we will be protected.'

Fareed grunted again and drifted into silence.

The desert wanderer had placed his faith in Hui, the gods knew why. But he had to hope that despite the risks, all would turn out well.

The camp of the Shrikes nestled in a rocky hollow in the foothills, protected from the unforgiving wind. When Fareed pushed himself upright to stare at the jumble of tents, Hui felt a rush of fear. He had to believe this was the right choice. He saw no other alternative.

Fareed eyed him to see if he had changed his mind.

'We walk up to them, as bold as merchants with a wagon of Assyrian silk to sell,' Hui said. His gaze drifted across that camp, and for a moment he was back in the hills near Lahun, feeling his terror as he crept through the heart of those cut-throats towards the booty tent. 'They will think we are likely fools—'

'Aye, fools,' Fareed interjected.

'. . . but better that. It will put them at ease. If they thought us enemies, we would be dead once we set one foot across the boundary.'

Fareed narrowed his eyes.

'I have ventured amongst the Shrikes before,' Hui said, hopefully reassuringly.

'And how did that unfold?'

'Oh,' said Hui. 'Well . . .'

'I have yet to decide if you are wise and cunning, or a fool who thinks he is wise and cunning.' Fareed strode on.

Hui walked behind him. Of course, he must be mad. As mad as Kyky accused him of being when he had led his friend to his death on that fateful night. Who in their right mind would ever brave the camp of the Shrikes?

As they trudged towards the tents, a whistle rang out. One of the sentries had seen them.

'No turning back now,' Fareed muttered.

Voices echoed from the camp – commands, responses. From amongst the tents, a knot of about fifteen bandits rushed out. Knives glinted in their hands.

Fareed continued walking, as calm as a moonlit oasis. Hui choked down the desire to turn on his heel and run away into the desert.

'Do nothing to anger them,' Fareed whispered.

'That is the farthest thing from my mind.'

'You have a natural ability to bring men to anger. You do not have to try.'

The rogues swept forward, emitting their blood-chilling howls. They were a hunting pack, ready to tear their prey limb from limb. Hui stared into faces twisted with murderous fury. The Hyksos warriors were strong, lithe, every aspect of them shaped for battle and killing. In comparison, these bandits were a ragtag group: teeth missing, eyes missing, fingers missing, filthy faces carved by scars, wearing robes that were little more than rags stained with blood and mud. Yet they were no less terrifying.

Hui stood his ground as the band swept around him and Fareed, his ears ringing at their baying.

Hui held his hands wide and began to announce, 'We have—'

A cudgel cracked across his head and his thoughts spun away.

Sensations ebbed and flowed like the tide. The ground rushed by beneath him in an ochre blur, and Hui realized he was being carried face down. Furious voices boomed and faded. He smelled sweat and excrement and urine and the earthy reek of unwashed cloth.

The world was chaos until he sensed he was passing amongst the tents, and his thoughts began to sharpen once more. He twisted his head to see if Fareed was safe, but a fist crashed against the base of his skull and he let himself go limp.

Finally Hui breathed in cold woodsmoke, and he crashed to the ground beside the mounds of grey ashes of a dead fire. Throughout it all, he had managed to keep hold of his bow. The jabbering rumbled, the tone turning from fury to mockery. He craned his neck to look at dancing faces and knives waving overhead. A foot crashed into his ribs and he pressed his face down into the hard ground. He heard the sound of hawking, and phlegm rained down on him.

After a moment, the noise drained away. In the silence that followed Hui could hear the crunch of approaching feet.

'Why have you chosen to die?' The voice was tinged with disdain.

Hui looked up, wincing in anticipation of further blows. But the crowd of bandits that circled him were all rigid with deference, heads turned towards the new arrival.

The sun hung behind the chieftain's head, and Hui squinted into the glare. The lord of the Shrikes shifted to block the light so his captive could see who was about to end his life.

Hui stiffened with terror, and he flashed back to the moment he'd watched the knife slitting the throat of his friend Kyky.

He was looking into the face of Basti the Cruel. That same beaked nose, those black eyes and sun-blackened skin. That hint of *habiru* blood. Tall and lean, in a pristine white robe that shone beside the dirty tatters of his men, Basti eyed him, his mouth tight in the thick black bristles of his beard.

Hui waited for the light of recognition to shine in the Shrike lord's face. The barked order, and the falling blade that would hack through his neck.

For the briefest instant, there was a narrowing of the eyes, a knit of the brow. A flicker of recognition, perhaps? But then the chieftain's features relaxed as the elusive memory slipped away.

But what of the days to come? Would this powerful chieftain at some point remember some lowly mill-rat who had stolen the Ka Stone, their most prized possession?

Steeling himself, Hui pushed himself to his feet. He sensed the crowd of cut-throats swell around him. Those dark eyes locked on his, and he felt his fear harden into unfamiliar cold anger. He remembered the unfeeling expression on Basti's face as he drained the life from Kyky, tossing his friend's body aside as if it were the leftovers from a hasty meal. He wanted revenge for that brutal act, and he realized many more equally murderous thoughts he never knew existed were beginning to awaken within him.

These were the passions that coursed through him, and he had skills to complement his rage. Patience. Cunning. Determination.

'I am an outlaw,' Hui said. 'One of the most feared in all Egypt . . .'

'An outlaw, you say.' Basti smiled, indulging him.

'In Lahun, in the west, I killed a man who wronged me. I slit his throat, and I did the same to his friend who came after me

seeking vengeance. The authorities hunted me, along the Nile, in the cities of the Lower Kingdom, and here into the Sinai, and I have always escaped them, for my wits are greater than theirs.' Hui tapped his forehead.

'And why would you throw your life away by walking into my camp?'

'I have come to join you.'

Basti laughed.

'*We* are the most feared men in all Egypt,' the chieftain said. 'You think you have what it takes to be a Shrike?' He looked Hui up and down. 'I think not.'

'My blood is cold. I will not turn away from killing any man, woman or child to bring riches into your coffers. I offer my wits in your service – and more. I bring you a gift to prove that I am the man I say I am.'

Hui pulled the bow from his back and held it out. Basti's eyes widened when he saw the distinctive curve.

'Is that . . .?'

'The bow of the Hyksos. This is the source of their power. It looses an arrow three times farther than the bows of Egypt.'

'How did this come into your possession?'

'I crept into the barbarians' camp at night and stole it. And killed three of their warriors during my escape.'

Basti's eyes glittered. Hui pushed the bow towards him.

'Take it. It is yours.'

'There is great value in this.'

'There is greater value in becoming one of your tribe. This is my offering to you, and the first of many riches I will bring into your possession.'

The chieftain took the bow and turned it over in his hands. When he looked up, his grin had become sly.

'Very well. There may be some worth in you after all.'

The first stage of Hui's plan was complete. But the rest would not be any easier.

Basti handed the bow to the man beside him.

'You will have to earn your place amongst us. But you will have your chance, and if you fail it will cost you your life.'

'I will not fail. I have no doubt about that.'

Basti seemed to like his confidence. He looked past Hui to where Fareed was standing.

'Kill him.'

Basti motioned, and a knife was pressed into Hui's hand.

The Shrike lord stared, a cruel smile flickering on his lips.

'If you are the cold-blooded killer you claim, you will have no qualms about this.'

The bandits thrust Fareed to his knees and yanked his head back so his throat was bared.

'Kill him,' Basti repeated.

Hui stared at Fareed. The desert wanderer showed only a cold face, empty of emotion, but there was a flicker of fear in his eyes.

Killing Fareed might be Hui's only chance to gain a foothold amongst the Shrikes – perhaps his only chance to save his own neck – but how could he? He moistened his lips, his thoughts racing, and then he said, 'I could slit his throat with ease, but if I did, you would lose something as valuable as that bow.'

'How can this desert wanderer have any worth?' Basti growled.

'Fareed is a scout—'

'We have many scouts.'

'Not like him. All your scouts are children compared to Fareed. He followed your tracks here, across the bleak Sinai, days after you passed. There is none better. That is why I have

made him my ally. Those on my trail? They will never find me with Fareed to guide me away from danger, and he can track through even the most inhospitable land.'

The Shrike leader let Hui's words settle. He looked to Fareed and they held each other's gaze. Hui sensed some silent communication, and when the Shrike lord next spoke, it was in some tongue he didn't recognize – the secret language of the *habiru*, he imagined. Fareed responded in the same dialect.

The chieftain nodded. 'Then we welcome two new faces into our tribe. Learn fast what it means to be a Shrike, if you both want to see the dawn.'

One of the Shrikes tossed Hui and Fareed a ragged tent, patched and half-open to the elements. They pitched it on the edge of the reeking camp, in the lee of a steep bank where tufts of thin, yellowing grass sprouted. The other men watched them with sullen-eyed suspicion as they sat in the openings of their tents, sharpening their small knives along whetstones. Hui imagined it would take a long time for any outsiders to be accepted into this close-knit, murderous tribe. That didn't concern him. He didn't need friends or allies. All he wanted was to become trusted enough so that he could gain Basti's ear.

As pools of shadows swelled amongst the tents, a high-pitched keening drew them to the now-relit fire. The bandits squatted in a circle around the blaze, watching with hungry eyes as the Masters of the Table moved amongst them, handing out flatbread and olives and cured meats, and filling their cups with beer or rich red wine, all of it looted. Hui saw that Basti was like the pharaoh, ensuring those who worked for him were well

fed and well treated. With his largesse, he bought their loyalty; they would not want for anything while in his care.

The cut-throats drank themselves into a stupor, as Hui would learn they did every night. As they sank deeper into their cups, one of the bandits, a broad-shouldered, shaven-headed man with pale eyes, brought forward a line of women and girls. They were naked, their bodies mottled with bruises and bite marks, their heads hanging like those of beaten dogs. Most of them were shapely and pretty, with large dark eyes and full lips. They must have been captured during the Shrikes' raids on settlements. Most would have been chosen from wealthy families for ransom, but Hui could see the bandits had decided to hold back some of the most beautiful for the enjoyment of the men.

The drunken bandits grabbed the women as if they were starving beggars thrown a few crumbs of bread. Soon they were rutting amongst the tents. One woman seemed more defiant than the others, her oval face bright in the firelight. Her eyes flickered towards Hui briefly, and he saw a strong wit deep within them. He sensed she was getting the measure of him in a flash. Instead of waiting to be chosen like the other women, she pushed past the bandits lurching towards her with grasping hands. Scanning the rogues, she identified the drunkest man there and grabbed his hand, dragging him away. The cut-throat could barely stand, and would likely be unable to perform. Hui admired the sharp intelligence he saw in her face. She had bought herself at least one night free of misery.

As the grunts and moans echoed through the camp, Hui and Fareed crept back to their tent.

'This is no place for a man like you,' Fareed murmured as they sat in the opening, looking at the trail of stars. 'For all your boasting, you are no murderous jackal. In the time we have been

together, I have seen into your heart. Too long in the company of these cut-throats will poison you.'

'I am an outlaw—'

'An innocent one, I would wager.'

'I do what I must.'

Hui felt the desert wanderer's eyes on him, urging him to reveal the plan that had been simmering away since he'd witnessed the carnage at the turquoise mine. Instead, he lay back and pretended to sleep. But his thoughts ran away from him along dark roads, and he feared that what Fareed had warned was already coming true.

Night lay heavy across the land. The fronds of the date palms rustled in the breeze and the rich fragrance of the fertile Nile valley drifted, the scents of steaming vegetation sumptuous after the lifeless wastes of the Sinai. Hui crouched in a ditch and his heart thumped so hard he thought it was about to burst from his chest. Black mud sucked at his feet and dirty water sluiced around his ankles. His calves tingled as rat tails flicked by them.

In the faint buttery light of the crescent moon, he could make out the brooding expressions of the Shrikes as they stooped in a line along the length of the irrigation channel. Knives were gripped. Some were armed with swords, others cudgels.

Ahead, beyond the patchwork of swaying barley fields, lamps glowed at the gate to the farm. The whitewashed house stood alone on the edge of this stretch of the cultivated belt.

'No one will hear the screams,' Basti had laughed when he'd gathered his men to prepare them for this raid.

Hui felt sick at what he knew lay ahead. He'd learned how to fight with a sword and a bow, but this was different. He didn't

want to be there, and Fareed's words about his soul being poisoned haunted him. The Hyksos were warriors, and while they raided settlements and caravans, they still had the honour of soldiers. The Shrikes were a murderous band who would slay anyone – man, woman or child – merely to fill their coffers.

How quickly things had changed. Sipping wine in his tent, Basti had interrogated every returning scout to learn what they had discovered.

On the eighth day, the Shrike lord had summoned his men to the fire to hear his command. Within the hour the camp had been broken, the tents packed away, the wagons loaded with looted riches and what remained of their supplies. And then it had been days and nights of a hard trek west, with Fareed and the other scouts guiding them away from the trade routes through land that seemed never to have felt a footfall, west, out of the Sinai and across the border back into Egypt.

Hui stared at the peaceful farmstead. He imagined the family inside: bright conversation after their evening meal, at peace; the weary slaves finishing up their day's duties and preparing for rest. Basti's scouts said a rich merchant and farmer lived there with his wife and daughter. In any other place, the daughter would have been kidnapped for ransom. But the farm was so isolated, Basti had decided to slaughter all who lived there and take what he wanted.

Hui felt eyes upon him and glanced at the bandit beside him, a hook-nosed man with broken teeth. Hui held up the copper knife he'd had with him since that fateful raid on the Shrike camp all those moons ago. The cut-throat nodded and returned his attention to the farmstead.

The world seemed to hang for a long moment. Finally a whistle at the end of the line pierced the night. As one, the

bandits raised themselves from the ditch. Hui pushed out of the loam alongside, all of them keeping low like ditch rats creeping along the bank.

As they neared the house, a mountain of a man thundered ahead. Stooping by the wall, he cupped his huge hands. Another bandit raced up. Everyone called him Monkey – a raisin-eyed, olive-skinned rogue barely bigger than a child. Launching himself, he planted one foot in the big man's hands and was propelled upwards to the top of the wall. He crouched there, silhouetted against the stars, and then he dropped to the other side.

The gate creaked open. The Shrikes surged forward, as silent as the grave. In the courtyard, the lone slave who had been guarding the gates lay face down in a swelling dark pool, silently dispatched by Monkey.

Hui realized he was the only one who took in that poor soul. The others ghosted by without a second glance, dividing into two teams. One headed for the slave quarters, the other towards the door of the house. Hui darted forward so he would be at the front of the attack on the family.

Furious howls erupted from the bandits. Hui shuddered at the sound, somehow both jubilant and bloodthirsty. The screams from the slave quarters ripped through the night, merging with the baying.

Hui ducked through the door ahead of the throng. Slaves rushed from the kitchen, wielding meat knives and cleavers and anything else that had come to hand. Hui looked past them and saw figures disappearing through a door to where the garden must lie.

The flood of bandits crashed against the defending slaves. Hui ducked around the edge of the fighting, his ears ringing

with the din of battle cries and screams and blades hacking into bone.

The garden was a pool of shadow. From the lingering aroma of smoke, Hui knew the lamps had just been extinguished.

Looking around, he spotted a glimmer of grey in the gloom – the hint of a white dress. One of the women was cowering behind a bay tree, the oily perfume of its leaves masking her own scent.

As Hui rushed forward, a figure separated from the dark and lumbered towards him. It was the merchant, a heavy man with shaking jowls and a belly that hung over the top of his kilt. Tears of terror were flooding down his cheeks. He swung a half-hearted punch at Hui, desperate to protect his wife and daughter, but he had enjoyed the fruits of his wealthy life for too long and he was in no shape for a fight.

Hui ducked his blow, and slammed his open hand into the man's chest. He slipped onto his back, and began to sob.

'Enough,' Hui urged, glancing over his shoulder. The thunder of battle still raged from the hall. 'I am here to help, if I can.' The murder of innocent people was not something he could countenance.

The merchant blinked away his tears, but his mouth gaped and his blank eyes showed he was struggling to comprehend. There was no time to explain.

'Heed me,' Hui said, gripping the man's shoulders. 'These bandits want only your riches and your food, but they will kill you the moment they lay eyes on you, nonetheless.' He glanced around and saw a sprawling sycamore fig tree, its gnarled branches reaching above the whitewashed wall. 'There is still a chance to escape, if you are fast.'

The merchant lurched to his feet. He didn't waste time asking why this strange raider was helping him. As the man beckoned his wife and daughter out of hiding, Hui ran to the foot of the

sycamore fig and cupped his hands as he had seen the mountain-ous bandit do.

'Here,' he said. 'Up in the tree, along the branch and over the wall.'

The merchant pushed his wife and daughter forward.

'Be quick,' Hui said. 'There is a chance.'

Once Hui had levered the two women up into the branches and they were crouching on the wall, he turned to the head of the family. The sounds of fighting in the house were dying down. They'd search the building for booty, but sooner or later they'd venture into the garden.

'Now you,' he said.

The merchant shook his head. 'I am too big.'

'You can still—'

'No,' he said in a firm voice. He looked to his wife and daughter. 'Hurry away, my loves. Seek shelter at Maged's farm. I will follow.'

The women dropped over the edge and the whisper of padding feet disappeared into the night. When the merchant turned to Hui, his eyes brimmed with tears again, this time of sadness.

'Take my life.'

'No.'

'Do it! I know the Shrikes' reputation. They will torture me to find where my wife and daughter have fled. And I . . .' He choked. 'I am not a strong man. Let me buy them time to escape. I love them with all my heart. I would do anything for them.' He gripped Hui's arm. 'Take my life!'

Hui swallowed. He'd never harmed a man in all his years, certainly had never killed anyone. And like this – in cold blood? But he saw the desperation burning in the depths of those eyes, and the love. It would be crueller to deny him.

'You have gold hidden away? Precious jewels?'

The merchant nodded. His eyes flickered towards his house. 'Tell me where. It will buy more time while the Shrikes search for it.'

'There is a flagstone in the corner of my office. Raise it and you will find a shallow well beneath it. Search there.' He stiffened, and Hui knew a bandit had appeared in the doorway. The merchant squeezed his arm tighter. 'I beg you . . .'

Hui lashed out with his knife. His speed was a mercy. The merchant clutched at his throat as blood bubbled out through his fingers. He sank to his knees, gurgling, but his eyes remained locked on Hui's as the flame slowly died within them. Hui thought he saw forgiveness. He prayed that it was so.

Feet pounded up behind him and a hand shook his shoulder. 'Excellent work. You sliced that fat leech well and good.'

Hui felt as if he was dying. A cold darkness pressed around his vision, and when he heard his own words, they sounded as if they were coming from another man whom he didn't recognize.

'Before he died, I prised out of him where he had hidden his gold. Come – we will sing songs of victory this night.'

'Raise your cups high! Here are two new brothers! Welcome them into our tribe, the Tribe of the Shrikes!'

Basti the Cruel's voice boomed across the drunken bandits. They roared their approval, slopping beer as they thrust their cups towards the night sky.

Hui's face bloomed from the heat of the roaring campfire. His eyes stung from the acrid smoke, his nose wrinkling at the greasy sourness of the fish stew bubbling in the cauldron. One day later, he still felt numb. He had never thought killing a man

could be so hard. But he'd done what he needed to do. There had been no other choice. And for all the misery it had caused him, Hui had learned another lesson that would serve him well in days to come. He would never shrink from killing someone again.

Fareed stood beside him, the honey light of the fire dancing in his black eyes. He showed no emotion.

Once the Shrikes had swarmed out of the looted farmstead, the flames licking up into the night from the fire that had been lit in the kitchen, word had travelled amongst the bandits of Hui's dispatch of the farmer, and the torture he must have inflicted to discover the location of the treasure. They had cheered his name.

And when they'd finally trekked back to this new camp tucked in a rocky crevass in the hills, Basti's face had glowed with pride when he'd heard of Hui's success. Pride not for Hui, but for himself: that he'd been such a wise leader, he'd seen Hui's attributes the moment he'd walked into the camp.

Hui stared at the Shrike lord's face, seeing the map of cruelty in every line, in the turn of the mouth, in the pitiless eyes. He imagined slashing the bandit chieftain's throat with his knife in revenge for Kyky's death, as he had killed the merchant. One slash – so simple. He'd never thought he would have found it in him to kill this raptor. Now he knew otherwise. He was capable of anything.

But Hui needed Basti – that was his calculation. One day, though . . . One day . . .

The Shrike lord raised his right hand and flexed his fingers to beckon the two new recruits forward.

Hui strode through a swirl of sparks to stand in front of Basti. Fareed followed a step behind. The chieftain raised his right hand, palm out, indicating that Hui and Fareed should do the

same. Once they'd followed his command, he lashed out with his curved knife twice. The blade sliced across their palms.

Hui felt the pain lance up his arm, but he held his trembling hand in place. He could not afford to show weakness. The blood dripped down his palm and splashed on the hard ground.

Basti held his gaze, a tight smile on his lips, watching to see how Hui responded. He nodded and held a cup under Hui's hand, and then Fareed's. Once the blood had drained into it, he swirled it around and tossed the gore into the flames, where it sizzled and spat.

'Blood brothers!' he roared, thrusting the cup high.

'Blood brothers!' the bandits bellowed back as one.

Turning to Hui and Fareed, he intoned in a sombre voice as if he were a priest at temple, 'You are one of us. For all time. You abide by our laws. You obey only me. And in return I vow that you will never go hungry, or thirsty. The riches of this world will shower upon your heads. You are bound to us by blood, an unbreakable bond. From this day forth, you are a Shrike, and you cannot turn your back upon that. You can never walk away from your tribe.'

'I am proud to be a blood brother,' Hui replied.

Basti signalled, and Monkey darted forward with two filthy rags, which he bound across the wounds on the two men's hands.

'Tonight we celebrate,' the Shrike lord said. 'You will eat and drink better than you have in your life. And later . . .' He grinned.

Hui slumped down onto a rock and someone thrust a bowl of the fish stew into one hand and a cup of beer into the other.

Fareed squatted beside him. 'This is our life now. Bound to the Shrikes forever.' He swilled some of the stew and wrinkled his nose at the taste. 'A life of murder and rape and pillage. This is your great plan?'

'This is the first part of my great plan. You must trust me—'

Fareed grunted. 'My trust is starting to wear thin.' For the first time he eyed Hui, his penetrating gaze seeming to cut deep. 'You are not the man you once were, and I fear for the man you are becoming.'

He tossed the stew aside and walked away.

Hui brooded over those words while the Shrikes feasted around him, their raucous voices raised in coarse song. One of the Masters of the Table filled his cup every time it was empty, but he only sipped on his beer. He needed a clear head for what he knew was to come.

Basti sauntered over.

'Your heart is not in the drinking,' he noted. 'Perhaps your passions lie elsewhere. And who could blame you. Then now is the time for you to indulge your every desire.'

The Shrike lord clapped his hands, and from the depths of the camp a line of naked women trooped out. The bandits cheered, but Hui thought he had never seen a sadder sight in his life. The hunched shoulders, the hanging heads, the ribs showing through skin.

Basti swept an arm towards the dismal queue.

'Tonight you are given the gift of the first choice. Whichever woman you crave, she is yours.'

Though his first instinct was to decline the offer, even though that might arouse suspicion amongst the lustful bandits, Hui realized he could at least save one of the women from a night of suffering. He looked along the line and his gaze settled on the woman he'd noticed earlier, the defiant one with the sharp intelligence. She already had her eyes locked on his, urging him to choose her.

'That one,' Hui said, pointing.

Basti grinned and some of the other bandits whooped.

'She flashes like a diamond, does she not?' the Shrike lord said. 'But beware, my friend, it will take all your powers to tame her. Watch out for those teeth, and those claws.'

The woman glared at the chieftain, the briefest flash, but her mask had slipped and in that instant Hui understood what Basti had said. She was a lioness pretending to be a house cat.

'I will take her,' Hui confirmed.

'Very well.'

The Shrike lord clapped his hands again, and the bandits fell on the other women like starving men at a feast. Hui turned away so he did not have to see. A moment later he sensed a presence at his elbow.

The woman smiled at him, her full lips warm and seductive. From what he'd seen, Hui knew this was an act, nothing more. She'd learned how to twist men around her finger to ensure her survival.

'My name is Ahura,' she said.

Hui told her his name and walked with her through the drifting smoke to his tent on the edge of the camp. Once inside, he said, 'Sleep. I need nothing from you.'

Ahura leaned forward and, with another seductive smile, traced her fingers along his cheek.

'But I want you.'

She seemed unashamed of her nakedness. Indeed, as she moved, she seemed to be presenting herself for scrutiny. Hui grabbed her wrist and pulled her hand away.

'I am not like the others.'

The woman punched his shoulders and thrust him onto his back. Swinging her leg over to sit astride him, she leaned forward until her breasts were brushing his chest and her face floated so close that he could have kissed her.

'I have heard the men talking about you,' she breathed. 'They said you kill without mercy. And that you alone uncovered riches from the last raid that would never have been found. A dangerous man, some say. A clever man.'

Hui raised himself up on his elbows, but she pushed him down.

'I would think a man like that would have Basti the Cruel's ear, if only for a while,' she continued. 'A man like that could have his pick of the women here, I would wager. Could favour one above the others. Could ask for her for his use alone.'

Hui slumped back. Her intelligence was sharper than that of almost anyone in that camp. And he had a chance to do some good, for one person at least.

'Very well,' he said. 'I will ask Basti the Cruel if I can take you for my own.'

Ahura curled her lips into a hard, brittle smile. She raked her fingernails gently along his chest, teasing him. Pressing her groin down upon his stiff member, her smile became knowing.

Ahura clapped one hand over his mouth, and with the other eased him into her. For a while, she rode him before he spurted his seed.

Rolling beside him, she heaved a silent laugh.

'So, you have never had a woman before.'

Hui's cheeks burned in the gloom.

Ahura laughed again, louder this time, but not cruelly.

'Then I have much to teach you,' she breathed in his ear, 'and we will take our time doing it, and your nights will be filled with pleasures you could only imagine.'

She pressed her lips on his and kissed him deep and long. He could already feel himself stiffening again.

Hui realized why she had insisted on giving herself to him. She had a sharp understanding of the weaknesses of men, and

she had him now. She could control him, just as the Hyksos guided their chariot-horses with their reins, and he knew he would never be able to resist her.

Once they had rutted again, and longer this time, he hugged her to him while his breath subsided.

'How did you come to be here?' he asked.

'My father refused to pay the ransom,' she said. Her words were delivered matter-of-factly, but they were as hard as the cliffs that soared up around them. 'His gold was more important to him than me, it seems.'

'He consigned you to this fate?' Hui couldn't keep the incredulity out of his voice.

'It was an important lesson. Never put your trust in a man. In the end, a woman can only rely upon herself.'

Her suffering had hardened her. That was no surprise, after all she must have endured at the hands of these rogues. But Hui knew he could not trust her either. She smiled easily, but it never appeared true, and when she stared, her eyes glittered like those diamonds Basti had mentioned. This was how she survived. She gave her body, but never her soul.

Ahura drifted off to sleep. Hui eased his arm from under her and crawled into the night. The camp was still. Fareed was squatting nearby, looking up at the skies. He eyed Hui, nodded, made no comment.

Hui wandered through the camp towards Basti's tent. A lamp flickered inside, casting a golden triangle across the ground from the open flaps. This was the moment of greatest danger. Whatever he said or did, the Shrike lord might somehow connect him with that night when the Ka Stone, the bandits' most prized possession, was stolen from them. It was a gamble he had to take.

Hui stepped into the entrance to the tent. Basti was sipping from a cup of wine. One of the women lay naked on a bed of cushions. The chieftain waved his hand and she scurried away.

'You have enjoyed your time with our Queen of Claws?' he asked.

'I have,' Hui replied. 'And I have a request to make of you. But first, some information that you might find useful.'

Basti narrowed his eyes, intrigued.

'I have heard tell of a prize beyond value,' Hui began. 'One that is ripe for the taking.'

A slash of white teeth emerged amongst the Shrike lord's beard. He poured another cup of the crimson wine and handed it over.

'These are words I like to hear. Go on.'

Hui breathed in the fruity aroma of the wine and allowed a taste of the sweetness on his tongue.

'Lahun is my home. Before I fled the authorities, the city was on fire with talk of a great wonder which had come into the possession of one of the wealthy families.'

'Gold?' Basti enquired. 'Jewels?'

'This is the strange thing,' Hui said, feigning puzzlement. 'Gold – that I could understand. But, no. The talk was of a rock – a piece of black stone like any you would find in the foothills along the valley. Is that not strange?'

Hui sensed Basti stiffen, but he did not look round. He sipped his wine and looked out of the tent flaps across the camp.

'But heed this,' he continued. 'All who had seen this rock said it had magical powers. And that it was a gift from the gods themselves. One that could transform the life of any man who owned it.'

Hui's skin tingled at the weight of the silence. He was afraid to turn in case he saw Basti's eyes blazing, and a finger pointing at him in accusation that would only end with his death.

'They called it the Ka Stone.' Hui swilled back his wine, braced himself and turned.

Basti's face had become stone itself, and he was staring past him into the night. His eyes flickered with the dark thoughts that lay behind them.

'The Ka Stone,' he repeated.

'I have been brooding on this matter for long days,' Hui said. 'If this treasure is as valuable as everyone says, would it not be better if it were in our hands? Think what we could trade it for.'

Basti gripped his cup so tightly Hui thought it might shatter. 'You know where this Ka Stone is held?'

'In a house in the Upper City.'

'And you know Lahun well enough to guide us to it?'

'I will have us through the gates and past the watchmen in no time. They can be easily bought.'

Of course, the Ka Stone would no longer be at his father's house in Lahun. By now it would be in the hands of the priests in Elephantine, being prayed over by the pharaoh. But that mattered little. All Hui needed was for the Shrikes to get him into Lahun and to cut down any who dared stand in his way. To carve a path to the Upper City, and let the streets run red with the blood of those who had betrayed him. He imagined the terror on Isetnofret's face when she saw the carnage sweeping towards her. He wanted her to suffer as Khawy had suffered, as he had suffered.

And then, finally, he would take his vengeance.

'You have more than earned your place here,' Basti said, tossing his cup aside. 'At dawn we will travel home, to my

stronghold, where we will begin to make our plans. This Ka Stone must be ours, at any cost.'

The column of men trudged across the final tract of hellish desert to the foot of the flat-topped mountain. Their heads were bowed, their faces covered with folds of cloth, as the wind blasted sand into them like knives.

'No man can survive this desert,' Fareed had said as the Shrikes set out into that horrific wasteland. 'That is what the *habiru* tell themselves on their long journeys under vast skies.'

And for a long while, Hui had believed him as the moisture was stripped from his body and the sun seared his head, and the whine of the gale in his ears became the constant voices of the dead telling him the end was near.

But now the journey was almost over. As they neared the towering copper mountains rising out of the featureless plain, he craned his neck to look at the summit. He could see why Basti the Cruel had made this place his stronghold. Surrounded by the most inhospitable land he could imagine, the fortress was almost invisible to the prying eyes of any enemy. It brooded on that flat top, as close to the heavens as any man could get, protected by sheer cliffs on every side. Impregnable, it seemed, and yet only two days' march from the eastern bank of the Nile and the busy caravan routes that moved alongside the river.

As they wound up a narrow path, the wind fell away and the sun blasted down fiercer still. The Shrikes were weary, some almost broken, but Basti had promised them a period of recovery before they embarked on their next raid.

And that will be Lahun, Hui thought, with barely concealed exhilaration.

He could almost taste the vengeance for which he'd prayed for so long. That was what had driven him to put one foot in front of the other in the crushing trek across this burning land.

On a broad ledge sheltered by a natural wall of jagged rocks not far from the summit, Basti ordered the Camp of the Women to be set up. The Shrike lord didn't allow anyone not bound by the blood-oath to see the riches he had salted away in his stronghold, for fear word might spread. The thirteen clans of Shrikes had an uneasy alliance, but all knew swords would be drawn in an instant if any of them saw an advantage. Once the tents were pitched, some provisions were left behind and one guard, to make sure the women didn't try to flee, though why any would risk crossing that desert alone was beyond Hui.

As he passed by, Ahura caught his eye. She presented herself, one hand on hip, to remind him what he would be missing. Hui smiled at her. He felt odd. He didn't love her, but he needed the warmth she offered.

From the ledge, a line of steps cut into the rock of the mountain wound up to the summit. They were wide enough for one man alone. Any enemy choosing to attack that stronghold would risk carnage raining from above, long before they could storm the fortress. Basti was as cunning as he was cruel.

Finally Hui stepped out onto the summit, his legs burning from the climb. The world spread out in a breathtaking vista, clouds of ochre dust rolling across the endless plains to the horizon. He mopped the sweat from his brow, enjoying the relief of the cooler air.

The palace, as Basti called it, was little more than a foundation wall of huge boulders, with an entrance and a roof of timber and stitched tent-cloth covering an area big enough

for the chieftain and his men to feast. Scattered around were smaller, similarly ramshackle structures: stores full with grain and oil; a kitchen belching black smoke from a hole in the roof; and a great many buildings for the booty that the band had looted but not yet disposed of. The Shrikes' tent city stood in the lee of the sole tower of rock punching up from the flat summit. A small green lake in a rocky crater stood on one side, not far from a mountainous midden heap which made Hui's gorge rise every time the wind changed direction.

The bandits who guarded the fortress whenever Basti and the remainder of his tribe were abroad lounged around, running whetstones along the edges of their blades with slow, bored strokes. That was all they seemed to do for most of the day. The returnees trudged back to their shelters to rest after their arduous journey, while Hui and Fareed pitched their tent as far away from the midden as they could find.

Once they were inside, Hui flopped onto his back and threw an arm across his face.

'I never thought I would miss my bed in Lahun so much.'

Squatting in the entrance to the tent, Fareed snorted. 'You are soft.'

'That I am. And I dream of being softer still. Clean linen against my skin. Wine that does not burn my throat, and meat that is not so greasy that it makes the acid rise in my mouth. One day this life of hardness will be behind me and I can return to being the man I was.'

'With that woman of yours beside you?'

'Ahura has had all the love in her knocked out by this miserable existence.'

'You have some wisdom, then.'

'I do not love her, but . . .'

Fareed sighed.

'I like her because she is stronger than most men – with a quicker mind than most men,' Hui added.

'Then she is a fine treasure at the top of a mountain with no paths to the summit. Admire her from afar, but don't let your spilled seed guide you. You will find a knife embedded in it sooner or later.'

For the next few days, Hui bowed his shoulders to the tasks given him: helping to load the profits from the farmhouse raid into one of the shelters; grinding corn; standing on watch, peering towards the distant horizon. From time to time, he would be called in to the councils that Basti led with his most trusted generals as they plotted the raid on Lahun. The Shrike lord knew it would be a risk. Isolated farmhouses offered little threat to his murderous band. But a raid on a city with walls and guards would need stealth to avoid the loss of too many of his men. But the lure of the Ka Stone was irresistible. Hui could see the hunger in his eyes, and hear the bitterness in his voice whenever he spoke of it. The humiliation he had endured by losing such a prize was a wrong he needed to right.

Hui was called on to describe the layout of Lahun in detail – the streets, the number of guards who could be called on to defend the city, the location of the house where the Ka Stone was being held. Hui bowed his head before the council in the shadows of the palace, rubbing his temple as he feigned struggling to remember. Some of what he told them were half-truths, or outright lies. Hui felt no desire to see innocent people cut down by those rogues. All he wanted was for the Shrikes to get him inside the city walls, and

to distract any opposition while he ended his mother's life. Then he would have no need of the bandits again. They could disappear back into the wastes, and he would lose himself in Lahun's streets until they were long gone.

As Hui trudged back to his tent after each council, he felt waves of anger wash up inside him. Isetnofret's face danced in front of his eyes, so clearly that he felt he could wrap his hands around her throat and choke the life from her. And Qen was there, too – his fine brother whom he had loved more than life itself, and who had consigned him to a terrible fate without a second thought. He could find no peace until there had been a reckoning.

Hui thought of his sister – loyal, brave Ipwet, who had risked everything to save him. He would not let harm come to her during the Shrikes' attack; he would defend her unto his own death. Could he keep her away from the grasping hands of those cut-throats? He prayed that was possible.

His shoulders stooped from the burden of those thoughts as he neared his tent and felt an urge for human comfort. But Ahura might as well have been a world away. Squinting into the growing dusk, Hui made out the silhouettes of the two guards standing at the top of the stone steps, the only way into the stronghold. Basti had posted them there as much to stop men leaving as to prevent any enemy creeping in. The Shrike lord trusted no one.

'You are thinking of your woman?'

Hui started at the voice. Fareed was standing almost unseen in the shadows.

'A waste of time, I know. Basti wants minds focused on the Lahun raid. The women will be their reward when they return.'

'There is another way down.'

'Where? And how do you know? No other man here has spoken of such a thing.'

Fareed looked up at the stars, his hooked nose silhouetted against the night sky.

'I use my time wisely. Basti would like to think of us as captives. I always like to have another way out of any difficult situation.' He pointed across the camp to the midden heap where few dared venture. 'There is a gap in the natural wall around this summit, little more than a useless crevice to any who pass. But I took the time to crawl into it, and beyond there is a narrow track. It is a difficult climb, make no mistake. For some distance, a man would have to cling tight to the cliff face. He would need a good reason to attempt it.' He paused. 'But good reason you have.'

Within moments, Hui was hurrying around the edge of the camp. He choked when he stumbled into the foul reek of the midden, and his eyes watered, but somehow he found the crevice Fareed had described and he lowered himself into it.

At the bottom of the gash in the rock, Hui edged out onto the dizzying path. It was barely wide enough for him to creep along, holding on to the cliff face. At times, the wind gusted so powerfully that his heart thumped as he thought he would be ripped off the mountainside and dashed on the rocks below. His fingers dug into cracks his eyes couldn't see, and he felt ahead with his left foot as he eased onto a steady downward slope. Soon, the path widened and the wind dropped and, as he rounded the mountainside, the lamp of the moon lit the way ahead.

Finally Hui sensed wisps of smoke from a donkey-dung fire and he stepped onto the ledge where the Camp of the Women lay bathed in the silvery light. Freed of their torments at the hands of the men, if only for a while, the women raised their

voices in joyful song here and there. He breathed easier. The lilting melodies would drown any footsteps as he approached.

The guard wasn't at his post, no doubt seeing little reason to be vigilant. Hui crept amongst the tents until he reached the spot where he had seen Ahura pitch hers. As he eased aside the flaps, she started, but he pressed a finger to his lips and she beamed with what he hoped was genuine pleasure to see him.

Crawling beside her, he whispered, 'I felt an urge to be with you.'

'Of course. How did you get past the guards at the top of the steps?'

Hui told her of the secret path and she seemed happy that they would not be kept apart as long as they'd anticipated; or, perhaps she enjoyed the control she possessed over him, knowing that he would risk his life to see her.

For a while, they kissed, and then she rode him. Once he was spent, they lay together, listening to the song drifting across the camp.

Since he'd left Lahun, Hui had learned to fabricate his past with ease. He'd changed his story time and again to gain an advantage. But as he lay there relishing the warmth of Ahura's skin, the urge to tell the truth overcame him.

'Soon we must part ways,' he began.

'You have had your fill of me?' she asked in a voice dripping with acid.

'No. Never. But in the next three days the Shrikes will be raiding Lahun in the west.'

'And you fear for your life in this raid?'

'No. But when the Shrikes return, I will not be with them.'

'You swore a blood-oath!'

'I have said many things in recent days. If the gods would damn me for breaking that oath, so be it. I will not live out my time amongst a band of cut-throats. I have business in Lahun. Ensuring that is completed is all that matters to me, and if I am killed in the process, I will die happy.'

Hui could sense Ahura considering his words. He'd never spoken to her in this way before.

She pressed her lips against his ear and breathed, 'Tell me all about this *business*.'

Hui told her his story. Ahura rested her head on his chest, listening without speaking until he was done, and then she said, 'You have suffered greatly.'

The words were flat, and stripped of pity – a gesture, nothing more. Hui knew he shouldn't have expected anything from her, but he'd secretly hoped for some comfort, at least. That had been sorely missing in his life for too long. He wondered if he had placed himself in danger by giving up his secrets – that she would use the information against him.

'This Lahun, it is a fine place?' she asked.

'It is.'

Something was worming its way through Ahura's thoughts. He'd been intimate with her enough times to sense the signs.

'What is on your mind?'

'Nothing that concerns you.' Ahura showed the familiar smile which told him he would get no more out of her. She was as implacable as the stone of the pyramid that overlooked his old home.

Once he'd told her he would return to see her again soon, Hui crept out of the tent and across the now-silent camp. He hurried across the ledge towards the secret path.

A voice stopped him before he'd barely crossed half the distance: 'Stand your ground.'

Hui felt his stomach knot. He'd been a fool. He'd forgotten the guard and now he'd pay for it with his life. Basti the Cruel would never tolerate anyone disobeying his command. Any man who dared go against his word was despatched mercilessly. In that way, order was maintained.

'Turn around,' the gruff voice said.

The guard was a short man with a severe burn scarring the left side of his face. He was levelling his sword at Hui.

'I was only visiting the women,' Hui said.

'You're coming with me to see Basti now. And then you'll be flying with the vultures off the top of this mountain.'

Hui looked around, but there was nowhere to run.

A gurgle rolled out. The guard clutched at his throat. Blood gushed between his fingers. When the guard slumped to his knees and pitched onto the cold rock, Hui saw a figure standing behind him.

'Help me push him over the edge,' Ahura urged, waving her hand. 'The others will think he tripped and fell.'

'You have a knife,' Hui gasped as he stared at the dripping blade in her fist.

Ahura stared at him as if he truly was a fool. She wiped her blade clean on her victim. Hui stumbled forward and helped her drag the guard to the edge of the vertiginous drop. Together, they heaved him over the side.

'What made you follow me?' Hui stuttered, hoping she might say she'd been overcome with love for him.

'I thought you might not take care. Someone needed to keep an eye on you.'

'You have my thanks.'

'More than that. You owe me your life now.'

'I am in your debt. And I will pay you back in full. Whatever you desire.'

Hui felt a moral duty towards her; his conscience had not yet hardened enough.

'You will. And I will tell you what I desire.' Her eyes gleamed in the moonlight. 'When you return to Lahun, you will take me. As your wife.'

'But I cannot,' he protested.

'You will find a way. Your life is mine now. Never forget that.'

Ahura turned and walked back into the camp without a backwards glance. Hui felt his head spin. Her demand would be impossible to achieve, yet this was a debt that had to be paid. Fareed would mock him relentlessly if he learned of this.

Cursing the mess he had got himself into, Hui ran towards the secret path.

When he finally hauled himself up beside the stinking midden, Hui looked out at a stronghold heaving with movement. Lamps sparked into life everywhere. Bandits scrambled from their tents.

Others hailed him, beckoning with furious gestures. Hui felt a tremor of fear that he had been found missing, and a hunt had been launched to find him and bring him to justice. But he noticed the dancing lights were flooding towards Basti's palace.

Curious, he eased himself into the flow. The cut-throats crowded around the entrance to the palace, but Hui pushed through until he could observe from the front.

Bathed in the glow of many lamps, Basti lounged on a mahogany throne glinting with gold inlay that must have been looted from one of his wealthy victims. One leg was thrown over the arm of the chair, and he sipped from a cup of blood-red wine as he narrowed his eyes at a rat-like man standing in front of him.

'I bring word from the clan of Maa-En-Tef,' the stranger was saying. His head was bowed in deference, his hands kneading together. Every time he shifted, red dust clouded the air from his coated robe and scarf after what must have been a long, hard journey through the desert. 'A gathering of the thirteen clans has been called. Never have we done this in our days, but the threat now is too great.'

Basti waved his cup towards the dishevelled bandit.

'What threat could warrant such a gathering?'

'The barbarians are pushing hard into *our* land—'

'The Hyksos?'

'Aye, those blood-soaked foreigners. They raid in our territory. People are getting scared of them, putting up more defences. Makes it harder for any of us to earn our rewards.'

Hui smirked at the irony in the stranger's words.

'And now they've slaughtered some of Serek's men. The truth here is clear as a mountain pool—'

'Not Shufti, then,' Basti said, and raucous laughter erupted amongst his men.

The new arrival's cheeks reddened, but he pressed on.

'If they're threatening us, we need to fight back or we stand to lose everything. And we can only do that together, shoulder to shoulder.'

Now it was Basti's turn to smirk, and a few sniggers rippled through the crowd.

'Maa-En-Tef has given me the power to speak on his behalf,' the man continued, the words tumbling out as if they had been learned by heart. 'And he says, yes, we have had our differences in days gone by, and some of those differences have led to bloodshed. But now is not the time to look to the past. At the council, the lords of all thirteen clans can find

common cause, and together we can plot a course through these times and save all that we have fought so hard for.'

Basti sipped his wine as he weighed these words.

'And where is this council to be held?'

'North of Gallala.'

'In Shufti's territory?'

The emissary nodded.

Basti thought for a moment longer. 'Very well. No member of the thirteen clans can ignore a call to council. The clan of Basti the Cruel will be represented at the gathering.'

Once the messenger had gone, Basti jumped up from his throne and tossed his cup aside.

'They must think me mad if they expect me to wander into the territory of that treacherous one-eyed jackal, Shufti,' he snarled as his generals gathered around him. 'He's never forgiven me for stealing that caravan from under his nose. Admittedly, our raid did cross over into his nome.' He shrugged. 'Nevertheless, I can likely expect a dagger between my shoulder blades if I sit with that viper.'

'We can't ignore a call to council,' one of the generals muttered.

'You will speak on my behalf,' Basti said to the man. 'We will show willing. Take with you a full force. I will stay here and await your return. Gather the men now and leave at dawn.'

'What about the raid on Lahun?' Hui blurted, realizing instantly that he had overstepped the mark.

Basti eyed him. 'Lahun can wait. Our prize will still be there when we are ready to move.'

Hui felt a rush of frustration. He had desired vengeance for so long that he could almost taste it.

The Shrike lord smiled, cold and hard. 'You go with the men to Gallala, you and that scout. You are new to this clan.

It will be a good lesson for you to witness this gathering and see our . . . friends . . . and hear what they have to say. You will better understand what it means to be a Shrike.'

Hui sensed that this was his punishment for speaking out of turn. Another gruelling trek through the searing desert, more meagre rations and a growling belly, and no doubt endless hours of dull debate until he could return and prepare himself for what he really desired. But compared to the punishment Basti could have meted out, he decided he'd got off lightly.

He bowed and hurried away to warn Fareed what was to come.

The natural bowl in the shallow valley throbbed with life. Hui squatted in the shade of a gnarled column of rock and looked out over a heaving multitude of bandits, breathing in arid air thick with the stink of sweat and filthy cloth. He imagined there must be a thousand sheltering in that rocky arena. They'd travelled from all over Egypt, dressed in little more than rags, but bristling with swords and axes and daggers and bows, so that no rival could ever think they were weak, or ripe for conquest.

His brothers from the clan of Basti hunched around him, eyes flickering with suspicion. There seemed little love lost amongst these rogues and cut-throats, whatever pretence they made. Only a greater threat could bring them together, and the Hyksos were certainly that. As bloodthirsty as the Shrikes were, Hui felt sure they wouldn't stand a chance once a deluge of arrows rained from the sky and chariots carved through their ranks.

The journey to this place had been hard, across what his fellow Shrikes called 'the thirsty sands'. Searing heat had sucked the moisture from his body, and rocks as hot as a kiln burned even through the leather soles of his sandals. Perhaps

he had become addled by the sun, but he had started to see some beauty in that inhospitable waste, where black rock out-cropped against tawny dunes. Perhaps this was the Desert Madness that all the *habiru* spoke of.

Hui moistened his cracked lips and swallowed his ration of one mouthful of water. Their supplies were just enough to get them back through the desert. Fareed levered himself up the slope on his staff. He'd been wandering amongst the tribes, one ear cocked as he scouted the human heart as well as he did the trackless wastes.

'I forgot to offer my thanks for the part you played in arranging my invitation to this gathering,' he said sourly.

Hui had apologized time and again, but it seemed they were now seen as a pair, with each of them punished for the other's crimes.

'What did you find?'

Fareed crouched so no one else could hear. 'Many of the leaders are here, but not all yet, and tempers are already wearing thin. There seems little trust, or honour, abroad. Maa-En-Tef, who called this gathering, is using his men to keep order as best he can.'

'Maa-En-Tef's home is on the western bank of the Nile?'

'As far as El Kharga. I have seen the clan of Ur. Akheku, the head of a southern clan that hunts in the lands around Assoun, Elephantine and the first cataract, and Serek, from farther north, the lord of Kom-Ombo. One of the lesser lords, Nefer-Temu of Qena. But as yet there is no sign of Shufti.'

'Perhaps Basti was right not to trust him. Could he be waiting to see if our own lord arrives late before he makes his move?'

The desert wanderer shrugged. 'The sooner this council is over, the sooner we can return to the miserable life we

have bought for ourselves.' Those dark, unreadable eyes fell on Hui. 'Although in days to come, we need to talk, you and I, about the road that leads away from where we have found ourselves.'

Fareed levered himself up and glided down the slope to circle the gathering again.

As the day crawled towards dusk, the bandits raised their voices in frustration. Fights broke out, men tearing chunks off each other with nails and teeth. Maa-En-Tef's men rained cudgel blows down upon them until they broke apart and scurried away like whipped dogs.

And then, as the sun edged the western horizon, a pained cry rang out. Silence fell across the seething pit of bandits. Hui peered into the gloom across the bowl as three men lurched out of the shadows towards the circle of light from the newly lit fire. Badly wounded, by the look of their shambling gait, and all of them naked.

'Shufti.'

The name rustled out, springing from lips to lips like an exhalation as it moved across the gathering. Hui stared, shocked. Shufti – the most brutal of all the leaders, so the stories said, even more bloodthirsty than Basti. What could have reduced him to this?

Two Shrike generals rushed forward, likely other commanders from Shufti's clan, and thrust a water skin to his lips. He swilled the precious liquid greedily, letting it gush down his chest. Another bandit threw a cloak over his shoulders to give him some dignity, but not before Hui and most there saw the lattice of seeping purple weals across his back. He'd been lashed within a whisker of his life, as had the two other men.

Shufti was tall, his face permanently twisted into a menacing scowl. His dark skin was pitted from head to toe with the scars of the smallpox. His nose was hooked like the beak of a vulture, and his right eye was near-white, no doubt destroyed by the burrowing blind-worm that afflicted so many who lived along the banks of the Nile.

Shufti heaved himself upright, wincing from where the rough wool of the cloak rubbed across the raw welts on his back.

'Brothers!' he boomed, his voice cracking. 'We have been challenged! My good friend, the lord Maa-En-Tef, has called this gathering so we can find ways to deal with the barbarians who are threatening our livelihood. But there is more pressing work now.' The Shrike lord was trembling with rage, and spittle flew from his mouth into the crackling fire. 'Fear – that is what gives us our authority. Fear, and fear alone. Any dissent is crushed, instantly. That is how we maintain our grip on the land.' Shufti clenched a fist and thrust it up high as if he were trying to crush the stars themselves. 'And if the people think we are weak – that our word can be challenged – that fear vanishes into the air like the smoke of this fire, and our power with it. Then we are nothing!'

Shufti staggered and two bandits rushed to support him. He threw them off, refusing to show any weakness.

Hui glanced around at the rapt bandits, their silence total after their previous raucousness. They respected Shufti regardless of what clan they called their own, and they were prepared to give credence to what he had to say.

Shufti steadied himself, sucking deep draughts of air.

'A caravan of Assyrians passed through my territory and, as is my right, I demanded payment in return for the Shrike Feather, our mark of safe passage – twenty of their slaves now, and half

of the profit from the sale of the other sixty. Our demands are known to all merchants. They are accepted by every caravan that passes by us, for they know the price they will pay if they refuse our demands. But this caravan master *did* refuse.'

A gasp rushed through the bandit army, transforming into angry mutterings and then shouts of defiance.

'This cannot stand!' Shufti pointed at the assembly.

'I was caught off guard by the deceit of the Assyrian slave master, as were my two generals,' he continued, likely trying to cover up his failings. 'This slave master – Kaarik, he called himself – refused to bow to my threats, and when I was distracted he struck like a cobra. Twisted my arm behind my back, stripped me of my robe, and his men, armed to the teeth with the crescent swords of those Assyrian jackals, beat the three of us until our brains were close to being dashed from our skulls. We fought back, with the courage you have come to know, but they outnumbered the three of us. And then we were pinned spread-eagled to the ground and each of us felt the brutal lash of the slave-whip. We survived, for we are as hard as the rocks of this land. But Kaarik stole our Shrike Feather and, as he left us for dead, he mocked the thirteen clans. Mocked us, brothers! He called us a flock of cowardly, chattering fledglings, that make more noise than a flock of sparrows. This! Cannot! Stand!'

'This cannot stand!' the bandits roared as one.

Hui looked around the bowl as the Shrikes heaved to their feet, swords thrust into the air. This common enemy had united them, and now, seeing the rabble become an army, he wondered if they might offer some serious resistance to the Hyksos war bands.

'We will deal with the barbarian threat in good time!' Shufti roared. 'Our first task is to show that the Shrikes are still the

true power in the land. That we will crush any resistance to our dominion. We will rise up as one, and smash this caravan and its defiant slaver. Only a show of force will do. And fear will once again rush across Egypt. Fear of the Shrikes!'

The bandits whooped and howled, like dogs baying at the moon. The turbulent sea of bodies swelled around the fire, obscuring the flames so all that was visible was a funnel of sparks twisting towards the stars.

Hui was gripped by the sight, and a little afraid, as would that slave master be when he saw this ferocious army bearing down on his handful of strongmen. He sensed a presence loom over him. Fareed was back from his intelligence gathering, watching the riotous display with a face like stone.

'The time for talk is done, it seems,' he intoned. 'Now there will be blood.'

The bark of the baboon thundered through that deepest dark before the dawn. Hui shivered as he listened to other male monkeys pick up the challenge to the army of men that had disturbed their peaceful existence. Once the cacophony faded, silence again descended on the cliffs overlooking the abandoned city where the Assyrians had sheltered for the night. Then, to his left, someone dropped a sword, and the clang of metal on rock rang out as clear as a bell through the still air. If the slavers hadn't known their caravan was being stalked, they did now.

Hui imagined the ranks of Shrikes on the clifftops circling the oasis below. The bandits had left only a handful of men at the camp to guard the women whom some of the clans had brought along, and the donkeys and the wagons. Nearly one thousand

waited for Shufti to signal the attack at first light – a terrible force that would drive those Assyrians mad with terror when they swept from the high ground. There were barely a hundred in the caravan, so Shufti had said, and most of them were slave-women, swathed in robes and shawls as was the Assyrian way. Twenty men. One thousand Shrikes. Hui felt his stomach knot at the thought of the carnage.

Not long after, the sun gleamed along the east and the ocean of dark flooded away. Below, in Gallala, grey shapes surfaced from the shadow. The ring of towering cliffs surrounding the oasis was riddled with the caves of ancient tombs. In the times of the ancients, a city had thrived here, so Fareed had gathered from the stories the *habiru* told each other on their long treks across the desert. But an earthquake had plucked slides of rock from those cliffs and wrecked the wells. The life-giving water had drained away, however deep the wells had been dug. Only a little remained there now, at the foot of steep earthen steps, enough for the caravan to fill the water skins, but not enough for a thronging city.

Hui peered down at the dismal sight of the dead settlement and thought of Lahun. He imagined the wealthy merchants and the clamour of the working folk, the beat of the smiths' hammers and the song of the farmers, the sumptuous decor of the harems and the perfume from the flowers in the gardens. Here there were only lizards basking in the courtyards. The crumbling walls glowed with a honeyed light as the sun struck them. The roofs had collapsed, adding to the desolation that hung heavily over all.

Hui couldn't see any sign of the caravan. He decided the travellers must be sheltering in the decaying temple to the patron god of Gallala at the heart of the ruins, taking advantage of the

sole entrance through the disintegrating gateway at the western end to protect themselves. The place was little more than walls surrounding rubble, a far cry from its days as a centre of worship.

As he studied the temple, Hui glimpsed shadows flickering in the ruins. His fellow Shrikes must have seen them, too, for he sensed a ripple of movement along the line beside him. He glanced along the ranks. That rabble were dressed for war, with bronze shields and swords gleaming in the rising sun, and leather breastplates over their filthy robes. Scarves of black wool were wrapped tightly around their heads, so only their malevolent eyes showed in the slits. Shufti would not be satisfied until those in the caravan had been hacked to pieces, with one man set free to spread the terror of this bloody dawn.

Hui searched in vain in the thin light for any sign of Fareed. The desert wanderer had spent the night up there with the other scouts, amongst the booms of the baboons, as he plotted the best way to strike against the tiny group of slavers. He could see them now, stirring with the dawn. Stretching on their sleeping mats beside the cold ashes of donkey-dung fires, descending the steps into a well to fill their water skins, tending to their beasts, stirring the slaves, relieving themselves in the corners of the temple.

'Ho.'

The signal spread along the vast line in a chain of whispers, and every Shrike stood. It was time.

As disciplined as the Hyksos, the bandits gripped their swords and waited. Spikes of dazzling light shone from the shields and swords. Shufti allowed the moment before battle to linger.

The Shrike lord's voice rang out through the stillness of the dawn, echoing off the cliff faces.

'Kaarik! Are you awake?'

Shufti was standing on the west wall of the cliff, where the road carved through into the oasis.

'Kaarik! It is time for you to pay what you owe me!' the bandit chieftain boomed. 'But the price has risen. I want everything now!' He ripped off his scarf to reveal his pockmarked face, twisted with fury. 'I want everything you have, including your stupid and arrogant head.'

In the ruined temple, a man threw off his sheepskin rug and stood up from his sleeping mat – Kaarik the slave master, Hui presumed – and drew his sword.

'You will have to come down and take it from me!' he shouted back.

Is he mad? Hui wondered. *Does he not see the mighty force ranked against him?*

Shufti raised his right arm and held it there. When he slashed his hand down, a battle cry roared from the men and they shook their weapons at the pale yellow sky. Shufti whipped his hand forward and the Shrike army heaved as one, flooding down the paths weaving through the cliffs into the narrow valley.

Hui raced alongside them. At least he would not be called on to kill this day. The battle would be over before he had even reached the temple.

Yet as he thundered towards the ruined temple, cries rang from the bandits ahead of him. The attack slowed. Shrikes milled, spilling out of the column on either side. The whine of arrows sliced through the air. A bandit spun away from the entrance, a shaft protruding from his eye socket.

Hui caught his breath. A slave master and his men armed with bows? Something was amiss. He could see confusion spark in eyes all around him. This was not how the battle should be unfolding.

A steep stairway led up to the temple entrance, barely wide enough for five men abreast. The steps were slick with blood and bodies littered the edges, arrows spiking out of chests and skulls. And those arrows were not the simple wooden shafts of hunters, Hui could see from some that had missed their mark. They were tipped with bronze, like the ones soldiers wielded, and so sharp that a shaft could punch through a man's head.

The dead and dying blocked the temple doorway, but the Shrikes wrenched them aside and the bandit army surged into the courtyard beyond.

Hui stumbled through the doorway with the mass of Shrikes. From the statue by the entrance, he could see the temple was dedicated to Bes, the god of music and dance, but there was no joy there. The small band of Assyrians huddled around the altar, with one – most likely the leader, Kaarik – standing on the god's table.

But that is no Assyrian, Hui thought.

He was tall and muscular, with a mane of fair hair and eyes as blue as the sea, and he gripped a great bow that shimmered with silver electrum wire coiled around the wood. An Egyptian?

The blue-eyed leader bellowed, 'Horus, arm me!' – a battle cry – and he tossed aside his bow and whipped out his sword. The battle was too close quarters for arrows, and the other men clustering around the altar drew their blades. The defenders, now looking more like warriors than slavers, leaped into a ring around the circle, a planned strategic position.

The Shrikes rushed forward and bronze clashed against bronze. Hui stepped back. He was not going to die for no reason. And he could see the skill of the defenders. Their blades flashed in fluid arcs, high, low, thrusting, hacking, like bolts of light dancing in the glare of the rising sun.

The bandits had the numbers, but they did not have the skill. A blade hacked into one man's neck and he fell back, blood gouting. Another sword stabbed through a rogue's chest. Arms were lopped, skulls split. A lake of blood flooded underfoot, the bandits slipping and sliding in the gore as they tried to advance.

And still the Shrikes did not retreat. As one bandit fell, another darted into the gap to take his place. But the defenders were tireless. They could not be slavers. They had the strength and grace of professional fighting men.

Shufti was holding back, spewing curses and waving his arms to exhort his men to greater frenzy. He howled, urging the men to fight until the end, for any coward would be punished with a terrible death.

'Get me the Assyrian alive!' he roared, unaware his foe was nothing of the sort. 'I want to kill him slowly and hear him squeal.'

But underneath the rage in his voice, Hui could hear the first hint of doubt.

The women slaves cowered on their sleeping mats, their heads covered with their shawls. They screeched and wailed. The bandits stumbled around them, paying them scant attention, almost trampling them as the thousand-strong Shrike army finally forced its way into the courtyard.

Now the reckoning would come. However brave and skilled those defenders were, they would be no match for such a multitude.

The tide began to turn.

The Shrikes hacked down two of the warriors who had been pressed against the altar. A third flipped his sword to his left hand while his right arm hung powerless and bleeding. He would not last long.

Yet despite the entire army of bandits crushed into the courtyard, the handsome leader of this strange band was laughing as if this was the greatest sport. Had the terror of death driven him mad?

The leader stabbed his blade into the throat of another Shrike and wrenched it loose. He threw his head back and bellowed, 'On me, the Blues!'

Was he calling on the gods, or the spirits of the dead?

And then Hui glimpsed sudden movement amongst the huddled slave girls. They leaped up as one and threw aside their heavy robes. They were not women, but men! Disguised!

A trap!

The whole scene had been a lure to draw the Shrike force in. And not a soul had guessed it.

Swords leaped into hands and those once-cowering 'women' fell upon the rear of the Shrike horde. Hui watched the bandits churn in confusion. Even as the blades bit deep into their flesh, they still did not comprehend what was happening.

Hui staggered against the temple wall, gripped by shock at what he was witnessing. The soldiers were like a desert storm of blades. The bandits fell under the relentless assault by the score. At least a hundred bodies splashed into the swelling crimson lake before the Shrikes realized they were under attack from another quarter.

Hui felt sickened by the slaughter. In the crush against the altar, the Shrikes struggled to turn to meet the new threat. Few found space to swing their blades, and as they swivelled they presented their backs to the defenders who had been fighting furiously at the heart of the bandit circle.

All hope was draining away for the Shrikes. Hui wondered if any of them would make it out of that courtyard alive. He marvelled at the skill of these troops, the finest he had ever seen.

The leader on the altar began to sing a battle hymn, and his men joined in, full-throated, as they hacked and thrust.

We are the breath of Horus,
hot as the desert wind,
we are the reapers of men—

The blades seemed to beat out the rhythm of the song. The battle became a massacre.

Some of the Shrikes hurled down their swords, falling to their knees and pressing their hands together as they pleaded for mercy. There was none. The swords were like scythes, cutting down all that had once stood tall.

The gods had turned their attention to the arrogance of the Shrikes. They'd thought themselves untouchable – that their reign of terror across Egypt would continue forever. But now all was done.

Hui watched the slaughter, his sword loose in his hand. Why should he give any credence to the blood-oath he had sworn? He had to survive this, for Ipwet, for the memory of his father. For his vengeance on Isetnofret.

Tossing aside his sword, Hui threw himself towards the entrance to the temple, slipping in the blood, scrabbling to gain purchase, trying to find a path through the chaos of churning bodies. As he reached the other side of that mass execution, he realized others were fleeing. But as those bandits raced to escape, another line of guardsmen formed across the gateway, swords in hand.

Hui already knew the truth: there was no way out. His fate had been sealed. He felt dread settle on him, and he threw himself behind a pile of bodies next to the wall. He'd learned to fight with a sword, but no one had taught him what to expect in

a pitched battle. The constant movement, with attacks coming from every side. The blood. The din. The horror.

Hui buried his head. A coward, then. That was all he was in the final reckoning. Not the man he'd dreamed of being, the one who would make his father proud. There would be no storm of vengeance. He was a whimpering child. Tears stung his eyes as the truth burned him.

As Hui waited for death, he peered over the corpses and saw chaotic flashes of battle. The leader of the soldiers, laughing and singing like a madman, his face a red mask. Shufti, racing towards a ramp of rubble at the ruined east wall, trying to scramble over it. A man in an Assyrian dress hurling a mud brick at the Shrike lord, cracking his skull, and then pressing a dagger against Shufti's throat when he tumbled to the ground. Blood. Blood and death.

The swords fell, and then stilled. The battle was over. Barely two hundred Shrikes remained alive, kneeling in the gore, pleading.

The blood-soaked lion of a leader leaped down from the altar.

'Take the heads of the wounded!' he bellowed to his men. 'We will waste no resources on them. Then we shall see about taking the heads of the survivors.'

Dead eyes stared, a multitude of them. The pyramid of heads towered up by the well of Gallala, already reeking of death in the burning sun. Any prisoner could look through the temple gateway and see what the future held for them. In the courtyard, the lake of blood had already baked hard on the cracked flagstones of the Temple of Bes, and the only sounds were the wind whining through the ruins, and the sobbing of men who had once raped

women and murdered children and had thought they strode across Egypt like colossi.

Hui's wrists burned. Since he'd been dragged out from his hiding place behind the heap of bodies, his arms had been bound behind his back. As much as he strained, he couldn't free them. Head bowed, he squatted amongst the long line of captives by the north wall. He could feel the shadow of death falling over him.

He closed his eyes and dreamed he was back in Lahun, lounging on the roof of his home as he listened to the comforting drone of his father's wise words. As Khawy's kind face floated in his mind, emotion rushed through him. Hui saw Qen, and then Isetnofret gloating at the misery she had caused, and he felt a desperate urge to cry. He had failed. There would be no price to pay for his father's death. All hopes of vengeance were now dashed.

Looking up, he glimpsed the strange sight of a man wearing the now blood-spattered skirts of an Assyrian wife walking towards the Egyptian leader and his officers. The man was as beautiful as any woman, with fine features and full lips, and he carried himself with grace and poise. He was wise, too, clearly well-read and knowledgeable on many a subject. Hui had been listening carefully to the chatter of the other Egyptians. The man was a eunuch, who went by the name of Taita, and he seemed to be close to the pharaoh himself – an adviser, perhaps? The leader of those courageous, skilled soldiers went by the name of Tanus. Even there, awaiting execution, Hui felt awed by that great warrior. There was a power to him that crackled like a great storm, a commanding presence that would convince anyone to fall in line behind him.

Taita and Tanus seemed the greatest of friends – an odd combination, Hui thought. He watched them walk together through the temple and sit on the steps, eating a breakfast

of cakes and fruit. The officers held up the severed heads of the Shrikes one by one, so the two men could examine them. They seemed to be searching for someone amongst the dead.

Tanus waved a hand and ordered the head of Nefer-Temu, the leader of the Qena clan, to be placed on the top of the pyramid of skulls he was building. Would Hui's own head soon sit there? Hui's stomach knotted as the interminable wait dragged on. The two men nibbled on their breakfast as if there were no more pleasant a place to linger.

Finally they had eaten their fill. Hui watched them wander back to the broken captives. Snatches of conversation floated to his ears. It seemed there had been spies in the Shrike camps, and when the opportunity arose for this ruthless strike to rid Egypt of the plague of the bandits, they'd taken it. But it was time for questioning the survivors, and Hui knew it would be swift and merciless.

Tanus bounded onto the stone altar of Bes. In his right hand, he raised the hawk seal of the pharaoh so that all there knew his authority, and then he smiled at the line of captives.

'I am the bearer of the hawk seal of Pharaoh Mamose,' he intoned, 'and I speak with his voice.' He looked along the line. 'I am your judge and your executioner.'

Hui looked down as that final word hovered over him.

'You have been taken in the act of pillage and murder. If there is one of you who would deny it, let him stand before me and declare his innocence.' After a long pause, he exclaimed, 'Come now! Speak up, you innocents.'

The shadow of a circling vulture flitted across the stone in front of him. The harbinger of death.

'Your brethren grow impatient for the feast,' the leader continued, glancing up. 'Let us not keep them waiting.'

None of the Shrikes responded. Hui couldn't tell if it was loyalty to their tribe or terror that kept their mouths shut.

'Your actions, which all here have witnessed, condemn you. Your silence confirms the verdict. You are guilty. In the name of the divine Pharaoh, I pass sentence upon you. I sentence you to death by beheading. Your severed heads will be displayed along the caravan routes. All law-abiding men who pass this way will see your skulls grinning at them from the roadside, and they will know that the Shrike has met the eagle. They will know that the age of lawlessness has passed from the land, and that peace has returned to this very Egypt of ours. I have spoken. Pharaoh Mamose has spoken.'

Soldiers grabbed one of the bandits and dragged him out of the line. They hurled him to his knees in front of the altar.

'If you answer three questions truthfully,' the leader boomed, 'your life will be spared. You will be enlisted as a trooper in my regiment of the guards, with all the pay and privileges. If you refuse to answer the questions, your sentence will be carried out immediately.' He looked down at the kneeling man and said, 'This is the first question. What clan do you belong to?'

The bandit stared at the stone slabs. Now Hui could see that it was not terror that silenced him. He could not bring himself to break the blood-oath of the Shrikes.

'This is the second question. Who is the baron that commands you?'

Silence.

'This is the third and the last question. Will you lead me to the secret places where your clan hides?'

The captive raised his head. Hui thought that he might break. Instead, he hawked and spat a mouthful of phlegm. Unmoved, the leader nodded to the guard who stood over the prisoner with his sword.

The blade swung up, glinting in the sun. Hui turned his head away as he heard the crunch of the blade biting through flesh

and bone, and the thud of the head bouncing across the stones, amplified in the near-unbearable silence.

'One more head for the pyramid,' Tanus said.

The guards dragged another captive forward to hear the same three questions. This time the bandit shouted a defiant obscenity. It must have angered the executioner, Hui decided, for his blow was not clean. The bandit flailed around on the ground, and it took three more strokes before the head rolled free.

Twenty-three heads bounced down the steps. Hui thought if he heard any more of that slaughter, he might be driven mad.

Finally his spirit broke. He threw himself to his feet and cried out, 'My name is Hui. I am a blood-brother of the clan of Basti the Cruel. I know his secret places, and I will lead you to them.'

He blinked away hot tears of fear and realized the towering leader was looking directly into his eyes. After a moment, Tanus nodded and flicked a hand towards his guards. They gripped Hui's arms and pulled him out of the line.

'Care for him well,' the leader said. 'He is now a trooper of the Blues, and your companion-in-arms.'

Hui could feel the searing eyes of his fellow Shrikes on his back. They hated him now, but they had never truly been brothers so this was no betrayal, not in his eyes. He had used them, to one end only.

And now, he thought, his heart leaping, *there is hope again.*

The guards prodded Hui towards the carpet of sleeping mats that had been part of the soldiers' disguise. He flopped down on them, his legs turning to jelly with the relief flooding him, and they brought him some bread from their rations and tossed him a water skin. He gnawed on the food, watching head after head bouncing down the steps from the altar.

Whoever this Tanus was, he must be a valued general in the army. The valour he had displayed in battle had been greater than any man should rightly show. Hui watched him as he completed the executions. He was like a god.

'Akh-Horus,' he murmured to himself. *The brother of Horus.*

Once the task was complete and only a handful of Shrikes who had confessed remained, Tanus wandered over. His eyes fixed on Hui, almost as if he was looking deep within him. Hui had already decided to lie – and lie a great deal – to his new allies. They couldn't know of the crimes he was accused of in Lahun, or they'd feel obliged to deliver him to the authorities. Nor must they find out that he'd recently been marching alongside the Hyksos, for they might consider him a potential traitor and his head could end up on that heap by the well. He'd say he'd been kidnapped by the barbarians as a babe, and that was where he'd learned their skills. Then he'd escaped and ended up in the hands of the Shrikes.

When Tanus stood before him, Hui murmured, 'I ask a boon.'

'A boon? Speak, then.'

'If he is yet alive, there is one of my clan I would beg of you to save.' Hui bowed in deference. 'Fareed is his name, one of the *habiru*, and he is the best scout you will ever know. You will find it a godsend to have him amongst your number.'

Tanus held Hui's chin and raised his head so he could look his new recruit in the eye.

'Pleading for another? Perhaps there is some good in your kind after all.'

'I am not like the other Shrikes, and I vow that I will show my worth to you. It is an honour to serve such a great warrior.'

If Tanus was moved by his words, he didn't show it.

'We will see if you have what it takes for a soldier's life. Now ready yourself. We have a long march ahead of us.'

The march was long indeed, and hard, conducted at a pace that was faster than anything the Shrikes had ever attempted. Hui felt determined not to show weakness now he was a member of a unit of the elite Blue Crocodile Guards, but from time to time they had to pause for him to catch up. Tanus had acceded to his wish. When the bandit scouts were rounded up on the cliffs above Gallala, Fareed was allowed to march with the soldiers. He never offered any words of thanks for Hui saving his life, and Hui would have expected nothing else from the dour desert traveller. But once they exchanged a glance, and there was a recognition of what had been done.

Avoiding the merciless sun by day, they marched by night across the rolling dunes until they reached the port of Safaga on the Red Sea. Hui was surprised that Tanus strode beside him, telling him tales of great battles and talking passionately of the value of honour and duty. Hui was entranced by the leader. He was clearly a driven man, but his heart was good. There was something of Khawy in him. As the days passed, Hui felt he would do anything Tanus asked of him.

At Safaga, Tanus made contact with a merchant, Tiamat, who seemed to have aided him in the past. All the captives who had survived the battle in the temple were herded towards the harbour and one of Tiamat's trading vessels, which was to take them to a slave compound on the island of Jez Baquan off the coast. Hui watched the captives with trepidation, fearing he, too, might be sent to that prison, but Tanus summoned him to one side.

'I have looked into your heart,' the one Hui now regularly called Akh-Horus said, 'and I feel I can trust you. Is this true?'

'You can.'

'Then you will stay with the Blue Crocodiles. We have work to do.'

'And Fareed?'

'Your friend did not fight against us in the battle against Gallala, and he gave himself up with no resistance on the cliffs. I do not consider him one of these captive Shrikes. We will need a good scout in the days ahead.'

Hui was relieved. The desert wanderer had suffered enough. As they spoke, Taita strode up. The man seemed to know everything upon this world, and that knowledge might be valuable in the future.

'Our work will not be complete until we have ended the foul rule of Basti the Cruel,' Tanus said. 'Tell us all you know of him.'

Hui summoned up everything he remembered of his former lord, and Taita recorded it all on papyrus with his writing-brush. Tanus was intrigued to hear the details of Basti's stronghold on the summit of that mountain in the harrowing desert.

'There is one path to the top, cut like a stairway from the rock,' Hui said. 'It is wide enough for only one man to climb at a time.'

Tanus frowned. 'There is no other way to the summit?'

'There is another route. I have used it often.' That was a lie, but it didn't hurt to instil confidence in his new benefactor. 'To return to the mountain after I had deserted my post to visit a lady friend. Basti would have had me killed if he had known I was missing. It is a dangerous climb, but a dozen good men could make it and hold the top of the cliff while the main force came up the pathway to them. I will lead you up it, Akh-Horus.'

When the burning sands had cooled, the column of men swept across the desert under the cover of night. The moon was a crescent, the light so thin they could move through the valleys of shadow between the dunes without being seen from afar.

Tanus pushed on his regiment of Blue Crocodile Guards with urgent exhortations. They needed to catch Basti the Cruel unawares.

The first time they rested, Tanus pulled Hui to one side.

'You have some skill with a sword,' he said, 'but you must learn to fight in battle. That takes a different skill. Come.'

With five members of the Blue Crocodiles surrounding him, Tanus pulled up Hui's shield arm.

'This is the correct position. We will start slow as you learn to dance like a soldier, and soon you will be moving like the wind.'

Tanus beckoned, and the first of the Blue Crocodiles moved in as if he were wading through water. He swung his sword in a slow movement and Hui raised his shield to block it. Then came the next soldier, then the next.

The following day they repeated the exercise, a touch faster, and each day faster still. Hui felt his reactions improving, his mind flashing, and, as Tanus had said, he found himself dancing amongst the blades, parrying and thrusting, balancing his weight with his shield.

'You are becoming a good warrior,' Tanus said to him, and he felt his heart swell.

Now, as the flat-topped mountain rose up against the starry sky ahead, Hui marched in step with Tanus.

Tanus scanned the silhouetted massif to the summit where the stronghold lay, and Hui knew he was judging the strategy, preparing himself for the assault.

'We could not have done this without you, Hui,' he said once he was done.

'I hope I do not let you down.'

'Do not doubt yourself. In battle, that is the first blow. A soldier wounds himself first, and the enemy wounds him second.'

Sometimes Hui felt his doubts would consume him.

'You are teaching me how to *act* like a warrior, Akh-Horus. But can you teach courage? Can you teach a man to have greater wits? Can you teach a man not to doubt? You were born to be the man you have become. And I . . . I was born to be the man I am.'

'What makes you say such things?' Tanus lowered his voice so that the others wouldn't hear.

'I was a boy who thought he was a man. I dreamed of a great life – a hero's life. I thought I had the courage, and the fire, to right a great wrong. But during the battle in Gallala, I was found wanting. I was shown to be a coward. I hid behind the fallen bodies of my comrades. I ran to save my own neck. Still, and always, a child.'

'Battle can drive even the most seasoned warrior mad.' Tanus stared to the point where the pale desert sands met the dark night sky. Remembering. 'No man is prepared for the first time he stares death in the face. When you see allies . . . friends . . . cut down, their bodies opened up to the air, when you feel the cold breath of Seth upon your neck. If you feel nothing in that moment – if you can carry on as if you are scything a field of barley – then you are not a man I would want to know. Your soul is withered, your heart as dry as the desert sands.'

Hui felt a hint of comfort.

'A good warrior is not cold stone. He fights because he feels for his fellow man. What is a hero? It is not someone born that way. A hero is a man who defeats his greatest enemy first – his own fear – and then carries on.' Tanus dropped his huge hand on Hui's shoulder and gave it a squeeze. 'Let me tell you what I see in you. I see honour. I see in your loyalty and dedication a warrior who recognizes that a great wrong must be righted, and sees it as his duty to do it, not another's. What happened at Gallala is not the measure of you. It is what you do next. Run, from yourself? Or fight? I think I know which one you will choose.'

Hui felt humbled by those words. Here was another lesson. If a great man like Tanus could see such things inside him, then perhaps there was still hope.

A figure strode out of the dark from the wastes ahead. It was Fareed.

'Basti has no guards at the foot of the mountain path. He has grown too confident in his belief that his stronghold is impregnable.'

'Good work,' Tanus replied. 'The rest of the task is ours.'

The column of warriors pushed on silently, their pace increasing as they neared the foot of the mountain. Not a sound escaped their feet as they crept up the winding track to the ledge where the Camp of Women lay, its occupants no doubt enjoying a peaceful slumber now most of the Shrikes were away. One of Tanus' closest aides, a robust soldier by the name of Kratas, ghosted through the dark and slit the throat of the dozing guard. Once the body had been tossed over the edge, the Blue Crocodiles massed at the foot of the narrow steps leading to the summit.

At the rattle of shields and the tramp of feet, bleary-eyed women came out of their tents. Tanus sent a group of men to calm them before their relief at being rescued alerted Basti's remaining force.

Hui watched Ahura search the ranks of soldiers until her eyes fell on Hui, and she nodded.

'I chose well,' she said once he had joined her.

'I would like to claim some credit for your rescue,' Hui said, 'but it is fate that has brought us back together.'

'And yet you are here, and I am free. Then, as always, we should thank the gods for how these things unfold.'

'Who is this?'

Hui turned to see Tanus looming over him.

'I am his wife,' Ahura said, without missing a beat, 'or soon to be.' She cocked an eyebrow at Hui, daring him to challenge her.

'Then we will celebrate once this business is done,' said Tanus, slapping Hui on his back and walking off.

Ahura pressed a finger to Hui's lips. 'This is not the time for talk. But do not forget . . . your life is mine now.'

As Hui made his way to the foot of the secret path, he tried to understand how he felt about what Ahura had said, but his thoughts were a tangle.

The entrance to the path was invisible to anyone who did not know it was there. Hui stepped to the front of the group of eleven men waiting, and Tanus eased in behind him.

'It will be us against whatever defences Basti has kept behind until Kratas can lead the rest of our force up the main approach,' Tanus said. 'Are you ready for that?'

'I am, Akh-Horus,' Hui replied.

'Then let the breath of the gods carry us up to the summit,' Tanus whispered to the men standing beside him, 'and let your swords sing a song of victory today.'

Hui edged out on to the path winding around the cliff side and rising steeply. It was fit only for goats, but the men pressed tightly to the rocky face, fumbling for cracks that would steady them. The darkness helped and the darkness

hindered, making each step treacherous on that narrow way, but also hiding the dizzying drops that would fill even the bravest man with fear.

Once the reek of the midden wafted down, Hui felt his stomach knot with apprehension. He crouched below that natural wall of jagged rocks that circled the summit and described to Tanus the lie of the stronghold beyond the lip. His words were passed down the line, so that every man was prepared as if he had lived in this fortress himself.

Finally, Hui pulled himself over the edge and crouched in the deep shadows beside the midden. The camp was still. One guard slumped at the top of the steps into the stronghold, drunk, by the looks of it. The campfire was little more than red embers, but the golden glow of lamps cut squares into the rocky ground around Basti the Cruel's palace. He'd be sleeping in his quarters at the rear. But how many men slumbered in the tent city on the far side?

Tanus raised his hand, and with a faint whistle from between his teeth, pointed it forward. The advance guard of the Blue Crocodiles swept out.

One of the men raced towards the guard at the entrance. But that was where fortune decided to abandon them. The guard stirred in what seemed to be the throes of a dream, and in that instant the sound of leather soles on stone reached his ears, and he snapped alert. He cried out an alarm before Tanus' man had rammed his sword into the guard's chest.

The signal to Kratas rumbled down the mountainside, a rolling bark like that of the baboons that Hui had heard on the clifftops above Gallala. But the sound was soon drowned out by a roar rising from the tents. Hui felt his blood drain from him as Hui saw the remaining Shrikes clamber out of their sleeping

places. They slept with their swords beside them, he knew, but at least they were not carrying shields or wearing their leather armour. A hundred, perhaps more – he couldn't begin to estimate the numbers.

'Get to the top of the steps and guide Kratas here,' Tanus barked to him.

As he raced away, the man who had slit the guard's throat passed him, returning to Tanus. He was grinning like a madman.

Hui crouched in the shadows at the top of the flight of stone steps. The clamour from the main force of Blue Crocodiles echoed up from below – battle cries and whoops and the beat of swords on bronze shields.

The silhouette of Basti lurched across the lamplight flooding out of the entrance to his palace. He was watching his cutthroat army fall like jackals on the handful of soldiers who had somehow found their way into his fortress, not realizing what was yet to come.

'On me, the Blues!' Tanus bellowed, his voice ringing above the din.

As they had at Gallala, his men swept into a circle, back-to-back, their swords levelled.

The first wave of Shrikes had yet to learn who they were facing. But once the first tranche of bodies littered the ground, the rest backed off. They still had the numbers and could take their time picking off this tiny group, however skilled they were with their blades.

But then the sound rising up the stone steps became a tumult, and a seemingly never-ending column of men flooded into the stronghold. Hui pressed against the cold rock, watching as the Blue Crocodiles surged into the midst of the milling Shrikes. This was no battle. It was a slaughter.

Hui saw the flashing blades, the spurts of crimson gleaming for an instant in the torchlight, the bodies falling before the relentless tide.

When the final Shrike had been killed, the warriors stepped into a wide crescent facing the entrance to the ramshackle palace. Basti glared at his hated enemies, but there was no escape for him.

Tanus stepped forward like a lion prowling towards his prey.

'Basti the Cruel!' he boomed. 'You are now my captive, by the authority of the pharaoh Mamose, and you will face swift justice for your crimes against the people of Egypt. The day of the Shrikes has gone. The age of peace and the rule of law has returned.'

At that, the Shrike leader threw his head back and laughed.

'Those words will come back to haunt you soon enough,' he said, his voice dripping with venom. 'You have no idea what lies ahead.'

The first rays of the sun carved through the deep shadows of the stronghold. As one, the soldiers raised their cups to the dawn and cheered. Ra had blessed them with another day. The air was thick with the stink of blood and the midden, but spirits soared. Another decisive victory for Tanus, the great Akh-Horus.

Hui perched on a rock looking over the stronghold, watching as the leader strolled amongst the Blue Crocodile Guards, congratulating his gore-soaked men. Tanus knew all their names, the details of their lives. He'd already allowed them to ransack Basti's stores of wine and beer, because he knew that men who lived in the shadow of death needed to celebrate life.

Hui could see why he commanded absolute loyalty from all who followed him.

Basti knelt with his hands tied behind his back, spitting bile at anyone who came near him. The bodies of the Shrikes had been heaped up next to the midden, a fitting place for them. Soon the Blue Crocodiles would ransack the stores of riches that had been looted from the people and heave the booty down those stone steps, to be returned to the authorities.

And yet, for all the celebrations, Hui felt no part of this victory. He'd done what had been asked of him, and he was grateful that Tanus had given him a new lease of life. But all of this was a distraction from his sole aim. He yearned to return to Lahun, to save Ipwet and to stop Isetnofret and her monstrous plans.

Tanus strode over.

'No beer for you? You have earned it. We would not have been able to storm this stronghold without losing many men if you had not shown us the way.'

'I am pleased that we have been victorious. But Basti's words haunt me.'

Tanus shrugged. 'He is a viper, not a raptor, and he will say anything to sow dissent and discomfort. Forget what he said.'

Hui hesitated. He knew what Basti had meant, but it was a subject he wanted to avoid for fear it would taint him. And yet he knew the Hyksos would attack sooner or later, and he could scarce believe that no one seemed to recognize the threat.

'I have heard tell of bands of barbarians, who have travelled from the east . . . ' he began.

Tanus looked distracted. 'There are always enemies. There are always stories of even more enemies.'

'These barbarians are different . . .'

The words died in his throat when Tanus narrowed his eyes at him.

'What do you know of them?'

'Nothing,' Hui replied with undue haste. 'Just talk, amongst the Shrikes. Of war bands pushing deep into Egypt, probing the defences, preparing for . . . who knows what. One of Basti's men told me our soldiers attacked one such band in the Sinai. If that were true—'

'If they were attacked, it was because they were bandits, like these Shrikes, preying on the caravans, and the mines, and disrupting the trade routes. No more than that. Have no worries.' Tanus looked into Hui's face again, as if he could sense something behind the new recruit's hesitant words. 'Unless there is something else you can tell me?'

Hui shook his head. He was not about to let Tanus think he was a traitor who had ridden with barbarians against Egypt. Bad enough that this great man thought him a lowly thief and cut-throat.

'Good. I have other work for you. Something only you would be good for.'

Hui frowned.

'My work is not yet done,' Tanus continued. 'Some Shrike lords still have their freedom. And I cannot rest until the Shrikes are crushed and all their leaders are dead, or my captives.'

'I know little of any other clans.'

Tanus waved a hand to silence Hui. He was impatient, his duty lying heavily on him.

'My spies tell me the remnants of the clan of Akheku who stayed behind to guard their plunder are hiding in the desert, hoping to rebuild their strength. They have been rudderless since I hacked off the head of their lord at Gallala, but I cannot

allow them to gain a foothold, or they will keep coming back like rats in a mill.' He wagged a finger at Hui. 'You, though, learned much in your time with the Shrikes, I would wager. How to spy. How to creep and crawl and sneak amongst men without drawing any attention to yourself.'

'That is true.'

It was, but Hui hadn't learned it during his time with the Shrikes. That had been his life ever since he had fled Lahun.

'My good friend Taita has returned to Thebes. I want you to carry a message to him, for his ears only, and I want you to do it without bringing any attention to yourself. Hiding in plain sight. No one must know you were sent by me.'

'That I can do,' Hui grinned.

And already he felt another plan forming in his head. If the gods were kind to him, here was his chance.

Hui hurried past the soaring obelisk into the teeming heart of Thebes. The crowd milled around him: wealthy merchants dressed in Assyrian silk and fine linen, and some of the most beautiful women he had ever seen, eyes bright with their malachite make-up, black wigs that gleamed like ravens' wings in the sun, cheek by jowl with filthy beggars in rags. Breathing in the sweet scent of jasmine from a nearby garden, a brief respite from the oppressive odour of sweat, he followed a street that led towards the harbour. His ears ached from the din of conflicting voices, all fighting to be heard. For all that he loved Lahun, truly Thebes must be the greatest city on earth. The stories did not do it justice.

Hui crouched in the shade of a date palm to catch his breath. As Tanus had told him, it was easy to hide in plain sight here. He could barely believe so many people existed in all Egypt,

never mind in this one place. The city sprawled over both banks of the Nile. Behind him to the east was the vast city of life, the pharaoh's palace and the Great Temple side by side, overlooking the homes of the rich, and then the one-roomed houses of the poorer folk reaching almost to the horizon.

Shielding his eyes against the sun, he squinted across the glinting waters of the Great River. There was the City of the Dead, the Necropolis, the monuments and the temples and the ordered processional streets. He pressed himself back as a column of pilgrims trooped by, chanting and clapping. Their robes had been dyed the colour of the sky with a yellow circle on the chest. Devotees of Ra. These acolytes travelled from all over Egypt to offer their prayers in Thebes, where the gods would no doubt hear them more clearly.

Hui joined the end of the pilgrim line. He still feared he might encounter Bakari on the streets, or be recognized by any of his men. Tanus wasn't to know that, of course, but he had to take extra care. He couldn't afford a slip at the last, not when he had come so far.

Fareed had guided him along the tracks from Basti's stronghold to the outskirts of Thebes, accompanied by three of the Blue Crocodile Guards to keep him safe from thieves. Many watched the approaches to the city to pick off merchants laden with wares. Once he'd arrived, he raced to the house where he'd been told the eunuch Taita was waiting, and delivered his message. It was about some woman or other, no doubt one of Tanus' lovers, but vague enough that Hui would never be able to discern her identity. It was clear the eunuch didn't think very highly of him. But he'd done his duty to Tanus. Then Taita had given him a message to take back. And he would . . . but not yet.

As the pilgrims neared the river, Hui slipped away into the throng of sailors and merchants. Huge ships creaked at their moorings along the wharf, and skiffs dotted the water like flies buzzing around a dozing hippopotamus. He watched slaves heaving bales and jars into the bellies of the vessels, and the rivermen inspecting the hulls for leaks.

His plan had been to sneak aboard one of the ships, to get as close to Lahun as he could. Whenever he allowed himself to think of his home, Hui was filled with worry for the safety of Ipwet. His sister was strong. But he could not judge what lengths Isetnofret had gone to. Had she somehow laid claim to the Ka Stone, thereby increasing her sorceress's power immeasurably? He could not say. But neither could he allow himself to give in to debilitating fear. He had to keep a clear head.

And yet, as Hui looked around, he could see the flaws in his scheme. He had nothing to buy his way aboard, and if he stowed away, he'd soon be discovered by the many crew members who milled about on the decks. It wouldn't be long before he was tossed overboard into the currents.

He prowled up and down the dock, trying to discover a way out of his predicament. Just when Hui thought there was no solution, he felt a hand tugging at his robe. He looked down and was shocked to see a familiar face. The boy who had accompanied him on the escape from Lahun, in the foul trader Adom's boat, was grinning up at him.

'You live yet,' he said.

'It takes a lot to kill a ditch-rat like me,' Hui replied, grinning back.

Bruises dappled Boy's face, no doubt from the back of his master's hand. Hui crouched, his own worries fading for a moment.

'What is Adom to you?' he asked. 'Master? Father?'

The boy shrugged. 'He is all I've ever known.'

'Do you have a name?'

'Adom says I do not need one. Boy is good enough for me.'

Hui felt a wave of pity for the lad.

'I will give you a name.' He thought for a moment, then said, 'Tau. It means "lion".'

'Tau?'

'Keep it with you in your heart. You will be a lion for the rest of your life.'

The boy beamed as if Hui had given him all the jewels in Egypt.

As he simmered at the cruelty of Adom, Hui felt a notion strike him.

'Your master is here?'

'Drunk, dozing by his wares, waiting to pay his taxes.'

'Do you want to help me teach him a lesson?'

Tau didn't need to be asked twice, and soon he was leading Hui along to the lower wharf where the smaller boats were moored. The boy jabbed a finger towards Adom's ramshackle skiff. Once Hui had impressed its location on his memory, he wandered several paces behind the lad to where his master was snoring. Adom's huge belly rippled with each rumble; his stubby fingers were folded on his chest, a thick line of drool falling from the edge of his lips. Hui crouched out of sight behind a mound of bales where he could watch Tau enact Hui's hastily whispered plan.

'Adom! Adom!' the lad cried. 'Someone is trying to steal your wares!'

Even drunk, fear of losing his earnings stirred the trader. He lurched to his feet, flailing his arms for balance. His

thoughts were several steps behind, in the throes of a drunken slumber.

Keeping his head low, Hui darted from his hiding place and nudged Adom seemingly by accident, as he pushed by.

The trader windmilled backwards to the edge of the wharf, where he hung for a moment, his eyes widening as his thoughts finally arrived. Then over he went, splashing into the river. Tau laughed and cheered and clapped, and Hui felt pleased to see such joy in the lad. He wished he could have punished Adom more, but the sad truth was that Tau needed his master as much as he suffered by his hand. A boy alone in the world would suffer a far worse fate.

From the water, Adom's cries rang out. Sailors and merchants rushed from all directions, some to point and jeer, some to save the trader from drowning in the currents.

Hui waved his thanks to Tau and raced to where Adom's skiff was moored. Throwing off the line, he leaped in and soon he was guiding it out into the waters.

'Now you think hard about the misery you cause,' Hui muttered, as he passed a dripping Adom being heaved onto the side.

Night fell and the hot desert wind cooled. Hui slumped in the skiff, letting the current carry him. He'd found the oars hard work, but the skiff was small enough to scull with both, leaning into one, then the other, at least for a while. But at this rate he'd almost have wasted away by the time he made it up the canal to Lahun.

The river was peaceful at that hour. The watermen had put into the banks to rest until dawn, when they could see

to navigate. Hui knew he couldn't afford that luxury. As he drifted, he sang a song his father had taught him when he was a boy, about how the river was like life itself, and soon he felt tears burning his cheeks.

When Hui saw the glow in the dark, he thought it was a trick of the moonlight. But he saw it was a fire somewhere beyond the edge of the fertile land.

The fire haunted him. Who would have a campfire there, at this hour? A caravan? None of the trade routes ran near this part of the river. Certainly not the Shrikes. If any had survived Tanus' fury, they'd be hiding deep in the wastes, not drawing attention to themselves. This was someone who didn't care if they were seen – who felt comfortable with the power they wielded.

Hui steered the skiff into the side.

As he crept away from the fields onto the rocky slopes of a hill, he breathed in a familiar scent and grinned. He'd been right, but he'd have to proceed with absolute caution from now on.

The Hyksos war band nestled in a shallow valley halfway up the hillside. The open end of the valley pointed towards the river – that was how he'd been able to glimpse the campfire. The breeze brought the musk of the horses to him once again. It comforted him; he'd learned to love those magnificent beasts as much as the Hyksos did.

The campfire crackled and the flames licked up to the sky. The wavering light washed over the tents and brought shimmers from the gold on the chariots lined up on the edge of the camp. The pen where the horses were kept was near the front of the camp as always, should the barbarians need to ride out at a moment's notice. He noted the silhouettes of the syces sleeping beneath the horses' bellies. He'd need to be more stealthy than he ever had been in his life.

Hui crawled around the lip of the valley until he was sure the only sentry was the one who waited at the valley's mouth, and then he slithered down the slope. As he neared the edge of the camp, he dropped low and moved with agonizing slowness. Those barbarians slept with one eye open.

This was the best chance he had of reaching Lahun fast and returning before Tanus missed him.

Hui eased alongside the edge of the tents. He could just make out the shapes of the dozing horses standing. The ones in a deeper sleep would be lying with their grooms curled beside them.

The pen, which the Hyksos carried with them and treated as lovingly as anything connected to their horses, was made of branches lashed together by leather thongs. It wouldn't support his weight if he tried to climb over. Instead, he felt along the top rungs for the gate.

Barely had his fingers slid along the wood than a soaring neigh cut through the silence of the night. Ahead, Hui could see the silhouette of a beast thrashing its head up and down, its mane flying.

Hui all but cried out in shock. But it was too late. From across the camp, rustling echoed. The chink of swords. Flaps torn open.

The Hyksos were rising.

The sound of a disturbed horse would have been like the alarm of a watchman to them. Hui scrambled along the pen, searching for the gate.

'What are you doing?' A sleepy-eyed groom bobbed up in front of him.

'Is that . . .? Is that Hui?' another said.

Hui reeled at the sound of his name. How could someone have recognized him? It was uncanny. Questioning voices rang out here and there. The tramp of feet moved his way.

'Where is the gate?' Hui barked.

'Three fences to your right,' the nearest syce replied, responding to the authority in Hui's voice.

As Hui began to fumble along the branch, the questioning voices became roars of alarm, the tramp of feet became thunder. He sensed the entire camp surging up towards him.

An arrow thumped into the ground near his feet.

'The next one will be through your heart,' a voice snarled. 'Turn around.'

Hui's hand crept over the thong tying the gate shut, but he knew how skilled those Hyksos archers were. He eased around. A line of barbarians stared at him from the line of tents, every man seemingly holding a cruel crescent-shaped blade. The one with the bow already had a second arrow nocked and had it aimed at his heart.

As Hui looked along that line of cold faces and black eyes, the barbarians at the centre parted to reveal a tall man striding towards them, silhouetted against the campfire.

'Who is this intruder?' the man roared, impatient that his night had been disturbed. He peered at Hui, and his features hardened. 'So, Little Rat, you have decided to return to us.'

The flames flickered and the shadows swept from the olive-skinned features of Khyan.

Hui stiffened. He'd expected the captain's body to have long been picked clean by the vultures. He was shocked that the war band had survived their encounter with the Egyptian unit, and that they must have been victorious, for their number did not seem diminished. And yet he couldn't comprehend why they were here, so far from the Sinai.

Khyan's smile tightened. He'd no doubt seen the surprise on the face of the runaway before him.

'A chance meeting, then. Our paths were always going to cross once more, the gods would have seen to that.'

'What are you doing here?' Hui asked.

The captain tapped the side of his nose. 'You think we are here by chance? We have been scheming for a long time, Little Rat, longer than you have been alive.'

Hui thought about lying, but he could see from Khyan's face that anything he said would be futile.

'I warned you what would happen if you did not remain loyal and true,' the captain said, as if he could read his thoughts. 'We took you in, treated you as one of our own.'

Hui watched a movement cross the captain's face – a sense of betrayal, perhaps, even hurt. After all, there had been kindness after Hui had saved his life. Teaching him how to ride the chariot, a secret that no one outside that clan would have learned, Hui was sure of it.

'You turned your back on our friendship,' Khyan was saying. 'When we needed you most, on the eve of a great battle. And you stole one of our bows. That could have cost lives. As it was, we were too strong, by far. The Hyksos never fail.' He paused, looking Hui up and down. 'I had not taken you for a coward, or a treacherous jackal, but that is my failing. And now I will correct my error. I will take your head myself. There is no point running, you know that.'

Hui knew it well. He'd seen how fast the Hyksos were, even on foot. He'd be dead before he got halfway to the sentry guarding the entrance to the valley.

Realizing he had only one option, Hui lunged for the thong on the gate, ducking low as he wrenched it open. He flung himself from side to side, knowing the archer wouldn't risk loosing his shaft and hitting one of the beloved horses.

As the gate swung open, Hui darted into the pen. The grooms fled from him, thinking him a madman. The horses stamped their feet and reared up, frightened by the sudden activity. One hoof lashed down towards him, a blow that could have smashed his skull. At the last, he rolled away, feeling the vibration as it smacked the ground, and then he was thrusting himself amongst the heaving mass of sinew and bone.

'Hai!' Hui cried as loud as he could. 'Hai!'

He threw himself up, waving his arms. Growing wild, the steeds crashed against him and he thought that he might be crushed. But he bellowed even more, until panic gripped the troop, and they crashed out of the pen and thundered into the camp. The barbarians leaped from their path as the horses ripped up tents and stampeded across the valley.

Hui caught sight of the horse he wanted, recognizing the blaze of white along the nose. Moon, his old steed, was wild-eyed, but Hui darted forward and calmed it with honeyed whispers and a stroking hand. Moon was the horse that had disturbed the camp with its neighing, he realized now. The beast must have recognized the scent of his former groom and had chosen to welcome him, for the bond between groom and horse was great indeed. And Moon was now the horse that would save his life.

He clambered onto the beast's back and urged it forward. Moon galloped out of the pen, and Hui turned it towards the entrance to the valley. He glimpsed Khyan racing towards him, sword held high. His face was twisted with rage. Hui had added insult to betrayal now, by trying to steal one of their prized stallions. Consumed with bitterness, the captain swung the sword over his head as he dashed forward. In that moment, Hui's death was all that mattered to him.

Reacting instinctively, Hui urged Moon towards Khyan. The captain flailed backwards as the beast thundered towards him, and at the last moment Hui turned his mount again. As it shifted its weight, he lashed out with his foot. His leather sole crunched into the captain's face and he spun to the dirt.

'Away, Moon, away!' Hui cried, and his ride pounded towards the entrance to the valley and the moonlit track leading down the hillside. Gripping on for dear life, Hui peered over the horse's head and saw the sentry had abandoned his post. He breathed a sigh of relief. No more fighting for now. The way was clear.

The rider thundered across the barren ground, raising a cloud of dust in his wake. Ahead, the lamps of Lahun blazed during the hour before dawn.

Hui had been riding hard since he'd escaped the Hyksos camp. Wherever possible, he'd tried to pick a path over stony ground so Moon's tracks wouldn't be visible. Sooner or later the barbarians would discover the direction in which he'd ridden – he knew how good their scouts and trackers were – but he hoped he would have completed his mission before they caught up with him.

And if they took his head then, so be it. At least he would finally have delivered justice for Khawy.

The white walls of Lahun loomed out of the dark like the bleached bones of a giant beast. The lamps in the watchtowers winked as the watchmen passed in front of them. By now they must have heard the beat of Moon's hooves drawing nearer, even if he was lost to the dark. Sure enough, a cry of alarm rose up, leaping from mouth to mouth along the wall.

This would be the critical moment. Somehow Hui had to gain entry without any alarm being raised, and then slip away into the Upper City, unrecognized. A feat worthy of the gods themselves! But he'd formulated a plan.

As Hui neared the gates, he slowed Moon and turned him so he could trot along the length of the wall, easily seen in that band of light from the lamps. Hui imagined those watchmen marvelling at this great creature. They would never have seen its like before. That surely would still their tongues and encourage them to investigate it further once he was inside.

Hui was surprised he didn't hear gasps of exclamation or excited questions about the strange beast he was riding, but the gate ground open nevertheless. It was strange. He guided Moon through the pool of shadow and into the lamplight beyond.

One of the watchmen greeted him as if he were an old friend. Hui was puzzled. These men would never have seen a horse before. And why wouldn't they be confronting a stranger who had arrived in the hours of darkness?

But Hui wasn't about to question his own good fortune. Keeping his head down so his face wouldn't be seen, he slipped off Moon's back and led him to one of the troughs for the merchants' donkeys. Once he'd tied his steed to the post, he stroked Moon's neck in thanks for his service and slipped away.

The warehouse he'd set fire to on his escape had been repaired, but charred streaks still scarred the walls. A faint hint of burning drifted from the interior, but it was soon swallowed by the reek of the middens amongst the shacks of the poorest in the Lower City.

Lahun still slumbered, but it wouldn't be long before the city would be stirring to begin its day's work. Hui needed to have

completed his task by then, and be riding back for Thebes, if he wanted to have any hope of survival.

He felt relieved to breathe in the jasmine-scented air of the Upper City. He felt a prickle down his spine, no longer remembering the streets as when he ran about as a spirited and carefree boy, but when he had been dragged through them as a captive accused of murder.

Hui found himself standing outside his father's house – though it was now the den of a murderous vixen. He looked up the walls to the flat roof, where he and Khawy used to sit and talk and watch the changing moods of the city. The thoughts stung him and the grief rose as clear and sharp as it had on the day his father had died.

His fingers closed around the handle of his knife and tightened until he thought his knuckles might break. One slash across that proud throat was all it would take.

Hui eased through the gate and crept towards the house. Inside the dark hall, he breathed in and realized it smelled different – sourer somehow, as if goat's milk had curdled. He imagined his mother labouring over her potions and poisons now there was no one to condemn her, chanting spells and calling down curses.

As Hui ghosted across the limestone floor, the dim sound of voices rumbled to his ears. Why anyone should be awake at that hour, he couldn't imagine. Following the low drone, he found himself outside his father's office. It was flooded with lamplight. Hui ducked behind a column and listened.

It sounded like three men, and one of them sounded familiar. And sure enough, Qen strode into view. His brow was furrowed, his face as dark as when he was engulfed by those bouts of rage as a youth. He was hammering his fist into his palm. Hui felt

his own anger when he saw his brother was wearing his father's finest robe, ivory in colour and embroidered with an intricate design of the sun in gold and scarlet – Ra's chariot, spreading his bounty upon the earth.

'There must be no room for error,' Qen was saying as he paced around the office. 'Everything we have planned, for seasons upon end, depends on this meeting today.'

'We are well prepared.'

Hui eased to the other side of the column and saw the speaker was Madu, an aged, wealthy merchant, large-bellied with a deep voice. The third man was smaller and quieter, with dark skin and hollow eyes. Zaim was his name.

'But we can take no risks,' Qen replied. 'The Hyksos like to talk, and barter, but they can easily take what they want, with blood aplenty, if they do not like what they hear.'

'There is no reason for them to attack us,' Zaim said, barely louder than a whisper. 'We made that clear. We are friends.'

Qen snorted. 'The Hyksos have no friends. All they see are people who will give them riches and power, and people who defy them.'

'I understand that your heart is pounding and your blood is high when there is so much at stake,' Madu said, trying to calm Qen. 'But we have been with the Hyksos long enough now, first in their desert camp and then here, you know that. We have thrashed out our agreement, and they seemed happy with the arrangement we proposed. They are already walking the streets of Lahun as if it is a home from home.'

Hui gritted his teeth. Now he understood what he'd seen and heard before he fled Lahun: the Hyksos war band roaming so close; Qen's attempts to persuade his father to adopt a milder

approach when dealing with the barbarians. How long ago had this treachery been set in motion?

Qen closed his eyes and pushed his head back, sucking in a calming breath.

'You are right. We share a bond. Our service to Seth, and their own worship of Sutekh – different names, but the same god. They understand our rituals and our prayers. We can see into each other's hearts, so it is only right that we share power here in Lahun.'

Zaim nodded. 'With you as governor, and your mother at your side, and all of us as faithful advisers. This is better than bloodshed. The Hyksos are coming whatever we do, and they will sweep across Egypt like a crimson tide. Lord Bakari seemed to have little interest in them. If this is how things are around the pharaoh, no resistance will be planned until it is too late. Why should we not look after ourselves?'

Look after yourselves, Hui thought with a burst of anger, *while selling out the city and everyone who lives here to those bloodthirsty barbarians who would drain Lahun dry of riches and turn all the citizens into slaves.*

His father would never have agreed to that, not even if Lahun had been under siege. Hui conjured a vision of Khawy making plans to raise an army to fight any barbarian assault. Was that another reason for his murder, beyond mere jealousy? Had Isetnofret and Qen already decided their fortunes lay with the invaders?

This was why the watchmen at the gate were unsurprised by the sight of a horse. They'd been seeing the Hyksos emissaries ride up time and again, and most likely thought he was one of them.

'All will be decided when the Hyksos negotiator arrives today,' Qen said with relief.

Was Khyan the negotiator, or was he guarding that man in his war band? Hui wondered. That would explain why he had ventured so far from the Sinai.

'And it will simply be a matter of waiting until the Hyksos enact their plans,' Madu continued. 'Soon, I would think. All praise to Seth, Lord of Chaos, our God of Fire and the Desert.'

'All praise to Seth,' Zaim said.

'All praise,' Qen muttered as he slumped onto a bench.

His face was drawn and he looked like he'd aged ten years since the last time Hui had seen him.

Why don't I hate him? Hui wondered.

By every right, he should. Yet even after Khawy's murder, all Hui could see was the boy he'd grown up with, played with, cared for those long years.

Now, time had grown shorter. If Khyan was arriving in Lahun shortly, Hui knew he'd be recognized by those barbarians swarming through the city and then his fate would be terrible indeed.

Qen and the other two men seemed to be settling into a discussion about another ritual that Isetnofret would be conducting in Seth's name that night. That should give him time to end his mother's life without Qen discovering him. There was little he could do about the Hyksos. Lahun's fate had been decided. But what then of Ipwet?

At the thought of his sister, Hui felt his stomach knot. He would go to her before he left, try once again to persuade her to come with him. Fate might have made him that way, but that was what he now was, he was convinced.

Hui ducked out from behind the column and slipped into the shadows beyond the light from the office door. He murmured a prayer, knowing it would take only a glance in his direction

for Qen to sense his movement in the dark, and with his heart pounding, he swept past the doorway to the stairs.

As quietly as he could, Hui hurried up the stairs to the bedrooms. He felt a strange calm settle on him as he padded towards Isetnofret's room. Everything he had done since fleeing Lahun had been leading to this moment. Finally he would find peace. Finally his father would be avenged.

Hui gripped the knife in front of him, turning the blade slightly so that it caught the moonlight flooding through the window.

One slash, he told himself. *One slash.*

He pressed against the wall at the edge of Isetnofret's door, listening. The steady rise and fall of breathing. Asleep, perhaps dreaming. Of what? The power she was soon about to have in her hands, the ultimate power standing behind Qen with all Egypt before her, manipulating him, twisting him, corrupting him further?

Hui stepped into the doorway.

Isetnofret lay on her bed, naked, her breasts splayed, her black hair spread out on her sumptuous pillow. The moonlight fell across her bared throat, almost as if the gods were showing him the way.

Hui raised the knife. His hand was trembling.

Hui choked back a sob. He had to do this. He had to end his mother's life, for all she had done and all she was yet to do. His head flashed with the vision of her blood spurting, soaking the white linen beneath her, Isetnofret gurgling, clutching at her throat, and him leaning over her, soaked in her blood, watching the light die in her eyes.

And yet where was the joy he should be feeling at imagining that sight? Where was the release – the peace?

His shaking hand dropped. He'd learned to fight and to kill, but Hui was no cold-blooded assassin. He'd never thought he

would feel this way. He would have to force himself to do it, then, though he'd be damned to all eternity. He'd vowed it to himself, on his father's memory.

Hui moved one foot across the threshold.

A hand fell on his shoulder and he almost cried out, but those gripping fingers wrenched him back, spun him against the wall and another hand was clamped over his mouth before he could utter a word. A face pressed so close he could feel breath bloom on his cheek, and he realized he was staring deep into Ipwet's eyes.

They sparkled with warm recognition at seeing her beloved brother again, and Hui felt a swell of love that surprised him. Ipwet pressed a finger to her lips, just to be certain he would do nothing so foolish as crying out, and then she tugged him away and into her room.

Ipwet threw her arms around him and buried her face in his shoulder. She held him like that for a moment, in silence, and Hui thought he could feel tears on his skin, but no, that would not be his sister. When she pulled back, she beamed at him.

'I always knew you were a fool,' she whispered. 'Returning here, where a sentence of mutilation and death hangs over you. Were there any rational thoughts passing through your mind, any that made sense?'

'I came to save you . . .' Hui began.

'You thought I might be sleeping in Mother's room? Whatever you were planning – and I will not dwell on the right or wrong of it – this is not the time. One more step into Isetnofret's room and you would have been dead.'

'Isetnofret was asleep.'

'Yes, but the things she conjures every night before bed would be watching.'

'Things?'

'Mother is a sorceress, you know that as well as I. What she is truly capable of . . .' Ipwet shrugged. 'But if you go back to her room now, and look down, you will see a circle painted on the floor around her bed and the glyphs of summoning. She warned me never to go in there during the hours of darkness. One time I ventured close, and I swear I heard the sound of hissing, as if the room was seething with venomous snakes.'

How much of this was real and how much was Ipwet's imagination, Hui couldn't decide. But he feared Isetnofret, there was no doubt of that. She was capable of anything.

As his surprise at seeing his sister waned, Hui glanced down at her and saw she was wearing little more than rags, stained and grubby. He felt shocked. He could only ever remember Ipwet in the finest dresses.

She followed his gaze.

'Mother was not happy that I helped you escape.' Her voice dripped acid.

Hui let his attention drift around her room, and now he saw it in a new light. The bed was gone and had been replaced by a mat of rushes like the slaves slept on, and all her possessions had been removed. He felt sick to see his sister punished so, and could only imagine what hardships Isetnofret had heaped upon her.

'She hasn't harmed you?' Hui breathed.

'No.' *Not yet* left unspoken.

Hui felt a rush of relief, but he knew it was only a matter of time until Isetnofret demanded a more brutal revenge.

'And the Ka Stone?'

'Long gone. Taken by Lord Bakari.'

Hui's relief soared higher. How his mother must have hated that.

He gripped his sister's shoulders and said, 'Isetnofret has to pay for Father's death.'

Ipwet's eyes were liquid in the dark, but then the first rays of the sun broke through the window and flames flickered in the centre of them.

'I will not stand in your way. Mother has revealed herself in many ways since you have been gone. She has a black heart. I fear what she is capable of. But I fear also what this act will do to you. You are not the man I see before me.'

'I am.'

'No,' she said firmly. 'The real you still hides within like a frightened child, and you must do nothing to harm him.'

'A child? I have ridden with barbarians, raided with cut-throats, and fought at the side of the bravest soldiers in all Egypt.'

'And yet still a boy.' Ipwet touched his cheek.

But then her smile faded and disgust seemed to swallow her features.

'What is it?' he asked.

'I am to be offered for marriage today.'

'Married? To whom?'

'To a Hyksos warlord, of course. Who else?' Her voice was bitter, and she looked away into the dark corners of her room. 'A loathsome man, filthy, cruel and cold.'

'This is madness.'

Her laugh was hollow. 'Madness? Not at all. This makes perfect sense, to Isetnofret, at least. What better way to seal the agreement with our new masters and to punish me in the process?'

Hui felt sickened to see the dismay in his sister's eyes. True, Khawy had arranged Ipwet's marriage to try to join with another powerful family. That was the tradition. But this was different. To throw Ipwet to the barbarians, who had different ways, different beliefs, merely to secure his mother's grip on her own power. He didn't think he could hate Isetnofret more, but now he did. First Qen, now Ipwet. Both her children used as pieces

in her great game of *senet*, played by king and common man and representing the journey of the *Ka*, the spirit, to the afterlife.

Hui moved to the door, his determination to end his mother's life renewed. But then he glanced down and saw the ruddy light of the rising sun burnishing the blade of his knife to the colour of blood. The shadows were flooding away from Lahun. A new day was dawning, and soon the Hyksos would be here. His gaze flickered to Ipwet's desperate face.

He could kill Isetnofret, whatever conjurings she'd made to protect her room, he was sure of it. But could he stop her crying out? Qen and those others would hear. The chance of him escaping would be slim.

And then Ipwet's life as she knew it would be over.

When he'd played through the scenarios in his mind during the long nights of his exile, he'd imagined his own life would be forfeit for his revenge. Hui was content with that. But he couldn't abandon Ipwet.

'Come with me,' he growled. 'Come with me now and we will leave Lahun behind. I will hear no protestations this time.'

Ipwet nodded, her eyes bright with love. She ran to him and grabbed his hand, and together they swept past the bedrooms and down the stairs. Hui felt a momentary stab of bitterness when he passed Isetnofret's bedroom. For so long he had burned with the desire for revenge, but this night he had learned there were things in life that were more important, like saving Ipwet and the love they shared. He would not forget what he had planned for his mother. Her fate had only been delayed.

Voices droned in his father's office. Hui urged his sister to be as quiet as possible. Qen and the others were laughing and clapping and whipping up merriment. Hui and Ipwet tiptoed by until they reached the door, and then their feet were flying over the stones.

Hui glanced at his sister and saw she was laughing silently, but joyously. To her, this liberation had never been a possibility. But he'd saved her. He, Hui, the black-hearted rogue, the coward, the failure.

Down through the Upper City they raced, and into the Lower City, hand in hand, as Lahun came to life around them. Bleary-eyed men staggering out from their shacks to relieve themselves on the edge of the street. Children bawling for food. Mothers singing to calm their babes. The potter carrying an armful of charcoal for his furnace.

Hui and Ipwet raced with abandon, her skirt flying behind her, until they reached the street that ran alongside the wall. The night watchmen clambered down their ladders from their towers, calling a cheery goodbye to their comrades, and the day's watch trooped up, sour at the task that lay ahead.

By the trough, Moon tossed his mane when he saw his master approaching. Ipwet gasped.

'You have one of these beasts?'

'His name is Moon. He is as bright as the orb that lights the night, and strong and fast.'

Ipwet stared at him as if he were mad.

'A horse, Hui. You are not Hyksos.'

'I can ride like one.'

'Tell me you do not expect me to ride on that thing?'

'I expect you to use those wits that always ran rings around me. You ride, and we escape. You do not ride, and you wait here for your new husband.'

Hui laughed, but when he looked into her face, he saw the fear there.

'You must trust me,' he urged. 'I have learned how to ride, and ride well. Put your arms around me and cling on tight, and

we will fly across the desert like the wind. To a new life for you – a better life.'

'Where?'

'In Thebes.'

Hui was certain Tanus would help him find a place for Ipwet to live and a way for her to keep fed.

'I told you, I am a well-respected soldier now. I bask in the glory that is showered on the Blue Crocodile Guards. Trust me, Ipwet. You saved my life, and now I will save yours. Thebes is a city of wonders, and all that it has to offer will be yours.'

Hui could tell she recognized his silver tongue, but for once she didn't scorn him. She nodded, and soon she was sitting on Moon with her arms wrapped around her brother for dear life. Hui bellowed for the gates to be opened, and urged Moon into life. As the horse heaved into a gallop, Ipwet screamed, her grip grew tighter, and Hui imagined her with her eyes screwed shut. He laughed, with a deep joy that he hadn't felt for a long time.

The shadow of the wall swept over them, and they were into the wastes, with clouds of dust billowing around, riding hard towards the red sun wavering on the lip of the horizon.

The thin cloud of dust shimmered in the heat haze. Hui felt his heart sink when he glimpsed that line rising up from the wastes and rolling towards them. It could only be one thing. And he knew that if he could see the Hyksos war band approaching, Khyan would be able to recognize the telltale dust cloud of a lone rider crossing the empty land. How hard would it be for him to realize it was the hated Hui, who had betrayed him and stolen one of their prized steeds?

'Perhaps they have not seen us?' Ipwet called at his back. Her intelligence was sharper than his, and she'd already divined what that cloud meant.

'Hyksos eyes see across great distances, for they spend their days with their horses on open land. They will have seen.'

Three smaller clouds broke away from the rolling storm, turning and flying like an arrow towards them.

'Hold tight!' Hui bellowed. 'The barbarians are more skilled in the saddle than I am, but we must pray their steeds are already weary from the distance they have travelled.'

Hui dug in his heels and Moon thundered faster, turning away from the caravan track.

'They have too much distance to make up,' Ipwet said.

'They only need to get close enough to use their bows. The Hyksos can ride as fast as the wind and still send a shaft true enough to hit a blade of grass.'

Hui leaned over his steed's neck, feeling the breeze tear at his face. Moon was strong and fast, but away from the track the sands edged into rocky terrain and he couldn't risk the beast breaking a leg.

He sensed Ipwet twist round behind him.

'Still coming,' she said. 'And they are closing.'

Hui felt the fire in his heart blaze brighter. He would not fail his sister. She deserved the life he had promised her.

'If there is one thing I am good at, it is running and hiding,' he said, trying to raise her spirits. 'And drinking and gambling and taking things that are not my own.'

Whatever she replied, there was only the throb of the hooves on the ground and the beat of the blood in his head.

Around sweeping dunes and the jagged teeth of rocky out-croppings, they rode for what seemed like an age, until Hui squinted ahead and felt a glimmer of hope.

'I have a plan,' he said.

'You always have a plan,' Ipwet murmured.

He didn't hear joy in her voice.

The land ahead was carved by low valleys, arid channels where rivers and streams had rushed during the flood season in days long gone. When the reservoir and the canal to Lahun had been built, water from all over this area had been diverted to a new path.

A wise man would have ridden along the edge of those treacherous valleys, but Hui guided Moon down the slope into the old river bed. They'd lost some time negotiating the rocky incline, but now they were below the level of sight of their pursuers.

Hui dug his heels in again, pushing Moon as fast as he dared go. They rounded towering rocks, which once must have been islands in the stream, and leaped over crevices. These channels and tributaries were a maze, some barely wide enough for Moon to trot down, some so shallow they would have been visible above the level of the land.

Hui muttered a prayer, choosing paths at random. If the barbarians wanted to search for their tracks, let them. They'd lose valuable time dismounting and examining the ground for signs.

Finally, as the tributary they were riding along died out, Hui brought Moon to a halt and cocked his head. The wind whined, but beyond that, only silence lay across the land.

'We have lost them,' Ipwet breathed with relief. 'Your plan worked. For once.' She hugged him. 'I might even begin to believe these wild tales of you being a skilled and courageous soldier.'

Hui laughed. 'Thebes, then, and a new life.'

But as they rode on towards the Nile, he glanced back. Lahun still waited in the distance, and Isetnofret and Qen would be celebrating a great victory, even without a marriage to bind it. That could not stand.

He would be back.

Blades of light flashed out from the gold box. The crowds lining the street gasped when they glimpsed the chest, blazing in the sun at the head of the slow procession of nobility and solemn priests moving towards the great temple of Thebes. How brightly it shone. Surely it must contain the power of Ra himself, many thought. And perhaps it did.

As the hiss of breath ebbed, the only sound to break the still of the morning was the steady tread of the leather soles of the priests in their pristine linen robes, eyes shadowed by azure make-up. Never had the tumultuous City of a Hundred Gates been so silent. Never had its populace been gripped by such reverence.

The onlookers bowed in awe as the chest drifted by, but Hui stared at it with a different emotion. He'd once clutched the contents to his breast. Wings took flight from each of the four corners of the lid. On the sides, craftsmen had engraved an intricate pattern of rays emanating from a circle, representing the power of Ra, the life-giving sun itself.

And inside rested the magical gift of the gods – the Ka Stone.

Hui looked past the line of shaven-headed priests and along the vast procession. At the rear, the members of the court walked in their finery, chins raised, gaze fixed ahead. For some reason, the pharaoh had decided to move the court from Elephantine to Thebes. Perhaps it was the rising threat from the Red Pretender, the false pharaoh who ruled over the northern reaches. Whatever the reason, it must have been great indeed to explain the decision to bring the Ka Stone from the temple where it had been held since Bakari had transported it from Lahun. Surely

the king must be concerned if he felt he needed the power of the gods close at hand to protect him at all times.

Hui's nose wrinkled at the sweet scent of incense. One step behind the priests, the temple boys were swinging silver plates on leather thongs on which the incense smouldered. Ahead, one boy sprinkled asses' milk to anoint the ground over which the Ka Stone passed.

Hui thought back to the passion he'd felt when he first stole that magical rock from the Shrikes. He'd been convinced it would change his life. And it had – but not in any way that he'd imagined.

As the golden chest passed, Hui's hand slipped unconsciously to the hilt of the new bronze sword hanging at his side, a mark of his rising status in the Blue Crocodile Guards. Tanus had been pleased with how he'd accounted himself on the secret mission to deliver his message to Taita. Akh-Horus had decided his new recruit was someone who could be trusted. The eunuch was not convinced, but once Tanus had made up his mind, no one could divert him.

And Tanus' spirits were high. Peace had come. For the first time in living memory, the Shrikes no longer preyed on the people. New farms were being built along the fringe of the fertile zone, an area that would have been deemed too vulnerable to bandit raids only a short while ago. Trade along the Nile had increased by almost a third, the river swelling with so many vessels that some said it was possible to walk from one bank to the next without wetting feet. Caravans clogged the routes from the east across the Sinai and along the banks of the water. The miracle that Tanus had achieved had transformed the lives of everyone, and it was said the pharaoh himself had the greatest respect for his general. Tanus had been rewarded with a greater position in the army, and all the resources he needed to swell the

ranks of soldiers and build more war galleys for the never-ending struggle against the Red Pretender in the Lower Kingdom.

All was well with the world. Except . . . Hui's eyes flickered to the west, and to Lahun brooding beyond the horizon. What lay there haunted his dreams. He could never find peace until all was put right.

As Hui stared into the haze beyond the river, he sensed eyes upon him. He glanced back to the procession. One face was turned in his direction. Eyes like deep wells, cold and dark. Granite features hardening, the lines deep shadows in the bright sun. A tall man, skeletal, a tomb revenant.

Bakari.

Hui shuddered and retreated, the crowd folding around him as if he had slipped beneath the surface of the river.

Had the saturnine lord recognized him, after all this time? Perhaps he had mistaken the malevolence in that glare.

Though Hui tried to calm himself, his feet flew away from the crowds, deep into the heart of the city.

Hui ran through the cool shade of narrow alleys, away from the grand whitewashed buildings. Dust clouded at his heels until he slowed and glanced over his shoulder. He wasn't being followed.

Slumping on the mud-brick wall of one of the compact homes, he sucked in a breath to steady himself before he entered.

Ipwet stepped out.

'There will be a death in this house before too long, mark my words!' she raged.

Hui sighed. 'Again?'

'Speak to her, before I . . .' The words died in her throat and, with a shriek of frustration, his sister threw her hands in the air.

Hui trudged by Ipwet and into the house. Inside, he felt heady at the perfume of lavender and rose, a far cry from the dank odours that had seeped into the brick when Tanus had first found this residence for his loved ones.

Ahura was standing in the centre of the hall. Her lips curled into a smile that many would have thought sweet, but Hui knew to be challenging. She, too, had been changed since her liberation from Basti the Cruel's stronghold. She was clean and fragrant, the bruises that dappled her body now fading. Her hair shone; her dark eyes were framed with shimmering copper make-up. Her plain linen dress hugged her curves, the spotless cloth glowing in the gloom of the room.

'Ahura,' Hui pleaded, holding out his hands.

'Your sister is like a rose petal,' she said. 'So easily bruised.'

'These arrangements are not perfect, but for now they are all you have. You must learn to live well together.'

'Why, I am as bright as a plate of gold. It is your sister who is the little black cloud.' Ahura raised a finger. 'She seems to think that I am some filthy whore, or a slave who must bow her head to the high-born lady. But we are equals, her and me.'

'I have never said anything other than that!' Ipwet raged at the door.

Ahura shrugged, half-turned away.

Ipwet's eyes blazed, but before she could snap back, Hui raised his palms.

'You have both endured hardship. You have both faced a miserable fate. And now you are free. Celebrate this time, I beg of you.'

'Very well,' Ahura sniffed, still taunting.

'If this is how you spend your days, I am happy my bed is in the barracks of the Blue Crocodiles.' Hui paced around the

room. 'We have bigger matters to occupy us.' He told them of Bakari's cold glance and the fears building inside him.

'You are no longer an outlaw,' Ahura added. 'You are a valued soldier in Pharaoh's army—'

'And Bakari has Pharaoh's ear.'

Hui slumped onto a stool, his head falling into his hands. He was sick of running and hiding. He could not bear fleeing Thebes – not now, when his life finally seemed to be moving back into the light.

Ipwet bit her lip. 'Perhaps it is time to clear your name. Start afresh.'

'How? The trial has been conducted, the judgment passed. I have been found to be a murderer. My sentence is clear.'

'Perhaps he did not recognize you,' Ipwet pressed. 'And even if he did, Thebes is a city brimming with multitudes and you are one face amongst them. This is not Lahun. And besides,' she continued, 'there is much to distract him. The war with the Red Pretender will soon burn hotter still, now that he has crossed the frontier to capture Asyut, or so the gossip says.'

Hui nodded. Perhaps they were right.

Once Ipwet had slipped out to see if she could find more from the wives on the street, Hui turned to Ahura.

'My sister is a good woman.'

'She is. I am not blind. It is possible we are too much alike. We both have a fire that burns brightly in our breasts.'

'That is true.' He sighed. 'Do what you can to find some common ground. If there is peace here, I can turn my mind to what we need to do.'

'Like seeing your mother again.' Ahura drew a finger across her throat.

Hui felt his face tighten. 'Fate has thwarted me time and again, but that is because the gods have decided it is not yet time for my vengeance. It will come. Soon, I hope, I pray.'

'You will find a way, a man like you.'

Hui felt surprised by Ahura's response.

Was that tenderness I heard in her words? Respect?

He found that hard to believe. She posed as his wife here in Thebes, to Tanus' amusement, but she no longer gave herself to him. There was no longer any need. And yet he feared he loved her, and probably always would, whatever her feelings towards him. She had a soul that raged like fire, and he was drawn to her like a moth to the light.

'Vengeance is something I understand,' she was saying, her voice as low and hard as it had been on those nights in the Shrike camp. 'I have thought long about visiting my heartless father again. I have not forgotten his abandonment of me. But for now, I can bide my time. As can you.' She leaned in and breathed in his ear, 'Dream, dream hard, and the way will open up before you.'

'The gods have cursed me.' The eunuch's voice was bitter as he stood in the doorway of his house.

Hui proffered an apologetic smile.

Taita stepped aside and swept an arm to usher him in. 'More business from Tanus? I have barely seen him in recent times, with the demands imposed upon him by his new elevated status, and all the work he is overseeing in the shipyards.'

Taita was wearing a robe embroidered with bands of many colours upon the chest and tied at the waist with a crimson sash. The skin of his forearms glistened with oil, and Hui could smell

the gentle fragrance of lemon and sandalwood rising from the warmth of his body.

'Akh-Horus, I am sure, would wish me to pass on his deepest regards to his greatest friend,' Hui said with a bow. When he looked up, Taita had narrowed his eyes. Too wise by far, this one. He could see through any ruse, Hui thought.

'Tanus has been greatly pleased by my loyal work for him,' Hui continued with haste. 'The message to you, and from you, and the rest of it. And it seems I have earned his trust. He has raised my status alongside his own.'

'Ah. You are a general now?'

'Not as yet. Not quite. But in time? Who knows?'

Taita's eyes fluttered shut, and he breathed deeply as if he was trying to contain a sneeze.

'The important thing is, he trusts me,' Hui said, sensing the moment slipping away from him. 'And of course Tanus trusts you. I would say for a man like Akh-Horus, that trust is a measure of the both of us.'

'Speak, I beg you. I can feel the life draining from me.'

Hui looked around the cool room, with its hanging strips of gauzy linen billowing in the breeze through the window, and saw heaps of scrolls, and ink-pots and brushes and papyrus, and he knew he had come to the right place.

'Tanus tells me you are the wisest man he knows. Perhaps the wisest man in all Egypt.'

'Go on.'

The eunuch's features pinched into the familiar haughty expression, but Hui thought he saw a flicker in the eyes that suggested his flattery was working.

'You know about the history of this land, and the line of kings, and the timing of the annual flood, and the flight of

birds and the movements of the river cows and the croco-
diles, and these are all great things. But Akh-Horus tells me
you also know about the higher skills – of healing through
medicine, and prophecy and dreams, and the ways of the
gods.'

'Some of these things are within my purview, yes.'

'Then I beg for your aid. Guide me—'

Taita held up a hand to silence him. 'I have important work
at hand. Do you think I am at the call of every thief and rogue
in Thebes?'

Hui felt despair, but then the eunuch's face softened.

'Enough time has been wasted already,' Taita said, waving
his hand. 'Speak, then. But do it quickly.'

'I had a dream, and I would know the meaning of it.'

'We are told there are two forms of dreams. Ones which are
false and designed to deceive. And ones which are informative –
prophetic – sent by the gods to guide the dreamer.'

'This one was sent by the gods. They visited me in it.'

Hui described his vision of Seth and Anubis which had come
to him after he had witnessed Isetnofret and Qen engaged in
the ritual of their cult. He watched the eunuch's brow furrow
and his gaze grow distant. He was clearly intrigued by what he
was hearing.

Once the tale was told, Taita tapped a slender finger on his
chin and said, 'The gods have indeed spoken to you.'

'What does it mean?'

'"Who will be king?"' the wise man mused, repeating the
words Hui had heard from Seth on that vast, featureless dream-
plain. 'Osiris. Killed and mutilated by his own brother, Seth.
This is a warning to you, to watch out for someone close to you
who wants to do you harm. You have a brother?'

Hui felt the hairs on his forearm prickle. If only he'd understood this communication from the gods that night, he might not have trusted Qen so much, and then, perhaps he would have found some way to prevent the plot.

'Who will be king?' Taita continued. 'Who will win this battle and inherit the world. You know the story of Osiris? You must do.'

Hui did, but he said, 'Tell me.'

'Osiris, the great king of Egypt, was murdered by his brother Seth to usurp the throne. Osiris' wife Isis restored his body so they could conceive a child – Horus. At first Horus was vulnerable and needed the protection of his mother. But he grew into a powerful warrior who became Seth's rival for the throne. Horus was ultimately triumphant, and in his victory restored the balance of Ma'at to Egypt.'

Hui sensed the parallels with his own life. He shivered, feeling the cold touch of destiny on his spine.

'And Anubis?'

'Anubis weighs the heart and decides which souls will be allowed into the afterlife, my little thief. He decides who is worthy.'

Hui squirmed. The eunuch's eyes seemed to be boring into him, as if this man could read every thought passing through his head.

'The gods are watching you,' Taita continued, 'and they are judging you.'

Could they judge me more than I've judged himself?

Now Hui could see what he'd always known, and what Ipwet wished was not true: that he could never turn away from his struggle for vengeance. The fight would continue until he or his brother and mother were dead. The gods had spoken.

Hui knew his victory would depend on his being worthy enough. Was he a thief and a coward and a murderer, or was he a good man, a courageous man? The choice was his.

He sensed Taita staring at him with that penetrating gaze, but the eunuch was kind enough – or wise enough – not to pry.

'You have my thanks for that. I have one other request,' Hui ventured. 'Tanus told me you are an adept of the Mazes of Ammon-Ra and that you can predict the future.'

'He should not have told you that.'

'But you can do it? You have the power to part the mists and see what lies ahead?'

'It is not that simple.' Taita's face darkened. 'Divination by the Mazes of Ammon-Ra takes a toll. The fuel it needs is the very life force of the seer. It would take me days to recover.'

'I would not ask of you anything which would make you suffer. But lives hang in the balance, perhaps many lives.'

Taita threw his arms in the air and growled a cry of frustration. He whirled on Hui, his eyes blazing.

'I will not ask you any questions about your business. And in truth I am still not certain I could believe words that trip from your lips, so asking would be pointless. But you have appealed to my better nature, by chance or design I do not know. And if you truly say that lives may be saved by acceding to your request, then I cannot deny you.'

Lives? Aye, his own certainly. But Isetnofret was a dark and brooding force, and he could imagine many others suffering in her pursuit of power and influence. Lying came easily to Hui since he'd fled Lahun, but here he felt he could be honest.

'I speak truly.'

Taita pursed his lips, annoyed that he had found himself in this situation.

'Very well,' he snapped.

The eunuch spun on his heels and bustled around his room, snatching jars of herbs and pots of unguents, a pitcher of sweet white wine, and a mortar and pestle. He dipped into a chest and pulled out a small leather pouch which he set on one side.

Hui studied every movement, trying to understand what this act of prophecy entailed. Taita ground up the herbs and, with two scoops of paste, infused it with the wine and slopped it into a cup. For a moment, he stared at it in his hand, almost as if he were afraid to drink it, and then he swilled it back in one gulp.

'What will that potion do?' Hui asked.

The eunuch eyed him, seemingly considering whether to answer this foolish question, and then he said, 'It will open the eyes of the soul.'

Hui watched the wise man's eyelids flutter and a dreamy expression cloud his face as the potion took effect with startling speed. Taita flopped down onto a well-stuffed cushion and emptied the contents of the leather pouch onto the flagstones. Ten ivory discs tumbled out.

'What is it you would know?' the wise man asked.

Hui's mouth felt dry. In his mind's eye, he saw Isetnofret's face, and that cold desire for vengeance formed a shell around his heart. Not a single day had passed when he hadn't imagined taking her life.

'If I will ever find justice for my father.'

'Ask the question of the spirits.' Taita glared at him.

'Will I find justice for my father?'

The eunuch picked up one of the discs and held it between finger and thumb, turning it so that it glowed white in the light from the window. Hui saw it was inscribed with a mark – two curving upright lines bisected by a third.

'I carved the symbols on each of the Mazes with my own hands,' Taita said, his voice slurred. He watched the light bounce off the ivory through slitted eyes. 'Ten, there are. Ten – the number of power. Each one represents a small part of every human life, from birth to death. Time and again I have breathed on them until I imbued them with a part of my own life force.' He smiled, marvelling at his handiwork, and then intoned, 'I open my soul to allow the spirits of prophecy to enter.'

Hui shuddered and looked around the corners of the room. What things would manifest there?

Taita jerked, seemingly becoming aware that Hui was still there. He flapped a hand towards the door.

'You will have your answer when the spirits are done with me. Come back here when night has fallen.'

Hui scurried away. He did not need to be told twice. Yet as he hurried, he could think only of Isetnofret. His thoughts flew back to days in his father's house when she had exploded into a rage that had come from nowhere. He remembered her beating a slave with a broom she had wrenched from his hands, and another occasion when she had hurled a piece of jewellery at one of her attendants, gashing the girl's head. In those moments of fury, her eyes had lit up with madness. If only he'd recognized those signs at the time, perhaps he might have prevented his father's death. But it was too late for those thoughts now. All he could do was make amends.

 Saws sang across the shimmering water. Hammers thumped an accompanying rhythm, and the shipwrights' full-throated shanties rolled out through the baking dry dock. Some of the boat-builders wore kilts, but others were naked in the searing heat, the sweat

rolling off them as they toiled without break. They heaved stacks of planks on their shoulders from the river's edge, where the carpenters cut and planed the fresh cedar timber recently unloaded from the barges travelling from Byblos. They thumped wooden plugs to hold the planks together, and strained to raise the towering masts with creaking papyrus ropes. Blades shaped oars with deft strokes, and rudders were hauled up aft. The dance of the shipwrights whirled endlessly.

The air was thick with the bitter reek of pitch. From bubbling cauldrons, the apprentices sloshed the thick black liquid onto the hulls to seal them. The lads wore scarves across their mouths against the choking fumes, but every now and then one would be overcome, crashing to his knees and vomiting.

In channels cut deep into the black earth, the skeletons of the ships rested on tree-trunk rollers, waiting for completion. Then the chocks would be knocked away, and they'd rumble down the ramp to where the water would be gushing through the raised barrier that separated the dock from the Nile.

Hui marvelled at the hive of construction. Scores – perhaps hundreds – of muscular men swarmed like ants. Shielding his eyes against the sun, he looked out across the thronging workmen. The docks here on the western bank had always been busy, but never like this. They were on a war footing. With the Red Pretender pressing beyond the frontier of his base in Lower Egypt, this seemingly endless war between the two pharaohs had, as Ipwet had predicted, grown hotter still. The enemy force had to be repulsed at any cost before they gained a foothold. The coffers had been opened. Gold rained from the sky. And this was the result.

Hui studied the war galleys taking shape. These were wooden ships, not the flimsy reed vessels used for trade – grand

by any standards, and built to be sturdy for the coming battle. At this rate of work, the navy would be bolstered in no time.

Hui sighted the man he had come to see. Tanus towered over the shipwrights bustling around him with arms full of papyrus plans, barking orders and gesticulating, in full command of the work being undertaken.

Hui hesitated to disturb Akh-Horus during his important work. But Tanus caught sight of him, dismissed the shipwrights and beckoned Hui over.

'Have you ever seen such magnificence?' the general said.

'The shipwrights labour hard under your command, Akh-Horus.'

'All praise to Pharaoh for providing the resources we needed. Our navy had grown too weak, the ships too old, for the fight that is coming. With these galleys we will be able to tear through the Red Pretender's fleet in no time.'

Hui said, 'The Red Pretender may not be the only threat. Rumours still reach us about the barbarians from the east creeping into Egypt. Is there not a danger that they could gain a foothold while our attention is elsewhere?'

'It will take much to convince me that bands of marauding barbarians are any threat. Certainly no more than the Shrikes, and their days are done.'

'I have heard tell there may be treacherous jackals in Lahun prepared to conspire with the Hyksos, welcoming them in behind the walls.'

Tanus eyed Hui. 'Your home?'

'In days long gone.'

Hui turned away from the other man's gaze. The less that was known about his past, the better.

'And you are concerned about your home,' Tanus said. 'I understand that. You would do what you can to help your people. That is commendable.'

'I know my duties under your service. But if there was any way I could return to Lahun . . .'

Hui allowed the words to hang in the air. Let his master see only honourable intentions in his words, not his grubby desire for revenge. But it seemed to burn hotter than ever this day. With war looming, it was all he could think about.

Tanus thought for a moment.

'Here is my offer. I need you with me in the coming battle. On board one of these ships, in a senior role. You have more brains than many men under my command. Sometimes that is a more powerful weapon than any blade. I will lead the army on the land assault on Asyut. You join the crew on one of the ships here. Stand with the captain and give him the benefit of your wisdom. And if we are victorious, and you have acted with courage, I will send three ships with you to Lahun before the journey back to Thebes. What say you?'

Hui nodded. 'I accept your offer.'

This was a man he had come to admire almost as much as his father.

Tanus nodded. 'Fareed has been scouting the approach to Asyut ready for our assault. When he returns, send him to Lahun, on my orders. As a desert wanderer, he will be able to enter the city, and he can learn much that will benefit you once you reach it. And if there is any threat from the Hyksos, Fareed is the man to let us know.'

As Tanus turned back to the clustering group of shipwrights, Hui was pleased. He'd been sure it would have been an age

before he could return to Lahun to confront Isetnofret. Now, all he had to do was to survive a bloody river battle and return with his head still on his neck.

Hui took the ferry back to the eastern bank and prowled along the quayside in the searing heat, searching the teeming masses of sailors and merchants. Eventually he glimpsed the familiar face he'd wanted to find.

Tau was dragging a bale from the edge of the wharf, his face red from his exertions. Glancing round, seemingly to make sure he was not being watched by his master, he slumped on the bale and mopped the sweat from his brow.

'You work harder than any beast of burden,' Hui said, walking up.

'If I did not, I would not eat.'

'I'd wager you are not beholden to your master. If I offered you work for better pay, though more dangerous by far, you would say . . .?'

'Yes!' The boy jumped to his feet.

Hui laughed. 'You should hear what the work is first.'

'It matters not,' said the lad. 'My days are endless misery and have been for as long as I can remember. I will do anything to escape.'

'Leave him be!'

Adom lumbered towards them, his jowls shaking and his face twisted with fury. Clearly he held Hui responsible for his humiliating dunking in the river.

'The boy is my property.'

'Not any longer,' Hui replied. 'Now he is his own man.'

'You will not take him from me.' Adom's huge fists bunched.

Hui whipped out his sword and levelled it at the boat-master's chest.

'You would challenge one of Pharaoh's men? Courage indeed, not to be afraid of one of the Blue Crocodile Guards.'

Adom stared, his eyes looking along the length of that shimmering blade, a sword that could only have belonged to one of the fabled guards.

'Wise,' Hui continued. 'Now away with you. Find a new slave to torment. But choose well, or he will slit your throat in the night and roll your carcass overboard.'

Simmering, Adom stalked away.

Hui turned to the boy. The lad's eyes glowed.

'I will never forget this. You will have my loyalty until the day I die.'

'Wait until you have stared into the face of battle before you thank me. Go to the garrison now. Find the captain who is hiring the new recruits and tell him Hui sent you. You will be joining me on board one of the war-galleys soon. Your knowledge of the river's moods will more than earn your daily bread.'

Tau's eyes widened, and without another word he spun on his heels and raced into the city. Hui felt pleased he'd done some good, though he still had far to go to wipe away the blood that stained his conscience. Whistling the song he'd heard the shipbuilders sing, he walked away into the darkening streets.

No lamplight flickered in the windows of Taita's house. Hui hailed him from the door, but silence hovered in the cooling air. He slipped inside and let his eyes become accustomed to the gloom.

The eunuch was sprawled across the cushion where Hui had left him, unmoving. Fearing the worst, he bounded over and grasped the wise man's hand. Still warm.

Hui fumbled around until he could light a lamp. The eunuch's beautiful features were haggard, his skin almost the colour of stone. Dark rings circled his eyes, and his cheeks had the hollow appearance of someone who hadn't eaten for days, even though it was only a short while since Hui had seen him.

Taita stared at Hui as if seeing him for the first time.

'I have journeyed far from this place,' he croaked, 'to the shores of the great black ocean.'

Gradually a flame flickered to life in Taita's eyes and he seemed to grow stronger.

'Up I flew, and higher still, until I floated in the heavens, staring down at this great land of ours.' His words rustled like dry leaves. 'Everything became darker than a moonless night, until I spied a tunnel. There was a light at the end of it. As I travelled along the tunnel, I found myself watching a horror unfold before my eyes – a sea of blood washing across all Egypt, draining into the sand.'

Hui crouched beside Taita and whispered, 'Is this your prophecy?'

'This will come to pass,' the eunuch averred. 'The gods have willed it.'

'But what does this mean? How does this answer my question?'

Taita's head flopped back and he lowered a fluttering hand across his eyes.

'There is more. But not all that the spirits reveal is clear. This blood is part of your answer, it is true. But it is not the whole of it.'

Hui felt his heart beat faster as he waited for the wise man to gather himself.

Finally Taita continued, 'I saw that crimson tide flow to the very walls of Thebes. The streets within were filled with

darkness, but they were not empty. A woman walked there. She may have been a ghost, I do not know. But when she turned and looked at me, her hands were red with blood . . . and she had no face.'

ui stumbled through the suffocating dark of the streets towards the garrison, but his thoughts flew ahead of him. He felt an oppressive sense of dread as he imagined that faceless woman – who could only be Isetnofret – stalking the streets of Thebes. Bloody hands, Taita had said. But was that Hui's own blood?

His mother was coming for the Ka Stone, the key to her ambition to rule all Egypt. That could be the only explanation. She was coming to Thebes and there would be blood.

Hui glanced over his shoulder, but the shadows were too deep. In his mind's eye, he could see her there, the ghost at his heels, drawing ever closer. As fear stirred, he threw himself into a run. When he neared the white walls of the palace, he glanced back again and felt the cold clutch of terror.

A figure loomed out of the dark.

Hui squinted into the gloom. At first he could only see the image of Isetnofret, but then another figure stepped out, and another, and he realized they were men. Palace guards, by the look of them. They seemed to be chasing him.

Surely this was a matter of mistaken identity? He thought of confronting them, but fear overcame him and he turned to sprint away.

Three other men were standing in front of him. The hilt of a sword swept up and crashed against his head and his thoughts spun away from him.

When he came round, he was lying on his back on cold stone, breathing in dank air. For a moment, he thought he was back in the Well in Lahun, and all that had happened since had been a dream. His head throbbed and his joints ached from what must have been a thorough beating.

As Hui tried to make sense of where he was, a door creaked open and lamplight flooded in. He was in a cell with filthy straw scattered across the flagstones. A rat scurried away from the sudden glare.

Hui pushed himself up on his elbows.

'What is the meaning of this? I am a member of the Blue Crocodile Guards. I serve Tanus.'

'No,' a low voice rumbled. 'You are a filthy murderer, and now you will face the punishment you have evaded for so long.'

Lord Bakari stepped into the beam of light from the cell doorway. Hui silently cursed himself. He'd been too distracted by his lust for revenge against his mother, and had barely considered the threat from Bakari. As Hui stared into those dark eyes, he felt a terrible fear at what he knew now lay ahead. Mutilation. An agonizing death. And no hope of being reunited with his father in the afterlife.

'Prepare yourself,' Bakari said. 'Your sentence will be carried out at dawn.'

The dry wind whisked dust along the deserted street. Shadows crept away from the rosy first light, and a cacophony of birdsong shattered the silence from the lush gardens of the big houses surrounding the palace.

Hui squinted into the light as he stumbled away from the gate of the Khnrt Wr prison, one guard on each flank. He was naked, bared before the gods and ready for his sentence to be enacted. Whenever his pace slowed, one of the guards thrust a hand between his shoulder blades to drive him on, or grabbed his wrist and dragged him until he almost fell.

He was exhausted – he hadn't slept – and his body ached from the regular beatings. Beyond that, no terror convulsed him. No tears of fear stung his eyes. He was not afraid of death, and that surprised him. All that simmered inside was a deep bitterness that Isetnofret would escape paying for her crimes, and that his father would never be avenged.

The guards herded him to the square where the public executions took place. A small knot of dignitaries waited, but no crowd swelled at that hour. It seemed Bakari was more intent on releasing him from this world than letting his final agonies provide entertainment for the masses.

Hui pushed himself upright as he neared those men in their pristine linen robes, with their emerald and black eye make-up neatly applied. He showed no defiance, only that he was unafraid of what was to come. Perhaps then they might realize that this sentence was unjust.

Bakari stood at the centre of the group, his cadaverous body towering over the others. His dark eyes locked on Hui's and they crackled with contempt for the worthless jackal before him.

'Will you finally confess to your crimes?' the aristocrat intoned.

'I am innocent,' Hui replied. 'I will not lie before the gods.'

Bakari nodded. The guards grabbed Hui's arms and wrenched him towards a stained and blistered timber column embedded in the flagstones. He saw a circle of crusted brown surrounded

the execution pole on the white limestone. The guards pulled his arms back around the column and bound his wrists.

'How cold-hearted you are that you show no remorse for your crime,' Bakari said. 'A man who would murder his own father for gain is lower than a snake. This world will not mourn you.'

'I killed no one. The true murderer still walks free.'

Bakari raised a hand to silence him. 'I will hear no more lies. The time has come.'

The wind whined around the empty square. Hui heard a steady grinding. One of the dignitaries stepped aside to reveal a man with a pock-marked face drawing a whetstone along the edge of a short, fat-bladed knife. He looked up and showed Hui a gap-toothed grin.

Hui studied the sharp edge of that cruel weapon, imagining what was to come.

When the executioner had completed his labours, he tossed the whetstone aside and ambled towards Hui.

Bakari watched intently, determined justice was to be done.

The executioner leaned in close. Hui smelled the bitter stink of old sweat. The knife swayed closer to his shrinking genitals. Under his jewels it would go, and then a steady sawing until Hui was relieved of his manhood. At least the agonies would only last a short while, he hoped . . . he prayed.

'Stop!' The command boomed across the square.

Tanus strode by Hui to confront the dignitaries. Ipwet hurried behind. She flashed a look at Hui.

'What is the meaning of this interruption, General?' Bakari asked.

'I am here to plead for the prisoner's release.'

'It is too late for that. The trial has long since concluded. The sentence has been passed. And it would have been completed many moons ago, if this jackal had not been a fugitive under the eyes of Ma'at.'

Tanus swept a hand towards Hui.

'This man is a valued member of Pharaoh's army under my command, and an honoured warrior in the Blue Crocodile Guards. He helped rid Egypt of the plague of Shrikes.'

'Nevertheless, he is a murderer.'

'He did not commit the crime of which he was accused,' Ipwet said.

Bakari narrowed his eyes at her. 'You spoke for the accused in Lahun?'

'Yes. I am his sister.'

'You gave no evidence of his innocence—'

'But now I know the truth.' Hui felt a rush of pride as he watched Ipwet hold her head up high. She was not about to be humbled in the presence of these great men. 'The poison was administered by my mother, Isetnofret, with the acquiescence of my brother Qen. They conspired to murder my father, Khawy, for one reason – so they could gain a grip on power in Lahun, and thereby usher in the barbarians who have been attacking the caravans and mines in the east.'

Bakari was not a man who would easily back down.

'Still—'

'She speaks the truth,' Tanus pressed. 'To punish this soldier for a crime he did not commit would be an abomination under the eyes of the gods.'

Silence fell on the square. Bakari raised his eyes to the blue heavens, no doubt wondering how he could save face.

'I will vouch for him personally,' Tanus continued, his voice softening as he tried to give Bakari a way out. 'I know the courage that lives in his heart, and his cleverness will be invaluable if we are to defeat the Red Pretender.'

'You think so highly of him?' the lord asked.

Tanus nodded. 'I have no better man under my command.'

Hui felt a rush of emotion to hear those words, even if Tanus had only said them to save his life. Only his father had ever spoken of him in such a way.

'Let me think on this,' Bakari said.

'There is no time, my lord,' Tanus pressed in a calm voice. 'The preparations for war are almost complete.'

In the long moment of silence that hung across the gathering, Bakari was wrestling with himself, Hui could see.

Finally the lord nodded.

'Very well. Your words have convinced me,' he said, still sounding as if he might change his mind.

'Thank you, my lord,' Tanus said with a bow.

Bakari clapped his hands and announced, 'I hear this new evidence, and the general's testament to the prisoner's character, and I will set this man free.'

The lord strode away as if all there were now beneath his interest, and the dignitaries scurried behind him. Ipwet tore at Hui's bonds until his hands came free. Then she threw her arms around him and hugged him deeply.

'I came looking for you,' she murmured, 'and they told me at the garrison you had not returned to your bed, so I set out to find you. When I heard you were in Khnrt Wr, I went straight to Tanus.'

'You have saved my life for a second time,' Hui breathed in her ear. 'I cannot thank you enough.'

When she pulled back, her eyes glistened.

'We must look after each other, brother. We are all that we have now.'

Tanus stepped up. He showed a stern face.

'You should have told me the truth from the beginning. Is there anything else I should know?'

'No,' Hui lied, grinning as widely as he could.

His life had been saved, but more importantly, he had also been given another chance to claim his mother's.

'Good. Then make yourself ready. The campaign to retake Asyut begins immediately. I want you on board ship before the sun is at its highest.'

A stern, the drummer swung his muscular arms as he pounded the stretched hide with the linen-wrapped sticks. The booming throbbed across the benches where the oarsmen strained in rhythm to the steady beat. Every man was stripped to the waist, their bodies glistening in the heat, faces grim, determined. Under the power of those rippling muscles, the war-galley cleaved downstream through the great Nile.

Hui stood on the raised platform in the prow with the captain, a seasoned sailor with a weather-beaten face and a paunch hanging over his kilt. Garwa was his name. Hui liked him from the moment he'd been assigned to this vessel. Though Garwa showed a serious face, his eyes twinkled and his humour was sardonic.

As the ship sliced through the current, Hui grabbed on to the rail to stop himself falling. Garwa remained erect, legs braced, hands folded behind his back. He eyed Hui.

'We will make a sailor of you yet. Or toss you overboard to the crocodiles with the rest of the waste. One or the other.'

'I answered the call of duty,' Hui gasped as his stomach churned, 'but as the gods are my witness, I swear I want to live out the rest of my days on dry land.'

'Aye, well, we'll see if you get through this day first.'

The galley was as long as a javelin throw, with a big belly, a single mast and a red and white striped sail, now furled. Astern, beyond the drummer, another raised platform provided a base for the steersman, who stood with his hand on the long wooden oar that guided the ship through the currents. Tau stood beside him, eyes fixed on the water. They were short of seasoned navigators for the burgeoning fleet, and the captain had praised Hui for bringing the lad aboard. He'd sailed the Nile all his life and knew its moods better than anyone.

And behind, the rest of the fleet swept, the many vessels spread out across the river. The booming of the mass of war drums sounded like thunder.

When they'd left Thebes, a crowd had gathered along both banks, cheering and whooping. It had been a magnificent sight. Even the pharaoh had been there, standing on a raised dais, his gold headdress glinting in the sun, with his oldest and wisest advisers attending behind him. Hui had stared long and hard at the king as the galley sailed past, trying to fix that vision in his mind. He'd never seen a king before, never dreamed he would ever see one. He remembered his chest tightening with euphoria at finally laying eyes on that representative of the gods on earth, feeling the wonder and the awe. But now, when he thought back, he couldn't remember the details of the pharaoh's face. In his memory, only a blur lay beneath that lavish crown.

Ipwet and Ahura had waved from the quayside, their ululating cries of support fighting to gain his attention, both of them jumping and jostling. Ipwet had been concerned about him

going into battle. Her eyes had filled with tears and she'd tried to find ways for him to remain in Thebes. Ahura had told her not to be so weak – Hui was a member of the brave Blue Crocodile Guards now, and he had work to do.

Tanus had led the army on ahead the previous day. That, too, had been a sight that made his blood pound. A horde of the finest warriors in all Egypt marching to a single step, like a great beast rising up after slumber, hungry and proud. Their bronze shields shimmered in the light, and from his vantage point on the rooftop of one of the houses, it had seemed that a sea of light moved towards the north. Surely no enemy could see that force bearing down upon them and not quake with terror. Hui imagined the Red Pretender's men throwing down their swords and fleeing like terrified children as Tanus marched relentlessly at them.

But now the battle was about to begin, and Fareed and the other scouts had returned from Asyut. The frontier city had long been a jewel in the crown of the Upper Kingdom. As the capital of the thirteenth nome, it had a commanding position, not far beyond a fertile valley, next to towering grey rocks on the edge of the desert. A great deal of trade passed through it, brought from the ports to the north in caravans across the western desert. From there the riches of other lands travelled south, to Thebes and the other cities of the Upper Kingdom. The Red Pretender had long coveted Asyut for its strategic position. Once he had the city in his hands, the trade to the south would be disrupted and much of it could be diverted to fill his coffers. He'd tried to take it, but the efforts had been half-hearted and easily repelled. This time had been different. The Red Pretender was growing bolder. It seemed that skirmishes along the frontier were no longer enough. He wanted all Egypt under his rule, and Asyut was the first step.

Back in Lahun, Hui had heard many tales of Asyut. The days were brutally hot, the nights bitterly cold. The people were strange. Some called it the City of Wolves, and it was said dead wolves were mummified and installed in tombs on the hillside. Why the people would do that, Hui had no idea, but the god they worshipped was Anubis, who oversaw the funerary rites. Death and the afterlife were always close to the people of Asyut.

Hui sensed a shadow fall over him. He glanced up and saw the sun was now a pale orb in a shifting bank of fog. His nostrils wrinkled at the acrid stink of smoke. The fields along the western bank were burning, red fires glowing in the thick wall of grey. The smoke was turning day into night and drifting across the vast river to hide all that lay ahead.

Who could have lit the blaze? Tanus and his forces, to cause confusion during the attack, or the army of the Red Pretender, bitter and determined to inflict as much damage as possible as they retreated?

The galley ploughed on into the suffocating smoke, and it folded around them. In that colourless world, sound became muffled, the drumming throbbing like a distant heartbeat, the din of the battle away on the land ebbing and flowing.

Hui's eyes watered and he wrapped his scarf across his nose and mouth to stop himself from choking. The captain had done the same. Garwa bellowed, 'Hold your oars!'

The sailors leaned on their poles and lifted the blades out of the flow. The boat slowed and drifted. The hull creaked as it flexed against the current, the closeness of the sound oddly magnified.

Blinking away tears, Garwa leaned on the rail and squinted ahead.

'Can't see a damn thing,' he grunted.

Hui watched the captain's body stiffen with unease. They knew the Red Pretender's fleet lay somewhere ahead, ready to engage them before they could offer support to the army attacking Asyut on land.

Garwa scanned the water and glanced at Hui.

'What course?'

'What . . . course?'

'Don't repeat my words back at me. Tanus says you've got a good mind in that skull of yours, though it must be hidden well. Let's hear what you think. What course should we take?'

Hui felt the captain's heavy gaze upon him. This was part of his rapid education in the navy, he knew, but Garwa was also testing him.

He ventured, 'We stay as close to the bank as we can.'

'If you have a notion that's worth hearing, speak boldly!'

Hui repeated what he'd said in a firmer voice.

The captain nodded. 'Why say that?'

'Because the Red Pretender's fleet will be waiting. They will expect us to take the deep channel in the centre of the river. If we stay near the bank we might earn a few moments of surprise.'

'We might make a sailor of you yet.' Garwa turned and waved to the steersman, beckoning him to direct the ship closer to the western bank. 'Tau!' he yelled.

The lad scrambled across the benches until he reached the prow. The captain thrust the long sounding pole into his hands.

'Over the side with you. I don't want any surprises. Test the depths and give full voice if we're heading into trouble.'

Tau nodded and clambered over the rail onto the sounding platform on the prow.

The ship drifted on through the eerie world. Hui strained to hear the sounds of battle away on the land, praying that Tanus

was victorious. And if the battle was lost here, what then? The Red Pretender would be emboldened. Other cities would fall. Could he even reach Thebes?

The captain stared ahead, his eyes constantly searching the grey folds for the first sign of the enemy. As they eased forward, one of their sister galleys sped by along the central channel, taking advantage of the faster current and the men still heaving on their oars.

Garwa frowned.

Another galley rushed after it. In the prow, the captain turned and gave a mocking wave to Garwa.

The first ship disappeared into the dense fug. A moment later a terrible rending sound ripped across the water, followed by a cacophony of cries and screams.

Garwa gripped the rail.

'In the name of Ra, what is that?'

Wind gusted and the curtain of smoke parted. Hui stared at a vision from hell. The lead galley had been half-torn apart, as if by the fangs of some giant beast, and was sinking fast. Some men still clung to their benches in terror. One sailor had his arms wrapped around the mast, his mouth torn wide as he screamed for help.

The rest of the crew thrashed in the river where they had been hurled by whatever had destroyed their vessel. Hui stared as lines of turbulent water swept from the bank towards the survivors. A dark shape beneath the surface reached the nearest sailor. Crocodiles. The man screamed, his arms flailing as he was dragged down. The river churned where he had been a moment before.

Realizing what had transpired, the other oarsmen thrashed even harder as they tried to reach the relative safety of their

sinking galley. One by one, the silent hunters pulled the men to their deaths. The river darkened, turned crimson, the water boiling. And as the final man's hand hovered close to the shipwreck, a giant crocodile surged out, rolling as it clamped its jaws around its victim and dragged him down.

'What happened to the galley?' Hui gasped.

Barely had the words left his mouth than the second ship raced out of the smoke and past the wreckage of the leader of the fleet. The same rending sound tore out, and this time Hui could see the vessel coming apart as if a knife had sliced it in two. Timbers shattered, shards flying. Men flew overboard, their cries more throat-rending as they realized what waited for them in the depths. The mast shattered and crashed down, pinning two men. Their howls rang out, then faded. The galley had suffered greater damage; it went down fast, the stern rushing below the surface as the river water flooded the broken hull. More screams as the crocodiles feasted.

Hui felt his stomach knot.

'What happened?' he cried again.

The captain was staring at the carnage around the two destroyed ships, none the wiser.

A hand appeared on the rail and Tau hauled himself over the top.

'I see!' he exclaimed. 'I see!'

He pointed to the water flowing through the deep channel.

'There!' Tau said, stabbing his finger. 'See?'

Hui followed the line of his arm and saw a circular eddy in the water before the current continued flowing on the other side.

'By Anubis' snout!' Garwa shouted. 'Those sons of whores have sunk barriers beneath the waters – a spike or some such

that will rip through the hulls of the unwary.' He glanced down at Tau. 'You did well, lad.'

The captain bounded from the platform and threw himself over the benches to the stern. By the steering oar, he roared and waved his hands furiously, trying to alert the following galleys to steer towards the bank. Some followed his orders. Others sped by, either not seeing or ignoring his warnings.

Another ship ripped itself in two and sank. A second vessel tried to divert at the last moment. One of the obstacles hidden beneath the surface raked along the edge of the hull, but did no serious damage. Yet the galley seemed to be caught upon the barrier, for it came to a halt and however hard the sailors heaved on the oars, it didn't move.

Hui understood. He looked around at the billowing smoke and the red glare glowing in the heart of it. The Red Pretender's men had lit the fires on the bank; that could be the only explanation. A distraction, a way to obscure the wrecked vessels as the others swept up behind. He cursed under his breath. They'd been too confident. The enemy was more cunning than any of them had expected.

Roaring with frustration, Garwa scrambled towards the prow. As he hauled himself onto the platform, the galley eased out of the bank of smoke. Hui turned away as the water glared under the brassy light of the now-revealed sun. But when he glanced back he felt the cold creep through him.

The Red Pretender's fleet massed ahead, from bank to green bank. Sails flapped, unfurled for the voyage upstream, a patchwork of crimson and brilliant golds and emeralds. Some looked smaller than the great war galleys that Tanus had ordered built. But there were so many!

Garwa spun round and bellowed, 'Bows!'

But as the command boomed across the deck, Hui winced at a high-pitched whine he knew too well. Acting on instinct, he threw himself down, grabbing Tau and burying the lad beneath him for protection. The air roared with the din of arrows thumping into the galley, splintering wood, the screams of wounded men on the benches.

Hui glanced up. Garwa wavered, his mouth slack and his eyes wide with surprise. Seven shafts sprouted from his chest. He crashed backwards, dead.

Another volley of arrows whined through the air. This time fewer crashed against the ship. Hui peeked through the rail and realized the attack had been divided, as another of their galleys emerged from the smoke. As he stared, more vessels appeared near the banks of the river.

Tau crawled over to the body of Garwa, his eyes welling with tears. In those burning eyes, Hui saw something he could understand: the searing desire for revenge.

Jumping to his feet, Hui lunged to the edge of the platform and roared, 'Shieldsmen, protect your archers!'

The crew responded without hesitation, bronze shields sliding up. The bowmen crouched behind them, nocking shafts. Hui waved at the steersman, who leaned on his oar until the galley began to turn sideways on. More arrows whisked by. Most clattered harmlessly off the shields or splashed into the river.

Once the attack had passed, Hui leaped to his feet again and shouted, 'Loose your arrows!'

The archers rose up from behind the shieldsmen and a torrent of shafts arced across the water. Hui punched the air as he watched the arrows rain down on the Red Pretender's fleet and heard the screams rolling across the river.

'They obey your commands,' Tau said. 'You are the captain now.'

Hui began to protest, but then he bit down on his words. If not him, who else could take that role? Every other man on board had important work to do. He felt terrified at the responsibility – all those lives in his hands, perhaps even the outcome of the battle – but he would do his duty.

'Do we turn tail and flee?' the boy asked.

'No,' Hui replied. 'We fight.'

He threw himself to the edge of the platform and stared down at the men crouching in the belly of the galley.

'This battle will be hard,' he shouted, 'but it is one we can win! Our ships are more powerful. Our arrows fly truer. And you are more courageous than any of the Red Pretender's jackals. Once they see what we have to offer, they will flee like the cowards they are. Let us fight. And let us win!'

The crew roared as one. Hui watched in astonishment as the spark of defiance lit face after face, and those brave warriors rose up together, inspired by his leadership. Never would he have thought he was capable of this. If only Khawy had lived to see it.

Hui shouted his command to the steersman and the ship turned again. The oarsmen dipped their blades, and the galley ploughed through the currents towards the enemy fleet. It was a show of bravado that he had learned from Tanus, and Hui knew it would give pause to those enemy sailors. Who would be crazed enough to attack such a fleet? Only someone supremely confident.

Hui muttered a prayer to Horus that his ploy would work, and glanced back. He'd feared they would be the only galley attacking in such a way – the other seasoned captains would

surely be more cautious – but he saw the rest of their ships were following in his wake.

The Red Pretender's archers launched another volley, but many of the shafts hurtled astray. They were unnerved, and it showed in their wavering aim.

Hui gripped the rail until his knuckles turned white and fixed his gaze on the ships ahead. Soon he could see the faces of the enemy, grim and ready for the battle to come. His own archers loosed shaft after shaft. And as the arrows rained down in such numbers that the sky seemed to darken, he watched terror convulse the enemy sailors.

Hui knew Tanus' plan, and he executed it exactly as he'd been told. Each vessel in their fleet took on an enemy galley one-on-one. As they swept alongside, the slingers leaped to the fore, swirling their leather straps around their heads and loosing the sharpened rocks that had been heaped astern.

Hui watched skulls explode from the force of impact of the deadly projectiles. Chests caved. Limbs were gouged. And as the Red Pretender's men dived for cover, Hui's archers leaped up and followed with another volley from close range. Shafts punched through faces and chests. Men pitched overboard, trailing crimson blood that glistened in the sun.

The crocodiles thrashed and fed in the heaving white water between the galleys.

Around Hui, the battle raged. One of their galleys was on fire, the flames leaping up the mast to the bundled sail. Another spun in the currents, every man on board sprawled across the blood-slick deck. Hulls crashed together. Arrows whipped back and forth. Whoever was commanding the Red Pretender's fleet was trying to force Tanus' ships into the shallows, where they could be grounded and become easy pickings.

Hui thrust a fist into the air and roared, 'Onward! We shall not be beaten!'

Other captains picked up his cry, and for a moment it drowned out the screams of the dying.

But even then, when he looked around, Hui could not tell who had the advantage. The battle seemed finely balanced. One wrong move and all could be lost.

Hardening his resolve, Hui turned his attention to the galley he had engaged. He studied the dwindling numbers of the crew, and when he decided it was in his favour, he bellowed, 'Now!'

The galley eased closer to the enemy vessel, and when a narrow channel lay between, his men unsheathed their swords and leaped across the gap. The bronze blades flashed, hacking and thrusting, as his men moved along the deck, cutting down the fleeing sailors. In their terror, some chose to leap overboard, only to find themselves the victims of the deadly predators of the river deeps.

Soon the deck was awash with blood and none of the Red Pretender's men remained alive. Only then did Hui glance back to the battle.

Bodies floated in the red foam and ships drifted unmanned. The tide had turned in their favour. A spear's throw away, his comrades yelled a battle cry as they put the last of the Red Pretender's men to the sword. Pinned to the mast with a blade against his throat, the captain cried out his surrender. Beyond the vessel, two of Tanus' ships swept in on either side of an enemy vessel. The sailors on board looked about in terror, seeing they were trapped.

The Red Pretender's ships were outnumbered – that was clear to both sides. And then the command to retreat rang out,

and what remained of the enemy fleet turned tail and sculled hard downstream to their safe havens.

Hui felt his heart swell. A spontaneous cheer rang from the warriors on board Tanus' galleys as they watched their foes flee.

But the job was not done. Hui raised a hand, and one by one the captains on the other vessels followed suit. Together they waved their arms forward, and the galleys moved away upstream to offer support to the ground forces.

This battle had been fierce and bloody. The attack on Asyut would be worse.

The campfire crackled and Hui jerked from his reverie. Moonlight flooded the banks of the Nile where his weary men sprawled beside the moored galley. They'd earned their rest. Exhaustion had turned his own limbs to lead, and there had been times when he thought there would be no end to the exertions demanded of him. When he closed his eyes, all he could see were the bodies littering the fertile valley on the approach to Asyut and the crimson pools steaming in the searing sun. His head still rang with the clash of sword on shield and the battle cries and the agonized screams of the dying.

Battle changes a man for all time, Tanus had once said to him. Back then, he hadn't understood what Akh-Horus meant. Now he did.

Hui tossed another brick of donkey dung on the fire and the sparks swirled up. Had it all been worth it? When it no longer became possible for the archers and slingers to offer support from the galleys along the canal, he'd stood on the platform in the prow and watched Tanus' forces flood through the gates and into Asyut. The outcome was still uncertain, for the bulk

of the Red Pretender's men would be waiting there to defend their prize. All Hui could do was return with the fleet to the banks of the Nile and await news.

A whistle rang out from the lookout on the edge of their makeshift camp.

'Messenger!' someone called.

Hui jumped to his feet and hurried towards the sound of the voice. There was not one messenger arriving, but a dozen of them, and as he neared, Hui saw Tanus was at the head. He felt a rush of relief. But when moonlight picked out Akh-Horus, a hellish vision surfaced. He was covered in blood, his hair clotted and his kilt crusted.

When he saw Hui he grinned and held out a hand.

'Victory!' he boomed. 'Victory!'

Though the men in the camp could barely stand from exhaustion, they clambered to their feet and thrust their swords into the air, cheering.

After the celebrations, Tanus squatted by the fire with Hui. Hui marvelled at the boundless energy that Akh-Horus displayed, as if the day was just beginning and he had not fought a long, hard battle of liberation.

'The Red Pretender has been driven from the city and back behind his borders, with vast losses,' Tanus said, poking the fire with his sword. 'This war is not over, but our enemies will need to lick their wounds before they try anything like this again. And Asyut is now in our hands – the pivot on which our northern defences turn. A good day.'

'But many lives lost on both sides,' Hui replied, his voice thin with weariness.

Tanus nodded. 'We will never forget our fallen.' He glanced at Hui and smiled. 'And you . . . What courage you showed this

day, what foresight. You may well have turned the tide of the river battle, or so my other captains say. They only had praise for you.'

Hui looked away, uncomfortable. 'When Garwa was killed, I did what I had to do. No more.'

'And therein lies the mark of a good man. A strong man. Time and again I have seen others faced with that choice and turn away from their responsibility. You shouldered your burden without a second thought. You were an outlaw – a Shrike – but you always had the soul of a warrior. Your father would have been proud.'

Hui couldn't bring himself to look at Akh-Horus for fear the weight of emotion in his chest would choke him.

'Today I make you captain of that galley,' Tanus continued. 'You have earned it, and you will be a shining example to all the men who serve under you.'

'And—'

'And I will be true to my word. Take your ship and two others and sail to Lahun. If enemies hide away there, let them quake now. A reckoning is coming.'

nder the full moon, the silvered wastes rolled out. The night wind stirred the sands and rustled through the leaves of the date palms, and there was a lonely quality to its moan. From the platform in the prow of his galley, Hui watched the waters of the canal glint in the lambent light. The channel had been dredged and was navigable by larger vessels. The repair of the quayside ahead had been completed.

He breathed in the rich scents of the cooling vegetation, but it did little to ease the tightness in his chest.

A reckoning, Akh-Horus had said. If only he knew how much of one.

The drum was silent – Hui didn't want to attract attention on the approach – but his men heaved on their oars in rhythm, the blades dipping and rising in a shower of moonlit droplets. The gentle splashes lulled him. But his hand still rested on the hilt of his sword.

Lahun was far away from the pharaoh's court and his thoughts in such tumultuous times. But Hui had never forgotten. He thought of Isetnofret, safe behind the white walls glowing at the end of the road from the dock, and Qen, asleep in his bed. Swaddled in the knowledge that they held power over the city of Hui's birth. That they could luxuriate in the riches that passed through its gates, and hold the lives of men in the palms of their hands. He'd thought his mood would burn white-hot once he arrived back in Lahun, and that his lust for vengeance would set his skull afire. But Hui felt only a coldness that reached deep into his bones. He was ready to be done with it all – to see justice for his father, and then to move

on with his life, with Ahura and Ipwet, and fulfil his duty to Tanus and the pharaoh's army.

Would the Hyksos put up a fight? He'd seen enough of their ways to know that they would. But he was ready. He'd designed the strategy with Tanus that night by the campfire, and all his men across those three ships had been informed of their roles. The Hyksos could surrender, or they could die. And Lahun would be free again.

His galley eased into the wharf and three men leaped ashore to tie the moorings. The other two ships creaked in behind. Hui strode down the plank to the end of the walkway and stared at the slumbering city and the ruined pyramid beyond. How peaceful it looked under the light of the full moon. It was deathly quiet, as it always was at that hour, but an oppressive atmosphere seemed to be hanging over the city.

Once his men had formed a line behind him, shields strapped to their left arms, Hui thrust his hand forward and the march began. After a little way, he stopped to listen, but heard nothing beyond the tramp of leather soles. The watchmen must be sleeping. Surely they had seen the arrival of a war band on their doorstep, yet no alarm rang out.

With each step closer to the gates, Hui's chest tightened. There was no explanation for this that he could imagine. He glanced back and saw that his men sensed it, too. Eyes shifted, hands hovered over sword hilts. Were they being lured into a trap? That would not have been the way in the old days, when the gates would have been barred, and the alarms ringing out from the watchtowers, and the guards and what few archers they had rushing down to man the walls. Perhaps a new strategy had been enforced by the Hyksos.

Hui held up his hand to slow the step of his men. He kept his eyes fixed on the gate, half-expecting it to swing open and a torrent of chariots to rush out, arrows loosed from those terrible bows.

Nothing moved.

Tau stepped up beside him and screwed up his nose.

'What is that smell?'

Hui sniffed the air. Now he could detect it, too – a faint, unpleasant aroma on the night breeze. He felt a chill creep down his spine.

As they neared the walls, Hui looked to the towers. All of them appeared empty. The gate was ajar, stirring in the breeze, each creak punctuated by a thud as it banged open and shut.

Hui jerked his hand to the left and the right. His column of men forked, and they raced to occupy positions on either side of the gate. Swords leaped to hands, shields were raised. Eyes flickered towards him, waiting for his command.

He nodded and two warriors crept forward, pressing their shoulders to the gate and easing it open.

The stink of rot rushed out of the dark and swept over them. Hui's hand flew to his mouth. The boy gagged, and Hui's men choked.

Hui wrapped his scarf across his mouth and nose and nodded to his men to do the same. He knew what that smell meant. He strode past his men and through the open gate into his home. A sea of darkness rolled out before him. No lamps burned along the wall, or in any of the homes rising up from the walls to the Upper City.

He sensed movement in the dark ahead of him. He drew his sword and levelled it.

'Who's there?' he said. 'Stay back.'

Footsteps crunched across the stony ground. A silhouette emerged with slow steps, darker than the surrounding gloom, but as it moved forward, Hui glimpsed more movement behind it. The shadows were heaving. A multitude creeping towards him.

'To me!' he called.

His men rushed through the gate and lined up on either side of him, eyes peering over their shields, swords raised.

A band of brilliant moonlight ran along the street next to the walls. The first figure stepped into it and Hui gasped. It was a woman, but she looked like she had clawed her way out of the grave. Her cheeks were hollow, her eyes sunken deep into her skull. Her arms were little more than bone covered with parchment skin.

'Please help,' she croaked, her hand reaching out towards him.

The crowd moving behind her pushed their way into the light – men, women, children, clothed in rags, all of them starving.

'Please help,' an old man begged.

'Please help.'

'Please help.'

'What horrors have happened here?' Hui heard someone exclaim behind him.

The crowd pressed on, hands grasping for aid. They cared little that the swords might hack them down in their tracks. Hunger drove them.

'They think we are here to help them,' Tau muttered.

'We are,' Hui replied, his voice low but filled with fire.

He raised his hands. 'Hear me now!' he boomed. 'We were sent from Thebes by Pharaoh himself to bring hope to Lahun!'

Across the line of cadaverous citizens, sobs rose up and many fell to their knees, wailing and pressing their hands together in relief.

Hui stepped up to the woman who had first spoken and peered into her face.

'What happened here? Tell me.'

'Please help,' she sobbed, delirious from her hunger. 'Please help.'

Hui turned to his men.

'We will get no sense from them. We must find out for ourselves.' He beckoned to two of his most trusted lieutenants and whispered, 'Take ten men and bring whatever supplies we have left on board the ships. Distribute them to the hungry. It will not be enough. Nor will we be able to feed all of them.' He turned to the crowd. 'Wait outside the walls. My men will care for you.'

'What now?' Tau asked.

'We venture into the city and learn what caused this terrible thing.'

And find Isetnofret and Qen, he determined.

'Is it wise?' the boy said. 'What if the Hyskos are waiting?'

Hui looked up and down the moonlit street.

'No horses, no chariots. No, the barbarians are long gone.'

He strode up the slope, his sword in his hand. His men followed behind him, keeping close together.

The full moon lit a path through the dark. Hui could barely breathe from the choking stench. As they moved through the silent city, sudden movement erupted on every side, darting away from them up the narrow street. The boy jumped and hid behind him.

A sea of rats moved everywhere, tails lashing the air as they scurried, so thick that it was impossible to see the ground beneath their undulating bodies.

'A city of vermin,' Hui breathed.

And as they moved on, he could see why the rodents now ruled that city. Bodies were littered everywhere – in the doors of their homes, on the midden heaps, lying on the side of the road, rotting and feasted upon by the rats and the birds. The people had been hacked down by swords, some as they defended their hovels and meagre possessions, others as they tried to flee the carnage.

Hui choked down his despair. So many bodies. Lahun had been a thronging city. Now it seemed all but deserted. Some at least must have escaped into the wastes, he prayed.

'The barbarians did this?' Tau asked.

'The Hyksos are an honourable people,' Hui replied, adding hastily, 'or so I have heard. If they are responsible for this slaughter, they must have been driven to it by something beyond my understanding.'

When they passed through the wall into the Upper City, Hui hoped for some respite from the grim scenes. There was none. The wealthy inhabitants of Lahun had died as the poor had – men and women he'd known since he was a boy, their bodies scattered outside their grand homes.

And then he was outside his father's house.

The gate hung open. Hui stepped in and past the body of the dead slave who had guarded it. His throat had been cut. The hall was bare; Khawy's prized possessions that had showed the family status were all gone. Hui mourned for those things, the final memories of the man whom he had admired and loved.

Tau stepped beside him, looking around at the emptiness. He didn't understand the significance of the place. How could he?

'Wait outside,' Hui murmured. 'I must explore this house on my own.'

The lad wandered out.

Hui stood listening to the silence, breathing in the dusty air. When he had prepared himself, he climbed the stairs. All the bedrooms were empty. Isetnofret's and Qen's beds didn't look as if they had been slept in for a while. A melancholy air hung over the terrace on the roof. The awning had been torn down, the stools where he had sat with his father smashed.

When he ventured back down the stairs, Hui sensed someone waiting for him in the dark of the hall.

'You yet live,' Hui said.

'I am hard to kill,' Fareed replied.

The two drifted through to the scented garden at the rear of the house, but the perfume from the honeysuckle could not stifle the reek of death. Hui glanced round to satisfy himself that his mother's and brother's bodies were not there, and then he slumped onto the stone bench and hung his head in his hands.

'You know what happened here?' he asked.

Fareed leaned on his staff, looking up at the moon.

'Some of it. The slaughter had happened mere days before I arrived.'

'You stayed here?'

'In one of the other houses. My order was to wait for your arrival.'

Hui looked at the desert wanderer, admiring his sense of duty in the face of such suffering.

'Tell me.'

'Before starvation gripped those who had survived, I ventured out to question any who might know of the events that led to this massacre.'

'How did it come to be? The Hyksos are warriors, fierce and bloody. But in all the time we spent alongside them, there was

no sign they would cut down men and women as they fled their homes.'

'Take comfort in that many citizens escaped into the wastes. Whether they survived the burning heat before they reached a place of refuge . . . that is another matter.' A shooting star wheeled across the vast vault of the heavens. Fareed watched its progress. 'An omen. A sign from the gods. Only one rules here in Lahun. Only one has ever ruled. Seth, god of chaos, Lord of disorder and violence.'

'The god of the Hyksos.'

'This blood is on your mother's hands.'

Hui jolted and stared into the face of the desert wanderer.

'What part did Isetnofret have to play in this?'

'As you requested before I left Thebes, I paid particular attention to your mother and brother and the role they played in welcoming the Hyksos into Lahun. Her downfall began the day you took your sister away from here.'

'The arranged marriage!'

'Around that, all other things did pivot. It was no small matter. Khyan did not believe Ipwet had fled Lahun of her own accord – that is what your mother told them and, perhaps, believed. The Hyksos knew your mother was a schemer and they thought they were being deceived, tricked to give up more than they had offered in the long series of meetings that culminated in agreement. Once they had ceded more ground, Ipwet would have appeared again, as if by magic. They are a proud people.'

Hui nodded. 'But still . . . Would that be enough to drive them to such slaughter?'

'The barbarians refused to continue with the agreement that would have put your brother in power here, and your mother

in power behind him. As they made their retreat, they began to loot the houses. Some of the citizens resisted and were killed. That drove others to take up arms against the enemy in their midst. They were not warriors. What weapons they had were used badly, and only made things worse. The Hyksos were angered by the resistance. But that was not all.'

Fareed closed his eyes, trying to remember the detail of what he had learned.

'Your mother is a sorceress,' he continued. 'Is this the truth?'

'She has always been adept at the occult arts. Some gift, perhaps, from Seth, for her loyalty to him. That is what I was told.'

The desert wanderer nodded. 'Now I understand more clearly. When I first heard what had taken place, I dismissed it as lies. Wild imaginings. Perhaps it was true.'

'What did my mother do?'

'Some conjurings . . . A spell, perhaps . . . Some potion. She could see power slipping from her grasp, and became desperate. Your mother thought she was losing everything she had sacrificed so much for. She was ready to take any risk to win the Hyksos back to her side. Before the barbarians left for good, she offered them wine – a way to smooth the troubled waters. Khyan turned his back upon her, but three of his generals drank her brew. The potion was meant to bend their will. To make them susceptible to her wiles. Perhaps in her desperation she had hurried her spell, or her potion, or made some other mistake. But the drink killed all three generals.'

Hui imagined the scene. Khyan's mounting rage as he watched his three most trusted men die before his eyes, foaming at the lips like his father had done. The Hyksos were suspicious of all foreigners. Would Khyan have thought this was the true plan – to lure them in and then see them killed?

Yes, Hui thought, *he would.*

'That poisoned drink had achieved more than any Egyptian war band,' Fareed continued, in his deep, rolling voice. 'It was a blow to the very heart of the Hyksos. In his rage, Khyan ordered his men to take their vengeance on the citizens of Lahun and to loot what they found.'

'Qen and Isetnofret only ever cared for themselves,' Hui said, his voice filled with bitterness. 'They had no love for the people here.'

He pushed himself to his feet and tried to calm his simmering anger. This was the true legacy of Isetnofret. Not merely the murder of his father. Slaughter on a grand scale. The ruin of a city. How many deaths now stained her conscience? And worse, none of it would ever matter to her.

'Tell me Khyan killed them both,' he breathed.

'They took your brother captive. Your mother fled before the Hyksos could get to her.'

Hui imagined Isetnofret using the powers she had at her disposal to evade Khyan's search party.

'Where she is now, I cannot say.'

Hui knew where she was. Taita's vision of the faceless woman with the bloody hands burned in his mind. She was in Thebes. She would not give up. Power was all she lived for. And the City of a Hundred Gates was home to the Ka Stone, the thing she lusted after to grant her the power of immortality . . .

Hui stood on the moonlit ground and looked back at Lahun rising up the hillside. Would this be the last time he saw the city of his birth? Crowds of starving men, women and children gathered outside the walls, wailing and begging to be fed.

His men tossed out the last scraps of the provisions they had brought from the galleys, but it was not enough.

Hui strode up to the throng, his heart breaking as he saw the hunger etched deeply into the faces of those who had once been his neighbours. If he got his hands around the neck of Isetnofret, she would pay doubly for what she had done here. A quick death would not be good enough. She would need to know the extent of her crimes, and then repent.

And once she was gone, Hui would cut up her body and toss it into the Nile, a feast for the crocodiles, so she would never find peace in the afterlife.

He beckoned the captains of the other two galleys and Fareed. Tau hurried over, too.

'We cannot help everyone,' Hui said. 'But we should take the children in the ships at least.'

'As many as we can hold,' one of the captains said, rubbing his chin. 'These are war galleys and there is little room on board.'

'We do what we can,' Hui replied. He turned to Fareed. 'Can you lead a caravan of the strongest across the wastes? Children, men, women?'

The desert wanderer glanced at the pathetic rabble.

'Some may not survive the journey.'

'If you can reach the nearest farm, beg for what bread you can for them. Tanus will make sure the farmers are paid back twofold for any aid they give, I am certain of it.'

Fareed nodded. 'I will do this task, gladly.'

His face was stony, as always, but Hui thought he saw compassion in his eyes. Fareed was a good man, though he buried it deep.

'The rest?' the second captain asked.

'There is no other choice for them. They must stay. Once we have reached Thebes, ships can be sent with supplies – or to bring them back from Lahun, whatever the authorities say.'

The captain rubbed his chin. 'There is enough meat for them here to keep their flame alive, if they are careful. As long as they learn to be good at catching scurrying things.'

Hui felt his gorge rise. But the sailor was right. What else was there for them?

'Is this the end of Lahun, then?' Tau asked, once the others had gone to select those who would be taken to Thebes.

'There is still a chance to rebuild it,' Hui said, though he could hear only feeble hope in his voice. Once the caravans had stopped coming and the traders had found new markets for their wares? Once the crops in the fields by the canal had died and the land had been reclaimed by the desert?

He showed a brave face and scrubbed the lad's head.

'Back to the galley. You have work to do, and I would like to be in my bed by tomorrow night.'

Tau hurried down the track to the quayside ahead of the two captains leading a meandering trail of children.

Hui's heart felt heavy at how much had been lost. He had many reasons to find Isetnofret and commit her to justice. But in a teeming city the size of Thebes, what chance was there of finding a sorceress who could change her form at will and blend in with any crowd?

Fareed lined up the starving refugees and set off across the wastes. As he passed, he nodded to Hui. There was respect there, and a shared sense that some good might have been claimed from this pit of misery.

Hui watched the ragtag caravan trudge towards the eastern horizon, a lonely sight in that empty land.

nce his ships had moored in Thebes, Hui commanded his men to deliver the children to the city authorities to be fed and housed. He hurried to Tanus to tell him what he had found in Lahun. He watched Akh-Horus' face grow grim.

'We will do what we can to rebuild your home,' Tanus said. 'Pharaoh will want no less for his people. But resources are scarce. Our battles with the Red Pretender are draining the coffers.'

Though Akh-Horus tried to sound positive, Hui could hear the note of resignation. He feared that any attempt to bring Lahun back to life would only be half-hearted.

'You will be commended for what you have done,' Tanus continued. 'For the survivors, disaster has been averted. We will ensure bellies are filled and livelihoods are found for all those you have saved. You have my word.'

After Tanus had returned to his duties, there was only the long wait for Fareed to arrive. When he finally saw the caravan of refugees moving along the river, Hui rushed to meet his friend. Scores had died from starvation on the long trek, but the others cried and fell to their knees at their salvation. Hui felt some comfort when he saw that.

And then Hui began his search for Isetnofret. From dawn until he collapsed exhausted into his bed, he pounded streets, from the wide avenues of the wealthy to the narrow streets and rat runs that criss-crossed the quarter where the poorest folk lived. He questioned drunks in the inns and merchants hawking their wares along the quayside and in the squares, the boys who ran messages from the palace to the docks and the incense-swathed priests in the temple. His feet burned and his frustration hardened until it seemed a great rock was crushing his chest.

Hui had to admit to himself that he would never find Isetnofret this way. The City of a Hundred Gates was too big, the constantly churning throng too great, even if his mother was not capable of using her sorcerous skills to blend into the background. He had almost given up hope of finding her. But he was certain that the moment he let his guard down she would strike, for that was Isetnofret's nature.

Three weeks passed. That morning, the crowd heaved on the quayside, shielding their eyes against the bronze light shimmering off the river. The wind had dropped along the lush Nile valley and a suffocating heat lay heavy over all. As Hui hurried, he could see all eyes turned to the north.

Hui shouldered his way through the crowd. One of the scouting galleys had returned from the front and was displaying the scarlet flag on the prow, signalling that it had urgent information to convey. Hui squinted, trying to read the faces of the crew: jubilation, or dismay?

For a while there had only been good news. Since the liberation of Asyut, the war in the north had been running in favour of the Upper Kingdom. The gods had smiled on them and continued to do so.

But now?

The steersman guided the scouting galley to the quay.

Before the ship's mooring rope had been tied, one of the men leaped from the deck and raced towards the palace. Hui pushed his way back through the gathered crowd and ran after the messenger.

The scout was fleet of foot. He reached the palace before Hui could come close to him. Hui paced in the shade near the gates, waiting for news to emerge.

As the shadows lengthened, Hui saw a group of men striding out of the palace. Tanus was there, and his friend, the eunuch Taita. The others were senior members of the Blue Crocodile Guards. Akh-Horus barked orders at them and they hurried away in the direction of the garrison.

When Tanus and Taita emerged from the palace gates, Hui approached them. The eunuch rolled his eyes, but Akh-Horus nodded, grim-faced.

'What news from the north?' Hui asked.

Tanus looked to the west, to where the necropolis lay across the river.

'The war is over,' he began in a hesitant voice, still staring into the middle distance.

'We have claimed victory?'

Hui knew from Tanus' face that it was not as simple as that.

'The Red Pretender was destroyed with his sword still in its scabbard,' Taita interjected. 'That was what the messenger said. His forces were scattered even before the war trumpets could sound the alarm.'

Tanus turned to Hui. 'This is what we know. The Red Pretender is dead. Memphis and Avaris have been destroyed – both those great cities, razed. The temples burned. The statues of the gods hurled to the ground and smashed. The Lower Kingdom is in flames, and the great river runs crimson. The Delta has fallen.'

Hui wondered how such destruction could come to pass.

'We have been at war with the Red Pretender for fifteen years and . . . barely made a mark upon his forces,' he stuttered. 'We received an account from the front only yesterday, and there was no mention of any of this ruination.'

Tanus nodded. 'Aye. One day. That was all it took. One day.'

'The entirety of the Lower Kingdom washed away in a torrent of blood between one dawn and the next,' Taita murmured.

'How can this be?' Hui heard his voice as if it were rising from the bottom of a well.

Tanus stared at him. 'You know.'

Hui stared back.

'You know, because you tried to warn me, and I was too confident to listen. I thought of them only as roaming war bands.'

Taita closed his eyes, remembering. 'The words of that scout are burned into my heart. "A new and terrible enemy has come out of the east, swift as the wind, and no nation can stand before his wrath. Though they have never seen him, our army is in full retreat from the northern borders. Even the bravest will not stay to face him."'

Now Hui understood. He felt his throat narrow.

'The Hyksos.'

'They have launched their attack, finally,' the eunuch said, 'and there has never been one as devastating in all the annals of warfare.'

Tanus placed a hand on Hui's shoulder.

'And they will be coming for us next.'

Echoes of footsteps rattled off the mud-brick walls as Hui ran through the dark, narrow streets. The air was rich with the succulent aroma of bubbling fish stew and roasting lamb, and out of the doorways rolled the lilting songs of mothers crooning to their babes. Thebes nestled in the peace of its unchanging ritual. But if Tanus was to be believed, all of this might soon be gone for good. There would be no peace ever again.

'Prepare yourself,' Akh-Horus had said to him. 'We must go to war, and as soon as we can. It will be a war unlike any of us have known before. More fierce, more bloody, than our worst nightmares.'

Hui knew he was right. When he'd marched with those barbarians across the reaches of the Sinai, he'd seen into their hearts. The Hyksos would never be satisfied with the Lower Kingdom. They would keep coming, in wave after wave, until all Egypt was crushed beneath them.

Too arrogant, Tanus had said. *Too confident.* They were guilty of that, true. The signs had been there – the rumours rustling on the wind, the fears of the poor folk who'd heard of the attacks on the caravans and the war bands riding closer. But all their attention had been focused on the old enemy – the Red Pretender – and they had ignored the new.

Prepare yourself, Tanus had said. How could any man prepare himself for war with the Hyksos?

Hui's thoughts turned to Isetnofret. The vengeance that burned in his heart would have to be put aside. But he would find a way to get to his mother, he vowed, though it was with his last breath.

He continued along the dusty street until he came to Ipwet's house.

Hold them back, at least for now.

Hui stepped inside. Darkness filled the house. That puzzled him. At this hour, Ipwet would usually have lit the lamps and Ahura would be preparing food. He sniffed the air. No scent of fresh food.

He heard a dim, muffled sound and his skin prickled. His thoughts flew to Isetnofret, the witch biding her time, circling his life, his sister's life, waiting for the moment when she could inflict the greatest pain.

Anger knotted his stomach and he lit a lamp, covering it with his hand.

Hui moved forward. The faint sounds grew louder, became whimpering. His chest tightened.

He crept along the trail to the bedroom at the rear of the house. At the doorway, he took his hand away from the lamp and unsheathed his sword. Light flooded the small room and Hui gasped.

His sister and Ahura were wrapped together on the bed, naked, kissing as deeply and passionately as he had seen any man and woman do, their hands hungrily exploring each other's bodies.

The women looked at him, faces frozen in the glare. Ipwet's features twitched with discomfort. Ahura grinned.

Hui stared like one of the fish thrown out of the nets on the banks of the Nile.

Later, Hui slumped on a bench, angry, while Ipwet sat opposite him and Ahura moved around the room lighting the remaining lamps.

'You do not hang your heads?' he asked.

'There is no shame in our love, brother,' his sister replied. 'My only discomfort is in you catching us in the private act of congress.'

Her tone was measured, and Hui knew she didn't want to heap more suffering on the annoyance he was already feeling.

'Nephthys was the constant companion of Isis,' Ahura murmured, distracted by her task. 'Though sisters, they shared an abiding love. The gods light the way. All men and women must follow.'

Ipwet smiled. 'You have been sheltered from the ways of the world, brother. There is much of the heart and desire that is tolerated in Egypt. Lahun was a small place, far away from a city like Thebes—'

'Do not mock me,' Hui said. 'I am no longer a boy. I am wise in the ways of the world. I am . . .' He let his words drift away, hearing the lies in them. A liar to the world and a liar to himself. 'How long have you both been indulging in this romance?'

The two women glanced at each other.

'Our feelings stirred when we first met,' Ipwet began.

Ahura laughed. 'Though your sister refused to accept it.'

'Until you seduced me.'

Ipwet glared at her. Ahura laughed louder.

Hui put his hands to his ears, then let them slide down to his side. He felt betrayed.

'You deceived me. Both of you, laughing at me.'

'No.' Ipwet knelt before him and clasped his hand. 'We wanted to protect your feelings, brother.'

Ahura crouched behind him and draped an arm over his shoulder.

'You never truly loved me,' she murmured. 'I know that, and who could blame you? But I love you. For your kindness. For your courage. For all that lies in your heart. But it is love of a different kind.'

'And how do you expect to survive without a husband?' he said to Ipwet. 'And you?' he said to Ahura. 'You planned to marry me, then deceive me and carry on this love in secret?'

'No more deceit,' Ipwet replied. 'Not to ourselves, nor to the world. We are who we are, and love is above all earthly things. If the gods will it, we shall find a way to survive.'

'I will not have it,' Hui said. 'You are harming yourselves, though you cannot see it.'

Ahura's eyes flashed, but she held herself calm.

'You are in my debt.'

Hui opened his mouth, but he could not deny this.

'You owe me your life,' Ahura continued. 'Then hear this – I will free you of your promise to marry me, if you let Ipwet choose her own path.'

Hui looked from one woman to the other and saw a change had come over them. Ipwet glowed with a joy he had never seen. And Ahura's hard heart had cracked and now she seemed to understand love. They should be together; he could see that.

For a long while, they talked, and then the women sat on either side of him and slipped their arms around his shoulders.

'And now it is time to express our concern for you, brother,' Ipwet said.

'I am well,' Hui said. 'Why worry yourselves about me?'

'We have talked long and hard—' Ipwet began.

Ahura jumped in. 'Your desire for revenge against your mother is poisoning your soul. Both of us understand your

loathing for Isetnofret, for what she did to your father, and to you. We feel the ache in your heart. But this is not the man you are. To follow this road can only lead to destruction for someone like you.'

'This is my road. There is no other choice.'

Ahura's face hardened. Hui knew that look – she would brook no dissent.

'You may think you are capable of what you plan to do. But if you take your mother's life, your guilt will end any hope you have for a better life. It will creep through you like an assassin in the night and slit your throat.'

'I am no stranger to killing,' he said.

'And I would wager each death weighed on your conscience?'

Hui didn't answer.

'To take the life of one of your own kin,' Ahura continued. 'Someone you called mother . . . That is far worse.'

'You have spoken about taking vengeance against your father—'

'True. But we are not the same, you and I. I have a black heart.' Ahura smiled, but her eyes glittered in the lamplight.

Ipwet grasped his hand again. 'We will not stand by and see you destroy yourself, brother.'

'There is nothing you can do,' Hui said, pulling away and standing. 'It has been decided, long ago. I will never give up my quest for vengeance. Isetnofret *must* pay for what she has done. She must be stopped from the horrors she yet plans to accomplish. Only then will I have a chance at peace.' He eyed Ipwet. 'You understand this.'

Ipwet bowed her head. She did.

'Now,' Hui continued, 'there are other things we must discuss about the days to come, and none of them good.'

Flames roared up towards the black pall lowering across the wide river valley. Walls cracked like thunder from the searing heat, and the ground rumbled as age-old buildings crashed down. The city of Minieh was dying. On the decks of the war galleys anchored off the docks, sailors bound scarves around their faces against the choking clouds of bitter smoke. All of them stood like statues, staring, scarcely believing what they were seeing.

On the platform in the prow, Hui blinked to clear his watering eyes. He watched a long section of the city wall creak and waver and collapse. Once the cloud of dust had drifted away, the true horror in the city was laid bare for all to see. Funnels of fire swirled up along the streets. The temple's columns toppled, and the shattered roof collapsed. The governor's offices blazed. The entire city had been sacked by the barbarians. Of those who had lived and loved and laboured in Minieh, there was no sign.

'Do we search for survivors?' Tau asked.

'We have our orders,' Hui replied, his voice flat. 'What more is there to see here? We turn around now.'

Tanus had sent Hui off with a single squadron of fast galleys to sail northwards as far as Minieh, or until he encountered the enemy. Avoid all action and report back in four days, Akh-Horus had said. The orders had left no room for manoeuvre, however much Hui wanted to help.

'We have seen no other ship and met no resistance,' the boy replied hopefully.

'We return and tell what we have found,' Hui said in a firm voice. 'Deserted villages. Farmers slaughtered in their fields. A land wiped clean by blood and death.'

Tau's head sagged. What they had observed was hard to stomach for even the seasoned warriors who served beneath him. But the lad was strong. He would recover. And in time this atrocity would light a fire in his belly – to fight back . . . to win.

Turning away from the desolate scene, Hui raised his hand to the captains in the other galleys, signalling the voyage home. For a long while, silence hung over all those on deck.

Hui's thoughts drifted with his vessel, back to those days after the scout's arrival with news of the Red Pretender's terrifying fall. For long hours, Tanus had debated in the pharaoh's council, accompanied by Kratas, who had been promoted to the rank of Best of Ten Thousand and now commanded the Blue Crocodiles. But the council had been divided. The younger warriors like Tanus recognized the threat the Hyksos represented, and argued that the main forces should be drawn back from the frontier between the upper and lower kingdoms to set up a series of deep defences along the river. While this was being prepared, Fareed and his other trusted men should lead scouting parties north to gather the knowledge needed to understand this mysterious enemy – the size of their army, their strategy and tactics.

But the old guard – those who had served upon the council from long before Hui had been born – refused to give up one cubit of sacred soil. Egypt could never be defeated, they said. The army would crush this intruder just as they had done all others before them.

Hui knew them to be fools.

As dusk fell, Hui glimpsed movement on the western bank: a knot of men stumbling south on exhausted legs. Deserters from the Red Pretender's shattered army. He yelled an order to the steersman and his galley swept in to the bank. A handful of fresh men with swords and shields was more than a match for the ragged band of weary fugitives, and soon they huddled

on the deck, shaking. These were the first eyewitnesses to the Hyksos invasion. What they had seen was so terrible they had fled at the first attack.

'Tell us of the barbarians and what transpired when they invaded the Lower Kingdom,' Hui demanded of them.

One of the deserters, a slender man with a missing ear, clasped his hands together. Tears streamed down his cheeks.

'We looked out into the east and saw an army that sailed across the desert as swift as the wind,' he stuttered. 'These are not men. They are fiends from the underworld.'

The crew laughed and mocked the soldiers for their cowardice. No one would believe them; of course they wouldn't. What could Hui say? That he had journeyed with the Hyksos, tended to their horses, slept with them, feasted with them, saved the life of one of their generals? If this truth was ever learned, no one would trust him again. He might well be taken captive as a treacherous spy. For the rest of the journey to Thebes, he tried to dream up some story that would both keep him safe and allow him to speak of what he knew of the barbarians, information that might be crucial in the coming battle.

As they neared the end of their voyage, Hui heard the huddled band of deserters talking about a treacherous Egyptian.

'Who is this?' he demanded.

The one-eared soldier looked up at him with sullen eyes.

'Before we fled, we saw a warrior in the vanguard of the attack. He looked nothing like the barbarians. No beard, no olive skin. He was an Egyptian, do not doubt it.'

Someone else snorted. 'You dreamed it. What kind of Egyptian would side with those devils?'

Hui knew. He stalked away, remembering what Fareed had told him in Lahun about his brother Qen leaving with Khyan's war band. Could this be?

Once they reached the City of a Hundred Gates, Hui recounted what he had found in the north. Tanus himself questioned the deserters. Still no one would believe their stories of the almost fantastical powers of the Hyksos, not even when hot coals were placed upon their heads and they howled as if they were dying. They never changed their accounts. Their talk, of how the Red Pretender's seasoned army simply collapsed under the relentless advance of the Hyksos and the bows that could kill a man at great distance, seemed unbelievable. In the end, Tanus ordered their execution. Hui felt unease when he saw everyone dismiss the information from the deserters – even Tanus, who was wiser in the ways of war than any of them. This was just another enemy, everyone said, of the kind that Egypt had crushed since the First Times. Hui tried to give weight to those deserters' stories, but who would listen to a mere captain of a war galley?

All minds became focused on the amassing of an overwhelming force that could stop these devils in their tracks.

For days, Hui battled with himself, feeling the rising tide of fear that everyone was drifting towards disaster. He had seen the chariots and bows of the Hyksos at first hand. But the question always haunted him. Who would listen?

Before Hui could find a solution, the day came. The proud fleet of war galleys sailing north would have been a stirring sight at any other time. But everyone watching from the banks, and all the warriors on board, had heard the grim reports and rumours coming from the frontier. Then the deserters came from the army that had marched ahead while Tanus organized the remainder of the force. Like a pack of rats, they had looted the villages along the Nile as they fled the terrors of the front. When Tanus learned what they had done, he ordered them executed, hundreds of them, their heads placed on spikes as a warning to any others who might think of such a betrayal.

Ignoring the wishes of the older council members, Tanus left a reserve of five thousand men at Asyut under the command of Remrem, while the flotilla sailed on north to the frontier. Once they reached their destination, Hui watched the fleet drop anchors across the river in the battle formation. Skeleton crews remained on board while the rest of the sailors joined the infantry on the eastern bank.

The king himself had travelled north with his queen and their son and his army, on the royal barge, for his divine presence would raise the spirits of everyone prepared to fight. When his vessel moored, the pharaoh ventured ashore and a camp was set up in a deserted village above the fields inundated by the recent flood. Hui glimpsed only an elegant figure drifting ahead of his advisers, but he felt emboldened nonetheless.

On the edge of the camp, Hui settled in a tent with Fareed, amongst the senior officers most trusted by Akh-Horus. There was no need for him to remain on board his vessel in the blockade. The scouts had confirmed the Hyksos had no fleet of their own. They saw no need of one. They could bring death from the land with such ease.

'You have news for me?' Hui whispered once they'd settled in the dark.

'It is true – an Egyptian rides with the Hyksos, the desert wanderer murmured. 'I saw him with my own eyes while scouting, and Khyan, too.' He gave his description. 'Your brother?'

It was Qen, Hui was certain of it.

'I beg you, tell no one of this.'

Hui brooded, imagining scenarios where he could capture Qen in the heat of battle, wondering how far he would go to seek revenge on his brother.

For the rest of the night, Tanus huddled in meetings while he marshalled the force. Astes, an experienced general, was placed in command of the fleet. Tanus himself took one flank and Kratas the other. Thirty thousand of the most seasoned warriors lay under Tanus' command. Never had Hui seen so many, and some of the old hands on deck said such an army had never been assembled along the Nile valley. Another thirty thousand would soon arrive under the command of Nembet, one of the oldest members of the war council.

And then all would tremble before the greatest army in history.

ui stirred from a dreamless sleep. He wasn't sure what had disturbed him – Fareed still slumbered peacefully – but when he poked his head out of the tent, he glimpsed a figure moving away towards the hill behind the camp. It was Taita, that wise eunuch, who, Hui had learned, was held in high regard by the pharaoh himself. Sensing the night beginning to lighten, Hui knew there would be no more rest for him, so he crawled out and followed.

At the summit, he lay on his belly out of sight of Taita, who was scanning the plain of Abnub. On the river, the lamps on the ships glimmered on the water and a faint mist drifted.

Taita was looking towards the east and Hui followed his gaze. The first light was shimmering across the desert, the sands the colour of ibis feathers, the dunes throwing strips of mauve shadows on their western curves. Hui felt his senses jangle. Something was not quite right with that peaceful view, and he squinted into the distance. An ochre cloud hovered low on the horizon beneath the ocean-blue sky. As Hui stared, the cloud grew and he realized it was sweeping towards them.

Hui jumped to his feet a moment before Taita threw up his arms in warning. Lights flashed across the gulf of the wastes, and Hui felt a chill when he realized what it was signalling: the sun's rays bouncing off polished bronze blades and shields.

The Hyksos were attacking.

Hui stared, aghast at the speed the cloud was moving, and he knew this was the chariot attack. But how many of them were there to raise that much dust?

The war trumpets were already sounding as Hui bounded down the hillside to the camp. The men swarmed, snatching up swords and spears and armour. A knot of men thundered past him in the opposite direction, and he saw that it was the pharaoh's slaves carrying the king to the summit of the hill. His throne had been set there so that he could watch the unfolding battle.

Tanus had prepared for this as only Akh-Horus could. His divisions were already massing in formation: spearmen at the front, the shield wall slotting into place; then the archers with bows strung, and the quiver boys behind them to feed the supply of arrows. At the rear, the fast and mobile swordsmen waited to be deployed for the mopping up.

Hui marvelled at those terrifying ranks, but still he felt a shiver of unease. The force was vast, but Nembet's army still had not arrived.

He looked at that rolling bank of cloud and his unease turned into a familiar dread. The chariots burst from the ochre dust – twenty, a hundred, a thousand, the gold on their curved boards afire in the dawn light. Hui's breath caught in his throat. They sped like ships with a strong wind filling the sails. He'd seen that speed at play across the Sinai, but here, with so many of them sweeping in unison, all he could feel was a churn of wonder and terror.

Tanus' officers stopped their battle planning and stared in awe as the chariots ground to a halt. They took in those unfamiliar wheels, and Hui could see their amazement as they realized this was the source of the desert-ships' speed. And then their eyes fell upon the horses. Their response was just the same as Hui's had been the first time he saw one: a hint of terror at the size and the strength, and then admiration at the power that rippled beneath the skin.

The silence hung in the void between the two sides for what seemed like an age. Then one of the chariots started forward and raced towards the Egyptian line. As it neared, Hui stared at the man guiding it. A tall square crown of gold glittered on his head. Surely this could only be the Hyksos king, Salitis, whom he had heard so much about. His skin was amber above this thick beard, his nose like an eagle's beak. His body armour of bronze scales shone like the sun.

The king turned his chariot and raced along the Egyptian ranks, so all could see him and his crescent sword in its gold scabbard and the two quivers packed with brightly fletched arrows. He slowed his course and flung down a lance with a fluttering crimson pennant tied to it. This must have been a sign, for his entire army began to advance as one and the ground throbbed.

Hui glimpsed movement in front of him. Tanus had snatched up his great bow, Lanata, possibly the most powerful of any in the hands of the Egyptian forces. He nocked it and loosed a shaft in one fluid motion. Such was the power of his arms that it arced towards the Hyksos king. Hui could not imagine any other soldier achieving such a monumental feat. Salitis raised his shield and the shaft punched into it.

Salitis grabbed his own curved bow and let loose. The arrow flew over all their heads and thumped into the base of the pharaoh's throne far behind them. The king threw up his arms and cried out in shock.

Hui sensed the terrible realization rush over Tanus' men: they had nothing to match that weapon, or the chariots and the horses. They should have believed the deserters' tales. They should have been more prepared. And now doom was coming to meet them.

From that moment on, Hui tumbled into a storm of blood and screams and battle cries, all thought that he might glimpse Qen gone from his mind. He'd experienced battle before, but nothing like this, not even the slaughter that day he'd first met Tanus.

A whirlwind crashed against the Egyptian army, tearing them apart. The sky turned black with arrows, and the screams of the wounded and dying became one howl of horror screeching around him, so that his ears ached even though he pressed his hands against them.

Blades had been fixed to the whirling wheels of the chariots, and they carved through the Egyptian ranks like ships cutting through the waves. Horses trampled men, crushed skulls and ribs. Crescent swords flashed everywhere. Hui covered his eyes against the blinding light.

As the Egyptian survivors fled, the battle became a massacre. The sands turned red.

In his battle-born delirium, Hui stared across the carnage and watched the Hyksos king's golden chariot break ranks. As it thundered forward, Salitis raised his curved bow and loosed an arrow.

Hui ducked from instinct, but the shaft flew high over his head. When screams cut through even the deafening tumult of battle, he whirled around. The shaft had smacked into the chest of the pharaoh. Dead or mortally wounded – Hui couldn't be sure – the king slumped in his throne, as Taita and his closest advisers milled around him.

The Blue Crocodiles and a few other survivors scrambled to form a ring around the pharaoh. Hui raced to join them. Somewhere Tanus' voice rang out.

'Leave the men! Kill the beasts!'

Egyptian arrows filled the sky. Two of the horses crashed to the earth, stricken, and the chariots heaved over and shattered. Seeing this, the other charioteers held back. It was a small victory, Hui thought. But when he looked across the battlefield, he could see that all was lost. The well-drilled army had become a wild rabble, fleeing in all directions as the Hyksos moved amongst them, cutting them down. Hui felt sickened at the butchery. Bodies piled up like the dunes of the desert.

'Back to the ships!' Tanus was yelling to the few survivors, and Kratas took up the command.

The pharaoh was placed on a litter and raised aloft, and Hui was racing alongside them, towards the river, away from the plain of Abnub which had now become a crimson sea.

Hui leaned against the rail of his galley, his stomach churning from the horrors he had witnessed. The sun was already low in the west, the shadows congealing along the edge of the ruddy water. Screams still echoed from the battlefield as the Hyksos mopped up those who had fled the fight, but the periods of silence between each terrible cry were growing longer. The enemy had not advanced from the plain of Abnub, no doubt believing their work to be done. Their foe had been broken.

How could it have come to this, so quickly? Even though Hui knew the strengths of the barbarian horde, he'd expected a more equal fight than this slaughter. He could see it etched into the faces of the survivors, their confidence, their arrogance . . . shattered. They staggered around like drunks, bewildered, and Hui felt sure that the same thought haunted all their minds: if they could not win here, where could they win? Had almighty and eternal Egypt already been lost?

Hui watched the pharaoh's unmoving form loaded onto the royal barge. Taita was at his side, his face ashen. There was the essence of this terrible day. The god-king taken down by a single arrow. His implacable enemy ready to take his place.

But this was no time for weakness. Hui had been given a job to do. Shaking himself from his stupor, he turned to his exhausted men.

'Bring the wounded aboard this vessel,' he shouted, 'and then on to the other galleys!'

When he glanced towards the huddled masses on the shore, Hui realized that few ships would be needed. Not far away, Kratas strode along the line of those still able to walk, rounding them up for the hurried march to safety.

A skiff rowed alongside and Tanus climbed aboard. His hair was matted with sweat and his eyes had the faraway look of someone who had stared into the land of the dead.

'How many left?' Hui croaked.

Tanus looked towards the darkening east.

'Of the thirty thousand men who stood on the plains of Abnub this morn, it seems to me that only seven thousand remain, and five thousand of those are wounded. Many will die.'

Hui felt his heart sink. He glanced at Tau, who sat by the oars, his arms wrapped around his knees. He didn't look up.

'And now?' Hui asked.

'Now you must burn the fleet.'

Hui started to protest.

Tanus held up a hand to silence him. 'We have few sailors left, not enough to man all the ships we have here. We can't risk them falling into the hands of the enemy or all will be lost.'

Hui nodded. Akh-Horus was right as always.

'And then?'

'We head south and make our plans for the next battle.'

Tanus strode away, still managing to hold his head high. Hui climbed down to the deck and beckoned to a few of his most trusted men. Night fell as they collected bundles of reeds along the bank and stowed them in the ships they had chosen to scuttle. Then, moving from ship to ship on a skiff, Hui set each one alight.

When he gave the order for the galleys set aside for the survivors to set sail towards home, he heard a thunder in the east. Hui struggled to comprehend what that sound was, for the skies were clear. Gradually, though, realization dawned on him. The Hyksos army was moving south, towards Thebes, to finish the work they had started this day.

As they caught the current and the ship began to move, Hui glanced back. Across the night-dark river, the pride of Egypt's fleet blazed, the flames leaping up towards the stars. The fires glowed in the vast sea of dark for what seemed like an eternity, and then one by one they winked out.

The body drifted on the current, pale and bloated like a dead fish. White eyes stared at the azure sky. Hui could sense the thick stink of rot floating on the hot breeze. Gulls clouded the sky ahead of them, shrieking as they swirled in frantic arcs. Hungry. Feasting. This would not be the last poor soul.

The crew fell silent as they watched the corpse bump against the hull and pass by. They could see he was an Egyptian soldier from his kilt marked with the sign of the Lion Guards, and they knew what that meant. This was one of Nembet's men, the force that had not reached the plain of Abnub in time for the battle with the Hyksos. Fate had caught up with them after all.

The galley sailed on. Soon the thumps against the hull became a steady beat. The crew moved away from the rail, busying themselves with oiling the handles of their oars or examining the lines on the sail. Hui fixed his gaze ahead, trying to remember the peaceful days in Thebes before this world had descended into madness. But the choking reek dragged him back, and he stared at the thickening mass of bodies until they stretched from bank to bank and the water was no longer visible.

Nembet's entire army of thirty thousand men lay dead, by the looks of it. The Hyksos had torn through them like the scythes of the reapers in the harvest fields.

Hui felt numb. This seemed like an ending. All they had known, wiped away. Closing his eyes, he heard once again the wailing that had emanated from the royal barge the previous day. The pharaoh was dead. Queen Lostris had ascended to the throne, her young son the Prince Royal Memnon in her lap. After the ritual obeisance, the war council had been convened. Tanus had attended, but whatever they had agreed had not yet been revealed to any of the surviving army. Perhaps they had no answers.

A cry from the lookout rang out. Hui followed the sailor's pointing arm to see a survivor of the Lion Guards stumbling along the bank, soaked in blood. The alarm leaped from galley to galley until a skiff was launched, and the soldier was brought onto the royal barge. When they moored as dusk drew in, Tanus came on board Hui's vessel. In the light of the riding lamps, Hui could see his grim expression.

'Nembet was a fool,' Akh-Horus said. 'He scuttled most of his fleet before the battle was lost, but he had beached fifty galleys for use later. They are now in the hands of the Hyksos.'

Hui stiffened. 'The barbarians now have the means to cross the river in force. All Egypt could be theirs in no time.'

'There is still a chance we can catch them, but we must be swift,' Tanus said. 'Divine Isis, fill our sails with your breath.'

Across the hazy eastern sky, countless wreaths of blue smoke swirled up.

'Campfires,' Tau said, pointing.

He was a clever lad, Hui could not deny it.

'The barbarian horde has broken its journey south,' he replied. 'Perhaps we are not too late after all.'

But he saw how far that pall of smoke reached – almost to the foothills of the desert. How great was the Hyksos army, how mighty.

Now, though, was the time. Hui strode across the benches to where Fareed crouched, his hawk-like eyes studying the eastern bank.

'I have no right to ask for your aid,' Hui began. 'Not when the request will place you in danger. But I will ask nonetheless.'

The desert wanderer looked up at him from under hooded eyes.

'Speak.'

'You are the best scout we have. Some would say the best in all Egypt. Only you have the skills to survive in land overrun by the barbarians.'

'Do not feed me honey,' Fareed rumbled. 'What do you want?'

'I would know where my brother is. If there is any way of reaching him. If he can be lured away. The risks will be great—'

'Put me ashore.' Fareed stood. 'I make no promises. If I can find him, I will bring word. Khyan's standard will be my guide.'

The desert wanderer batted away Hui's hand of thanks, grumbling.

Yet Hui felt his chest tightening. As if emerging from the smoke of a devastated city, he began to see the outline of the enemy's plan. Khyan had spoken of the Ka Stone, and what a great prize it would be for his people. That would be vivid in the minds of the Hyksos commanders as they bore down on Thebes. Little did they know they were about to be betrayed. Qen could only be riding with them for the same prize, at his mother's behest. And Isetnofret would not now let the Ka Stone slip from her grasp.

When Fareed was ashore, Hui slipped into the overgrown fields, abandoned by the farmers who had taken shelter in the walled towns. Hui prayed he would see him again.

The delay meant Hui's galley was at the rear of the fleet as the vessels swept around the wide bend of the river. Hui peered through the forest of masts and saw a line of captured ships across the Nile. A small band of the Hyksos were transporting horses and chariots to the western bank. The plan was to race to the necropolis opposite the city, and loot the funerary temple of Pharaoh Mamose where he would soon be interred. At least, that was what Akh-Horus believed.

But these barbarians were not used to being away from dry land, Hui could see. The captured vessels were ranged in a ragged line, some twisting in the currents. The oarsmen skimmed the water as much as they dipped their blades. They were ripe for the plan Tanus had devised.

The sudden deluge of fire-arrows blazed down from the sky in gold and amber trails. The shafts had been wrapped in papyrus and dipped in pitch. Akh-Horus had calculated the Hyksos would not have seen their like before, and he was right, the

sailors scattering as death rained down on them. Flames rushed up the sails and across the decks. Men raced back and forth, tongues of crimson licking at them.

In the lead vessel, Tanus roared above the crackling of the growing inferno as the bronze ramming horn ripped through one galley. Water flooded into the ruptured hull. Hissing clouds of steam swirled up as the waters swallowed ship after ship.

The fire-arrows rained down, thicker and thicker, until the cowering enemies no doubt thought the deluge would never end. The Hyksos sailors hid under benches, the steersmen raced from their posts. The directionless vessels twisting in the current were easy prey. Tanus stormed on, picking off one after another. The air filled with the thunder of rending wood.

Hui punched a fist into the air as the final vessel went down. As the survivors scrambled onto the western bank, Tanus sent his most seasoned warriors ashore to hunt them down. The horses that had made it across the river cantered up and down the bank. Whatever syces had been caring for them had long since fled. Hui smiled as he watched Taita splash ashore and creep towards them with clear trepidation. The eunuch had a curious mind, that was clear.

Hui felt a notion sneak up on him. His own galley had been scuttled near Abnub and now he was a captain without a ship. He needed a purpose in the coming battle.

Amid the cheering of the Egyptian crews, the remnants of the fleet sped south. The furious barbarians loosed volleys of arrows after them, but all plunged harmlessly into the waters. It was a victory, and a good one – a setback for the barbarians' plans. After the devastation they had suffered, every man had a renewed fire in his belly. And now they had moved ahead of the rampaging horde. That had bought them some time.

When they moored for the night, Hui ventured ashore to where Taita had gathered a small group of men. The eunuch eyed him askance as he always did, but Hui put on a broad grin.

'I hear you wish to capture the horses that escaped from the Hyksos,' he said.

'How do you know that?' the eunuch asked with a scowl.

Hui tapped the side of his nose. 'It is a wise plan. Those powerful beasts will benefit us in any battle against the Hyksos.'

'I am glad you approve.' Taita sniffed.

Hui raised a hand to halt the eunuch before he moved away. 'What do you know about horses?'

Taita frowned. 'Obviously not as much as you do?'

'I was once a syce.'

'And what creature is that?'

'A groom, one who cares for horses.'

Seeing Taita's doubt, Hui told the fantastical story he'd been creating to avoid any suspicion – about how he was captured by a tribe of barbarians when he was a child, and how he was taken with them to roam the plains to the east, a year's travel beyond the Euphrates river. That was how he learned about horses. Only later did he escape and make his way back to Lahun.

Hui swallowed, waiting to see if the eunuch had fallen for his lies. But Taita was so keen on stealing those magnificent beasts that he cared little for any flaws in the story.

For the rest of the night, Hui ran alongside Taita's band as they stalked the horses through the deserted fields. When they finally rounded them up, Hui felt pleased to see a light dawn in the eunuch's face as he stroked the nose of one of the steeds to calm it, as Hui showed him. It seemed Taita was not

as hard-hearted as he pretended, and he had as much admiration for the horse as Hui had the first time he encountered Moon. He and Taita would never be friends, Hui knew, but a bond had formed over these wonderful creatures.

With its lamps ablaze, Thebes glowed like an enormous ship adrift on the ocean of night. Hui's heart swelled to see it as he rode ahead of the knot of men along the western bank towards the necropolis. As expected, the remainder of the fleet had already docked, pools of lights glowing around them on the black waters. Weary warriors trailed along the quayside, helping the wounded to where they could be treated in a makeshift camp alongside the city of the dead.

Tanus would already be at the half-built Palace of Memnon, where he planned to establish his headquarters, close enough to Thebes to observe, but kept safe from the marauding barbarians by the wide expanse of Mother Nile.

Hui glimpsed a figure waiting in the shadows and slipped off the back of his mount, handing it to Taita, who had been watching his display. The eunuch had been tasked with overseeing the funerary rites of the pharaoh in the absence of the temple priests, and Hui could see the burden of responsibility in his face. Once the stallions had been led away, Hui turned to Fareed, who looked as fresh as if he'd spent the day reclining on the riverbank.

'The barbarian hordes are on the move,' he said. 'They have only one aim, for now – to lay siege to Thebes.'

Tanus had discovered the Hyksos had reached an agreement with a treacherous member of the court, Lord Intef, who had told them all they needed to know to take the city.

'My sister and Ahura . . .' Hui began, the words almost choking in his throat. 'I must bring them here to the western bank where they will be safe.'

'I thought as much. But you must act with haste. The Hyksos are bearing down on the city and our forces are not great enough to stand in their way. You will soon be able to feel the ground shake.'

'And my brother?'

'He rides with Khyan. I saw him with my own eyes. The Hyksos king respects Khyan, as you know, and he has chosen him to be in the vanguard of the assault on Thebes.'

To imagine Qen so close after all this time! Could Isetnofret be far away? Perhaps now the gods had decided the time was ripe for him to gain his vengeance, after all the times they had ensured his attempts had failed. Hui would offer a prayer to Horus as he travelled across the waters.

'I will always be in your debt,' he said to Fareed. 'There are no words that can convey my gratitude for the risks you have taken.'

The desert wanderer stared at him, his face unreadable.

'This is what we do,' he said.

Before Hui could ask what he meant by that, Fareed had turned away and was striding towards the men streaming into the necropolis.

'We will meet again when you return with your loved ones,' he said without glancing back.

The black water gurgled around the prow of the rowing boat. Gold bands wavered along the river's edge ahead, and the lamps above them blazed by the quay. Sweat slathered Hui's face and drenched his

kilt as he heaved on the oars across the strong currents towards those welcoming lights, but his heart was thumping. In the distance, he could hear the sound of thunder that was not thunder. It rumbled towards Thebes faster than he could have imagined, promising a storm that would wash them all away. Time was short.

Once he'd drifted alongside the wharf, Hui tied the rowing boat and clambered up the stone steps from the water to the quayside. No sailors lounged on bales, drinking and laughing. No vessels were moored along the dock. Only a tense silence hung over the waterfront. Word must have reached the city of what was coming.

Hui cocked his head, listening, and felt a queasy twist in his gut that the booming was near. The sounds that comprised it rose out of the morass: the rumble of chariot wheels; the hammer-strike of hooves; the roar of tens of thousands of voices hollering with euphoria at the coming victory. So great was that army it felt like the ground was quaking beneath his feet.

He hurled himself along the road to the river gate. He'd been as fast as he could finding the boat and setting off from the western bank, but he hadn't been quick enough, he could see that now. But what could he do? Abandon his sister and Ahura? Ignore his hope that he might be able to pluck the Ka Stone from his mother's grasp at the last?

His feet pounded over the limestone slabs that would normally have been thronging with life – wealthy men strolling to take the air, merchants haggling, apprentices playing *senet* on a grid scratched into them, the lines of laughing whores trying to catch the eyes of the rivermen. Now there was only the warm breeze blowing the stink of the middens from the poor quarters.

As Hui closed on the gate, the storm broke. Chariots suddenly surged along the river road, an endless flood. Whip arms lashed. The steeds threw themselves on to greater speed. There were so many. From what Tanus had said, the rest of the Hyksos army would be entering Thebes along the eastern side, encircling it in a siege that would crush the life from the greatest city in all Egypt.

Too late now, for everyone sheltering here, and for Hui, too. Once he was inside, he would be trapped. He had sacrificed himself, and for nothing. He wouldn't be able to save Ipwet and Ahura. But at least he would die with them.

On he ran. The lead chariot was closing fast across the broad open space to his left. As Hui glanced over, he saw the man guiding it was none other than Khyan, his aquiline profile clear in the lamplight. He was laughing like a madman, his gaze fixed upon the gate ahead.

Dust clouded from his wheels, and then an outrider overtook Khyan and Hui saw it was his brother. Qen had his head low over the beast's neck, his dark features cold with determination. The Ka Stone would be burning in his mind.

Hui felt his stomach run cold at this first sight of his brother in what seemed like an age. Qen had mastered the horse as he seemed to master everything, but Hui still could not believe his brother's treachery – that he would betray his own people, all for Isetnofret's lust for power.

And then Hui watched his brother's eyes flicker towards him and lock upon his own in an instant of shocked recognition. Qen's features twisted with loathing. He thrashed his mount harder still, urging more speed as he guided it towards Hui. Qen unsheathed his sword, whirling it high.

Ahead, the great gate, which was always left open, was beginning to rumble shut.

Hui's legs burned, but every fibre of him was focused on that narrowing gap. He could sense Qen riding ever closer, almost feel his brother's desire to hack him down as he ran. Hui didn't dare look round, or slow his pace for an instant.

He imagined the guards heaving their shoulders against the other side of that gate. One by one, the lamps inside were winking out as the huge portal swung shut.

Hoof beats thundered closer until Hui's head swam with the pounding. His neck prickled at the thought of the blade biting deep, and amid the agony of his final sensations, hearing Qen's laughter.

And then he was through the gap and sprawling across the flagstones as the gate shut behind him.

The great bar boomed down into its rack.

Hui gripped the stone, face down, blinking away tears as he sucked air into his searing lungs. Safe, for now. Then, scarcely able to believe he had survived, Hui scrambled to his feet and brushed the dust off himself. Staring at the gate, he imagined his brother raging in frustration, yelling and shaking his fist at being denied . . . what? Vengeance? Hui had done nothing to Qen. That hatred must have burned in his heart for so long.

The din of the barbarian horde roared so loud he couldn't hear the captain of the guard raving at his men. Turning, Hui raced away into the city, yet even then there was no escape from the tumult. The siege of Thebes had begun.

When Hui reached the house, he found Ipwet and Ahura cowering on the bench, hugging each other tightly. His sister jumped up and threw her arms around him.

'You are safe!' she cried, her eyes brimming with tears.

'The gods blessed me with the wings of Horus to carry me far above danger,' Hui said.

Ipwet stared into his eyes. 'It is true, then.'

This time Hui had no words.

'We heard the rumours.' Ahura paced around the room, listening to the clamour throbbing through the walls. 'But the army was gone, the pharaoh, too, and the court sheltered far away from common folk. The truth was hard to come by and there was no one to protect us beyond the handful of men left behind in the garrison to keep order.'

'Pharaoh is dead,' Hui said.

As the looks of horror dawned on the faces of the two women, he recounted all that had happened since his arrival at the plain of Abnub.

Ipwet wrung her hands. 'Then there is no hope left—'

'There is always hope!'

Hui's voice rang with passion, and he wanted to believe it. But the barbarian horde was vast. They could close off the city for as long as they wanted, until the grain warehouses were emptied, and the people were starving and sick, and threw open the gates in the madness that comes when death is close.

'Tanus will save us,' Hui said in a firm voice.

Ipwet's eyes brightened. 'Of course. A great general like Tanus, with the army at his back. He will attack the barbarians from the rear and cut through them like barley in a field.'

Hui didn't have the heart to tell his sister the army was nothing but a shadow of its former power. Tanus, who was searching for a way out of the impending disaster, would not sacrifice his men to no end. He sensed Ahura staring at him, and he looked away. She could always see through his bravado and guile.

Before Hui could say another word, cries of alarm rang out. Ipwet's eyes widened.

'That came from within the city!'

Hui bolted from the house and raced along the street. The cries of alarm grew louder, growing in intensity, along with the clash of bronze upon bronze. Surely the barbarians could not have stormed the city so quickly. The gate was as thick as his outstretched arm, the walls more than six times that length, and they towered far above his head.

As Hui stumbled out into the long street running from the river gate past the palace, he caught sight of furious fighting between a tight knot of barbarians and a handful of palace guards. At the end of the street, though, the gate remained closed, with another line of guards defending it.

'How did the barbarians get in?'

Ahura stood at his elbow, breathless. Ipwet was hurrying behind.

'Return to the house!' he yelled, but Ahura shoved him aside. She pointed to where more of the Hyksos warriors were hurrying towards the battle.

If one of the gates had been smashed, a torrent would be flooding into the city. But this was only a handful. Hui could see, though, that these were seasoned warriors, perhaps an elite force. The crescent swords whirled around their heads in fluid movements, and they danced with grace and agility to avoid the lumbering guards' blades. Their moon-swords cut high, then low, carving through the guards who were running up from all directions. The Egyptian defenders were little more than a rabble, attacking in a clumsy fashion with no sense of strategy.

Hui ran to one of the guards who was slumped at the side of the street, clutching a gash in his arm.

'Where did the barbarians come from?' he asked.

The guard nodded towards one of the side streets.

Hui knew the killing blow was coming. He heard Ipwet scream. The curved blade slashed towards his neck with enough force to take his head clean off his shoulders. Somehow, at the last, he stumbled to one side and as it twisted, the flat of the blade struck his skull.

Down Hui went, his wits flying away into a dark hole. When he came round a moment later, Ahura and Ipwet were frantically shaking him. His attacker had left him for dead. Through a haze, he stared past the two women. Trailing bodies in their wake, the barbarian band had fought their way to the gate. They cut through the last line of defence with ease.

Dazed, Hui watched the barbarians put their shoulders under the bar and heave it up. The wooden beam thundered to the ground. And then the barbarians were grasping the papyrus rope handles on the gate and dragging it towards them.

As the gate ground open, the roar outside the walls was stirred into a frenzy and became the bellow of a ravenous beast.

Grabbing his sword from where it lay on the flagstones, Hui lurched to his feet. The blade wavered in front of him as he wondered if he had the courage to stand his ground.

But then the gate swung wide and the Hyksos horde charged in. The chariots surged forward along the processional avenue. In desperation, the surviving guards tried to flee, but they were crushed under the wheels. The foot soldiers raced in behind the chariots, filling the street from wall to wall.

Ahead of the horde, the Egyptian citizens fled. Faces frozen in terror, their screams mingled with the tumult. A woman stumbled and fell and was instantly trampled underfoot by the panicked crowd. Hui watched an old man crushed against a wall, and two more go down beneath the wave of terrified people.

'A hidden tunnel under the walls, or so it seems,' he said through gritted teeth. 'They lifted a slab in the square and came out of a hole beneath.'

The tunnel must have been there before – there had been no time to dig one – but how did they know of it? There could only be one answer. Lord Intef, the traitor from the court who had been helping the Hyksos with their plan. Only a wealthy aristocrat like him could have had a tunnel dug in secret. He must have been privy to the barbarians' plans for many moons.

Hui felt sickened. Lord Intef, Isetnofret, Qen – how many Egyptians were prepared to betray their own people for gain?

He could see where this plan was leading. The barbarians were cutting a path along the street to the gate. Once it was opened, all would be lost.

Ahura could see it, too, and she could also see the barbarians were not about to be stopped. As Hui drew his sword to join the defence, she tried to grab his arm to hold him back. Hui threw her off and then he was running towards the fighting. His feet skidded across bright limestone slick with blood, past dead and dying guards.

One of the Hyksos warriors saw him approach and whirled. His blade slashed towards Hui's chest. At the last, Hui swur up his blade to deflect the strike, and the clash of metal se spikes of pain stabbing up his arm to his elbow.

The force knocked him back on his heels, and then the v rior was swinging his sword high, then low, each blow li hammer strike as Hui parried them. His thoughts reeled the speed of the attack. Though he'd learned much fro sparring with the Blue Crocodiles, Hui was no match for rior of this calibre.

And then Hui glimpsed a familiar face – Adom, the cruel boat-master, lumbering like a water-cow on dry land. He howled as he had once made Tau howl. As Adom fell behind the fleeing crowd, he screamed for help. A chariot bore down on him. As Adom half-turned, the charioteer hacked with his sword. The blade ripped open Adom's vast belly and his glistening guts tumbled onto the street. And then he was lost from view, whatever life was left in him crushed beneath the wheels of the following chariots.

The gods have brought justice, Hui thought as he turned away.

'We must run!' Ipwet yelled.

'Where?' Ahura's voice, for once, held no confidence. 'Do we hide?'

'No!' Hui shouted. 'We must get the Ka Stone!'

Before the two women could complain, Hui grabbed Ipwet's arm with one hand and Ahura's with the other. Together they rushed away from the stampeding mob. Not a moment too soon. The crowd churned as the chariots carved a path amongst them.

Hui wanted to plug his ears against the howls of those dashed beneath hooves or crushed beneath wheels, but he plunged on up the steps towards the square, and the palace and temple beyond.

As he glanced up, Hui glimpsed a figure silhouetted at the top of the steps with the moon looming behind – an old woman wrapped in a shawl. The crone raised a trembling arm and pointed at him.

'Here!' she shrieked. 'He is here!'

'Who speaks?' he said, a chill going through him.

Ipwet was staring, her mouth wide.

Hui glanced again at the waiting figure. Had his eyes played a trick on him? This was no hunched crone, but a tall, stately woman, her face cloaked in shadow.

The shadows shifted and the truth struck Hui like a bolt of lightning.

'Mother . . .?' he whispered.

Isetnofret stared down, her face contorted with rage, her eyes glowing with the fires of madness. Hui felt a whirlwind of emotion, battered and buffeted by the desire for revenge that had eaten into the heart of him for so long.

'Here!' Isetnofret yelled again.

Hui heard another blood-curdling scream behind him. He wrenched his head away and turned towards the new threat. Qen was fighting to bring his horse under control in the heaving mass of people, his hate-filled gaze fixed on Hui. The beast began to push towards the steps.

A cry rang out and Hui spun back. A blade flashed down towards him.

Ipwet lunged, grabbing Isetnofret's wrist before the knife could plunge into her brother. For a long moment, Ipwet held her fast, and Hui found himself staring into his mother's blazing eyes once more. He felt a surge of loathing and the desperate urge to wrap his hands around his mother's throat, to deny her the immortality she craved, to kill her there and then.

'I should have ended your life that night in my father's house when I stole my sister away from you,' he snarled.

Isetnofret's features hardened as she realized what he had done, and her knuckles whitened as she forced the blade down.

'Your life must be sacrificed to Seth!' she hissed.

'No!' Ipwet cried.

She twisted her mother's wrist and yanked Isetnofret to one side. The sorceress stumbled and fell down the steps.

Ipwet and Ahura grabbed Hui and dragged him up the steps and across the square to the temple.

'What now?' Ahura cried. 'Our only choice is death or slavery. And I will not be a slave again.'

'First, the Ka Stone. Then . . . Yes, there is a third choice.'

Hui glanced over his shoulder. Isetnofret was nowhere to be seen, but Qen had urged his horse to the top of the steps and was now preparing to ride them down.

'Run faster,' Hui urged them.

'What third choice?'

'We leave the way the Hyksos came in – through the hidden tunnel. No one will think to look for us there. And I have a rowing boat waiting to take us across the river to safety.'

'Are you mad?' Ipwet cried. 'Why waste time on the Ka Stone? And how will we reach safety with the barbarian horde between us and the tunnel?'

Hoof beats pounded on the stone behind him, drawing closer. Hui could see beyond the columns framing the entrance to the temple two terrified priests standing on the steps. Hui barged past them.

They hurried through to the sanctuary at the rear of the temple. Lamps danced along the white walls, suffusing the interior with a misty golden light, and the air was potent with the spicy scent of incense. Stone pillars lined the walls, and between them were finely painted murals of men and the bounty the gods bestowed on them, each underlined with a description in the sacred writing. A statue of Horus stood in one corner, towering three times Hui's height. The falcon-headed god looked down at him, the red and white pschent crown upon his head signifying that he was the king of all Egypt.

'Great Horus, give me protection,' Hui muttered, tapping two fingers to his forehead.

Against the far wall stood the altar, and upon it was the Ka Stone, as black as the night.

Hui felt his stomach knot when he saw it. Perhaps it was cursed, or perhaps this was always the path the gods had chosen for him when he had accepted their gift. When cries rang out at the doorway, Hui turned round and levelled his sword, backing towards the god's table. He gestured to Ahura and his sister to take shelter behind the columns.

Qen stalked in, his features like stone. Blood dripped from his sword. The priests would no longer be making their supplications.

'Brother,' Hui said defiantly. 'It has been too long since we last spoke.'

'How someone like you is still alive astonishes me.'

Someone like you. Hui winced at the contempt he heard in his brother's voice.

'There is no need for us to fight,' he began.

Qen snorted. 'The world will be a better place without you in it.' His eyes flickered towards the Ka Stone. 'And with that in Mother's hands.'

He strode forward, tightening his grip on the hilt of his blade.

This time Hui felt such a surge of hurt he could no longer contain it.

'Where did this loathing come from? None were closer when we were children. You protected me. You cared for me. We shared so much laughter and song and good times . . .'

Qen's face twisted into a snarl so savage that Hui stepped back. Yet he thought the expression looked odd, like a mask his brother had been forced to wear, with the real Qen's desperate, haunted eyes peering through it.

'I never felt anything for you but hatred.'

'But I remember—'

'You remember it wrong.'

Qen strode forward. Hui edged back, waving his sword from side to side.

'Father had only love for me before you arrived. Before he married that witch Kiya, who twisted his thoughts away from his true children and from my mother.'

'That is not true!'

'It is!' Qen raged. 'Mother told me all of it. You were his favourite, always. I was nothing to him.'

In that instant, Hui could see the poison Isetnofret had poured into Qen's heart – years and years of it, blackening his soul. He would never recover from those lies. Hui felt a flood of grief at the loss of the brother he thought he knew, but then Qen lunged and their blades clashed as Hui parried the thrust, his mind suddenly empty of everything except the will to survive.

Teeth pulled back from his lips, Qen hacked from the right, then the left, in broad downward strokes. He'd always been hard, cold, calculating. But Hui was surprised to find he was parrying his brother's attacks with ease, and he realized that anger had consumed his opponent.

A clear head is required for any battle, Tanus had once told him as they sparred on the way to Basti's stronghold. *Never lose your temper or you will lose the fight.*

Qen thrust again, spittle flying from his mouth. Hui stepped back, easily avoiding the tip of the blade, but that only drove his brother to greater fury. Qen gripped his sword with both hands as if it were an axe cutting down a tree and stormed forward, hacking in wild strokes.

Seeing his moment, Hui slipped to one side and whipped his sword up. It clattered against the blade of Qen's weapon with

such force that it flew from his hand and rattled across the stone flags.

Qen whirled, seeing his sword was too far away to reach. But his fury burned too hot for him to back down. He hooked his foot around Hui's ankle and wrenched the leg out from under him. Hui crashed onto his back, his head bouncing off the polished limestone.

Through his daze, Hui glimpsed Qen snatching up the Ka Stone from the altar and swinging it above his head. The moment seemed to hang, and all Hui could do was stare into those black, desperate eyes. Qen would only stop when he'd dashed his brother's brains out with that gift from the gods.

'Do not do this, brother,' Hui said.

'The gods will decide your fate.'

Hui sensed a shift in the quality of light. He glanced up and saw the Ka Stone was limned with a faint white glow. Whispers rustled around the edges of the still temple, like the ones Hui had heard that first night he had found the gift of the gods in the Shrike camp. Those whispers became louder until they echoed off the stone walls like voices in a deep well. Voices in a language he could not understand, but which drove dread into every part of him.

It was true! It was all true! The gods were speaking!

A bolt of that white light flew off the Ka Stone, and another, sizzling across the temple. Hui glimpsed Ipwet and Ahura scrambling away, just in time. Another bolt slammed into the altar, splitting it in two with a thunderous crack.

Hui gaped. The judgment of the gods was about to be visited upon him.

As the lightning danced around the stone, Qen glanced up and marvelled at the power he held.

And in that moment, Hui glimpsed his one chance. He rolled to one side and thrust up with his blade, deep into his brother's gut.

The Ka Stone plummeted to the ground as it had that night it fell from the heavens, and smashed against the stone floor. The glow vanished. The voices died. The gift from the gods, the object that had been prized above all others by greedy and powerful men, shattered into pieces. Shards of rock and glittering black dust streaked across the flags. No wondrous light. No breath of Horus. Nothing but the detritus that littered the endless burning desert.

Ipwet screamed and ran forward. As Qen slumped to his knees, clutching at the lethal wound in his stomach, she grabbed him and cradled him. Hui felt a terrible ache in his heart, certain that he had not only killed his brother, but also his sister's love for him.

Hot tears streamed down his cheeks. A gentle hand slipped under his arm – Ahura – and pulled him gently to his feet.

But Qen didn't relent.

'I have only hatred in my heart for you,' he croaked.

'And I have only love in my heart for you,' Hui murmured, choking back a sob.

He watched as the light in his brother's eyes died. Qen was gone.

Hui looked down at the broken Ka Stone that so many had been prepared to risk all for, then glanced at Ipwet. She laid Qen down, wiped away a tear and stood and hugged him.

'I mourn for Qen,' she murmured in his ear, 'but he left you with no choice.' Her voice hardened as she added, 'Mother made him this way.'

Ahura tugged them away. The clamour of the barbarians ransacking the city echoed through the walls. At the doorway,

Hui allowed himself one glance back at his brother's body, and then he steeled himself for what was to come. At least now he had denied Isetnofret the power of the Ka Stone, her dreams of immortality shattered like that black rock. But she would never relent. The fate of all Egypt was still at stake.

And Hui was sure he knew what she would do next: kill the one person who stood in her way. Tanus. With Tanus gone, all opposition to the Hyksos horde would wither. Isetnofret could still use her sorcery to become queen.

Hui shivered. His mother's dreams hung in the balance now. Never would she be more dangerous.

In the chamber where the priests kept their vestments, they pulled on the white linen robes, white papyrus sandals and the leopard skin strapped over one shoulder. In the confusion, Hui was gambling that a cursory glance would only reveal three frightened, fleeing priests, and that the pillaging barbarians would leave them for more appetizing targets.

Outside, the night pulsated with throat-rending screams and jubilant roars. Hui pushed on, past the bodies of the two dead priests and across the square to the steps. The street still seethed.

'Now our fate is in the hands of the gods,' he murmured to the two women.

At the edge of the street, Hui picked a path through the running bodies and pushed forwards. Fleeing Egyptians raced past him in a blur. A chariot raced towards him and he dashed on, feeling the breeze of its passing stir his robes. He glimpsed a blade sweeping towards him and he ducked, still hurtling onwards.

Somehow Hui reached the other side with Ipwet and Ahura, and then they were running down the side street towards the

tunnel. Darting into the entrance to the square, Hui slumped against the wall in the shadows. Ahead, the hole to the tunnel gaped. The flagstone lay shattered beside it.

'One more prayer,' he whispered to the women next to him. 'If the gods are with us, we will be safe soon.'

'Your gods seem to have abandoned you.'

The voice boomed behind him. Hui felt his blood run cold. He turned to see Khyan, dripping crescent sword in his hand, and a line of familiar faces from his war band assembling alongside.

'I thought I recognized the Little Rat scurrying away,' he added. 'Your disguise is pathetic and unbecoming.'

Hui stepped forward. 'Take me, but let these women go.'

Khyan looked Ipwet and Ahura up and down.

'Why should I?'

'They are innocent.'

'No one is innocent, Little Rat.'

Hui stared into Khyan's eyes and saw in them a deep hurt that had turned into a burning rage. The betrayal had stung him deeper than Hui could ever have imagined.

'Hyksos blood.' Khyan rolled the words around his mouth and spat on the ground. 'No Hyksos warrior would ever act like you. They have honour.'

He levelled his curved blade. Hui swung up his own sword.

'I told you what would happen if there was any sign of treachery,' Khyan continued. 'This night I will take your head.'

The Hyksos commander lunged, but Hui danced to one side easily, as Tanus had taught him. Khyan cocked an eyebrow, clearly impressed.

'You have learned your lessons well, I'll give you that,' he said.

He swung his blade again and this time it whisked by, a hair's breadth from Hui's chest. And then they were at each other, swords clashing high, then low. Showers of sparks hissed through the night.

Round and round, they danced. Hui felt the world close in around him. Ipwet, Ahura, the other Hyksos warriors . . . all gone. All he saw was that flashing blade and Khyan's searing eyes behind it.

What seemed like an age passed as they whirled, hacking and thrusting. Hui drifted into a dream where his instinct took over, all the things he had learned with the Hyksos and the Shrikes and the Blue Crocodiles flooding through him.

One thought flashed in his head: they were evenly matched. Hui almost reeled with amazement. He, the Little Rat from Lahun, and this seasoned warrior who had carved his way across the east. Equals.

He'd always admired Khyan – his courage, his cleverness, his honour . . . aye, and his kindness, too. Now Hui could see his enemy's eyes narrow. The anger no longer seemed to be there, only sadness.

'You fight well,' Khyan said, so low no one else would have heard. 'Perhaps you are one of us after all.'

Barely had the words left his lips, than Hui jerked his sword up with such force it raked across the back of Khyan's hand and knocked his own crescent blade out of his grip. It flew away and clattered on the flagstones.

Hui lunged in, turning his sword. He cracked the hilt across the Hyksos commander's jaw, dazing him. As his enemy crashed down, Hui loomed over him, pointing his sword towards the heart where he let it hover.

'Kill me,' Khyan gasped. 'That is your right.'

Hui pressed the tip of his sword against his fallen foe's chest, then hesitated.

'Do it!' Khyan snapped. 'I would have killed you.'

But as he stared into the other man's eyes, Hui wasn't sure that Khyan would have done as he claimed.

For a moment, Hui battled with himself. He pressed down with his blade, withdrew, pressed down again.

Finally, he stepped back.

'I cannot do it,' he said.

Hui heard Ahura cry out in disbelief, but his gaze was locked on Khyan's. Something passed between them – an understanding, perhaps.

The Hyksos commander nodded and pulled himself to his feet.

'Go,' he said, 'and may your gods go with you.'

Snatching up his crescent sword, he turned to his men and yelled, 'Away! We have a city to sack!'

The warriors darted away from the square and Khyan followed. On the edge of the shadows, he paused and looked back. One last lingering look that signalled, if not warmth, at least respect. And then he was gone.

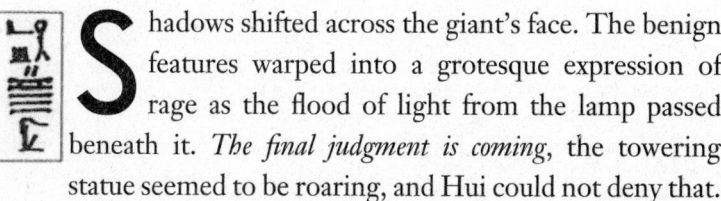

Shadows shifted across the giant's face. The benign features warped into a grotesque expression of rage as the flood of light from the lamp passed beneath it. *The final judgment is coming*, the towering statue seemed to be roaring, and Hui could not deny that.

Unnerved, he averted his eyes as he hurried by that monumental effigy. As tall as eight men, it was one of a pair that guarded the entrance to the vast funerary complex of the pharaoh that sprawled out across the western bank. Much of it

was still being constructed – the palace and the walkways, the smaller funeral houses and the statues and the obelisks – but it still dwarfed all the other final resting places of the kings of old throughout that City of the Dead.

Once Hui stepped onto the paved entrance road, he slowed his step and stared. The necropolis had been transformed. What seemed like a thousand campfires blazed in the dark on either side of the street, reaching almost as far as he could see to the edge of the desert. Figures hunched around them, the desperate masses of refugees who had fled the settlements along the Nile when the storm of swords broke, together with wounded soldiers, bandages dark with blood, and other starving warriors, shattered by the brutality of the battle they'd lived through. In the distance, he could make out trails of other refugees staggering in to seek shelter. Makeshift tents flapped in the breeze and beneath the drifting woodsmoke the air was choked with the reek of human waste.

Steeling himself against the misery, Hui dashed along the road through the moans and cries for aid until he reached the entrance to the courtyard surrounding the half-built Palace of Memnon. The guards waved him through into a more peaceful oasis scented by incense. Members of the king's council milled around, their heads bowed in worried conversation, and some of Tanus' closest advisers hurried by, faces drawn.

Hui breathed in a deep draught to ease the tightness in his chest. Part of him had thought he'd never reach here alive, even after Khyan gave him safe passage. They'd scrambled along the ink-dark tunnel and crawled out beyond the city walls. In the distance, chariots raced back and forth, their gold glinting in the moonlight, but fortune had smiled on them and the area

around the tunnel entrance was deserted. Keeping low, Hui had ushered the two women towards the wharf and they'd climbed into the rowing boat. Then he'd heaved on the oars until he thought his chest would burst.

He'd left Ipwet and Ahura to follow behind – they would be safe on this bank of the Nile – but they hadn't caught up, so he strode into the courtyard. He felt frustration as adviser after adviser brushed aside his pleas to speak to Tanus.

Hui glimpsed Taita leading his horse past a mountain of stone ready to be shaped by the masons.

Running over, he gasped, 'Where is Tanus? I must warn him.'

The eunuch rolled his eyes.

'Tanus has no time for the likes of you. His war council is in permanent session, and he has barely slept for days.'

'His life is in danger.'

'All our lives are in danger. Have you looked across the river?' Taita pointed to where flames roared up from the buildings in the city that the Hyksos had put to the torch. 'The barbarians will not stop there. Our spies along the eastern bank tell us they are already commandeering every vessel they can get their hands on – skiff, barge, raft . . . whatever they can find. Even with our depleted fleet, we can foil an attempt at a crossing, but they have the entire river at their disposal. We do not have enough spies to cover every crossing point.'

Hui clenched his fist in exasperation. 'Those are worries for another time. Tanus may not live to see the dawn.'

The wise man narrowed his eyes, silently urging Hui to continue.

'Somewhere amongst this great city of refugees is an assassin who will stop at nothing to take Tanus' life. But this is no ordinary cut-throat. No filthy Shrike or rogue. The one who plots

murder is a sorceress, with powers to turn men's minds, powers given to her by Seth himself.'

Hui's voice cracked with emotion and Taita's features softened. The eunuch seemed to be taking this seriously at last.

'Who is this sorceress?'

'My mother, Isetnofret.'

The revelation seemed to give the eunuch pause. Hui recounted all he could about his mother and brother, his father's murder and why he had fled Lahun, and about the magical powers he thought Isetnofret wielded, although he couldn't be certain about any of them. When he was done, Hui was surprised how good he felt finally to have told the truth.

Taita stroked the nose of his horse.

'You are a man who loves this beautiful beast, and that tells me much about who you really are.' He whistled and Tau ran over. Taita handed him the rope tied around the steed's neck. 'Take him to our new stables. And make sure you care for him!'

The boy winked at Hui and led the horse away, singing to himself.

Taita looked past the entrance to the Palace of Memnon, to that constellation of campfires flickering in the vast dark and the mass of people who gathered amongst them. Hui knew what the eunuch was thinking. If his mother could cloud men's minds so they saw her as another, how would they find her in that multitude?

'All she needs to do is to get close to Tanus,' Hui began. 'We will never see her until it is too late. A knife dipped in poison . . . She could lose herself in the crowd before Tanus even knows he is dead.'

Taita tapped a finger on his chin.

'Then we must draw her out.'

The group of soldiers stepped onto the paved street running from the palace complex to the twin statues at the river end. Hui stood at the front, searching the crowds spread out on either side.

'Remember,' Taita whispered, looking back, 'if anyone approaches, be prepared to act.'

The soldiers' hands fell to the hilts of their swords. They knew that an assassin lurked somewhere in the masses, but no more. That was as it should be.

'And you? Are you ready?' the eunuch asked of the man who would be Tanus, standing in the centre of his guard.

'Ready,' he grunted.

His voice was deeper than the general's, but he could play the part well enough. Taita had searched amongst the men until he found a warrior with a resemblance to Akh-Horus – the same build, the same mane of hair.

Taita set off on the street and called, 'Here is our great general, Tanus, who will save you from the barbarian invaders. He walks amongst you now to see that you are well.'

As planned, this Tanus didn't speak, for fear he would reveal himself.

Cheers rang out in the dark, and the buzz of chatter grew louder. Hui watched heads turn towards them, faces that had been drawn with despair now lit with hope.

On they walked at a slow pace, as Taita had planned, so that all could see and hear his constant exhortation of the same speech. Hui's chest tightened with each step. Faces passed by in shadow; even if his mother had not been disguised he would have struggled to recognize her. Now and then he was convinced he felt

Isetnofret's cold breath on the back of his neck. She could be anywhere.

A figure clawed its way out of the crowd. The soldiers half-drew their swords, but it was an old man with a milky eye. He was reaching out a trembling hand of thanks, and crying. The soldier pretending to be Tanus said the breath of Horus would put new life in his breast by dawn.

As the silhouettes of the twin guardian statues loomed up against the starry sky, a woman stepped onto the street in front of them. Her pale face was mottled with the marks of the pox. Hui flinched, Taita stepped to one side, and this time the soldiers unsheathed their blades.

'Please, save my children,' the woman begged.

She held out an arm, and two grubby urchins scrambled out to clutch at her legs.

Hui stared, his muscles taut in case this was some ploy Isetnofret had manufactured. But a few platitudes and prayers eased the desperate refugee and she stumbled back to her place. Taita eyed Hui. With a nod, they continued.

At the statues they turned and walked back up the long street, even more slowly. By the time they had returned to their starting place, the eunuch's face had darkened.

'Perhaps we should try again?' Hui ventured.

As Taita weighed the suggestion, Hui looked ahead and stiffened. Jabbing a finger, he cried, 'Has she crept in behind our backs?'

At the entrance to the courtyard in front of the Palace of Memnon, the guard slumped against a pile of half-carved stone blocks. He was awake, Hui could see, but his head was nodding as he stared into the distance with heavy-lidded eyes.

Hui and Taita raced up to him, the soldiers clattering behind.

'What happened to you?' the eunuch demanded.

The guard stirred himself and his thoughts seemed to rise to the surface.

'A woman came . . . asking to enter. When I refused, she opened her hand and a pile of white dust lay on her palm. She blew it in my face, and it tasted sweet and sickly in my nose . . . and . . .' He shook his head, unable to recall any more.

Hui grabbed his shoulder and shook him.

'What did she look like?'

'I . . . I cannot recall. Her face was a blur . . .'

He drifted back into his drugged stupor.

'With me,' Taita commanded.

He hurried across the courtyard, his robes sweeping the dusty flagstones.

A hushed atmosphere hung across the Palace of Memnon, but Hui could make out the murmur of voices in the distance. One day, when this mortuary temple was completed, it would be a magnificent monument to the pharaoh, grand in scale with soaring columns and high ceilings, the walls decorated in shimmering colours, and a great statue of Horus to welcome the god-king into the afterlife. Now, though, it was little more than bare white walls that near-blinded in the glare of the lamps flickering along each side.

Their leather soles clattered as they ran. Taita slowed his step as the rumble of voices got louder. Finally he was creeping towards a smaller chamber at the rear, suffused with lamplight. Hui peered past the eunuch and saw Tanus holding forth at the centre of the war council. The elderly advisers and newly promoted generals bowed their heads and nodded as Akh-Horus outlined his strategy for protecting the necropolis from any Hyksos attack, at least until the pharaoh could be interred. Hui felt a rush of relief that Tanus was still alive, but unease knotted

his stomach at what he heard in those words: there seemed little hope. Once the pharaoh was in his tomb, what then? A last fight, and death for all of them?

Tanus narrowed his eyes when he saw the new arrivals, but kept talking. Taita nodded to him and turned back to the accompanying soldiers.

'Stay here,' he hissed. 'Guard Tanus with your lives, and when he leaves to visit the queen, as he will, I am sure, stay close by his side with your swords drawn.'

'What now?' Hui said once they were moving back through the palace. 'Isetnofret must be here somewhere.'

'We go our separate ways. You search to the west, I to the east. That way we can cover more ground. At this hour there will be few abroad on business. Raise the alarm if you see anything that troubles you, however insignificant it may seem.'

At the doorway, Hui watched the eunuch disappear into the shadows and then turned back to the now-deserted courtyard. The dry wind moaned from the desert beyond, whipping up funnels of dust that danced across the stones.

He roamed about the space, exploring the shadowed areas beyond the mastabas, peering into the trenches and clambering up stacks of masonry. As he rested against an obelisk, he glimpsed a figure moving on the far side of the courtyard. It slipped into the moonlight, and he saw it was Queen Lostris. Hui wondered where she might be going, then recalled Taita talking about Tanus visiting the queen later. He might be poor with a sword, but his wits were sharp, and he'd long since suspected that Akh-Horus and Lostris were involved in some secret affair. He knew Taita had been close to Lostris since she was a girl, guiding her and teaching her. He thought back to when Tanus had sent him from Basti's stronghold to Thebes,

to deliver to the eunuch a message about a mysterious woman. Was Prince Memnon even the pharaoh's son? he wondered. What a scandal that could be!

'Hui!'

He turned at the sound of his name to see Ahura and Ipwet hurrying towards him. Their eyes shone and their smiles were wide, despite the terrors they'd experienced in the city earlier that night.

'We have news,' Ipwet said.

'This is not the time,' Hui began, but he could see she would not be denied.

'It seems you are held in higher regard here than I could ever imagine,' Ahura said with a smirk.

'What do you mean?'

'We followed behind you, as you insisted,' Ipwet said. 'The guard let us in when we mentioned your name, but one of the queen's advisers mistook us for the women who tended to her. Despite our declarations, he herded us to the quarters that had been set aside for her—'

'A tent,' Ahura interjected. 'A magnificent tent filled with all the luxuries you could ever imagine.'

'The queen was there,' Ipwet continued, 'and we fell to our knees and bowed in her presence, begging her to forgive us for intruding. But when we explained the confusion, she only laughed.'

'And when we mentioned your name this time,' Ahura said, 'and that Ipwet was your sister, she seemed delighted. Tanus had mentioned what a courageous and wise soldier you are.'

Hui smiled to himself. His suspicions were correct. Why else would Tanus be talking about such matters with the queen, if not in some private setting where idle chatter floated between them?

'And then?' he said.

'The queen insisted we join those women who tend to her every need,' Ipwet said. 'That way, we will gain protection during whatever is to come. All because of you, brother.'

'I am pleased that my meagre reputation has been of some assistance,' Hui said with a bow. Then something struck him. He looked past them in the direction from which they had hurried to meet him. 'You have come from the queen?'

'Just now,' Ipwet said, puzzled by his change in attitude.

'And she is still in her tent?'

'Her nightly ablutions have begun,' Ahura said. 'The water has been fetched, the creams prepared . . .'

Hui snatched out his sword.

'What is it?' Ipwet gasped.

'Isetnofret is here. I saw her just now, posing as the queen.' His voice was tight.

Before the two women could ask him any more, Hui started across the courtyard, running towards where he had seen the woman who had appeared to be Lostris. How cunning his mother was! What better disguise? No one would approach her, question her. And she would be able to get close to Tanus with ease when she thought the time was right.

The wind whipped around Hui as he raced away from the lights of the palace, towards the darkness that clustered around the edges of the mortuary complex. Isetnofret would be biding her time out there, watching, waiting, in the deep silence of the necropolis away from where the huddled masses had been contained. Hui felt the weight of long months of loathing solidify until it seemed a rock pressed down on his chest.

On the edge of the slabs of moonlit white limestone, a maze of deep trenches stretched into the shadows, the black bands running past jumbles of masonry and wooden cranes, discarded mallets, chisels and spades. When Hui reached the edge of this chaotic area of abandoned labour, he stopped and listened.

Only silence.

He looked around, trying to pierce the curtains of gloom that seemed to hang across that place, and his nostrils flared. A bitter scent hung in the air, like crushed poppy seeds, the ghost of a presence that had just passed by.

Levelling his sword, Hui turned in a full circle. Those areas of deep darkness seemed to swell. His eyes and ears told him he was alone, but the prickling on the back of his neck suggested otherwise.

Isetnofret was there – Hui was sure of it. Close, perhaps close enough to smell his sweat, watching like a wolf, waiting for the right moment to pounce.

He tightened his grip on the hilt of his sword. Sweat trickled down his back.

'Mother?' he breathed.

He should not be afraid of her. A woman her age, lacking his strength and agility, and he a warrior, wielding a long blade that would cut her down before she got close to him. Yet her cruelty and cunning and madness gave her power, regardless of whatever sorcery she wielded. Isetnofret would go to any length to destroy him. Hui felt a flicker of dread and looked about again. Now he was seeing his mother in every shadow.

Hui fought against the fear. He imagined his sword thrusting through Isetnofret's breast, cutting her cold heart in two. There she would be, tumbling to the blood-spattered limestone in front of him, pleading for mercy with a trembling outstretched

hand, and he looming over her, as cruel and emotionless as she had always been: denying her, revelling in that terror he saw in her eyes when she realized her crimes had brought her to this dismal end. Hui would be her equal in that contempt for anything which stood in the way of desire. She had made him this way.

And then Hui saw his father's kindly face hovering before his eyes. Justice at last, for the man who had been better than all of them. Justice for the man who had loved him, and taught him . . .

Hui turned quickly, but too late.

Fingernails raked his face and he fell back. He tasted blood on his split lip, and a moment later Hui realized those claw marks were burning like fire. He tried to push himself up, but his legs seemed incapable of supporting his weight. Somehow he found the strength, but when he stood, he lurched like a drunkard. The distant lights on the palace flared like starbursts, and the darkness all around seemed impenetrable.

'What have you done to me?' he croaked.

As Hui fought to keep his thoughts from slipping away, he sensed someone approaching. A woman swayed up and placed her hands on her hips as she looked him up and down. Contemptuous laughter echoed. When he peered into the blurred face, he was sure he was looking at the queen. But then he blinked, and Lostris' features melted before his eyes, slipping away from the skull as the spell faded. And there stood Isetnofret, as cold and hard as the last time he had confronted her after the damning judgment of Lord Bakari.

His mother's dark eyes glittered, but that laughter sounded hollow, and then it turned into a low moan of anguish.

'You killed him. My boy, my handsome boy. You killed him.' Tears rimmed her lids, but her lips were pulled back from her

small teeth like a cornered desert cat. 'For that alone you will suffer as no other.' She spat on the ground.

Hui's vision swam. He could still feel the furnace of his rage growing hotter by the moment, until he was sure it would consume him.

'There was no need for Qen to die,' he slurred. The scratches on his face seared from whatever she had infected them with. 'Do you not see? It was your lust for power—'

'You took his life!' Her cry became a shriek, and in it Hui heard only madness.

Hui levelled his sword at her. The moonlight shimmered along the bronze blade.

Isetnofret sneered at it, swaying beyond its tip, almost as if she was daring him to attack. She slipped to one side and started to circle him. Hui did his best to track her, but every movement was slow and clumsy.

'You think any earthly weapon can harm one such as I?' she said. 'Seth has blessed me with his power. He has seen my dedication to him, my sacrifice. Seth, Seth, Lord of Chaos, our God of Fire and the Desert, King of Envy, Master of Trickery.'

She smiled and her eyelids fluttered shut in ecstasy.

Hui saw his moment and stepped forward, but he was too weak, too ponderous. Inwardly, he cursed himself. Surely he could not fail now, not after all the sacrifices, after fighting so hard to reach this moment.

Isetnofret's eyes opened and they were harder than ever.

'Seth, Lord of Violence!' she cried. 'Look!'

She stabbed a finger at the nearest trench.

Hui peered into the depths. The dark at the bottom was squirming, and when his eyes adjusted to the shadows, he saw the trench was filled with venomous serpents: cobras,

their jewelled cowls glinting, and horned vipers, ochre scales ghostly in the dark. Scores of them, hundreds perhaps, twisting and coiling around each other.

'The serpents serve me as I serve Seth,' she breathed.

Hui staggered away from the edge of the trench. The world seemed to be shifting around him as if there had been a great earthquake, and he wavered, flailing to keep his balance.

'I will finally have the power I deserve.'

'The Ka Stone is destroyed,' Hui croaked. 'And so is your dream of immortality.'

Isetnofret paced around him, beyond the reach of his blade.

'But Egypt will still be mine. The gifts Seth has bestowed will let me bend the Hyksos to my will. The Queen Lostris, the young pharaoh, your master Tanus . . . all will become dust. This night I will ascend to the height of the gods.'

'No.' Hui waved his sword weakly.

'All my life I have struggled, and calculated, and forfeited the simple pleasures of lesser people.' Isetnofret seemed to be speaking to herself now as she continued to circle. 'I agreed to marry your father, that weak and cowardly man, because his office brought the influence I needed. He gave me a son, a beautiful son, the only good thing he ever did for me during his miserable life.' She spat again. 'And when he took that sow to be his second wife, he had no further interest in me, or in his son.'

'She was a good woman.'

'I prayed to Seth for her death, and he answered me.' Her voice was as cold as the bitter wind across the Sinai.

Hui swayed and felt the ground crumble away beneath his feet. Catching himself, he stumbled forward.

Isetnofret's eyes flashed. She knew victory over him was only a breath away.

'And you are your father's son, to the very core.'

His mother meant to wound Hui with her words, but he felt pride. He remembered Khawy's decency, and his generosity and love, his deep belief in duty and honour. The fire in Hui's heart burned brighter, driving away some of the effects of the poison with which she had tainted his mind.

Hui lunged with his sword, but it was a sluggish strike and his mother laughed. He cursed himself again, but he was growing stronger.

Isetnofret seemed to sense it, too.

'Now your time is done.'

She slipped off the straps of her dress and let the sheath slide down her body until she stood naked before him. Moonlight gleamed across the curves of her breasts and her belly and her hips.

'I bare myself before Seth so he can see my intentions are pure,' she breathed. 'I offer myself to him, and I will become his consort.' Her lips curled into a cruel smile. 'You will die as it was always intended. And then I will cut up your body and scatter it to the four winds, so the afterlife will be denied you. You will not be trapped here, though. No. For I will swallow your wizened soul and it will only add to my power. And then not even Tanus will be able to stand against me.'

When Hui looked at her nakedness, he thought of her congress with Qen by the pyramid in Lahun. The disgust strengthened him, tipping the scales as he fought with his own conscience. Isetnofret had not only stolen his father from him, but his brother, too. She had corrupted everything she touched. She could not be allowed to survive.

Isetnofret raised her arms to the heavens and muttered words in that same language which had echoed from the Ka Stone. The wind blasted colder, and he shuddered. Overhead, the

stars seemed to be going out, like candles snuffed by the priests in the temple at the end of a ritual.

A shadow swept across the necropolis, coalescing behind Isetnofret, taking form. A towering figure, as black as night, with a beast's head. The edges wavered, but Hui felt sure he was looking at Seth himself. Slits of light glimmered as the eyes opened.

Was he dreaming this? Was it delirium? The vestiges of the poison coursing through his veins?

Hui thought back once again to that secret night-time ritual by the pyramid in Lahun, and the crazed desire Isetnofret had later admitted to him when she visited him in his prison. To ascend to godhood and join with Seth – that was what she had said. Madness. Of course it was. It must be. And yet . . . And yet, what if Seth had come now to create that dreadful union?

Only her death could prevent that terrible outcome. Hui felt his resolve grow even stronger.

'Cower,' Isetnofret breathed. 'Cower before powers beyond your imagining.'

Hui held his head up. 'No. I stand here for my father, for Ipwet, for Tanus. For Egypt.'

'Will that courage stand in the face of this?'

Isetnofret swept a hand towards the jumble of trenches. Hui could see nothing at first. Then he sensed movement, a figure swathed in shadows, lumbering towards them with the uneasy steps of a child learning to walk.

'Who . . .?' he began.

But then Hui realized the outline of that form looked familiar, and all warmth drained from his body.

'Your friend Kyky was denied the afterlife,' Isetnofret uttered. 'And now he is coming to punish you.'

Hui thought he might go mad.

'This cannot be!'

'Kyky loathes you for what you did.'

Images of his friend's dead face, the decaying flesh, flickered through Hui's mind, and he drove them aside. He felt a sickening rush of remorse for the part he had played in his friend's death.

'No!'

Hui's anger surged and he threw himself forward, slamming into Isetnofret. Caught unawares by his sudden movement, she couldn't resist when he flung his arm around her neck so her head was pressed against his chest. Her body writhed against him like one of the snakes in the trench. She clawed at his arm, but this time the wounds didn't burn. Hui could smell her musk, that bitter scent of poppies, and it filled his head.

Kyky moved towards them, step by step, as relentless as death.

Hui gritted his teeth, trying to drive the vision from his head. But he felt his resolve begin to drain from him. He was unmanned by that terrible remorse. He held his sword below her ribcage. One stab and this would all be over. Vengeance achieved, finally.

His hand trembled, growing weaker.

Isetnofret muttered a stream of incomprehensible words, and Hui felt his skin crawling with the sensation of sudden rapid movement. He glanced down. Scorpions swarmed across his body, curled tails ready to pump poison into him.

Hui cried out and leaped back, sweeping his free hand to knock the lethal creatures away. But his fingers met no resistance, and when he glanced down again he saw the scorpions had vanished. An illusion.

Isetnofret stepped away, smirking.

'Weak, like your father.'

Kyky edged closer. Soon the moonlight would strike his face.

Hui looked past Isetnofret, to where he thought he had glimpsed the god. He still sensed a brooding presence, but it had retreated into the darkness. Another illusion to terrify him? He would never know.

Illusions, everywhere.

Summoning up the last of his fading strength, Hui turned to face Kyky. Terror gripped him for one moment, and then he pushed through it. He slashed his sword across his friend, but the blade passed through as if it were cutting mist.

Kyky faded away. The spell had been broken.

Hui felt his resolve come flooding back, and he spun round. Isetnofret was muttering another spell, distracted. Leaping forward, Hui lashed out with his blade. This time he felt it bite, and glistening droplets trailed behind its flashing arc.

His mother had thought him weak. She'd believed that her conjuring of Kyky would reduce him to a quivering wreck. But Hui was no longer the son she knew. And now she would pay for her mistake.

Blood gushed down Isetnofret's naked body. Her hands flew to her neck, where a gaping wound had appeared. She tried to staunch the flood, her eyes wide with shock.

Hui's sword fell to his side. Isetnofret lurched, her body now drenched from neck to thighs. She pawed at the slash across her throat with increasingly weak strokes. Hui stared deep into her eyes, hoping to see some contrition for her crimes at the end, but there was only a dumb incredulity that someone so powerful could have failed.

Hui glanced across the trenches. No sign of Kyky, if he had ever truly been there. The god, too, had departed.

Here, finally, was an end to it. His father had been avenged. Egypt had been saved from his mother's cruelty. Perhaps now he could find some peace.

Isetnofret pitched to one side, into that long, dark trench. A wild hissing rose from the depths, and when Hui peered in he saw the pit of serpents churning over Isetnofret, biting her flesh, pumping their poison deep into her. Still clinging to life, his mother lay there as the burning venom flooded her veins, paralyzing her, the agony coursing through her system.

Her eyes stared up to the stars, even unto the end.

The sails billowed and the lines strained. A fair wind hurried along the river, taking away the sulphurous odour of burning that still hung over Thebes. On the deck of the galley, Hui shielded his eyes against the brassy morning light and studied the broken city that had once been his home. Khyan had been right. It was lost to them, as was all Egypt.

The Hyksos had crossed the river. King Salitis had three hundred chariots on the western bank, and two full regiments of elite warriors. Under Tanus' guidance, Hui had overseen the building of forty of their own chariots to bolster the Egyptian defence. It was not enough. They did not have the men, either. No victory could ever be achieved now. Any resistance would quickly become a slaughter.

That left them with one option.

Hui walked to the prow and followed the snaking line of the river to the hazy horizon. They would go south, beyond the cataracts into the wild lands that had never been mapped. South, into Africa. An exodus unlike any that had been known, with the Queen Lostris and Prince Memnon on the royal barge, Tanus and the remnants of the army, and as many citizens as they could carry, on their decimated fleet of ships.

'What will it be like out there?'

Tau had appeared at Hui's side and was following his gaze into the distance.

'There will be danger, no doubt,' Hui replied, 'and adventure and mystery and wonders of which we can only dream.'

Hope, he wanted to add, of a new life, free from war and misery and the cruelties inflicted by those who only desired power.

The boy grinned as if it was all a game, which it was to some-
one of his age. Hui remembered that time well. He felt drained.
The lust for vengeance that had been his constant companion for
such an age no longer lived within him, and yet he felt no release
either. No peace. His mother was gone, his brother, too. His
father had finally been avenged. But it did not put things right.
Khawy was still gone. The love he had showered on Hui was still
missing. And now there was no purpose to his life. He was adrift.

Once Tau had ambled away to throw pebbles into the eddies
along the riverbank, Hui trundled down the plank to the quay-
side where the frantic preparations for the voyage were still
being made.

Fareed leaned on his gnarled staff, his stony features as
unreadable as ever.

'Any news from the scouts?' Hui asked.

'The barbarians are racing towards us as fast as they can,
in a twin-pronged attack. One from the north, from Asyut,
the other from Esna in the south, where they had already
penetrated. They will smash us to pieces between hammer
and anvil – at least, that is King Salitis' plan. I would wager
if you stood on the roof of the Palace of Memnon, you would
see their dust clouds approaching in three days.'

'Three days,' Hui mused.

Could they complete their exodus in that time?

Fareed eyed him askance as if the desert wanderer could read
his thoughts.

'I hear Tanus has hatched a plan to buy more time.'

'What can he do?'

'Risk his own neck, and those of his men.' Fareed shrugged.
'I would expect no less of him. Kratas is to lead a force to the
north to slow the Hyksos advance. Tanus will travel south.

They will do what they can and then board ships to join our voyage south. If they survive.'

Hui felt his chest swell. He didn't think his admiration for the general could get any greater.

Yet when he looked along the western bank, he could see what was at stake. Those thousands of refugees clustered beyond the docks, waiting, watching with yearning eyes. They all knew that if they were left behind, many of them would die – from hunger, from disease, from the barbarians' swords. Others would be reduced to little more than slaves.

'How has it come to this?' Hui breathed. 'Eternal Egypt, the beating heart of civilization, gone.'

'Nothing is ever over,' Fareed replied.

Hui left the desert wanderer studying the frantic activity along the docks and threaded his way amongst the bellowing men heaving jars and baskets and bales of food onto the ships. Scribes stood by with scrolls and brushes, marking the inventory. Quartermasters barked and pointed directions, back-handing the apprentices when they did not move fast enough. After the vile atmosphere that had hung over the refugee camp in the mortuary complex, Hui breathed deeply of the spicy aromas of cumin and coriander and the fruity scents of the oils.

Pushing his way through the confusion of the crowd, Hui stepped into a calmer stretch of the quay where the royal barge was moored. Slaves busied themselves on board, making sure the vessel was ready for Queen Lostris and Prince Memnon. The journey south would be arduous, and they would be sailing into uncharted territory. Every effort would be made to ensure the royal family had all the comforts needed, and that both were kept safe.

For a while Hui lounged against a pile of bales in the morning sun, until he glimpsed the familiar faces striding from the

necropolis with a group of the queen's attendants. Ipwet and Ahura pulled away from the others when they saw him.

'The physician has tended to you?' Ipwet asked, reaching out towards the scratches on his face.

Hui pulled back – they were still sore.

'Whatever poison my mother used has already faded,' he said. 'The physician has given me some foul-smelling unguent to paste on them at night.'

'Will it scar?' Ahura asked. 'Scars make a man, or so the Shrikes believed.'

'Missing teeth and eyes and fingers make a man, according to those rogues,' Hui said. 'In which case, I am happy not to be one.'

Ahura smiled, an honest smile free of the coldness that had once consumed her. Ipwet was good for her. Hui could not deny that.

He leaned in and whispered, 'Will you have to keep your love a secret on the royal barge?'

Ipwet and Ahura eyed each other.

'Half the queen's attendants enjoy each other's company,' his sister replied with a sly smile.

Her face softened and she hugged him. Hui was enchanted by her show of affection, and he held her for what seemed like an age.

'Father would have been so proud to see the man you have become,' she whispered in his ear before pulling away.

'You! I would have a word!'

Hui looked past the two women and saw Taita marching down the gangplank from the royal barge. He remembered the eunuch's praise when he'd been shown Isetnofret's body. He'd hurried away to inform Tanus of the plot and the part Hui had played in disrupting it.

'You are well?' Taita asked.

Hui felt surprised. The wise man had never asked after his well-being before. Yet there was a world behind those three words, was there not? Had the death of his mother and brother wounded him? That was what Taita wanted to know. Hui was warmed by the concern.

'I am well,' he replied, 'and all the better for leaving the past behind.'

Taita nodded. 'Let us be hopeful and trust what lies ahead.' His face darkened as he studied the heaving mass of desperate refugees. 'Every fleeing Egyptian wants to be part of the exodus.'

'Do we have enough ships?' Hui asked, looking along the masts swaying on the river's edge.

Taita sighed. 'I calculated we had space for only twelve thousand. The queen, of course, had her own opinion. No hard choices should be made, she insisted – no abandoning of the aged to a terrible fate, no leaving behind the wounded or the sick. These are her people. She said that time and again, and she would care for them all as if they were her children. Anyone who wishes to come will be allowed to do so.' He shook his head. 'Our ships will be so low in the water, a sudden swell might send them straight to the bottom.'

Hui was moved by the queen's words.

'The magnificence of Egypt will live on in these people. The carpenters and scribes and artists, the farmers and potters and smiths. There is the hope of days yet to come. Egypt will survive, and one day a return will be made.'

Hui sensed Taita looking at him oddly, as if with new eyes, and he frowned.

'What is wrong?'

'Come with me.'

Taita strode ahead and Hui followed. They rounded the throbbing life on the quayside and moved away from the swarm of refugees. Beyond the edge of the docks, a pen had been built for the horses they had rounded up. Hui watched them canter and play. Proud beasts, strong and noble. No finer sight had he seen all day.

'Tanus wished for you to be rewarded for your success in disrupting the plot to take his life.' Taita was smiling as he stared at the steeds, and it brought a light to his features that Hui had rarely seen before. 'But what reward would be of use to a man like you? Wine, gold, women?' The eunuch shook his head.

'Any or all of those would suit me,' Hui ventured.

Taita shook his head. 'But here – *here* – is a great reward, that only you or I could ever appreciate.'

He reached out an arm towards the horses.

Hui furrowed his brow, not understanding.

'You will be our Master of Horses,' Taita said. 'The care of these creatures will be under your eye. The grooms will work to your commands, as will our charioteers, whom you will train until they have all the skills you have exhibited.'

Hui felt his spirits soar. This was a fine reward indeed.

'The future of Egypt lies here,' Taita continued. 'Once we have amassed enough horses, we will be ready to take on the Hyksos and reclaim our land. And you will be the one who makes that happen.'

Hui couldn't tell if the eunuch was teasing him, but he didn't care.

'I accept this fine gift,' he said.

'Good. Then ready yourself. You will lead our chariots and grooms with these beasts south today, along the banks of the river, farther inland where necessary. And you will meet with

the fleet past the first cataract. From there you will continue south, matching the pace of our ships.'

Taita walked away, calling, 'Do not let us down, Hui of Lahun. This is the first step along a new road for you. A new road and a new life.'

Hui grinned. He liked the sound of that.

Afterword by Tom Holland

Tom Holland is an award-winning historian, author and broad-caster. He has adapted Homer, Herodotus, Thucydides and Virgil for the BBC. In 2007, he was the winner of the Classical Association prize, awarded to 'the individual who has done the most to promote the study of the language, literature and civi-lization of Ancient Greece and Rome'.

Holland is the presenter of BBC Radio 4's *Making History*. He has written and presented a number of TV documentaries for the BBC and Channel 4, on subjects ranging from religion to dinosaurs. He served two years as the Chair of the Society of Authors, as Chair of the PLR Advisory Committee and was on the committee of the Classical Association. His most recent book, *Dominion*, published in 2019.

The New Kingdom is a work of fiction; but like all Wilbur Smith's novels in the series that began with *River God*, it is deeply rooted in historical fact. Egypt is the most golden, the most glamor-ous of civilisations. It is also one of the most venerable. *The New Kingdom* is set more than three and a half millennia ago. Even then, however, Egypt was fabulously ancient. The Egyp-tians of Taita's day were as far removed from the founding of the pharaonic kingdom as we are from the collapse of Roman Britain. No other state had such a profound sense of its own antiquity.

The chief cause of the continuities that run like threads throughout Egyptian history, and which reached all the way back to the fourth millennium BC, was geography. Egypt, observed the Greek historian Herodotus, was the gift of the Nile. Every year, in August, the great river performed a miracle. Swollen by summer rains falling in distant Ethiopia, it burst its banks. For several weeks, all the cultivable land in Egypt lay under water. Although this might sometimes bring death, more generally it brought life. The silt deposited by the floodwaters provided the Egyptians with soil of a quite staggering fertility. Mud sustained harvests; harvests sustained a flourishing population; a flourishing population sustained the writing and the art, the ceremonial and the extravagance, the temples and the monuments of an incomparable civilization.

Small wonder, then, that the Egyptians themselves should have oriented themselves not to the north, as we do, but to the south: the direction from which the Nile flowed. The great river, they believed, began its course beneath the series of spectacular and dangerous rapids they termed the First Cataract. All of Egypt between these rapids and the location far to the north where the Nile Valley broadens out to become a delta they termed Upper Egypt. The delta itself they called Lower Egypt. Originally, the Egyptians knew, these had ranked as distinct kingdoms. Then, around 3000 BC, the king of Upper Egypt, a great conqueror by the name of Narmer, had annexed the Nile delta. Upper and Lower Egypt had been joined in a single kingdom. Every pharaoh, from that moment forward, had taken as his title 'Lord of the Two Lands'.

It was the Nile, then, that provided Egypt with its spine. More than that, however, it provided those who lived beside it with their very understanding of the cosmos. The contrast

between the fertility of the Nile valley and the aridity that stretched beyond it, between the blackness of the alluvial soil and the redness of the sands, between the monuments to civilization that lined the river bank and the savage emptiness of the desert, haunted the Egyptians. In particular, it sharpened for them, to a peculiar degree of intensity, their sense of the joys of life. If they can often appear to us today a people haunted by death, then this is because they yearned so very passionately to triumph over it, and live eternally. Originally, back during the early centuries of Egyptian history, the prospect of attaining divinity in the afterlife had been something only a pharaoh could enjoy. It was the dream of attaining resurrection that had inspired the construction of the most celebrated of all the many monuments in Egypt: the pyramids. Each one had been designed to set the dead king laid inside it on the pathway to the gods. 'A staircase to heaven is built for Pharaoh, that he may ascend to heaven thereby.' In time, however, the dream of an afterlife had come to be shared by an ever broader proportion of the population. Spells and rituals that previously had been exclusive to Pharaoh had ended up mass-produced. Officials who had the walls of their tombs decorated with scenes from daily life, be it a sumptuous feast or the beauties of the Nile, dared to dream of enjoying such pleasures after death. The alternative was too dreadful to contemplate. The Book of the Dead, a guide to the afterlife, left anxious Egyptians in no doubt as to the horrors that might await them if things went wrong. They might be menaced by giant snakes; have animal-headed demons hack off their limbs and consume their hearts; be forced by the gods to eat their own excrement. Even pharaohs were haunted by such nightmares.

In death, then, as in life, the Egyptians imagined the world as divided between twin realms: the Nile valley, and what lay beyond it. The horrors that a soul was obliged to negotiate in the afterlife were merely enhanced versions of the dangers that lurked out in the red sands of the desert: vermin, bandits, and the like. Beyond the deserts in turn, of course, there lay other kingdoms; but these as well, so Egyptians knew, only served to emphasise the degree to which their own beloved Egypt was a land apart. Foreigners were inherently contemptible, the agents of barbarism and chaos. The supreme duty of Pharaoh was to keep them at bay. So it had always been. Narmer, the first king of a united Egypt, was portrayed on a stone tablet standing resplendent in front of ten headless corpses. Scholars today debate what precisely the scene illustrates: perhaps the conquest of the Delta, or perhaps the symbolic victory of royalty over the forces of anarchy. Either way, it conveyed an understanding of good and evil that the Egyptians were never to abandon: that it was the responsibility of Pharaoh to uphold the divinely ordained pattern of the universe; that only if he were successful in this mission would his subjects be able to enjoy peace and order; and that danger, out in the savage wilderness, was perpetually lurking.

For most of Egypt's history, the authority and power of the monarchy was sufficient to keep the frontiers of the country secure. The Egyptians, protected by their ramparts of desert and sea, had no need to worry about predatory enemies as did the less fortunate peoples of other lands. The centuries passed. Pyramids came to dot the land. On the banks of the Nile, the rhythms of daily life continued much as they had ever done. Then, a thousand years after the time of Narmer, the pharanoic state began to implode. Its authority fast became a wraith-like

thing. Fleeting monarch succeeded fleeting monarch. Rival centres of power emerged along the length of the entire Nile valley. For almost a century there was no central authority at all. It was a chilling reminder to Egyptians of just how precarious the unity of the two lands, of Lower and Upper Egypt, of the delta and the river valley, might all too easily become.

Its collapse, however, did not prove terminal. By 2000 BC, its various parts had been stitched back together again. The triumphant pharaoh, Mentuhotep, had his power base in Upper Egypt – and specifically in the city of Thebes. His dynastic seat was duly enshrined as the kingdom's capital. True, this status did not endure: for royal authority was more easily exercised further north, at the point on the Nile where Upper and Lower Egypt met. Even so, Thebes did not sink back into the dusty obscurity that previously had been its condition. The city was enshrined as the capital of the south. Great temples were built there. It became a stage for gorgeous ceremonial. When, four centuries after the reign of Mentuhotep, central authority began to disintegrate again, and the bonds that joined Upper and Lower Egypt to fray, it did not take long for Thebes to become a royal capital once again. True, the writ of the dynasty that took residence there did not extend beyond Upper Egypt. The delta had become a separate kingdom. Egypt, as it had been back in the days of Narmer, was divided in two. Nevertheless, Thebes was a great and glorious city. A worthy stage for a man such as Taita, and the people he gathered about him . . .

THE MASTER OF ADVENTURE RETURNS TO EGYPT IN AUTUMN 2022

FIND OUT MORE AT
WWW.WILBURSMITHBOOKS.COM
OR JOIN THE READERS' CLUB
TO BE THE FIRST FOR ALL
WILBUR SMITH NEWS!

THE COMPLETE ANCIENT EGYPTIAN ADVENTURES

Set in the land of the ancient Pharaohs, Wilbur Smith's bestselling series vividly brings Ancient Egypt to life. Following the beloved Taita, Smith's most iconic hero, this is an unmissable series from the Master of Adventure fiction.

RIVER GOD

THE SEVENTH SCROLL

WARLOCK

THE QUEST

DESERT GOD

PHARAOH

BOUND BY LOVE. DRIVEN BY REVENGE.

CALL OF THE RAVEN

The son of a wealthy plantation owner and a doting mother, Mungo St John is accustomed to the wealth and luxuries his privilege has afforded him. That is until he returns from university to discover his family ruined, his inheritance stolen and his childhood sweetheart, Camilla, taken by the conniving Chester Marion. Fuelled by anger, and love, Mungo swears vengeance and devotes his life to saving Camilla – and destroying Chester.

Camilla, trapped in New Orleans, powerless to her position as a kept slave and suffering at the hands of Chester's brutish behaviour, must learn to do whatever it takes to survive.

As Mungo battles his own fate and misfortune to achieve the revenge that drives him, and regain his power in the world, he must question what it takes for a man to survive when he has nothing, and what he is willing to do in order to get what he wants.

An action-packed and gripping adventure about one man's quest for revenge, the brutality of slavery in America and the imbalance between humans that can drive – or defeat – us.

AVAILABLE NOW